White Gypsies

RACE AND STARDOM IN SPANISH MUSICALS

D0746574

Eva Woods Peiró

 University of Minnesota Press
Minneapolis
London

Portions of chapter 1 were previously published as "Visualizing the Space-Time of Otherness: Digression and Distraction in Spanish Silent Films," in *Visualizing Spanish Modernity*, ed. Susan Larson and Eva Woods (London: Berg, 2005), 283–300. Portions of chapter 2 were previously published as "Silencing and Celebrating Spain's Roaring Twenties: Negotiations of Identity in Two Silent Films, *La Venenosa* (1928) and *La sin ventura* (1923)," in *Mountain Interstate Foreign Language Conference Review* 9 (2002): 36–57. An earlier version of chapter 3 was previously published as "Ambivalent Stardom and the Race for Modernity in *El negro que tenía el alma blanca* (Benito Perojo 1926)," in *Arizona Journal of Hispanic Cultural Studies* 10 (2006): 59–67; reprinted with permission.

Published by the University of Minnesota Press
111 Third Avenue South, Suite 290
Minneapolis, MN 55401-2520
http://www.upress.umn.edu

Library of Congress Cataloging-in-Publication Data

Woods Peiró, Eva.
 White Gypsies : race and stardom in Spanish musical films /
Eva Woods Peiró.
 Includes bibliographical references and index.
 ISBN 978-0-8166-4584-8 (hc : alk. paper)
 ISBN 978-0-8166-4585-5 (pb : alk. paper)
1. Romanies in motion pictures. 2. Musical films—Spain—History and criticism. 3. Race in motion pictures. 4. Ethnicity in motion pictures. 5. Stereotypes (Social psychology) in motion pictures. 6. Romanies—Spain—Andalusia. I. Title.
 PN1995.9.R67W77 2012
 791.43'6552—dc23

 2011031751
Printed in the United States of America on acid-free paper

The University of Minnesota is an equal-opportunity educator and employer.

20 19 18 17 16 15 14 13 12 10 9 8 7 6 5 4 3 2 1

WHITE GYPSIES

To my father, William Forrester Woods

Contents

Preface

W hile I was writing this book, several global media events reso-
nated in all-too-familiar ways with the films that I discuss. In
2004, in anticipation of his performance in Madrid, Ben Harper, the
popular African American musician, was lauded as "Cantautor negro,
corazón blanco" (Black singer, white heart) (El país, 28 May 2004).[1]
The surprising cachet that this expression still has in the early twenty-
first century was echoed by the tragic death and subsequent perverse
memorialization of Michael Jackson, whose desire to be white repli-
cated the fate of the Afro-Cuban protagonist in El negro que tenía el
alma blanca (The black man with a white soul).

In the political sphere several European governments, among them
Spain, established the Decade of Roma Inclusion in 2005, suggest-
ing that public opinion was leaning toward a more hopeful and ex-
panded political consciousness of people of Roma descent. In January
2010, Spain assumed the EU presidency, and the year was labeled the
European Year for Combating Poverty and Social Exclusion;[2] imme-
diately after, the Roma advocate George Soros called upon Spain to
lead Europe in bettering the conditions of the Roma. Following this
request, the Spanish prime minister, José Luis Rodríguez Zapatero,
announced that during his presidency he would push for initiatives
for the pueblo gitano (Gypsy people), and in April 2010 he officially
recognized the celebration of the Second European Roma Summit.

Yet in the aftermath of the August 2010 order by French prime
minister Nicolas Sarkozy to dismantle three hundred Roma camps
and expel from French soil thousands of Roma men, women, and chil-
dren, a curious article by Andrés Cala appeared in the September 16,
2010, issue of Time magazine. The title, "Spain's Tolerance for Gyp-
sies: A Model for Europe?" opportunistically showcases the purport-
edly good behavior of Spanish governmental authorities toward their
Roma, in stark contrast to the French deportations. Cala's article em-
bellishes the past and present of Roma with questionable statistics and

euphemistic references to the sedentary Spanish Gypsy population, a misleading term that whitewashes centuries of violent assimilation-ist protocols—restrictions on language, dress, and profession—as well as state-sanctioned segregation.[3] Spain has not, it is implied, misused European social funds in this time of austerity. "Spain is different," he explains. Any reader remotely familiar with Spain's history would wince at this expression, which was coined by Manuel Fraga, Spain's minister of information and tourism from 1962 to 1969. Whereas most writers today use the expression for sarcastic emphasis, Cala blithely offers this cliché as if it were a novel tourism slogan. Perhaps, he knows full well that if Spain became a new and better destination for Euro-pean Roma, the grandiose façade of tolerance would crumble.

Whatever Cala's aims, his (faux) tourist catchphrase dovetails per-fectly with its human interest story, anchored by a racial uplift narra-tive. Including just one interview with a token Roma person, a certain Antonio Moreno, owner of a four-bedroom home replete with a swim-ming pool and a photography and video studio, Cala simplifies and naturalizes the remarkable success of one individual within a complex macrocosm, erasing the Roma's long history of virtual economic slav-ery in Spain. In other words, *Time* makes commonplace the unique trajectory of Mr. Moreno, who has risen above the drug trade while living on "Madrid's most dangerous street."

Time's story displays remarkable similarities to the films discussed in this book. Like the quasi or white Gypsies who starred in these films, Moreno's gumption and inherent talent allowed him to "make it," to move up and secure a spot on the stage of Spanish modernity. Both Moreno and *Morena Clara*'s protagonist demonstrate the power-ful ideology of this mobility narrative, which continues to appease and inspire non-Roma audiences by whitewashing the historical violence toward Roma in Spain. Whether literary, journalistic, or filmic, stories of hypervisual (white) Gypsies constitute an archive organized under a regime of racialized vision whose contents—folkloric (primarily Andalusian) musical comedy films popular between the 1920s and the 1950s—are linked to important geopolitical strategies and conflicts.

White Gypsies is the first microhistory of these musical comedies to focus on the intersection of race and modernity and thus runs counter to most academic, critical, and virtually all mainstream views of the genre. My analyses will probably not coincide with how Spaniards have

remembered or interpreted these films. Movie audiences of the time might have enjoyed these comedies as escapist fare or even as comforting, or bracing, flirtations with lawlessness and transgression. With the energy of song, the appeal of stardom, and the accompanying lure of film fan and marketing culture, these films, at least since 1975, have triggered nostalgia for a past unburdened by the demands of history and politics.

Exactly how such films were consumed when they were released is elusive, but their critical significance lies in the historical terrorization of the Roma, popularly known as the Gypsies, and other groups of color in Spain. The way these groups were known—*gitanos, mulatos, negros, moros*—was directly influenced by language and law, knowledges built upon the construction of otherness. For this reason I have carefully chosen my terminology so as to separate the fictional or filmic construct—what I term Gypsy—from the actual, historical people, whom I refer to as Roma.[4] In this book film study thus is not an end in itself but a vehicle for understanding the social, legal, and linguistic constructions of race and their material effects, a structural inequality which is in turn transversely present in cinema. By laying bare the inscription of race into film, this analysis demonstrates that the story of self and racialized other is a key structural component of Spanish mass entertainment.

Film's role in the racialization of Spanish culture has largely been ignored, however. *Racialization* refers to the process by which race was used descriptively in "situations in which it was previously absent" (Murji and Solomos, 17). But it is not enough to merely point out racism. We must probe racial constructions and their dynamics. David Theo Goldberg encourages framing such analyses of racialization so that they are "regionally prompted" and "parametered"—or mapped within their own material and intellectual histories, prior conditions, and specific modes of articulation—in order to avoid categorizing different modalities of racialization in broad, ideal terms ("Racial Americanization," 87). Goldberg seeks to analyze racial Americanization, but the concern of this study is with racial Spanishization. In Spain racialized social practices such as the written or visual representation of otherness were in place long before Columbus's voyages, and they were manifest in the Spanish state's structures of government and representation—in short, in its management of populations

(Mariscal, 15). Therefore, although the conversation around discourses of race has changed over time, continuities are evident in the way that strategies of coercion converged in the imperialist drive to protect an authentic, unitary national identity while simultaneously participating in the larger European project of capitalist modernity.

In the 1990s immigration flows from North and Sub-Saharan Africa, as well as Latin America and the Caribbean, prompted a range of reactions from scholars, media networks, and politicians. Conversations about race thus reemerged and vacillated between reactionary fears of an invasion by Arabs and angry postcolonial subjects to progressives' condemnations of these views. Many film scholars, who have rightly located these discussions within the racialized social practices and historical contiguities of coloniality, have restricted their focus to the genre of immigration cinema of the 1990s to the present. Detaching the racialization of recent immigration as it plays out in film from the larger archive of Spanish film enacts historical and philosophical blindness. It denies that racialized visions—frameworks such as borders and visibility—have been fundamental to the production of knowledge under Spanish modernity and that they inhere as much in today's cultural processes and artifacts as they did in the cinema of the early twentieth century.

In the visual regime the overly visible figure of the Gypsy plays a disproportionate role in representing Spain in fiction and film (Charnon-Deutsch, "Exoticism," 254), embodying the popular understanding of racial realities and molding these realities in the process. In this book I show how racial, sexual, and class anxieties reverberate within the filmic forms and throughout their complex plays of meaning. Exploring the racial parameters of a filmic genre obsessed with identity, I reinterpret these texts and their contexts in light of their Gypsy-faced white Gypsies or racialized characters and performers. These imaginary individuals index how racial thinking is projected and understood in a broad swath of Spanish cinema. Understanding these racialized mappings does not in itself enact social change, but it can inform the attitudes of scholars, teachers, and students toward the seemingly endless struggle against poverty and racism that continues in twenty-first-century Spain. It is to this committed, critical reading of the white Gypsy archive that we now turn.

Modernity, Race, and Visibility

The logics of empire are still with us, bound to the fabric of
our daily being-in-the-world; woven into our posture toward
others; connected to the muscles of our eyes, dipped in the
chemical relations that excite and calm us; structured into
the language of our perceptions.
— Joe Kincheloe, *White Reign: Deploying Whiteness in America*

We are race makers, Don Juans, magnificent, virile studs.
— Ernesto Giménez Caballero, *Genio de España*
(The Spanish temperament)

White *Gypsies* traces the development of a racialized vision whose
most salient expression manifested itself through Gypsy-face
and racialized characters in early to mid-twentieth-century Spanish
folkloric musical comedy films. High racial visibility contrasting with
a marked valuation on whiteness provided the audiences of these box
office hits with ideological solutions to the "problem" of race and its
protracted debates since the mid-nineteenth century. Historically cast
as ethnoreligious blood purity or as a racial alloy of different cultures,
Spain's difference had been either denied (we have no problem with
race) or experienced through the fantasy windows of literature and film
(Martin-Márquez, 39–50; Goode, 1–3; Rohr, 7–14). By examining a
few emblematic films—rather than writing a comprehensive history—
and by framing these films with readings of their silent film precedents
and their post-Franco recyclings, this book argues that folkloric film
has its origins in a range of racialized histories, story cycles, and media
and performance practices. These various texts give range and depth to
folkloric film's melodramatic narratives and its stars, called *folklóricas*,

exposing spectators to historical discourses of race particular to the Iberian Peninsula, while also bringing them into the mainstream of Western capitalist modernity.

From risqué constructions of multiracial identity in the twenties to a consolidated national brand of filmic, almost exclusively Andalusian Gypsy folklore in the late thirties and forties, these films imagined both the whitewashing and the racialization of the face of Spain. Yet charming and wily half-breed female Gypsies in mixed-race relationships with white Spanish males failed to lift eyebrows, having been stock conventions of both Spanish cinema and narratives from Miguel de Cervantes to Prosper Mérimée. By the late forties the Andalusian *españolada* film, the colloquial, pejorative term for the Spanish folkloric film, sat comfortably among the other well-established Spanish cinema genres of the historical epic, the military film, and urban comedies and dramas.[1]

Folkloric musical films were profitable ventures and sufficiently innocuous so as to warrant little surveillance. Called *españoladas* because they typically reduced Spain to flamenco and bullfighting—a tendency dominant since the eighteenth century in both autochthonous and foreign representations of Spain as an exoticized nation (Torrecilla, 3, 7, 25)—these films and their characters were relegated by critics and intellectuals to the dustbin of cinema history. In return their white, non-Roma filmmakers argued that *cine racial* (regional folkloric cinema) was the antidote to the threat that cosmopolitan films posed to core Spanish values (García Carrión, 25–47). Marginalized by the exclusively male tribe of film critics, while popular with cross-class female and queer audiences, these films celebrated a mediatic mirage of economically segregated Roma—the screen Gypsy—who became symbolically central for both the national imaginary and its market.[2]

Like the rhetoric of invading Moors that has flowed between genres and texts over the past five hundred years (Flesler, 9–10), these folkloric films were "dominant fictions" in which Spain could "catch up" to European modernity, having supposedly been excluded or at least confined to its waiting room (Flesler, 17–19). Through film the nation participated in the various strains of race talk that was in vogue in Europe and the United States between the mid-nineteenth and twentieth centuries by drawing clear boundaries between those who were considered Spanish (even when they considered themselves of mixed-race heritage) and

internal ethnic others (like the Roma or others considered to be racial contaminants), who were seen as more closely related to Arabs than to northern Spaniards and Europeans (Torrecilla, 25).[3] The creation of such symbolic (and ultimately material, or economic) frontiers was an attempt to situate Spain's racial identity as coherent and contained, whether it invoked a notion of racial fusion or the concept of a race-less Spain (Martin-Márquez, 39–50; Goode, 1–3; Rohr, 7–14). While racial fusion was in reality held together, according to Américo Castro, by the concept of racial purity, or *casticismo*—what Goode calls the "glue" that bonded different conceptions of national purity among the different parts of Spain (Stallaert, 70; Goode, 1)—the denial of race was necessary to distinguish Spain's racial purity from that espoused by the Nazis and to refute allegations that post-1942 Spain had racial conflict (Goode, 1–3, 210–16). For one of the challenges of modernity was the ability of the nation-state to project a stable notion of race.

So race was not a problem—at least, not officially. In 1948 Spain's Commission on Censorship banned the film *Gentleman's Agreement* (dir. Elia Kazan), Fox Film's highest-grossing picture of 1947, the overt reason being its heresy. Examining the reception of this film in Spain exemplifies not only how race was a problem but also how it regularly informed both policy and practice. Following the ban, a charged de-bate was waged among journalists, political and religious leaders in the United States, and high-ranking members of Spain's organs of reli-gious and cinematic censorship. It made plain how underlying reasons for the film's censorship were in fact multiple and symptomatic of how racial denial and acknowledgement penetrated the heart of the conver-sation on cinema's portrayal of racial difference, its relationship to the nation, and the nation's place in global modernity.

Kazan's drama is about an Anglo-American journalist (Gregory Peck) who goes undercover as a Jew in order to investigate anti-Semitism in New York City. Based on the novel by Laura Z. Hobson, the film was praised by North American critics for its exposure of ra-cial and religious prejudice. In line with their attempts to win over the Spanish-speaking world market, Fox had produced a Spanish ver-sion of the film, but it failed to pass the censors because of its "doctri-nal errors." According to an ecclesiastical member of Spain's Higher Council for Cinematographic Subjects, *Gentleman's Agreement* belied major axioms of Catholicism. It showed, first, that "civil divorce annuls

matrimony," second, that "there is no difference between Jews and Christians," and, finally, that "in the religious order, Christians are not superior to Jews and that if they are held to be superior, it is because of the venom that millions of fathers have inoculated in the minds of millions of children" (*Spain and the Jews*, 12). Although divorce and adultery were the church's ostensible concern—mortal sins according to the Catechism—other Hollywood films with similar taboo subjects had been allowed distribution in Spain, albeit with a nip and a tuck.

Condemning the ban, the *New York Times* published a spate of articles between October 1 and 2, 1948, protesting Spain's censoring of the film. In a dramatic riposte Spain's director-general of cinematography and theatre, Gabriel García Espina, sent a note to the North American press, via the embassy in Washington, responding to the *New York Times*: "There are no racial problems in Spain. We have no Semitism or anti-Semitic conflicts in this country, and due, precisely, to the beautiful and traditional Spanish concept of human liberty, all these distressing racial differences that have perturbed and apparently continue to perturb the life of countries are foreign to us and we wish that they remain to be so." He continued, "*Gentleman's Agreement* depicts a stormy and cruel aspect of North-American life, an aspect that is totally unknown to Spaniards. Judging from the Spanish text provided by Fox Films, this film tells of racial struggles that do not affect or interest us, because we solved this problem many years ago with ample human spirit."[4]

If there had been racial tension, it no longer existed. What most likely underlay his defensive response was an acute sensitivity to the Black Legend, an argument that spawned visual and literary story cycles portraying the Spaniards as obsessed with pure bloodlines and willing to expend all resources to subjugate their colonies under Catholic rule. Fervently stoked by England and France and other European players in empire, this narrative provoked just as many defensive Spanish literary and visual retorts (Mariscal, 19). But Spanish imperialists, counter to the dominant fiction of the Black Legend, argued that unlike England, Spain was enriched by its *mestizaje* (racial mixture) with the indigenous population (133). This "mestizaje bicultural" (Walter Mignolo's term) operates as a final synthesis in which the dark side of modernity, especially Spain's full collusion in African slave commerce, is cloaked by a mythic and salvific interethnic cohabitation with American indigenous

peoples. Blackening and racism are outside of Spain's horizon of consciousness and foreign to "our home," situated though it is within a western European environment: "The evil is without, and the racists are the others" (Buezas, 136). As Calvo Buezas has said, Spain's racial fusion has been manipulated to justify both its colonial enterprise in Latin America and its expansion in Africa.

The *Times*'s articles had threatened Spanish Catholicism's unbreakable tie to biological race (Catholicism was in one's blood) and its rejection of secular ideas of self and government. In the rethinking of nationalism after World War II, states that considered themselves modern were pressed to take a stance on the issue of race, and Spain was being called upon to defend its position in the face of pressure from one of the most powerful and influential countries on the globe.[5] The legitimate citizenship of ethnic, immigrant, and racialized groups—whether Jews, African Americans, or Spanish Roma—was an issue of population management, a way to gauge the productivity and control the unruliness of marginalized populaces. As *Gentleman's Agreement* showed and Al Jolson had proved in *The Jazz Singer* (1927), Jews were white and thus modern and needed to be recognized on the level of national discourse. But how could Spain's most conspicuously racialized group, the Roma, be modernized in light of the long history of Gypsy romanticization and exploitation? And how could Spain's relationship with its Roma be modernized, taking into account its complicated racial history, its national struggles over Castilian centralism versus Catalan, Basque, and Galician claims to autonomy, and its protracted colonial presence in Africa?

If being modern meant imitating Hollywood but with a Spanish twist, and if racial critiques like *Gentleman's Agreement* were modern, then Spanish film needed to take a stance on Spain's internal discriminations. In the forties Spain's filmic conversation about race had failed to represent Roma as totally white and assimilated. Race could not be invisible, not just yet. Once its "fundamental theological errors were corrected," *Gentleman's Agreement* was released in Spain as *La barrera invisible* (The invisible barrier). It was a reasonable new title. Gregory Peck's all-American character exposes how discrimination can affect even those whose skin color does not pose a visible antecedent. As his searching, balanced investigative report implies, the United States is inevitably moving toward integration, race neutrality, and increased

individual liberty, however problematic that is in actual practice and for a country still fully segregated.

In Spain, despite the supposed absence of racial tensions, race was ubiquitous, an idea that over centuries had been palpably felt—people believed that being Spanish or Catholic was in their blood. Yet blood was invisible, and it was virtually impossible to tell Jews, Arabs, and Christians apart. Thus, "the very lack of visible signs that so troubled the Inquisition indeed shows the difference between this earlier instantiation of religiously raced difference and later versions of racism attendant upon the hugely profitable African slave trade" (Greer, Mignolo, and Quilligan, 14). Popular thinking thus revolved around notions of ethnoreligious purity or contamination. In the nineteenth century, however, as anthropology became a science and began to influence public legal discourse and colonial policy, the idea that Spaniards were the product of a mixture of races became amenable to both liberal and conservative anthropologists, doctors, politicians, and intellectuals. Spanish identity was the culmination of a process of racial fusion. That accepted, differences of opinion arose as to which kinds of fusion were more advanced or less advanced (Goode, 166). Depending on one's prejudices, fusion could lead to healthy or degenerative mixing. These ideas were not, as Goode demonstrates, emerging in isolation but in dialogue with other, primarily German (like the Aryan supremacist Otto Ammon), French (de Gobineau), and Italian social scientists (Cesare Lombroso) of the time. Indeed, conversations about race were becoming increasingly transnational, and film would offer an opportunity to display racial ideas. The difficulty was how to present such a historically charged and debated concept in a coherent way. If in the United States race was being grafted onto cultural images of progress (Peller, 131), how could a Spanish notion of race preserve its dominant status in the face of Cold War exigencies?[6]

Spanish Race Talk

Spanish identity, if it was to be distinct, required terminology that could signal the border between racialized otherness and the self. In this section I briefly outline some racial terminology and historical debates that supported much of the ideological work of Spanish film before the fifties. As we shall see, most efforts to circumscribe a pure

racial identity most often ended up in confusing and contradictory representations of racial fusion or in a racial mixing that justified the goal of empire (Labanyi, "Political Readings," 10, 16–17). Although terms like *white* or *black* were less frequently employed by Franco's political-religious National Catholic rhetoric or Falange propaganda, notions of whiteness were safeguarded by constant references to *raza* and *lo castizo* (racial purity). *Castizo*, a word derived from *casta* (caste; from a Latin root transferred to India by the Portuguese), originally denoted purity of plant or animal species, or ethnoreligious purity. During the Christian Reconquest (718–1492), casticismo defined the struggles of Christians who drew strict boundaries between themselves and the increasingly confusing mixtures of old and new Muslim and Jewish converts to Christianity. Castizo identity imbued Spanishness with supposed innate characteristics—asceticism, military discipline, chivalry, and fanatical Catholic morality. From these associations castizo also symbolized rancid conservatism (fear of the new), as opposed to the enlightened, *afrancesado* (Frenchified), and, following that, popular, marginalized, and exoticized tastes that became the fashion for *gitanismo* (Torrecilla, 21–22, 33).

In the sixteenth century, however, *castizo* simultaneously acquired the valuative connotation of sexually pure, or lineage uncontaminated by Jewish or Arab blood (Stallaert, 21–22). Here, we clearly see the ideological shift in the sixteenth century from "religiously coded racism" to "color-coded racism," the "consequences of early modern European expansion in Africa, the subjugation of the indigenous populations of America, and the evolution of [slavery] into the hugely profitable transatlantic slave trade" (Greer, Mignolo, and Quilligan, 2). In the eighteenth century *castizo* came to express linguistic or stylistic lack of contamination.[7] Although one could be castizo from Andalusia (a "pure" Andalusian), the association was most often made with Castilian identity (hence Américo Castro's notion of *lo castizo* as the glue holding together Franco's otherwise plurinationalist Spain). Spanish identity thus inherited the binary of white, Visigothic, Christian, European versus black, Arab, Jew, Gypsy, African, Native American.

Although the term *castizo* was still used by liberals and religious nationalists alike, intellectuals and anthropologists that did not accept racial purity's existence still believed healthier racial mixes could invigorate the nation, such as if Spaniards mixed with northern Europeans

instead of Africans. Although Miguel de Unamuno, for example, distanced his position from the belief that pure races were superior, his belief in the need for Spain to regenerate itself was eugenicist in its assumptions. By rejecting the Restoration system and its antiquated Inquisitorial politics and by opening "itself up to contacts from abroad and europeanizing itself, Spain could racially reinvigorate its identity" (Rohr, 14). Unamuno thus unwittingly made clear his partiality toward higher races or a more distilled notion of race. Other liberals, such as Ángel Pulido y Fernández, prescribed philosephardism as a way to filter and strengthen racial identity. That the expelled Spanish-speaking Sephardim could aid in the recovery of Spain's former glory, "eventually became a tool in the hands of a neo-colonial lobby which argued that peaceful commercial penetration of Morocco would pave the way to colonial expansion there and help regenerate the Spanish economy" (Rohr, 7).

The María Moliner *Diccionario del uso del español* (Dictionary of Spanish usage) defines *castizo* as what is pure, proper to a certain region; not falsified or inauthentic (549–50). Folkloric musical films tried to present a castizo version of Spain, but critics and audiences were divided on whether they could faithfully represent either Andalusia or Spain. This quixotic search for truth in representation resembled historical and political efforts to locate and maintain blood purity or, in contrast, a more pure racial mix. Such quests invariably created contradictions.

A case in point is casticismo's remaining a commonsense ideological signpost for the political Right: the Fascist Falange Party (founded in 1933) and the monarchists, both of whom supported Franco throughout the Spanish Civil War (1936–39) and installed his dictatorship on the ideological pillars of National Catholicism. In contradictory fashion Franco navigated the global political conversation on race by shifting his position on the Jewish question between a standpoint of embrace (philosephardism) and one of rejection (an insistence on racial purity), depending on the circumstances. He allowed safe passage for Jews fleeing the Holocaust, but their entry was contingent upon their agreement to pass through and not remain in the country.[8] At the same time, in his conversation with Nazi ambassador Dieckhof, Franco declared on December 3, 1943: "Thanks to God and the clear appreciation of the danger by our Catholic kings, we have for centuries been relieved

of that nauseating burden" (Robinson, 8–9). He blamed "all ills on the Ashkenazi Jews of German and Northern European origin" (Rohr, 7) and viewed the Sephardic Jews of northern Morocco as mere instruments in the hands of Spain's geopolitical interests. Most recently, the journalist Jacobo Israel Garzón found the document that exposed Franco's collaboration with the Nazis to eliminate the six thousand Jews that were known to reside in Spain in 1941 (Jorge M. Reverte, "El regalo de Franco para Hitler: La lista de Franco para el Holocausto," elpais.com, February 16, 2010).[9] Jews in Spain supposedly existed only in novels (principally by Galdós) or in scholarly works by specialists in Hebrew studies (Díaz Más, 346–47).[10] In film, as Román Gubern has assiduously located, they were confined to oblique views, as in the documentary Los judíos de la patria española (1931), by the Falangist and philosephardist Ernesto Giménez Caballero,[11] or secondary roles, as in Rojo y negro by the Falangist Carlos Arévalo (1942), ¡A mí la legión! (dir. Juan de Orduña, 1942), and La torre de los siete jorobados (dir. Edgar Neville, 1944) and more explicitly in La dama de armiño (dir. Eusebio Fernández Ardávin, 1947) and Alba de América (dir. Juan de Orduña, 1951).[12] But these pale exceptions made race even more quantifiable, confirming that Jews were the statistical outlier and thus diminishing any potential threat of otherness from within the Spanish state.

The idea of difference as an invisible barrier to sameness—recall the translation of Gentleman's Agreement to La barrera invisible—had cultural familiarity for Spaniards. Spanish audiences could grasp the logic of sameness and difference that ran across a spectrum of black to white, together with the racial values associated with these colors since the early modern period. Castilian whiteness was an invisible norm, and blackness, a hypervisible difference. The Gypsy and the Jew were, however, the racial difference that defied vision attuned to phenotypical appearances.

The critique of race in Gentleman's Agreement was fundamentally destabilizing to Spain's self-conception as a modern and fully assimilated nation. First of all, translating the title literally to "Un acuerdo entre caballeros" would have actually made sense, to a certain degree. The problem lay in how the term "gentleman," or caballero, was co-opted by National Catholic discourse.[13] In 1938, García Morente wrote, "To my mind the intuitive image that best symbolizes the essence of hispanidad is the figure of the Christian knight" (55). He argues that in

English "gentleman" is "an entire ethos, a sociology and a way of being that is typical of the English people," whereas in Spanish *caballero* is both "gentleman" *and* "knight." *Caballero* captures the essence of the Spanish soul, the paladin defender of a Catholic God, whereas the public, cosmopolitan, and liberal notion of the gentleman is embodied in the English social contract and in civil and human rights (109).[14] The feudal term *caballero* breathes a historical spirit that kept Spain isolated from European liberalism, enlightenment, and capitalist development during the eighteenth and nineteenth centuries (115). In García Morente's opinion, however, the ideals of feudalism (individualistic, private, spiritual, warrior-like being) are not reactionary. Writing in the late thirties, it seemed to him that they gave renewed life to the mission of National Catholicism and that the organization of society must combat the crisis of "public culture" (democratic liberalism): "Human civilization will once again go through a kind of Middle Ages" (115). The *caballero español* (Spanish knight/gentleman) represents, then, "the predominance of reality over abstraction, the individual over the nation, the private over the public" (115). Far from the austere Protestant work ethic compatible with capitalism, this Catholic-individualist model was nevertheless quite well suited for capitalism, as Botti and others have convincingly argued. The *caballero cristiano* has no interest in cultivating fine interests, art for art's sake, or earthly pleasures: these other cultures—socialist, liberal, Masonic, and Jewish—apply their energies to terrestrial virtues and see "human commerce like a system of refined pleasures and the depth and sanctity of love as a complicated web of delicate subtleties . . . but the Christian knight feels in the depth of his soul disgust and disdain for all of this adoration of life" (98).

This shaky logic nevertheless proved successful in promoting the nationalist claims that blamed Spanish Marxism "on the racial fusion of Jews and Moors with Spaniards," as well as the Hispano-German nationalist warning to Muslims that "in the event of a Republican victory Jews and Communists would rule Morocco and that [the Muslims] would become the underdogs" (Rohr, 6). Spain would become a province of the Soviet Union, and Communism would overrun humanity (Flesler, 26). Collapsing Judaism, Communism, anti-French sentiment, and Hollywood, such paranoid remarks were the cornerstone of Francoist cultural policy. Although not immediately present in film, this anticosmopolitan and anti-Communist rhetoric governed

state practices (censorship) and influenced filmmakers' decisions. In contrast to Goebbels, the Spanish Right rejected outright popular film for its link to base mass entertainment; film, it was argued, should have loftier goals.

In *Primer plano* (Close-up), the right-wing cinema magazine begun in 1940 and edited by Manuel Augusto García Viñolas, the chief of the Departamento Nacional de Cinematografía (National Ministry of Cinematography), Ernesto Giménez Caballero describes Spanish cinema as having "one of the highest and deepest moral tasks of all of Europe." He asserts that since Spain is "a Catholic, essentially Roman country with a universal sensibility," perhaps other Fascist cinemas, such as Italy's, should look to the potential of Spain's Fascist cinema industry, which had the values of Fascism but was run by private hands. Even when Spain collaborated on films with the Germans, from 1936 to 1938, the joint company was private on the Spanish side, though state run on the German side. For the mystical and heroic mission of Spanish cinema could not be expressed by comic, rebellious Gypsies. Arguing that the españoladas should be rejected, Giménez Caballero wrote: "We will not accept the return to Gypsies, to the knife, because these Gypsies and knives are more of an exogenous invention than one of our own and they have heaped upon us enough ridicule and confusion" (*Primer plano*, May 30, 1943).

Film was key to the expansion of this imperialist discourse.[15] During Franco's forty-year dictatorship (1939–75), passing as Catholic and pro-Franco was not merely recommended but legally enforced, and infractions were punishable by garrote. Even at the cinema, which had offered an escape from Franco's cultural revolution in the early postwar, spectators were obliged to sing the Nationalist anthem and perform the Fascist salute before the start of every film.[16] For the *caballero cristiano*, penetrating the space of the private and the individual was not hypocritical but an honorable and civilizing gesture.

The same day the *New York Times* published "U.S. Catholics Hit Spanish Film Ban" (October 1, 1948), Spain observed the Day of the Caudillo (Leader) national holiday and Franco's twelfth anniversary as chief of state. Institutionalizing National Catholicism (the regime's sanctioned ideology) had rehistoricized the national narrative and transformed holidays, street names, and all other traces of the former government, the democratically elected Second Republic (1931–36).

Through censorship of all media, including the mail, the National Catholic police state patrolled the limits of all public discourse, enforcing citizens to chant Franco's slogan, "España, una, grande y libre" (Spain, united, great, and free). The Spanish objections to *Gentleman's Agreement* were only logical given the prohibitions against divorce, adultery, the practice of any religion besides Catholicism (Spain was a confessional state), and the teaching of any material unfriendly to the church (the church had charge of the schools). The freedom Spaniards *were* encouraged to pursue was the freedom from the oppression of left-wing ideology—Communists, Masons, Jews, and atheists—all equated with cosmopolitanism and, ironically, modernity. On this same day of celebration, October 1, 1948, the *New York Times* wrote: "The Generalissimo elaborated on the strained relations between the East and West and the 'great danger' of Communism being spread not only in continental Europe and Britain, but also in the Americas, especially the United States." In this sense Franco was useful to the United States; despite the Allied boycott, Spain's commitment to fighting Communism would ultimately be rewarded, albeit U.S. style, through benign tolerance and a lack of interference.

In the same *New York Times* article, Senator Chad Gurney (R-SD), chairman of the Senate Armed Services Committee, courted Spain as a potential ally to the United States in its neocolonization of Latin America: "Spain is the mother country of almost all the Western world and it is only natural that the West looks with interest on the revival of the Spain that we knew in history." Spain's policy of Hispanismo, or Hispanic brotherhood, which had begun much earlier than 1948, envisioned the cultural reinscription of Spanish empire in the Americas primarily through film, mainly folkloric musical film coproductions with Mexico and, to a lesser extent, Argentina and Guatemala. This vision was now aligned with U.S. foreign policy (see chapter 5; Gallardo Saborido).

Because of its relationship with the Axis powers between 1936 and 1944, Spain had been boycotted by the West. The United Nations denied it membership until 1955, and Argentina was the only country willing to send aid. Yet by October 1, 1948, things began to change. Senator Gurney met with Franco to discuss "complete reestablishment of all relations between Spain and other great powers" (*New York*

Times, October 1, 1948). The next day in the *New York Times,* however, Senator Theodore F. Green (D-RI) retorted: "[M]illions of Americans are shocked that this prominent Republican has seen fit to express party approval of a government that has just banned an American film for anti-Semitic reasons."

Spain's censorship of *Gentleman's Agreement* took place not only when its film industry was churning out folkloric musical films but also at an ominous moment when world events were shaping the course of the twentieth century. Folkloric films had yet to be self-referential or parodic (as they would become in the fifties) and, despite their complex inner semantics, remained ostensibly attached to Franco's brand of the civilizing mission, as well as to larger contemporaneous geopolitical strategies and conflicts. Spain, although less famously than during the Spanish Civil War, was once again at the eye of a global political maelstrom. The U.S. postwar imperial project was on its juggernaut's path to annihilate Communism and expand its dominance in Latin America, and Spain, while not supporting American exceptionalism, ambivalently lived in its shadow and even followed suit when possible. As a consequence, Spanish modernity, a project orphaned by the death of the Second Republic, now entered a different phase in Franco-controlled Spain. Francoism was not, as many have argued, an antimodern phase but a neoimperial one that drew upon rhetoric from the Crusades and fifteenth-century notions of ethnoreligiosity, while it careened forward with a mix of quasi-Fascist will to power, the Catholic Church's integration of capitalism, and hispanidad (Spanishness), all of them ultimately amenable to U.S. capitalist imperialism. Indeed, capitalist development and Catholicism were compatible: the Fascist, authoritarian, and antidemocratic system of National Catholicism simply became an authoritarian capitalist modernity (Botti, 20–21, 30, 42). In effect, the nineteenth-century disentailment of church land and the Republican expropriation and nationalization of church property (Payne, *Spain's First Democracy,* 61, 63) drove the church to reformulate (if not reform) itself as a profitable, modern enterprise (Botti, 42–43). The person most responsible for this thinking was Ramiro de Maetzu, whose travels to the United States in 1925 had profoundly influenced him, leading to his proposal that Spain adopt American individualism and develop a viable Spanish and Hispanic capitalism (a *caballero*

capitalista [capitalist knight]) that was complementary to Catholic tradition (Botti, 62).

That Spain could now be seen as part of this larger U.S. agenda marked a shift from its previous role as bearer of the mark of antimodernity. Senator Gurney's reference to the history "we knew" was an allusion to Spanish global empire—where Phillip II's "sun never set" (a grudging admission for most Western powers of Phillip's time). Only fifty years earlier, in 1898, the *New York Times* had noted that "Spain is situated between two continents, the most advanced and the most backward, the most illumined and the darkest—Europe and Africa. . . . There are, then, in the Spanish national character, dwelling side by side, . . . civilization and barbarism" (quoted in Kagan, "From," 25, and in Martin-Márquez, 42). The *Times* ascertained and mirrored the alternating demarcations between Spain/Africa and Spain/western Europe, a vacillation that as Flesler and Martin-Márquez show, defined Spanish intellectual assessments of its ability to carry out the mission of modernity.

Where and when Spain's modernity began was thus bound to issues of race and temporality, which in turn structured filmic form and cinematic identification.[17] Whether Spain was more European or African was built into plots of interracial romance and the ensuing play between plot digressions (to spaces of otherness) and dominant story lines about the heteronormative family.[18] This visual enactment of race and time (modernity), which expressed a conflict between self and other, crystallized the question of being and not being. Such self-conflict, as thinkers from Descartes through Hegel and Sartre to Paul Gilroy have pointed out, is at the philosophical heart of modernity.

But just as plot digressions to a racialized space-time confirmed the centrality of race to the self-family-nation, the period of supposed autarchy and "antimodern" dictatorship was fully complicit with capitalist modernity. For politically and economically, the decades of dictatorship before and after the democratically elected Second Republic were never a time-out from modernity, as is sometimes thought. Instead, they were a crucial preparation for Spain's negotiations with the United States in the late forties and the early fifties; the fifties' and, especially, the sixties' expansion of media, transportation, and tourism industries; the mid-seventies' introduction of parliamentary democracy; and the

union with Europe in 1986, still under the auspices of a late–Cold War global modernity.

Nevertheless, scholarly periodization of modernity in Spain has often been clouded by the notion that Franco's dictatorship was situated in a premodernity, despite the fact that cinema was a capital-intensive product. This idea was a political symptom of the eighteenth- and nineteenth-century foreign traveler's view of Spain, yet it was grafted onto scholarly critical practice on Spain throughout much of the twentieth century.[19] Fascist anticapitalist rhetoric and the church's condemnation of individualism were taken by outsiders and internal critics as signs that Spain had arrived late to modernity, if at all, and consequently had missed the general moment of capitalism. This bias is particularly acute in arguments emphasizing autarchy and the forties' Years of Hunger, which downplay capitalist modes of production.[20]

No doubt consumerism was limited. Yet as cinema culture demonstrates, as early as the late 1910s, cinema magazines such as *Pantalla* were proudly displaying products for consumption. Although it catered to a smaller percentage of buyers, the ad culture was there, in shop and department store windows, as well as on posters and in newspapers. Magazine and billboard advertising surely played a significant role in the consciousness of femininity and spectatorship in the twenties through the forties in magazines like *Popular Film* (1926–36), *Cinegramas* (Madrid, 1934–36), *Primer plano* (Madrid, 1940–62), *Cámara* (Madrid, 1941–52), *Cinema* (Barcelona, 1946–48), *Imágenes* (Barcelona, 1945–59), and *Fotogramas* (Barcelona, 1946), to name only a few. Their stylish pages revealed sophisticated knowledge of consumer desire. Indeed, film culture of the twentieth century and its consumerist links cannot be separated from the processes of capitalism, identity formation, and racialization. Spanish capitalism did not suddenly emerge full blown in the sixties.[21]

For José María García Escudero, for instance, Francoism represented the very pinnacle of modernity. As general director of cinematography for the state (1951–52 and 1962–67), García Escudero argued that "until 1939 there is no Spanish cinema, neither materially, spiritually nor technically speaking" (19). In his view it was the arrival of Franco that brought together promotion, financing, and production in a cohesive cinema industry. Before this time cinema was, according

to González Romero, sporadic, disconnected, and individualistic. His term for many of the films of the twenties, *producciones minifundistas* (pocket-sized productions; González Romero, 19), might cast capitalism as late in coming to the Peninsula, but it also espouses the will to ambition. Film would display Franco's project as both modernizing (technologically) and ideologically (racially) superior vis-à-vis colonial subjects, internal others, and the Jewish-Communist-Masonic conspiracy. *Gentleman's Agreement's* postulation of racial tolerance as an index of modernity—however problematic we may view today's terms such as "racial tolerance"—flew in the face of a regime which asserted that Spain's modern-feudal and raceless face could be reconciled with modernity. For as Martin-Márquez, Rohr, and Goode have shown, even arguments that championed Spain's melting pot were never about accepting racial diversity, whether in theory or practice, but were instruments for justifying the expansion and maintenance of Spanish colonies in Africa and cultural and economic policies of neocolonialism in Latin America.

Spanish historiographers of the Franco regime thus shifted their portrayal of Spain to its imperial role. A natural development could be imagined connecting the Christian consolidation of the feudal kingdoms, the reconquest of Arab Spain, and the forced conversion or exile of the Jews and Muslims. The Catholic kings had been heroes of a united Spain, and Franco would pick up that banner, restoring Spain to its golden days of global empire through aesthetic styles (architecture, painting, and literature) and rhetoric that incorporated the idiom of imperial language (Dent Coad, 223–25). That the quest for a mythically pure Spain might be quixotic was itself a censored question, and this denial was written into Francoist history textbooks. In its construction of the nation, National Catholicism skimmed lightly over eight hundred years of occupation and rule by the Muslims. The following excerpt, from a second-grade history book published in 1958 and bearing an equestrian Christian knight on its cover, poignantly illuminates the visual and narrative inculcation of an implicitly racialized Christian superiority:

> Muslim civilization does not originate with the Muslims: the Arabs appropriated this civilization as they went along conquering peoples. In reference to our own country, it is clear that

the invaders [the Arabs] learned from her, among other things, agricultural techniques. Spaniards were, in many cases, those who directed the great works of Muslim architecture.[22]

History books' covers and images were considered, like the cinematic historical epics, military films, and missionary films in Africa or the Philippines, vital instruments for guiding Spanish spectator-citizens through the visual optic of castizo culture or its complement, the racially fused imperialist contender in capitalist modernity.[23]

Film, indeterminate and polysemic, both the embodiment and the projection of modernity, was not only the dominant form of media in the period discussed in this book but the visualizer par excellence. By the twenties most theaters had been converted into cinemas. By 1911, Barcelona, a city of under one million inhabitants, had 139 locales where films were being projected. (Madrid had considerably less cinemas by all accounts—only 25 by 1918). By 1913, going to a movie cost less than a theater ticket in a ramshackle theater (Minguet Batllori, 94; Sánchez Vidal, El siglo, 29). Radio was complementary to film rather than competitive with it, and television—confined to a black-and-white format and thus less spectacular than Technicolor—would not significantly impact spectatorship until the 1960s and 1970s. Cinema was modern. "[It] was the first mass-based, international, modernist idiom to offer a cultural horizon in which the traumatic effects of modernity were negotiated" (Williams, 22). It followed that the expression of race through the ongoing technological development of film, from silent films to talkies to color, articulated Spanish modernity's most vivid concerns.

Race, Visuality, and Spanish Gypsies

The filmic Gypsy was the result of myths, stereotypes, and fictions, an imaginary conglomeration of historical, legal, and discursive trickledown. Ironically, the large-scale fascination with Andalusian Gypsies was articulated by many of those who wished the Gypsies to disappear. Even characterizing the Gypsies was a problem: Were they thieves and itinerant beggars? Were they a cohesive ethnic group or a mix of mudéjares (Muslims who lived under Christian rule) and others marginalized by blood laws (Pym, 36)? Discussion of the extent to which

they should be integrated or removed from society filled the pages of literature and legal documents (e.g., letters of safe conduct, decrees, ordinances, and diatribes). The proliferation of this written and visual material was in blatant contradistinction to their actual population: Roma have never comprised more than 2 percent of the total population (see chapter 4 for an extended discussion on law and the Roma and Gypsies).[24]

As Richard Pym makes clear, *conversos* (Jewish converts to Catholicism), *mudéjares*, and, later, *moriscos* (Muslim converts to Catholicism) were vastly more threatening than Roma to the inquisitorial apparatus that safeguarded "Old Christians" (23, 26). Nonetheless, the crown repeatedly attempted to expel them from Spain and prohibited them from acquiring possessions in the New World (Pym, 36–41). But its efforts to assimilate, forcibly sedentarize, or annihilate Roma failed, despite the continual reiterations of the same laws over two centuries (Pym, 128). The laws' mere existence acknowledged either the crown's or the local authorities' inability to solve the Gypsy problem, and the lack of disciplinary control magnified the "acute crisis of confidence that . . . had begun to affect the nation's intellectual and religious elite" (Pym, 2). During the Borbon period's centralization and uniformization of the state, an inchoate sense of realism and draconian pragmatism inaugurated the modern period's policy toward Roma. In the late nineteenth century anthropologists, as noted, cast Roma as an obstacle to regenerating the race, while Spanish criminal anthropologists saw them as responsible for introducing violent, degenerate genes into the Spanish racial mix (Goode, 165–68). In the twentieth century Republican Spain favored the continued assimilation of Roma through benevolent paternalism, while the outright criminalization of later Francoist laws would lump together Roma, vagabonds, and homosexuals. Needless to say, none of these policies were successful (Pym, 128).

The effect of these shifting policies has been catastrophic, sedimenting racial apartheid through more than five centuries of criminalizing and ghettoizing a minority whose lack of access to basic services—housing, health, education—has been a humiliating stain on the modern face of Spain. In *El país* the journalist Javier Arroyo asks, "Why can't the Gypsy community get ahead, either in the schools or elsewhere?" (December 6, 2000). Speaking of the increase of schoolchildren from immigrant families, he laments, "All kinds of diverse

groups—regional, cultural, religious, ethnic—are being assisted, and yet Gypsies don't fit into practically any of these categories." Demographic statistics support Arroyo's claims: the low percentage of Roma receiving a complete education has been a recurring topic. Despite the attention paid to multiculturalism in the classroom, as of 1998 only 35 percent of Calé (Spanish Roma) schoolchildren had completed the state's educational requirements, one-fifth of teachers described themselves as anti-Roma, and one-fourth of students said they would like to see Roma expelled from school.[25] In 1985, "Only a quarter of Gypsy children attend[ed] school, only 26 percent of Gypsy men [had] regular employment" (Ellman, 2). According to the organization Proyecto Baraní, Roma women represent less than 1.6 percent of the population yet comprise 25 percent of female prisoners.[26] Despite having a larger minority population, the U.S. African American diaspora offers a striking parallel. As in the United States, the incarceration of the Spanish Roma constitutes a legalized form of slavery, while the symbolically central yet socially marginal role of the flamenco entertainer, like the jazz and, now, rap entertainer, remains a profitable success both in music and on film.

Spain's inability to assimilate Roma fed a history of negative and, later, romantic stereotypes that worked their way into Andalusian musical comedy films. Drawing on religious iconography such as images of virgins, the imaginary figure of the Gypsy took shape long before the twentieth century. But it was undoubtedly vitalized by emergent visual technology, consumerism, and the rise of the social sciences. The Gypsy look conveyed in prose by French travelers and bohemians was eventually commodified in film and put to service in the homogenous space-time of capitalist modernity. Thinkers such as Joseph Arthur de Gobineau, who associated entire nations with racial typologies, had been a strong influence on Prosper Mérimée, who in 1845 established the fiery Gypsy Carmen as a Spanish icon. Remarks like "Africa begins in the Pyrenees" (Alexandre Dumas) or Victor Hugo's comment that "Spain is in the Orient" effectively dislodged Spain as an imperial or cultural competitor, relieving the paranoia of Europeans worried about global empire.[27] Instead, romantic Andalusian Spain could be said to offer a useful proto-tourist escape from industrialized bourgeois life in England and France (Charnon-Deutsch, *The Spanish Gypsy*, 242).

Gypsy hypervisibility maintained the imaginary boundary between white European Spain and its internal and external others, just as it reassured spectators that there were "no racial problems in Spain," meaning that Gypsies were appropriately placed at the margin or safely assimilated. Film titles, racial visibility, and racial anxiety had been coding and managing race long before the dilemma about *Gentleman's Agreement* erupted. *La negra* (dir. Oscar Micheaux, 1919; originally titled *Within Our Gates*) is the earliest surviving U.S. feature-length film known to be made by an African American director; its change in title upon exportation to Spain revealed much about racial politics in Spain at the time. First, it brought to center stage the heroine's skin color. The earlier title referred to violated boundaries in a lynching scene, advertised in the United States as the "Spectacular Screen Version of the Most Sensational Story on the Race Question Since Uncle Tom's Cabin" (Gaines, *Fire and Desire*, 163, 321n10).[28] This lynching of a husband and wife (they were hanged together) remains one of the most gruesome images in American cinema. But for the Spanish distributor who changed the title, the switch to *La negra* allowed audiences to perform an associative leap from the unfamiliar racial uplift narrative to the centuries-old story cycle of mixed race couples. The uplift narrative, which focused on the collective experience of the rising African American bourgeoisie, was not translatable to a racial context in Spain. Spanish spectators could conceive of the white working and peasant classes in a collective drama but not the Gypsies. It was thus commercially logical to change the title to a recognizable interpretive frame—the racialized female mingled with the white male—despite the fact that this change countered the film's internal logic.

Spain was steeped in the racial contradiction of *sangre pura* (pure-blood) and *mestizaje*, and scriptwriters and directors of folkloric musical films through the end of the 1950s used it to attract viewers.[29] *La gitana blanca* (The white Gypsy), *Morena Clara* (Light-skinned brown one), *Canelita en rama* (Cinnamon flower), *La Venenosa* (The venomous one), *Torbellino* (Twister), and *La cigarra* (The cricket) were titles that insisted on race, whether it was hybrid, more white but still Gypsy, or essentially Gypsy or black. These slippages from the racial norm reaffirmed the messiness of race, which had produced terms like "mulatto" in attempts to classify an ever-elusive hybridity (Buscaglia-Salgado, 51). *La gitana blanca* takes its title most directly from a little-known

film by Ricardo de Baños in 1919, released the same year as *La negra*. Originally entitled *Los arlequines de seda y oro* (Harlequins of gold and silk), it was renamed *La gitana blanca* in 1923, apparently because whiteness might appeal to wider audiences and its white star, Raquel Meller, had enjoyed a boost in popularity since 1919. In fact, no harlequins were in the film; instead, it featured an aspiring singer and a bullfighter, two stereotypical performance careers in nineteenth- and twentieth-century Spain and the only professions that offered socioeconomic mobility in a sedimented class hierarchy. In this, they were like the old commedia dell'arte harlequin, a comic buffoon who wore a black mask and multicolored costume and who, as far back as the sixteenth century, had sometimes been played in blackface. The mask and multicolored costume embodied a spirit of mixture, passing, and fluid identity. It was therefore significant that *La gitana blanca* privileged the female character's racial makeup, banking on Meller's reputation as a popular white singer who performed both orientalist and castizo repertoires on the popular sound stage. Both her celebrity and the new film title suggested that racial essences were becoming more, not less, important as Spain experienced the modernity of the 1920s.

Like other European spectators, Spanish filmgoers were participants in Hollywood's portrayals of interracial conflict—*Broken Blossoms* (1919), *The Son of the Sheik* (1926), *The Jazz Singer* (1927), *The Singing Fool* (1927)—and over time, their relationship to the visualization of race was naturalized. Normalization did not mean that race ceased to be taboo but that the mental process of racial othering through the "interpenetrating cycle" of racial film melodrama became familiar and highly visible (Williams, 8). *La gitana blanca* interwove the formulas audiences had seen and read in Cervantes, in romantic and turn-of-the-century novels and plays, and, most important, in the popular theatre of the Hermanos Álvarez Quintero, whose works, written between 1890 and 1940, practically authored the entire folkloric musical comedy genre and constituted what Álvaro Retana calls "la dictadura del Andalucismo escénico" (the dictatorship of scenic Andalusianism) (Moix, 19). At the outset of *La gitana blanca*, white, well-born children are sold to a family of Gypsies. White slavery was a recognizable plot device.[30] Cervantes's 1610 story "La gitanilla" has as its motif the kidnapping of a child by Gypsies.[31] And in 1631, Juan Quiñones de Benavente, in a treatise called *Discurso contra los gitanos* (Discourse against the Gypsies),

"claimed that it was common knowledge that Gypsies stole children to sell them as slaves to the Barbary pirates" (Charnon-Deutsch, *Spanish*, 36). In religious pastoral plays Gypsies plan to steal baby Jesus but then undergo conversion. Actual evidence of Roma kidnappings is negligible, yet ample documentation does exist of Roma children being separated from their parents for the purpose of assimilation, especially in eastern Europe, where Roma slavery was practiced until the late nineteenth century (Charnon-Deutsch, *Spanish*, 36). At any rate, the nineteenth century was rife with narratives about Gypsies and babies, and film and the press continued this cycle. In films like *Rescued by Rover* (dir. Lewis Fitzhamon, 1905) and D. W. Griffith's first films, *The Adventures of Dollie* (1908) and *The Peachbasket Hat* (1909), Gypsies steal the babies of white families. Charlie Chaplin's Gypsy chief, Eric Cambell, abducts Edna Purviance in *The Vagabond* (1916). Reviving and visualizing a myth like baby snatching by Gypsies linked national policy concerns over indigent populations with the safety and health of the spectator-citizens who watched these dramas with morbid fascination.[32]

Even worse than slavery and baby stealing was the plot of *La gitana blanca*, where Raquel (played by Raquel Meller) and Juan are sold by their own father, who suspects their mother of adultery, soiling the family's blood purity. The two children then grow up, one a bullfighter and the other a *cupletista* (a singer of *cuplés*, short, popular narrative songs) whose arresting stage name, La Gitana Blanca, propels her to stardom.[33] Now celebrities, Raquel and Juan meet by bizarre coincidence (a classic feature of melodrama) and, ignorant of their histories, fall in love, edging toward the precipice of incest. But the climax gracefully avoids taboo when their absent father suddenly reappears and confirms that Raquel and Juan have identical birthmarks on their necks. The epidermal/paternal mark, which once again foregrounds their white skin, bears witness to the family bloodline, the historical measuring stick for racial purity in Spain. (In *La negra*, Sylvia, the protagonist, is also identified as legitimate by a scar on her neck). So Raquel marries her brother's bullfighting rival, and this happy ending reaffirms the racial status quo.

But Raquel's journey from nobility to Gypsiness, her subsequent triumph as a racialized star—La Gitana Blanca—and her final transformation into an aristocratic celebrity express a doubleness.[34] Recalling

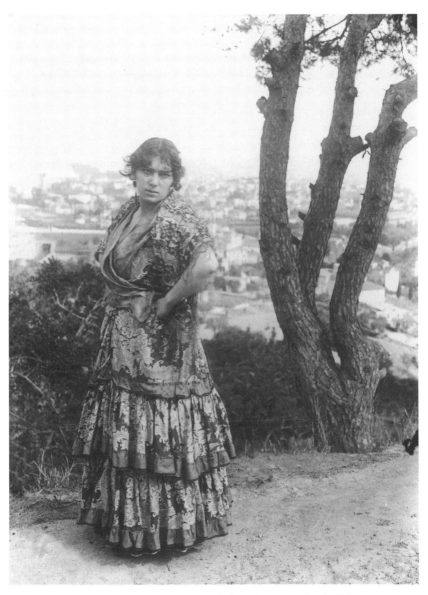

Figure 1. Raquel Meller as a rough and tough Gypsy in a promotional still from
La gitana blanca

Richard Dyer's mantra about stardom—stars are both ordinary and extraordinary—Raquel is a both/and figure, both a Gypsy cupletista and a middle-class white, a vampy Louise Brooks but, delightfully at the same time, the girl next door.

Ricciotto Canudo, an Italian film critic writing in the 1920s who was enchanted by Meller's performance in *La gitana blanca* and untroubled by the mistaken racial identity plot, found in georacialism the perfect lens for his review. Far from restoring whiteness, Meller's character marks the racial ambiguity of Spain within Europe. Of Spain's dual Latin and Saracen (North African) nature, Canudo writes, "Spain, forever tormented by its dual Latin and Saracen nature, forever in constant struggle, must without a doubt, carry out an important role in the evolution of the Latino world, or better still, the entire world" (248).[35] Canudo is referring directly to Spain's role in European capitalist modernity and its logic of empire. Spain's Latin role derived from its place in the Roman Empire (Hispania), its invasion by Visigothic tribes in the wake of Roman decline, and, eight hundred years later, Isabel and Ferdinand's unification of Christian Spain—the beginning of empire and Spain's "true destiny." Using his film review as a manifesto to call for renewed Spanish geopolitical leadership, Canudo reflects the ambition of Spain's historical-epic cinema: a cinema that was rewriting, consolidating, simplifying, and mobilizing the millennial history of the Spanish self and various dark-skinned others, a history played out in the folkloric film genre.

What was so compelling about mixed-race heroines (e.g., half Gypsy, half African, half indigenous, or half "oriental"), mixed relationships, and partially assimilated Gypsies who also looked white? White Gypsy heroines penetrated the heart of the conversation on Spain's nationalism and its place in global modernity: to be modern meant manipulating hybridity by assimilating racial difference or by excluding it from the definition of Spanishness. They foregrounded the visibility of race while they finessed the structural racism that materially underwrote Spanish society. The strategy through which folklórica white Gypsies indexed this racial modality was indirect and hardly conscious, being as they were figures of inclusion. A mirage of miscegenation, the white Gypsy embodied the difference of Gypsiness but kept this excess at the margin so as to retain the fantasy that society's main antagonism was to be found at this margin, within itself. The white Gypsy's enduring

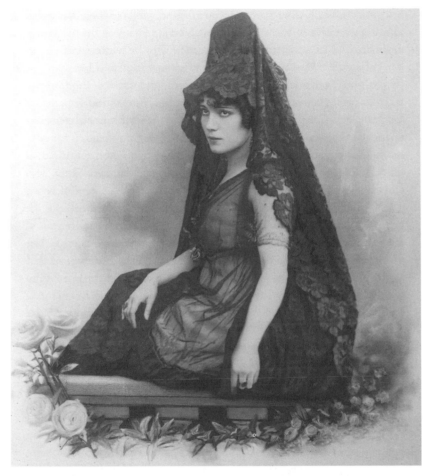

Figure 2. Raquel Meller (as Raquel, a white Gypsy) in *La gitana blanca* (1923)

success over multiple decades and with millions of spectators, then, lay in the productive liminality and the performative uncertainty that she symbolized.

White Gypsy Stars

The star was a familiar accoutrement of everyday life in small and large cities thanks to the photos of stars on posters that flanked cinemas and on magazine covers that decorated kiosks and bedroom walls.

Stars magnetically drew spectators to films, which inscribed in people's minds a narrative of becoming. A racialized star, such as the folklórica, performed whiteness, showing filmgoers how to be white. Ordinary in her antimodernness, or Gypsiness, but extraordinary in her stardom (her publicity outside of the realm of the local and thus her modernity), the folklórica's stardom dramatized more than just an individual success story; it implied that social reality is the effect of human agency— purposed and motivated action—and it became an analogy for successful participation in the larger project of Spanish modernity. A star like Concha Piquer (born María de la Concepción Piquer López), who emerged in the twenties alongside a panoply of performers of color, produced raciness (see chapter 3): an ambivalent relationship with race that toyed with physical proximity to race (juxtaposition against Afro-Cuban and Afro-American singers and dancers) while in the last instance ensuring the sole success of whiteness, a victory demonstrated in the literal and symbolic death of the Afro-Cuban singer in *El negro que tenía el alma blanca* (The black man with a white soul). Being modern thus meant the ability to mix and shock without disrupting the status quo. Concha Piquer's modernity also stemmed from her connection to the new technologies of sound film. A synchronized sound film starring Concha Piquer and dating from 1923 has been recently rediscovered at the Library of Congress. Exhibited in New York four years before Alan Crosland filmed *The Jazz Singer,* this film featuring a Spanish singer was heralded by *El país* as substantially revising film history's version of the arrival of sound (November 11, 2010). Filmed by Lee DeForest, the eleven-minute proto–music video shows Concha Piquer singing the typical repertoire of a stage folklórica: an Andalusian cuplé and the folk songs of Aragon and Galicia, *jotas* and *fados.* But it also illustrates how folkloric, localist, and racialized performances of identity signified modernity, as opposed to backwardness, when projected through breakthrough technology such as synchronized sound cinema. In the filming of Piquer singing a folkloric repertoire, the live character that had before characterized folklórica performances, in addition to the local theatrical exhibition practices, was now rendered uniform from place to place. Unhindered by the local yet projecting performances homogenously reproduced beyond national borders, the cinematic folklórica could be both familiar and cosmopolitan.

Folklóricas who were glamorous, triumphant, and—outside their

fictional roles—white contrasted with racialized characters played by real Roma like Carmen Amaya in *La hija de Juan Simón* (1934) or *María de la O* (1936). Carmen Amaya's firmly established racial identity did not project a fluid persona, resulting perhaps in her failure to project a glamorous star narrative. Her decision to transfer her career to Latin America during the Spanish Civil War would also wipe her off the Spanish charts and might explain her abbreviated relationship with film. Additionally, her Barcelonese, as opposed to Andalusian, heritage clashed with the demands for Andalusian locations, themes, and characters. Those who were lighter in skin color and qualified as white through their performance of ethnicity found it easier to assimilate with nonracialized Spanish identity formations. This racial rhetoric of color transcended politics and religion, and in a stroke it annulled the task of resolving race in any realistic way.

The same year Carmen Amaya starred in a nonparodic role as a Gypsy in *María de la O*, the film *Morena Clara* (1936) emblematized racial (con)fusion through its title, which flaunted an is–is not mode of being. "Soy Morena Clara," its hit soundtrack, translates literally as "I am the light-skinned brown one." The Morena Clara, Trini, played by the white Imperio Argentina, a famous half Gibraltarian, half Malaguenian singer and dancer born in Argentina, where her parents met performing, was not in the least brown. She embodied the somatic normativity of an Iberian variant of Hispanic whiteness, a white face with dark-brown to black hair—"a darker somatic norm image of whiteness" (Candelario, 224). Her epidermic capital, white but not too white, so that her Gypsy-faced performance could remain plausible, accommodated both Republican and Francoist binary understandings of racial identity, which either upheld racial mixing as regenerative or branded liminality as suspect. By exploring tensions emanating from the ambiguity of the Morena Clara and other filmic Gypsies, *White Gypsies* seeks to deepen understanding of Spaniards' mass production of filmic identities and how these identities either betrayed or affirmed historical, philosophical, political, and racialized conceptions of Spanishness.

The utopian aspirations embodied in the mixed-blood characters played by folklórica stars, their simultaneous whiteness and Gypsiness indexing Spain's paranoid fears of backwardness, carried an ideological load of imperialism and race that merged seamlessly with the industry of stardom. Race and empire, the dark sides of modernity,

made meaningful the trajectory from Carmen to slick cosmopolitan stars, titillating cupletistas, and, finally, flamencoized folklórica singers who somehow managed to be both the femme fatale and the girl next door (see chapters 2 and 3). In the wake of the cosmopolitan twenties and the flowering of Republican ideas, the white Gypsy, as in *Morena Clara*, made it easier for a more materialistic bourgeois society to imagine a "good Gypsy who could by example teach others a better way of life, in contrast to the femme fatale that she had represented in some modernist fictions" (Charnon-Deutsch, *Spanish*, 226). Much more than mindless escapism, then, folklóricas and their films involved citizen-spectators in entertaining narratives that revolved around issues of belonging, mobility, law, and origins, concerns that were crucial to the maintenance and perpetuation of modern Spanish subjects.

The Chapters in Review

The first three chapters of this book study the films of the 1920s that established paradigms for folkloric musical film, illustrating the ways in which local and global conversation about race was woven into the genre. Chapter 1 examines how silent film melodrama's use of colonialist narratives as plot digressions created precedents for appropriate kinds of identity and subjecthood for citizen-spectators. The insertion of these fragments of reality, framed by melodramatic family narratives, brought the spectator into a disturbingly intimate contact with Gypsy camps and the colonial battlefields of North Africa. This internally contradictory feat of filmic manipulation questioned the coherent portrait of white modernity. In chapter 2, I show how stereotypes of exoticized and idealized women in early narrative films—the fallen, the bad, the vamp, the good, and the saintly—reflected profound societal changes that occurred in the twenties in Spain, providing spectators with an amplified spectrum of womanhood. These transgressive performances by orientalized female stars would haunt the later white Gypsy narratives of stardom. As the Jazz Age ended, diverse musical expressions and more relaxed attitudes toward sexuality gave rise to the standardized and profitable folklórica stars and the Andalusian musical comedy film. Chapter 3 treats the more dangerous features of silent film—masculinity, jazz, and blackface—which were later diluted and made more digestible, feminized, and Andalusian (i.e., folklóricas).

The tragic death of Peter Wald, an Afro-Cuban jazz dancer in *El negro que tenía el alma blanca*, anticipated later constructions of race and masculinity.

The second part of the book, chapters 4 through 7, focuses on the 1936 to 1954 period of civil war and dictatorship, when sound cinema promoted itself as a national cinema, domesticating the raw projections of race of the 1920s become what modern-day spectators know as the uplifting "cornball flamenco movies."[36] The chapters progress chronologically but also overlap. For example, chapter 4 covers 1936 to 1954, whereas chapter 5 covers 1938 to 1939. Whereas in the twenties and early thirties several types of otherness occupied Spanish films (e.g., the blackness of Peter Wald or the orientalism of *La Venenosa*), post-1936 film focused on two predominant kinds of otherness: Gypsies and North Africans. Since the orientalization of Arab culture in musical films such as *La canción de Aixa* (dir. Florián Rey, 1939) and its relevance to the construction of Spanishness has been dealt with elsewhere (for example, by Elena, Labanyi, Martin-Márquez, and Santaolalla), this book concentrates on the Gypsy image. Gypsies in Spanish films became even more common after 1936, dominating the vision of otherness in Spain. Chapter 4 looks at how a folklórica playing a Gypsy at once affirmed and undermined notions of Spanish Fascism and nationalism. This chapter deals with the period between 1936 and 1938, when Hitler's minister of information invited two Spanish film directors to produce five Spanish-language films in UFA Studios in Berlin. Chapter 5 inquires into why folkloric musical films with imaginary Gypsy protagonists, such as *Morena Clara* (1936 and 1954), *Canelita en rama* (1943), and *El caballero andaluz* (1954), are invariably set against a background of legal scenarios. In contrast to the "foundational fiction" of *Carmen*, where the Gypsy is outside the law or bound by atavistic Gypsy laws, the law in these folkloric films helps to assimilate folklóricas-as-Gypsies.

This book concludes by examining two films that express different ways in which real and fictional individuals during the immediate post-Franco period not only appropriated folklórica and cupletista iconography as a platform for expressing queer desire and critique but also tapped into the excessive, queer aspect that lay residual in this genre since its vaudevillian beginnings. The transvestite folklóricas and *imitadoras de estrellas* of the twenties reemerge in these films in queer

recyclings that reconstruct the aesthetics of the white Gypsy folklórica along openly political, sexual, and racial lines.

Taken together, the wide-ranging concerns that underlay the production, content, and reception of the films analyzed in this book—(anti-) cosmopolitanism, mobility, nostalgia, law, and heteronormativity—reveal that despite these films' ostensible aim to entertain and distract, they were steeped in ideologies intrinsically connected to preoccupations about race and whiteness. We should thus see the enduring attraction of the folklórica over the twentieth century as a willingness on the part of Spaniards to engage with issues of race not posited as such but experienced in fetishistic, nostalgic terms. In other words, the folklórica provided the spectator with a final, pleasurable, and racialized end product whose history is whitewashed and made palatable. Not unlike the annual parades of orientalized Arab and idealized Christian costumes still celebrated in Levantine towns during the festivals of the *Moros y Cristianos* (Moors and Christians), the insistence on playing Andalusian dress-up on film provides insight into the contradictory ways in which race, gender, and mobility are played out as submissive and assimilable while simultaneously intriguing and desirable. The privileged optic for envisioning this economy of race was the generic lens of the folkloric musical film and its folklóricas, an interface whose tension between diversity and homogeneity was central to the transmission of national images both within and beyond its national borders.

Time, Racial Otherness, and Digressions in Silent Films of the 1920s

Those were the days in which our Army intrepidly fought in
order to carry out its civilizing mission.

— Intertitle of the film *El cura de aldea* (The village priest)

T
he time-based medium of film visualized Spain's need to "catch
up" to European time by erasing boundaries between itself and
Europe while drawing more clearly the barrier between Spain and
Africa. The preoccupation with race, coupled with a stardom narrative
that portrayed the whitewashed yet ethnicized female as a conveyor of
modernity, was a naturalized element of the folkloric musical comedy
films of the thirties and beyond. In the 1910s and 1920s, however, this
feature had already joined the mix of musical entertainment sequences
and dominant plotlines of silent film. To be sure, folkloric musical film
had its origins in a wider musical film history that included both silent
and sound film but which also imagined Spain in a specific time and lo-
cale that linked it with Europe while adding digressions that ventured
into a frontier landscape where a coherent notion of time was lacking.

The encounter with the other—Gypsies and Moroccans—took
place in the filmic digressions, which spectators had come to under-
stand as a contingent temporality where contact was both frightening
and intriguing. Late nineteenth-century historicist views of capitalist
modernity began with Europe and then spread out from this center
(Dussel; Mignolo). European time was therefore the measuring stick of
modernity, used to "conceptualize relationships between us (or our the-
oretical constructs) and our objects (the Other)" (Fabian, 28), but also
to organize and ultimately control European subjects under capital-
ism, for "rational" time occurred as discrete units that measured human

/ 31

labor, giving rise to the equation "time is money." This quantifiable time was undergirded by a kind of continuous time—what Walter Benjamin calls "homogenous time"—the time of "progress" that ran along and underneath labor time as a continuum.

Countering this continuity was the idea that time is neither divisible nor continuous but composed of contingent, unpredictable, and unknowable instants that are ultimately unrepresentable. Like Benjamin's notion of the shock, or Anthony Gidden's description of ontological insecurity and psychological vulnerability, the contingent produced genuine fear in the modern citizen-spectator. A streetcar could rush by, threatening to crush passing pedestrians; a disease, a bomb, or a baby-stealing Gypsy might appear, as it were, out of nowhere.[1] But in the safety of the cinema of attractions, the representation of such an encounter with chance exhilarated the spectator. A temporality of excitement offered relief from the monotony of labor time, while it necessarily produced anxiety. Cinema was a mechanism that ran in standardized time, but it also privileged the ultimate, impossible immediacy of the moment, the instant, so foreign to a standardized world. On film, *contingency felt real*. And for a nation concerned with its supposed backwardness, there were high stakes involved in controlling what was seen as reality.

Melodrama is inextricable from this contingent ontology of the cinema. Combinations of narrative and spectacle propelled by emotion, melodramatic excess, swift turns of events, and outrageous coincidence constituted the essence of early cinema; later, these digressions provided the scaffolding for silent narrative film and finally the theatrical subgenre of the *película hablada* (talking film), which began imitating film's rapid succession of scenes (Díez Puertas, 264). By merging narrative and the cinema of attractions, filmmakers reflected on alternative temporalities. Cinema was thus marking out modern sensibilities that Spanish viewers recognized, smoothly folding these modes of feeling (chance and the unexpected) into the melodramatization of consciousness already developed since the nineteenth century, so that the viewing experience simulated actual emotional work.

Like the digressions from homogenous time just outlined, the filmic representation of race often functioned as a digression from the dominant narrative of white Spanish space-time; at the same time, racialized space-time worked to restructure the dominant melodramatic narra-

tive. Unless they served the gaining of capital, the imaginary Gypsy or Moor were distractions from the project of modernity, as shown by the Moroccan War (1909–27) and, more specifically, the Rif War (1921–27). Yet their successful assimilation could guarantee the glory of the white castizo race, an imperative before and after, as well as during, Francoism. The narrative of self-modernization, through a white identity capable of whitewashing the Moorish-Gypsy-Jewish past, nevertheless asserted its primacy through digressions into the space-time of otherness. By the end of *La gitana blanca*, Raquel Meller's story of progress told as a stardom narrative signals the triumph of white, capitalist homogenous time over racialized space-time. In the meantime, the insertion of these fragments of reality brings spectators into a realistic and gripping contact with the other and then allows them to comfortably slip back into the (national) family narrative. Contingency could thus be effectively simulated within a familiar (and timeless) context. But this filmic manipulation exposed the real, exacerbating anxieties Spaniards felt about Moroccans and Gypsies.[2] The desire for stability was logical when dictatorship, boom-and-bust economic trends, rampant rates of illiteracy, and an imperialist foreign policy culminated in the lunacy of a colonialist war in Morocco while Spain was still reeling from the Disaster of 1898.

Akin to the anxiety over public and private identity in this time of flux is the structural instability in silent cinema of the 1920s that combines fiction, or simulated time, with documentary or real time. Siegfried Kracauer defines the area between the actuality (i.e., documentary) and the episodic or serialized fiction film as a "border region" (249).[3] His notion of border inevitably recalls contemporary references to borders as space-times of ambivalence: on the one hand traumatic and hysterical yet, on the other, constitutive of productive hybridities, unimagined utopias, and hope. In effect, the digressions in the *La gitana blanca* and other similar films are border regions with different modalities of time—that is, in tension with but not necessarily bound by capitalist modernity. But what happens to the representation of time, as an object of knowledge within practices of looking, when it is racialized within these digressive border spaces? Equally important is how the subject inhabits this space-time's conjoining pressures and pleasures, and how these relate to Spain's internal and external others, the Gypsy and the Moroccan.

To demonstrate the significance of racial digression, I look at the fictional silent films *La gitana blanca* (dir. Ricardo de Baños, 1923; The white Gypsy) and a range of other examples from the 1910s and 1920s that contain temporal and spatial digressions to the space of Gypsiness and Africa. The space-time of Gypsy camps and "Africa" (the overdetermined signifier) enables the cinematic drama of the white bourgeois subject or any moviegoer identified with this position. The significance of these digressions derives from a confluence of events: the changing phenomenology of time, the emergence of cinema, and the imperative to reassert imperial control in Africa in the aftermath of 1898, the latter being essentially an attempt to better define the anxiety-producing Spain–Africa border. In *La gitana blanca* the digression contains two parts: (1) a mother is separated from her children who are sent to a Gypsy camp; and (2) the mother's sister's lover is sent to Morocco to join Spanish troops in subduing Rif rebels. The traumatic loss of the colonies is overcome by transferring the space of otherness from Cuba, Puerto Rico, and the Philippines to Africa. And by visualizing the Gypsy population within a digression, viewers can imagine spaces of otherness as being familiar yet safely on the other side of the border. The racialized digressions in *La gitana blanca* and other similar films converge with central narratives of family separation and of threatened social hierarchies, dramatizing fears about separation and instability on the Spain–Africa border, among the anonymous yet visible enemy. If the later transparent editing of narrative cinema interpellates the spectator as a unified, transcendental subject, glossing over her fundamental difference (Hansen, 3), these silent deviations, which incorporate themselves into the narratives but tenaciously remain in tension with them, deliver a resistance and a check to this homogenizing momentum.

Some Film Genealogy

In order to understand how later cinema uses contingency and digression (and how this relates to race), it is worthwhile to turn briefly to the most elemental and inchoate forms of cinema. In the late nineteenth century, cinema played a crucial role in the representability of time. Like statistics, philosophy, and psychology, it participated in a general cultural injunction to structure time for capitalist modernity (Doane,

The Emergence, 3). The potential representability of time became an insistent issue as labor time and leisure time were fundamentally reconstituted by the expanded circulation of capital.[4] Studies by Serge Salaün on the reorganization and regulation of leisure in Spanish urban space due to electricity, or Jo Labanyi's study of the nineteenth-century novel's location within a widespread reformulation of time as seen in the rise of banks, railroads, and clocks, have shown how the media was constituted by and contributed to this restructuring, although the effects were felt in uneven ways, depending on one's socioeconomic or geographical place in society.

The earliest Spanish cinema (1896–1907) typically consisted of one long shot devoid of editing or special effects, although it did contain an element of chance and contingency, given its provenance in live events. In slightly more advanced cinema, the contingent was represented by the practices of the "actuality," Tom Gunning's term for the prenarrative "curiosity-arousing" cinema of attractions, a medium of "direct stimulation" and a "gesture of presenting for view, [or] of displaying," akin to the spectacle of fairs, popular exhibits, and the circus (73). For André Gaudreault, this was the first phase of the institutionalization of cinema, which lasted until 1908 and was characterized by sequences of attractions with no narrative interlinking them (26). By offering vistas of foreign, exotic places and times or filmed events that captured a sense of the ephemeral—for example, *La vida de los gauchos en México* (1898; The life of the gauchos in Mexico), *Un tren escocés* (1898; A Scottish train), or *Vistas de las capitales de Europa* (1898; Views of the capitals of Europe)—cinema could ease the monotony of factory work or temper the overstimulation of blasé urban dwellers, as Simmel explains (35). Even the routine could appear novel, in films such as *La Puerta del Sol* (dir. Alexandre Promio, 1896) or *Salida de misa de doce de las Calatravas* (dir. Ramón del Río, 1896; Leaving twelve o'clock Mass). New modes of spectatorial address enabled more immediate viewing experiences, and audiences now *expected* to be astonished by the visuals that assaulted them in mass print, photographic reproductions, and cinema (think of spectators rushing for cover when a train sped toward them on screen). Benjamin calls this experience "the shock." The receptive experience was, Benjamin writes, like a state of distraction "symptomatic of profound changes in apperception" (240). Mirroring capitalist modernity's new way of perceiving the world, cinematic special effects

made visible what was in everyday experience, in particular the instantaneous shocks and accidentality of the isolated instant (Doane, *The Emergence*, 133), impossible to capture in representation because representation is by defininition repetitive and therefore predictable. The playing of live music, the use of elaborate sound effects, and the shock of ethnographic photographs or anthropological films (with their seemingly unmediated portrayals of difference) enhanced this cinematic immediacy.

Cinema's capacity to record, store, and project images or sound and, eventually, to project narrative through transparent editing, enabled it to represent time in a way that was controlled, despite its own fragmented nature of instantaneous, separate frames. In broad Marxist terms, in order "to make tolerable [the] incessant rationalization" of labor that characterized industrial society, cinema interrupted its seamless narratives with digressions (Doane, *The Emergence*, 11). These travel sequences, live performances, or military exploits helped spectators escape the oppressive memory of labor time. Merely by creating the digression, cinema moved the narrative outside of homogenous (capitalist) time. Fixing this digression in an "other" time, in particular a time that was racialized and not coeval with the present, not only controlled the digression but even made it structurally useful, reinforcing the ideology of homogenous time that was symbolized by the dominant melodramatic story line. Capitalism, the supportive web within which these tensions between story line and digression, labor time and leisure time found expression, was the supporting context and the effect.

Between 1908 and 1914, during what André Gaudreault terms the second phase of cinematic practice, narrative began to integrate with the actuality sequences, even though it might still be subordinated to the actuality (26). But the desire to represent reality as the "the accidentality of the isolated instant" (Doane, *The Emergence*, 133) continued after narrative became dominant, appearing in the form of dramatizations. These residues of the actuality informed the structures of many films and were necessary to them. As Tom Gunning notes, the actuality and the narrative were "two ways of addressing spectators [that could] frequently interrelate within the same text" (81).[5]

During this period, Segundo de Chomón, arguably the most famous Spanish early silent film director, stopped making his *scènes a*

trucs (trick photography and attractions) for their own sake and began integrating them with narrative:

> Many of the distinctive features of the cinema of attractions were kept, but these defining or unique features began to be inserted into a continuous narrative which is initially very weak but which grows stronger with every film. . . . Chomón has abandoned his taste for the cinema of attractions style for its own sake, and these films are no longer a succession of trick shots, of effects designed to fascinate, and are now, just the opposite, presented to the spectator as stories, stories filled with fantasy and seductive devices, but stories nevertheless. (Minguet Batllori, "Early Spanish Cinema," 99)

Rêver reveillé o superstition andalouse (dir. Segundo de Chomón, 1911; Dreaming awake or Andalusian superstition) is significant for this embedding of narration into attraction and for its racialized topics of Gypsies and Andalusia. Here, "fantastic elements are harmoniously blended in with the diegetic whole, which displays a great command of complex narrative resources" (Minguet Batllori, "Early Spanish Cinema," 99). In the setting of an Andalusian *cortijo* (country estate), Juanita, the daughter of the cortijo's patron, and Pedro, her Aragonese fiancé, are enjoying a visit when a female Gypsy (the actress is clearly wearing brownface) interrupts them, begging for alms. Juanita throws her off the property, and Pedro takes leave of Juanita. Was his departure motivated by her intolerance of the fringe elements that live off the cortijo's charity? Here, Juanita begins to daydream, and as the camera closes in on her face, we cut to a medium shot of the Gypsy promising revenge. Here also begins a racialized digression that dominates the film, becoming the main narrative and turning the family narrative into a mere frame. In Juanita's waking dream, the bandits sequester Pedro, and despite a chase by her father's work hands, the Gypsy bandits elude them with magical powder and force Pedro into a house whose interior connects to a cave that, in turn, leads to a fantastical room. In this chamber Pedro finds grotesque monsters superbly rendered by Chomón's trick photography: human heads on crustaceous and reptilian animals preserved in bottles and supernatural arms that reach out in protest when Pedro extracts a

sack of gold from a closet. The last paranormal vision is of a ghost under black cloth holding a candelabra who then turns into the female Gypsy. Excitedly, she runs over to Pedro and leads him back to the closet with the gold and begins to hand him sacks of it. Pedro refuses to take the gold, initially confusing the Gypsy but ultimately proving his benevolent paternalism: Pedro is a model for the treatment of Gypsies. We immediately cut back to a close-up of Juanita's face, the camera retreats, and we cut to an intertitle, "Reconciled," that then cuts to the last scene, where Pedro and Juanita reunite in the cortijo patio and Juanita calls the Gypsy over to join them at the table. Exemplifying how the family narrative of a female white Spaniard (Juanita) could merge with a plot consisting largely of a racialized space-time narrative digression, the film also foreshadows later folkloric films that attempt to provide solutions to the Gypsy "problem."

In Ramón de Baños's 1911 version of *Carmen*, *Carmen, o la hija del bandido* (Carmen, or the daughter of the bandit), Carmen's band of thieves captures the painter, Salvador, who falls in love with her.[6] When royal officials attack the gang, an extended chase scene ensues in which Carmen wounds one of the guards. The painter is saved by the soldiers and is invited to stay in the castle, but remains in love with Carmen, whom he has captured in painting. At carnival festivities Carmen sheds her male bandit attire in order to attend the celebration and to seduce the painter; her partner is spotted by the officials and arrested on the spot for the death of the guard, while Carmen is apparently pardoned by the king, due to the painter's good relationship with the court. Here, the digression, in the form of Salvador's brief encounter with the Gypsies and a subsequent chase through the forested outskirts of civilization, takes place in the no-man's-land beyond the law. Salvador's longing for Carmen's body, whose painted image he caresses and swoons over, merges with the space of racial alterity in a living fantasy when Carmen puts on the Gypsy dress and becomes, like the future folklóricas of musical films, the embodiment of acceptable racial and sexual otherness.

In the last phase of silent film, after 1914 and before sound, residual attractions continued to invade the main narrative, taking the form of disastrous accidents, leaps and falls, aerial views, comic interludes, travel sequences, documentary-like episodes, long parties, leisure activities, live performances, and entertainment spectacles, all of these more

or less irrelevant to the main story's development. The more notable examples of Spanish films that immersed spectators in such digressions are *La sin ventura* (dir. Benito Perojo and E. B. Donatien, 1923), *El abuelo* (dir. José Buchs, 1925), *Malvaloca* (dir. Benito Perojo, 1926), *La Condesa María* (dir. Benito Perojo, 1927; The Countess Maria), *La malcasada* (dir. Francisco Gómez Hidalgo, 1927), *La Venenosa* (dir. Roger Lion, 1928), *El sexto sentido* (dir. Eusebio Fernández Ardavín and Nemesio Sobrevila, 1929), and *El misterio de la Puerta del Sol* (dir. Francisco Elías, 1929).

A film that reflects the influence of the actualities with especial clarity is *Águilas de acero*, aka *Los misterios de Tánger* (dir. Florián Rey, 1927), which is based on the war novel by López Rienda, an acclaimed chronicler of the Moroccan war. The novel deals with the Spanish Air Force (Aviación Española), including an airplane chase involving a Spanish pilot and a Polish female spy. The film's debt to the actuality tradition and its embedding of documentary material are evident in the following advertisment from the March 23, 1927, issue of the film magazine *Mundo gráfico:*

> In the most exciting part of this grandiose Spanish super production we see a parade of beautiful scenes, the production of which was made collaboratively by the Spanish and French armies of Morocco, the commanding general of the French troops in Morocco, the Spanish high commissioner, and the navy and Air Force. The scenes that serve as backdrop for this movie are the most gorgeous corners and landscapes of Morocco, as far as Fez, for which the excellent operator Carlos Pahíssa, who filmed the movie, obtained marvelous photographs.

In *Águilas de acero*'s multiple digressions, Spain, in its collaboration with the French army, is configured as European. In the deployment of military power and the maintenance of race distinctions, the elements of chance and contingency fuse with the normative narrative of state power and actually seem to further its goals. Carlos Pahissa's ethnographic photography makes all of this possible. The landscape registers as a set of facts, data that is then converted into scenic material for the fiction of the digression. Clearly, the bulk of the film's budget was spent on equipment and airplanes, whose speed and domination of the land

Figure 3. Publicity material for *Águilas de acero, aka Los misterios de Tánger* (1927), reading, "*Steel Eagles:* A Grand Movie about Adventurers in Tangiers"

reconfigure time and space for the spectator, bringing Africa closer yet firmly within the bounds of the civilizing mission.

Sánchez Vidal speaks to the early importance of combining fiction and reality in *Águilas de acero*, noting that it was even more important than the plot, "since one of its principal assets resided in the audacious mix of fiction and reality, half way between the documentary and the reportage—if we give credit to the testimony of those who managed to see it" (*El cine de Florián Rey*, 91). As Carlos Fernández Cuenca points out, the film was shot completely in exterior locations in Morocco; famous aviators of the day flew the planes; and the Abd-el-Kader even agreed to be an extra in the scenes showing the judicial administration of Morocco. He adds that Rey rehearsed, with good result, "a daring mix of fiction and reality, of documentary and reconstructed reportage" (Fernández Cuenca, 14). This was the Florián Rey, future director of the quintessential folklórica star vehicle *Morena Clara* (1936), who would be one of the staunchest defenders of the españolada film. Melodramatic romance playing out against the backdrop of the war appears in several other films from the twenties, among them *Alma rifeña* (dir. José Buchs, 1922), *Malvaloca* (dir. Benito Perojo, 1926; Hollyhock), *El cura del aldea* (dir. Florián Rey, 1926), *La malcasada* (dir. Francisco Gómez Hidalgo, 1927), and *Los héroes de la legion* (dir. Rafael López Rienda, 1927).

Malvaloca, based on a popular 1912 play by Álvarez Quintero, was remade in 1942 (dir. Luis Marquina) and again in 1954 (dir. Ramón Torrado). Its premise, the redemption of Rosita, a fallen woman from Málaga with a heart of gold, is a classic plot that was later used for folklóricas in *Mariquilla terremoto* (1939) and *Filigrana* (1949). The phrase "Merecía esta serrana que la fundieran de nuevo como funden las campanas" (This lass deserves to be founded as bells are founded) is repeated several times throughout the film. An abusive home encourages Rosita to seek refuge in the arms of the local playboy. Somewhat later, known as Malvaloca, she emerges from this backstory having had a child out of wedlock and better financial prospects owing to—it is assumed—intimate relationships with men. She has also become the center of attention at parties, as seen from the perspective of a drunk lieutenant whose cross-eyed gaze bifurcates and blurs the image of her dancing on top of a table. Here is the keystone of the folklórica narrative: she is an attraction to men and a distraction for citizens in general.

The significant digressions from these exhilarating, racialized space-times come when Golondrina (Nightingale), the broken bell of the convent, is refounded. In a brilliant crosscut episode, as the bell is carted to the foundry, several apparently random street spectacles create a tense buildup to the forging of the bell, which represents Malvaloca's transformation. First, a company of puppeteers features a strong man who performs "astonishing jumps" in Russian fashion while astounded onlookers comment and gawk. Then, an argument begins about whether or not Golondrina can be refounded, and a woman in brownface intervenes but only incites the entire crowd to break out into a brawl. As Román Gubern notes, it seems that Perojo had the unexpected fortune of coming across this street performance while filming in this town (*Benito Perojo*, 113). The next significant digression is to Morocco, which according to Gubern merits special reference for its novelty (*Benito Perojo*, 114). As the townspeople are donating metal items to make the new bell, an old woman brings her son's war medals to the melting pot. In a flashback she remembers the death of her son in Morocco, the military parade of recruits being sent to war, the smoky battle scenes in the trenches, cavalry charges, and a nocturnal scene at the military encampment. The bell of the convent is a racial alloy, composed of war medals earned by a hero of the Moroccan war, as well as Malvaloca's jewelry, offered up to the virgin in an earlier act of contrition.

In some films war digressions were heavily adapted. In the novel *El cura del aldea* (Pérez Escrich, 1861), the digression deals with the Spanish war of independence from France. But in its later film adaptation, the digression takes place in Morocco.[7] In another film, *La malcasada* (The unhappily married woman), the digression to Morocco serves, however, as a conclusion rather than a digression. In effect, it is the solution to the failed marriage of the noble white countess, María Escobar, to the Mexican bullfighter Félix Celaya, a philandering, aimless character haunted by the memory of the woman he dishonored in Mexico. Félix has tried to atone for his adulterous lifestyle in Barcelona's illustrious society (the film is a virtual parade of cameo appearances by famous figures of the time) by divorcing María, freeing her to remarry. But the church will not permit the divorce—a political issue embraced by the film—and he simply abandons her, going to live in the Mexican countryside with the woman and child he had

dishonored before leaving Mexico. María, with no future in Spain, moves to Tetuán to be a nurse in a military hospital, where she consoles soldiers wounded by the Rif rebels. The hospital is the equivalent of a convent: surrounded by desert and the racialized enemy, it allows her only brief contacts with civilization, although these include visits by General Sanjurjo (played by the man himself), who comes to thank her for attending to the fallen Spanish soldiers.

Although accidentality is mainly an illusion—except in rare shots where the director cannot control what moves into the frame of a stationary camera—the spontaneous events in these films disrupt the otherwise predictable narrative flow. In *La gitana blanca*, for instance, extensive footage of real bullfights was incorporated into the sequence that explains the trajectory of Raquel's brother, who becomes a bullfighter and her star counterpart. Not all spectators were impressed by such footage, however, as Ricciotto Canudo, the Italian film critic and theorist laments: "And how intolerable it is, then, the abuse of the 'documentary' of the bullfight!" (248). Canudo was perhaps right that the bullfighting scenes were excessive and lengthy, thus defeating the purpose of the digression, which offers respite from the other story lines. His critique establishes that a critical debate over *accidentality* was in progress at this time.

The organizing motif in *Misterio en la Puerta del Sol* (dir. Francisco Elías, 1929) is a tour de force display of cinematic reflexivity in which the cinephile's dream merges with the filmic material.[8] The wannabe movie stars Pompello Pimpollo (the almost juvenile Juan de Orduña) and Rodolfo Bambolino (Antonio Barbero), desperate for fame, audition with the foreign director Edward Carawa, a reference to the North American director Edwin Carewe, who sought to establish sound film in Spain (Sánchez Oliveira, 65). Waiting for their screen test, they are "distracted" and flirt with second-rate flamenco performers (aspiring folklóricas) and a cupletista, Lia de Golfi (a reference to Lya di Putti); when Pimpollo falls asleep, they enter his dream. The dream sequence is the bulk of the film, an overt commentary on the power of digressions to structure and, in this case, overtake the dominant film story. The space-time of this digression is filled with a staged, macabre murder, a sensationalist hoax based on the crime of Pablo Casado, quartered by his servant, and an eleven-minute airplane sequence comprised of documentary footage from other films with military themes.

The accidentality of these events is a glorification of technology and progress, the thrill of spectacle from a bird's-eye view that implies individualism and social mobility. This rhetoric of mass flying assured consumers that airplanes were safe, making them confident, while they enjoyed its thrill. Yet there remained the fear of technology, its irrational force and specter of violence—the plane as an instrument of war and empire. In this sequence, technology aids the spectator in overcoming the trauma, the real and deadly force of technology itself. Film distracted, covered up the trauma, encouraging us to note the anxious looks exchanged by the two passengers through shot-reverse-shots but using our excitement for the plane trip to override the fear of being destroyed.

Sometimes, documentary footage is spliced in to make the dramatization seem all the more real. These digressions often follow a character journeying to distant lands, using flashy techniques such as the pan and extreme long shots and the camera's ability to record live events, like battles, which had been previously shot for military purposes but could be used in a fiction film without referencing the source. Such scenes could prompt the writing of an entire narrative digression or justify surprise plot twists. *Découpage*—the taking of footage from other films so as to incorporate foreignness—serves both to unify two disconnected spaces and to show their difference (Ďurovičová, 147).

In *La Condesa María* the aristocratic hero is also sent to Morocco, in a digression so long that it practically constitutes a film in itself. The dominant narrative is the romance between Luis, the son of the countess, and Rosario, a seamstress. Luis's cross-class relationship with Rosario is threatened by his parasitical cousins, who fear that his relationship with Rosario will jeopardize their own degenerate existence, enjoyed at the expense of the countess. Just before Luis is ordered to Morocco, Rosario falls ill (a euphemism for pregnancy out of wedlock). In an expressionistic scene, Luis and Rosario bid farewell and receive marriage rites, framed by a play of shadows, silhouetted profiles and crisp images that contrast sharply with the white walls of the convent hospital.

Then, immediately following Luis and Rosario's austere demonstration of faith, and about thirty minutes into the film, we cut to a pan of Tetouan and its chaotic urban menagerie. The clean lines of the hospital contrast with the urban montage of unmanageable excess, where

chance dominates and scurrying robed individuals mill around the camera, emerging apparently at random from streets, houses, and suqs. These unnarrated frontal and rear shots of the citizens of Tetouan add up to a sequence of eleven takes that provide an ethnographic tableau of everyday life in the bustling city. The camera archives the activity at various urban intersections and plazas while people and animals rush past from all directions. Fruit sellers, vendors in the suq, street vendors, veiled women sitting in groups, and children and adults are shot against the architectural idiosyncrasies of the city, its arches, tunnels, doorways and windows, and decorated walls. Spectators are inundated by a wealth of detail, in sharp contrast to the castizo severity of the convent hospital.

Abruptly, high-angle long shots of a linear, orderly regiment marching through the narrow Tetouan street displace the shots of anarchic inhabitants clumped together against the buildings. As the column slices through this chaos, the camera takes medium angles of Luis, the protagonist, mounted on his horse, methodically capturing the symmetrical column from all possible angles and distances, while it documents the regiment's exit from the walled city. Emerging from the crowded metropolis, the troops are flanked by vast expanses of desert, the effect of which is once more to make the troops into a surrealist play of shapes. Like ants marching across the sand, they scar the frame in series of zigzagged lines in eleven shots of about one minute each, mapping the landscape in pulsing geometric diagrams.

In the combat scenes of *La Condesa María*, against a background of tanks firing, explosions, soldiers scrambling for cover, and montages of heavy cavalry attacks, we see the figure of Luis, edged with glowing light. His appearance in this montage is an instance of what Paul Virilio calls a "phatic" image, "a targeted image that forces you to look and hold your attention," since only specific parts of the image are defined or illuminated, while the context recedes into a blur (14). Overwhelming us with Luis's "enlightened," struggling figure, the film blurs death and barbarism, focusing only on his heroism. We are forced to accept the outward representation of Luis's inner desire to lead his men to glorious victory as the meaning of colonial war. The reality that the working classes are the ones who fight wars (the riots in Barcelona in 1909 during the Semana Trágica (Tragic Week) were rooted in the anger of the urban proletariat who were being sent to Morocco)

is pushed back by the aristocratic Luis's nationalistic heroism. Then Luis falls to the ground, slumping against a canon, and we realize that he has been shot. As he looks up, the film cuts to a second montage of scenes of destruction against which his agonized heroic figure is silhouetted. But this time Luis is the spectator of the event-hallucination, signaling that he might not live to enjoy the fame. The last shot is of a white flag brandished against the sky, a symbol of the Rif surrender and a return to whiteness, which then fades to tragic black. Then we return to the dominant romance: the camera reopens on close-ups of a rocking baby carriage and Rosario's face as she leans against the cradle, mourning for Luis. Our return is made possible by digression, proving once again that the digression is constitutive of the (national) family narrative.

La gitana blanca's digressions to Morocco closely integrate fragments of private and government-sponsored newsreels and documentaries of the Spanish–Moroccan War. In the narratives these Morocco scenes take place between the so-called Disaster of Annual in 1921, in which the northern Moroccan Riffian tribes defeated the Spanish, and the consequent revenge of the Franco-Spanish counteroffensive, which crushed the Rif independence movement of Abdel Krim in 1925. In actuality, these scenes were filmed at various times before, during, or after these major battles, an eight- to ten-year span when this war was constantly on the horizon. Such dramatization of war scenes through a documentary mode may have derived from the regular industry practice of lifting military footage from documentaries and pasting it into new films to create entertaining digressions and prowar propaganda.[9] Similar images appear in a 1925 military propaganda film entitled *Alhucemas*. This news film briefly narrates the final stages of an extremely long and drawn-out counteroffensive by the Spanish military and their subsequent reassertion of control over the protectorate, culminating in Franco's troops' amphibious landing at the bay of Alhucemas (Al Hoceima).[10] The trend would continue through the forties with Carlos Arévalo's insertion of documentary footage from Carlos Velo's *Romancero marroquí* (1939)—"stereotyped images of the muezzin, the market, and veiled women"—into the narrative segments of *Harka*, a principal African colonialist film based on a script by the former legionnaire Luis García Ortega (Martin-Márquez, 209–15). But these propagandistic insertions had unanticipated effects on the

aesthetics of Spanish cinema: they began to usurp control over each film as a total event.

War scenes, military escapades, quasi minidocumentaries—were these digressions? Or were they just as important as the main story line? The same question can be asked of supposedly digressive performance sequences in the later folkloric musical films. Did spectators attend the film to see the plot or to see the song and dance numbers? The difference between military digressions and racialized performance digressions is quite nominal, for both respond to the same internal logic. Just as military footage or ethnographic film were integral to the military digression previously discussed, the *zarzuelas* (operetta), circus acts, short theatre skits, and song and dance numbers that preceded the films were integral to the spectacle that affected Spanish cinema during its first thirty years, and they were an important feature of the folkloric musical comedy films of the thirties and onwards (see Cánovas Belchi). Even the theaters retained the memory of these spectacles, for prior to their renovation for cinema after World War I, they were the home of the popular and often tawdry variety shows. Such spectacles were alike in their formal conventions, which is to say that they were an incoherent, unmotivated successions of acts. The only remaining copy of *La gitana blanca* contains a variety number in its first digression—in fact, it occurs before the film narrative begins.

Throughout the fifties, Spanish melodrama continued to rely on spectacle but also blended spectacle or paralleled it with a racialized digression. Indeed, the near-exclusive focus on Gypsiness in folkloric films established the españolada as a racial genre quite unlike the history of progress that Spanish national(ist) cinema embodied. (The exceptions are those films set in Aragón, *Nobleza baturra* and *La dolores*; Morocco, *La canción de Aixa*; and Cuba, *Bambú*; and the Spanish-Mexican and Argentine coproductions made after 1948 [see Gallardo Saborido]). As shown by the debates between directors and critics over the usefulness or authenticity of the españolada, its status as popular yet superficial cinema excluded it from discussions of nation building. Though pundits expostulated about serious film, it can be argued that because of its lasting popularity, the españolada more profoundly and subliminally shaped the Spanish national imaginary.

The Spanish silent films of the 1920s—which had become full-length narrative features in the early 1910s—continued to rely on spectatorial

deviations and digressions structured by a racial narrative that *seemed* digressive. But as spectators became accustomed to sophisticated editing techniques, such as shot-reverse-shots and continuity editing (which, ironically, simulated reality far more convincingly than the uncut take of the actuality), they were less inclined to sit through the long interludes necessary to filming live action in real time. Dramatized live events, because they were edited, took up less time, had more shock value, and could immerse audiences in what appeared to be a chance instant. Moreover, they visualized the action from an exotic location, in this case Spain's colonial frontier in North Africa, or the borders within the nation that marked the space of internal others, such as the Roma.

Internal Others

As mentioned, *La gitana blanca* was originally called *Los arlequines de seda y oro*. It was shot in 1918 by Ricardo de Baños, shown in Barcelona in 1919, and then reedited with some newly filmed sequences in 1923 and renamed *La gitana blanca*. The print discussed here was made for a Dutch audience and attests to the translatability and popularity of this narrative.[11] When speaking of silent films, however, it is often difficult to say what constitutes a text, since so many different versions were created by the various translations of intertitles. Therefore, my analysis deals mainly with the filmed images rather than the narration or dialogue in the intertitles.

La gitana blanca's complicated tripartite plot relates the adventures of two aristocratic children. Raquel and Juan de Dios are sold to a family of Gypsies by their father, the Count of Rosicler, in order to punish their mother, whom he suspects of committing adultery. The transferring of the children to the Gypsy camp and the interactions of the butler with the Gypsies comprise the first spatial, racial digression. The second narrative digression takes off from within the first, a digression within a digression, and carries us to Melilla. Here, the camera eye becomes a full-fledged protagonist as it scans the landscape and documents the military exercises in which Captain Álvaro, the suspected adulterer (we know he is innocent), carries out his duty to the state. After the brief episode in Melilla, the film turns to the children's melodramatic rise to stardom and to the mixed identity plot. Under

the tutelage of her surrogate Gypsy family, Raquel (played by Raquel Meller) is physically and emotionally abused but nevertheless learns flamenco dance and song and eventually escapes the Gypsy clan to become the famous cupletista La Gitana Blanca. She rockets to stardom, her family history effaced by the marketable star biography of the poor Gypsy orphan who became a star. In a series of melodramatic coincidences, the adult Raquel then rejoins her long-lost father and brother, all of them recognizing each other by birthmarks on their necks. These physical signs, deeply derived as blood itself, reassign Raquel's tainted racialized identity as unambiguously white and aristocratic. Raquel marries her brother's bullfighting rival in a happy ending that reaffirms the status quo, unites the family on patriarchal property, and gracefully elides the anxieties of racial mixing or class struggle.[12]

La gitana blanca contained all the racy ingredients necessary to spawn a second film in 1923 and a novelized version of the film (published in *La novela cinematográfica*) that made the most of its adultery, Gypsies, stardom, and war sequences in Morocco. When Baños made the second version (collapsing what was originally three episodes, or serial films, into one), it was largely an attempt to profit from the star cachet of Raquel Meller, whose fame had exploded since she had starred in the first *La gitana blanca* (Pérez Perucha, 67). Chapter 2 offers a detailed analysis of Meller's career and its links with racial identity; suffice it to say here that she epitomized the beginnings of the star system in Spain. Better, she was Spain's first produced star: her stardom was fashioned by biographies, gossip, photos, knowledge of her parallel and previous stage career in Spain, Europe, and America, and her work with other American and French cinematographers.

In *La gitana blanca* the setting and buildup to Raquel's stardom take place in spaces of racial alterity. Deeper messages about racial identity and its maintenance surface in a subsequent digression that leads us first to the Gypsy camp and then to the city of Melilla. These embedded messages manifest bourgeois subjectivity, defined by its full embrace of capitalism and progress and its aspiration to power within a liberal state. The melodramatic romance reflects the claims of the bourgeoisie through the contractual union of two free souls, while the digression to otherness within the family romance provides the excitement we require from melodrama.[13] Raquel's aunt, Elvira, is unhappily married but having an affair with Captain Álvaro Valdés, who has

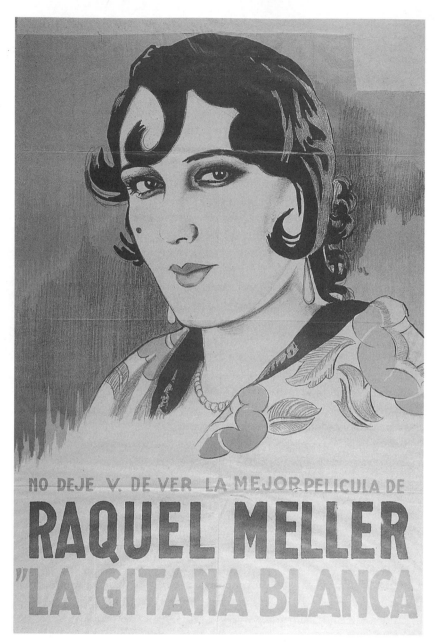

Figure 4. Poster for *La gitana blanca* (1923)

received orders to join his regiment in Melilla. Elvira and the captain have been sending their letters through Raquel's mother to avoid suspicions, but as luck would have it, the count, Raquel's father, intercepts one of the captain's letters notifying Elvira of his immanent transfer to Melilla. Thinking his own wife is having an affair, the count takes revenge. Here begins the two different plot deviations to space-times of otherness: the Gypsy camp and the following journey to Melilla, where Álvaro battles the rebellious Riffians.

The digressions are situated within a melodramatic mode that incorporates spectacle and excess (residues of the cinema of attractions), as well as hyperbolic emotion and Manichean extremes—the very stuff of mainstream storytelling, as Linda Williams puts it (*Playing the Race Card*, 22–23). The overall "homogenous time" of the bourgeois family is paced by the distractions of spectacle and shock and motivated by desire and fear (the focus on the Gypsy reinforces that ambivalence). The lens on adulterous mothers and the tragic dissolution of family shifts to the sexually and racially threatened white woman: this motherless daughter will not only grow up with the Gypsies but also, as a Gypsy, is further stigmatized by prostitution, the livelihood of even successful entertainers.

The father's revenge involves sending the butler to dispose of his now tainted patrimony. As the butler drives along on his mission, the camera advertises automobile technology and, by extension, superior European technology by its insistent shots of the car entering and speeding away from a variety of perspectives. The car disappears over the horizon, and the scene cuts to a customs-and-manners portrait of a Gypsy camp, replete with wagons and campfire, recalling the rustic, ragged Gypsies of popular illustrations, so-called ethnographic photography, and travel literature—what tried to pass for the real Roma people. For audiences of the time, the spectacle of the Gypsy camp merged with the manufactured visions of racialized entertainers, child abusers, and highway vagabonds offered by travel novels, picture postcards, and film travelogues, which presented the Roma as people of a different temporality (Alleloula, 120).[14] Abruptly, a "Gypsy hag" grabs money the butler offers them for the children, and the audience is left to wonder how the two defenseless noble children will survive their impending slavery.

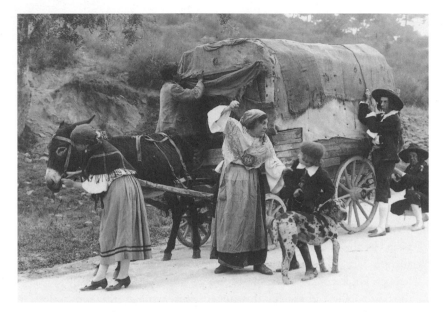

Figure 5. Gypsy caravan and the count's son getting a beating in *La gitana blanca* (1923)

The scene ends with a male Gypsy sweeping his arm across the frame as it cuts to a train busily making its way through the landscape. Such train sequences signal the departure from or arrival to a new space-time, but they are also separate digressions in themselves. The actuality of a train rushing toward the spectator is an immediately remembered icon of silent cinema, and other train films were even fresher in the spectator's memory. Ten years earlier, in 1909, for example, Ricardo Baños recorded a seven-minute reel entitled *De Málaga a Vélez-Málaga* (Hispano Films). Shot from inside a moving train as it traveled between the two cities, the film belonged to a series of similar films commissioned by Barcelona cinema theater owners Domènech Comamala and Joan Canudas, who had decorated the orchestra of the theater like the interior of a passenger wagon (Ventajas Dote, 220). Ricardo de Baños also filmed *Barcelona en tranvía* (1909) by placing a camera on the front of a streetcar. Obviously, train films were popular and predictable: they elevated a train trip to art and in essence proved that train-riding Spaniards were at the forward edge of modernity.

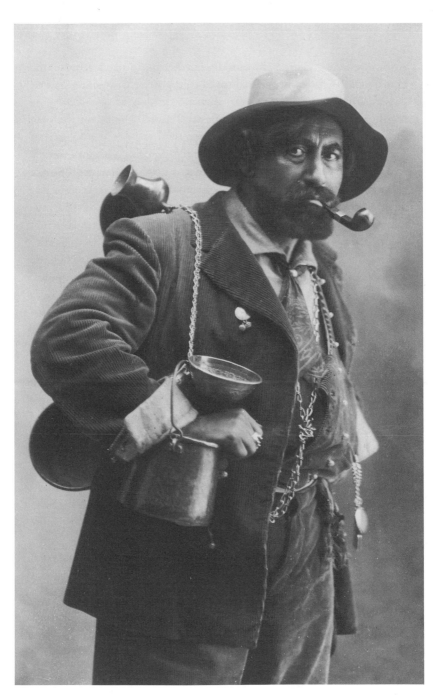

Figure 6. Gypsy man in *La gitana blanca* (1923)

And since a train digression would seize the spectator's attention, the Gypsy's barbaric gesture was sutured to the same onrushing images that unseated audiences just years earlier.[15]

This suturing makes a stark contrast between the primitive, seen through the precapitalist optic of slavery, and the modern force that slices through the land. By juxtaposing the Gypsies with automobile and railroad technology, the digression sets up the obvious economic and temporal disparities as opposing terms: "preliterate vs. literate, traditional vs. modern, peasant vs. industrial, and a host of [other] permutations" (Fabian, 22). These oppositions, which had been fundamental to modernity's own story, are strengthened as the film cuts to the butler looking out the train window at the passing landscape. Moving beyond the traditional versus modern polarity, Frederic Jameson has proposed that train tracks disappearing on the horizon operate allegorically and diegetically: the converging tracks point to a possible utopian future or utopian possibility (Jameson, 52–54).

As a passenger on a moving train, the butler is a working-class subject who (through this technology) can pass as middle class. As the interpellated protagonist of new technologies emerging in the nineteenth and early twentieth centuries, he represents the worker no longer imprisoned in the factory but now a domestic, serving the upper classes but nevertheless identified with the middle class through his train ride. With Gypsies on one side of the border and Spanish nobility on the other, the now transnational aspiring petite bourgeoisie could bridge the gap and live a larger life. Decades earlier than the cinema, the railroad had ruptured perceptual frontiers, forging intimate connections between the body, time, and space. In some ways, riding the train was eerily like watching films: "The railroad journey anticipated more explicitly than any other technology an important facet of the experience of cinema: a person in a seat watches moving visuals through a frame that does not change position" (Charney, 6). Also like the train, cinema had fused the spectator's space with other worlds. As the butler peers out the window, a match shot shows his cigarette smoke in parallel with the train's puffing stack, identifying him with the iron juggernaut shearing through the landscape. Indeed, he *becomes* the train. Like the steam engine, the aspiring white middle class embodies the modern and serves the upper classes (who own the technology) just like the machine. For many viewers in the mid-1920s, though, references to railroad technology might

have evoked the Spanish workers who died building a railroad in sacred Muslim territory in Morocco. The violent resistance by the Riffians in the battle remembered by all Spaniards as Barranco del Lobo was an invitation for the Spanish government to send even more workers, this time from Barcelona. The incident spawned the massive rioting of Barcelona's Tragic Week and is often equated with Annual as one of the major colonial disasters in Morocco (Martín Corrales, 93–94).

Everything after this point carries a double meaning. The scene where the children are sold is focalized through the butler and thus evokes contempt for the Gypsy buyer but a kind of sympathy for the butler, who has his orders but loves the children. Still, scapegoating the Gypsies for buying the children overlooks the unscrupulous participation of the middle class in the oppression of the weak (children) and the racialized (Gypsies). Cementing this overdetermined doubleness, the camera takes the viewer back for one last look at the camp where the demonic Gypsies, now the evil stepparents, struggle to lead the children to a caravan headed for an unknown destination whose unknowability is laden with terror but also offers possibility of contingency and hope. The digression at this point is driving the film due to the intriguingly ambivalent characterization of the Gypsies, who seem at once delightfully evil and horrendously cruel. The original focus on adulterous mothers and the tragic dissolution of family has shifted radically to how a motherless daughter, raised in a degenerate environment, must survive by prostitution until she wins fame as an entertainer (like the few successful Gypsies).

External Others

The next digression takes us further into moral darkness. An analysis of this disjuncture requires my own lengthy digression into Spanish military and colonial history. The last shot of the Gypsy camp is followed by the abrupt intertitle "MELILLA"—a jolting address that evokes Eisenstein's montage theory of thesis, antithesis, synthesis (two very different images are conflated to produce an entirely new meaning). Here, the contingent time of the itinerant Gypsy camp suddenly gives way to the rational time of the military sequence where the Spanish army, propelled by the flood tide of Western technology, subdues the outskirts of Melilla, the wild frontier of contingency. The columnar

intertitle, with its official weight of capital letters, strengthens the comparison between Melilla and the Gypsy camp. Its powerful title, whose signal of ellipsis functioned just as effectively as a nonlinguistic sign, had immediate resonance with Spanish audiences of the 1920s. Melilla was the military seat of Spain's closest extranational territory and the point of departure for penetration into Morocco. It was and is the most enduring Spanish colonial foothold in Africa, one synonymous with war and suffering and a source of collective angst over the safety of its Spanish civilians and military personnel (Díez Sánchez, 51). After 1911 it was normal for war events in the eastern region of the protectorate to be generically called "Events in Melilla" even though they occurred hundreds of kilometers away (Díez Sánchez, 50–51). As Margarita Lobo has put it, "The majority couldn't read and Africa was all the same place" (pers. comm.), so the Spanish protectorates of Ceuta and Melilla became metonyms for Africa. Films could be equally vague about place. In silent film production it was common practice to edit newsreels by cutting and pasting from several different shorts, and it was understood that certain images might not belong to the battle being described. For spectators, too, times and places tended to merge with each other. In this particular film the events in Melilla could have evoked the battles of Barranco del Lobo in 1909 or Annual in 1921. At Annual the Riffians retook most of the Melilla region, forcing the Spaniards into Melilla city. Not until the battle of Al Hoceima (1925) did the Spanish finally put down the Rif rebellion.

The defeat at Annual was so disastrous that it took on a mythical quality. Depending on who was counting, between 8,000 and 12,000 Spanish soldiers died. According to Sebastian Balfour, it was a "national tragedy on a much greater scale than any other military defeat suffered by Spain, including the war of 1898" (70). That the Rif saw Annual as the crowning victory of a holy war is understandable: their growing antagonism to colonial penetration, exacerbated by the errors and abuses of Spanish officers (looting, raping, disregard for local customs, disruption of the local economy), finally resulted in an explosion of violence. But for the Spaniards, only the ruthless extermination of the Rif people was sufficient to avenge the enormous casualties that remained on the battlefield, mutilated, unburied, and half eaten by vultures after the panicked retreat. Later came the bitterness and anger over military incompetence and the hordes of Spanish prisoners of

war. This loss of face for the Spaniards was exacerbated by a wave of racism in the media that reactivated myths of Arab cruelty and savagery, fueling the perennial obsession with recuperating Spanish masculinity.[16] During this time media objects such as *literatura de cordel* (broadsides) chocolate wrappers, matchbox covers, song lyrics, and comic strips promoted a graphically vulgar version of orientalism featuring extremely racist caricatures (see Martín Corrales).

Although many politicians rallied for war, it was mainly the gruesome photos and film footage of Spanish soldiers that won support for it (Martín Corrales, 126–38; Martin-Márquez, 161–74). The Spanish military explicitly supported this colonialist cinema between 1909 and 1927 in order to justify the conscription to the working class. The emergent cinema companies sent droves of cameramen to capture battle scenes, which were then shown all over Spain, and sometimes this footage quietly found its way into film melodramas. In *La Condesa María*, for instance, the digression to Morocco is comprised of footage filmed in the exteriors of Tetuan, Chauen, Mogador, and the surrounding desert. For this film Perojo obtained the full collaboration of the army based in the Rif for the shoot of the war scenes (Gubern, *Benito*, 143–44). Perojo seems to have expended every resource to glorify the army, directing two thousand extras at a time and coordinating military parades through the narrow streets of Tetuan.

Slavery, revenge, and racialized scapegoats drove these melodramatic film plots, and such topoi were easily translated to the mediatized invasion of Alhucemas. Newsreels, documentaries, and the Morocco digressions in *La gitana blanca*, *Malvaloca*, and *La Condesa María* all make use of similar structures of feeling, similar scenarios of revenge and victimization. In the second part of the digression in *La gitana blanca*, Álvaro's abrupt transfer to Melilla is sentimentally attributed to the adulterous letter discovered by the husband. But this unwarranted punishment of being sent to Morocco to fight a questionable war is unavoidably associated with the unjust draft that sent workers to die in Africa. War tore families apart and allowed for extramarital affairs, both of which weakened the nuclear family. Loyal to melodrama's strong pathos, the film consolidates these different scenarios, strengthening the need for revenge, reinforcing black-or-white morality, and channeling hatred against a single enemy. The cloudier the origins of the revenge, the easier it was for film and other ideological vehicles to

continue spreading revenge propaganda (Martín Corrales, 127). In fact, the majority of the Spanish population was against the war, due to the devastating loss of Spanish lives. To counteract this antiwar sentiment, the government, the military, upper-class colonialist interests, and the conservative mass media launched a massive publicity campaign that cast the Moroccans as inherently bloodthirsty, treacherous by nature, and in need of annihilation if civilization was to be saved (Martín Corrales, 127). In the end, the combined marketing of military footage and melodrama appealed to both male and female audiences—there was something for everyone: for men, on-location war scenes and, for women, romance and family. That appeal, combined with the inflammatory need for revenge, complemented the colonial enterprise by manufacturing compatible notions of personal and national identity.

After the brusque announcement that the spectator has arrived in Melilla, the camera pans slowly left to right across the rocky promontory of this port city. In early cinema, pans created the unstaged, on-the-scene actuality that converted the spectator from passerby to witness (Doane, *The Emergence*, 153–54). From its first use, the pan has been synonymous with this effect—as if the cameraman happened to be there at the right time to "capture" an event (Doane, 154). Negating distance and enhancing the appearance of instantaneity, the pan denies the frame as boundary, destabilizing the binary perspective of newsreel and dramatization and making the passive spectator a participant. The power of this scene, as with panoramic camera views in general, is its latent dynamism: "not man posed in landscape but man poised to move in landscape; for in a moment, the figure will ride down the cliff and across the plain" (Marantz Cohen, 72). As André Bazin wrote of the western film: "Perhaps the cinema was the only language capable . . . of giving [the West] its true aesthetic dimension. Without the cinema, the conquest of the West would have left behind, in the shape of the 'Western stories,' only a minor literature" (148). So, too, North Africa gathered magnetism not only from Flaubert and Nerval but later from Gillo Pontecorvo's using panoramic footage. Without film many landscapes "would not occupy such a prominent place in national mythologies" (Marantz Cohen, 72). Morocco, bereft of natural resources, needed to be made more attractive. Because still photography of the late nineteenth and twentieth centuries had unwittingly revealed the unsavory side of Morocco, its poverty-stricken barrenness and lack of

technology, it behooved colonialist boosters to find an alternative mode of visualizing landscape. Film could remedy this lack through montage and the carefully chosen pan, manipulating images to provide a cohesive, if illusory, vision. Morocco, albeit in a vastly reduced scale, became the setting for Spain's "Riffian Westerns," a notion that Alex de la Iglesia cleverly employed in *800 balas* (2002; 800 bullets) and that was frequently used in colonialist film between the 1940s and 1960s (see López García).

During this pan the viewer witnesses barely discernable insect-like people running across the streets of the town. The slow, methodical encroachment of the camera onto this unsuspecting coastline ironically echoes dictator Primo de Rivera's reference to the war as Spain's colonial conquest. As Sebastian Balfour reports it, "Eschewing the parallel frequently made with the Reconquest against the Moors, [Primo de Rivera] implicitly compared the Moroccan wars to the conquest of the New World, which in traditional discourse was the struggle to convert pagan and barbarous peoples of the Americas to the true faith. Thus mixing traditional and modern images, he implied that the army had had to conquer an ignorant semi-savage people in order to bring them the benefits of civilization" (117). Inevitably, graphic representations of Moroccans were linked with the success or failure of the Spanish colonial apparatus, with its need to project either a paternalistic civilizing mode or an all-powerful war machine that used any means necessary to quell the enemy (Martín Corrales, 84). The image of the Moroccan thus tended to oscillate between the naïve primitive other and the brutal, cruel savage, the latter predominating between the disasters of Barranco del Lobo (1909) and Annual (1921).

Exaggerating the power of the Spanish by fetishizing war technology through visual technology, the fiction films dealt with in this chapter and documentaries such as *Alhucemas* contain virtually identical action scenes of troops that celebrate military organization, efficiency, and speed through geometrical visions of space and mass. Striving to reenact, or construct, an image of military order and invincibility, these ostensible recordings nevertheless betray their transitional status between the actuality and the narrative film, a status that corresponds to anxieties about the mirage of impermeable strength that they try to project. In fact, many historical accounts (e.g., Balfour's, Fernández Colorado's, and Martín Corrales's) attest to the absolute chaos and

the unregulated barbarism of the Spanish forces. Perhaps the most illustrative text glorifying Spanish cruelty in North Africa is Francisco Franco's *Marruecos: Diario de una bandera* (1922 and four subsequent editions; Diary of a battalion/flag), which relates the Spanish Foreign Legion's defense of Melilla after the battle at Annual.[17] Despite Spain's foregrounding of technology in representations of its encounters with Morocco, its actual technological capabilities lagged far behind those of other European countries, feeding insecurities about its modernness that seeped through the visual representations of its supposed technical superiority (see Elena and Ordóñez).

The documentary *Alhucemas* illustrates these insecurities. Here, the camera slowly pans across the Bay of Ceuta to rest upon the landing crafts and the warships laden with troops. The film becomes an inventory and a cataloging of men, machines, and firepower. Spanish spectators identified with these remote scenes replete with technology just as it was normal for filmic fantasies of travel, technology, and modernization to gloss over the realities of Spain's illiterate majority population. Of course, when the intertitles announce that we are seeing K-boats, we cannot know that in reality these vessels had been used in the Gallipoli landings and were bought from the British in Gibraltar. According to Balfour, these aging vessels broke down as soon as they reached the shore (111).[18] Later in *La gitana blanca*, a suspenseful medium shot shows Álvaro discussing plans with commanders of the foreign legion, the fanatical military organization that was instrumental in avenging the Spanish cause. Established in 1920, the legion's "stellar role" in the cinema of the 1920s (Martín Corrales, 134) aided its mythification as fearsome Spanish troops who would surpass even the enemy in savagery.

After informing us that Melilla's strategic situation is critical, the camera obsessively documents the movement of troops in a lengthy sequence where the soldiers cut across the frame from a variety of directions. The film records the regiment engaging in combat, then rushing toward targets, climbing and descending the terrain, rising up from kneeling positions, crouching down to shoot, and loading cannons. In other films of this period, the troops are flanked by vast expanses of desert, the effect of which turns the troops into a geometric play of shapes, giving these quasi-documentary scenes a surrealist aesthetic (the surrealists were fascinated with the accidental and the scarcely

describable). The attempt to represent instantaneity, time unfolding before our eyes, privileges the movement of bodies and machines over land, so that the numerous shots appear as parts of a machine, avoiding uneventful time and productively moving us through the narrative of military advance. This vision denies coevalness to the Riffians and conceptualizes Spaniards as a logical system, an ensemble of machines, characterized by its expediency of procedure. The quick, numerous cuts allow for more action, even though we see less of each shot, ensuring an economy of time that will not allow one wasted moment. A solidarity of method unites the filmmaker and the army he is shooting.

In *La gitana blanca*, once Spanish techno-superiority has been established, the film hurls the spectator into otherness, cutting to a line of cacti, from behind which the armed Riffian enemy emerges. The cut leads to an opposing point of view from which Rif men shoot from crouched positions behind the plants. The Andalusian's patient, vegetable-like existence, ready for penetration by the northerner, would be noted by Ortega y Gasset in his "Teoría de Andalucía" (1932), and covertly ironic establishing shots of cactus groves were common in films such as *Morena Clara* (1936) and *Filigrana* (1949). More immediate to viewers of the time would have been the postcard and newspaper images of Moroccans lying in wait behind rocks or desert flora (Martín Corrales, 128). Even the legionnaires deeply feared these snipers, or *pacos*, who shot Spanish soldiers in the back from hidden positions, feeding the already widespread myth about the traitorous nature of the Riffians. The inexpertness of the Spanish troops, who were primarily peasants with little or no military experience or instruction, made them easy prey for what the press labeled "traitor attacks" (Martín Corrales, 127), a term that distracted attention from the ineptitude of the military and ethically polarized enemy and hero.

As we near the enemy positions among the cacti, a lone fighter is captured so closely by the camera that we detect the whites of his eyes and even a fake beard. The illusion of the real breaks down when he points his rifle and fires directly at the camera. In a point-of-view reversal, we switch to Álvaro, wounded by the shot, and then back to the Riffian, who turns and disappears into the cacti. This relatively long take of the Riffian sharpshooter completes a sequence in which shots become longer, distances between camera and object narrow, and intertitles cease to intrude, especially during scenes that show the enemy.

Like train technology, cinema broke down space and eliminated previous barriers of time and distance. Whereas Benjamin has argued that modernity and its mass technology has phenomenologically changed the way humans experience and see life, Virilio has insisted on the inseparability of seeing the world and the awareness of speed, acceleration, or deceleration (21). This technological mobility, made possible mainly by war technologies, brought the viewer closer to the Other. Such a collapse of time-distance provokes the viewer's desire to reenter the different time of the Other. Thus, while the camera remains fixated on the enemy rifleman, we are immersed in duration, forced to engage with the image, unmediated by the cut. Suddenly, we are overwhelmed by wasted time, with its unstructured meaning and its disturbing sense of contingency and random events. Once past the digression, however, intertitles return to dissect the action of the film, giving the impression of a structuring device that ascribes meaning to the image (as opposed to the naturalistic fluidity of the digression).

Anxiety over the real and its representation belongs to a revolutionary change in the regime of vision that Paul Virilio locates in the "fusion-confusion" of the eye and the camera lens. Eye–camera fusion marks the completion of the passage from vision to visualization—that "apocalyptic deregulation" of perception that occurred when "the mass of Americans and Europeans could no longer believe their eyes, when their *faith in perception* became slave to faith in the technical *sightline*: in other words, [when] the visual field was reduced to the line of a sighting device" (Virilio, 13). We have moved from vision to visualization when the camera no longer gives us long shots (as if we were free to direct and focus our vision) but rather focuses on this one image of the sharpshooter. It is as if the camera has replaced the gun in the act of shooting. This visual technique elicits an effect that prepares us for the potential violence contained in this one image. Such an image will be employed in the war against the Other throughout the twentieth century and parallels current media depictions of the Iraqi or Palestinian sniper. We trust the camera's truth because if we doubt its veracity, we become visionless, for we have already conceded that we can see only through this sighting device. The desire to believe in the truth of the dramatization is thereby rendered all the more intense by our knowledge of its artificiality.[19]

The affect of this Rif fighter recedes as he disappears into the

background brush and the film cuts to new images. The cut simulates the passage of time and is actually necessary in an extended take, eliminating the need to show the sequent events of real time. Moreover, it reasserts the Riffian's status as belonging to an economy of film in which editing renders invisible the lacks in film (e.g., the spaces between frames and the separation between off-screen space and filmed screen space). A real is posited behind the representation, consoling the spectator's anxiety about the inherent instability of what we perceive as reality and confirming our subjectivity.

These sequences demonstrate that identity and meaning are not merely affected by the digressions but fully located within them. Otherness lures us to its different temporality, and despite our fear of confronting the Other, the digression encourages our identification with this difference. The indigenous Rif fighter and Melilla itself represent the disruption of bourgeois unity, a nostalgic gesture, surely, given the impossibility of that utopia. But according to the logic of the film, what made Raquel a star rather than a housewife, Captain Álvarez a war hero instead of an adulterer, or Luis worthy as defender of the white family was precisely the time gap and confrontation with the Other in the Gypsy camp and in Morocco. Raquel in particular gains from the experience a more exciting, fuller existence, unhampered by the exigencies of work or domestic life. These digressive intervals represent the true ontology of cinema: the distraction from everyday life as represented by the bourgeois dramas of romance, family conflict, and patriotism and the relationship of such distractions to the psychocultural processes of subject formation and spectatorial desire.

Film, as it was thrust upon the public by the developing national cinema, was thus a performative example of the movement toward modernity. Its transportability and translatability (given the lack of sound) enabled its massive dissemination throughout the West, announcing Spain's arrival in the world market, a coming out made possible by establishing its internal and external borders. The progression and retreat across internal and external borders is a pattern seen in stardom narratives about whitewashed Gypsies from the mid-1930s through the 1950s.

Female Spectacle in the Display Case of the Roaring Twenties

No Spanish artist, not even Tórtola Valencia, the wonderful
interpreter of dance, has achieved such universal renown
outside of Spain as Raquel Meller. She and the unforgettable
Fornarina have been the only national performers who have
granted prestige to the Spanish *cuplé*.

— *Popular Film*, August 12, 1926

The display of women's bodies in moving film was born when cine-
matic ethnography met the cinema of attractions, or short actu-
alities, which thrilled audiences with shockingly immediate versions of
reality. Such early cinema combined features of erotic performance, the
erotic novel, shopping window displays, printed pornographic ephem-
era, and the various practices of local sex businesses. In the sexualiza-
tion of these spaces and their association with the popular, lowbrow,
mass-taste systems of entertainment, "class, gender and race circulated
promiscuously and crossed with each other" (Young, xii). Stereotypes
based on racial exoticism and vampirism mutually inflected and re-
inforced stereotypes of excessive female sexuality and metaphors of
consumption.

The opening scene of *La gitana blanca*, like an early form of the
trailer, provides an unwitting insight into the reciprocal relationships
among the development of star publicity, cinema's increasingly so-
phisticated apparatus of spectacle, the digression, and race. In a di-
gression from the dominant narrative (it is as if separate footage had
been awkwardly pasted on the front end of the film), the camera opens
on a woman in an ornate black dress with *mantilla*—the traditional
Andalusian attire—who walks away from the camera to the base of

a staircase to examine a publicity poster for a cupletista, whose image we cannot clearly discern, mounted on the wall. As she slowly turns toward the camera, we realize it is the cupletista Raquel Meller. Glancing to her left, she beckons coquettishly to a spectator out of the frame and then proceeds up the stairs. Of what significance is this scene to the film? In this residual remnant of the peep show, both Meller and her character, Raquel, are femme fatales, emphatically not the picture of innocence or victimhood that Meller exudes in some of her interviews or that Raquel the character will demonstrate throughout the film. The function of this digression is to link sexuality and stardom to the film, establishing it as the base for a narrative about racial identity. This striking, teasing initial image of Meller/Raquel invites the intra- and extradiegetic spectators into a film about an erotic entertainer, reinforcing her fetishization as an adored sex goddess who personally beckons us to watch her perform. The stark contrast between her black dress and white skin hints at the notion of a white woman playing a racy role. For even though the audience does not yet know who this woman is, they do know that she is not a Gypsy. The knowledge is reassuring because they can safely identify with Meller as La Gitana Blanca and, by extension, all folklóricas playing the role of a Gypsy. In this way, the spectacle of the star brings otherness closer, even while it brings us closer to a folkloric fantasy of ourselves. At the same time, the star's presence undermines the film's linear narrative and visual regime, which strives toward closure, unity, and primacy: "The star performance weakens the diegetic spell in favor of a string of spectacular moments that display the 'essence' of the star (and which are often circulated separately in the form of publicity stills and trailers). In such a moment of display, the star system taps into a persistent undercurrent of the 'cinema of attractions,'" which would serve as the scaffolding for later folkloric film and stardom (Hansen, 246–47).

In this chapter I focus on discourses of sexuality, cosmopolitanism, and consumerism that promoted female subjectivity as a complex and fractious coupling of acceptable and threatening models of womanhood. An examination of the star text of Raquel Meller, arguably the first Spanish cinema star construct, and the silent films *La Venenosa* and *La sin ventura*, clear precedents of the musical film genre, shows the broadening of the spectrum of female subjectivity and, at the same time, the centrality of race and whiteness to the national effort

to maintain proper womanhood. The creation of a modern Spanish woman who could radiate intrigue while retaining a veneer of wholesomeness would be fundamental to the creation of the post-1936 folklórica figures.

In the twenties, however, various experimental models of femininity were enthusiastically circulated, echoing the general social turbulence of the time. Although Spain was experiencing a phase of relative economic prosperity between 1923 and 1930, military dictatorship under Primo de Rivera had bypassed the constitution with the support of the monarchy, the industrial bourgeoisie, and political groups of the Right.[1] Adding to the commotion were rampant rates of illiteracy, the colonial war in Africa, increasing discontent among the working class, the attendant growing popularity of Marxist and anarchist ideas, and intellectuals' and politicians' insecurity about Spain's modernness in the wake of the Disaster of 1898, which all converged in a macrocosmic case of troubled identity. In the midst of this change, theatre and cinema directors, certain factions of the literati, and the primarily female workforce of the entertainment businesses participated in a collective invention of what they thought a modernized, cosmopolitan, urban Spanish citizenry should look like. And race, in particular the orientalism of racialized exotic female figures, showed how modernity could be comprehended. That is, modernity was embodied in political, psychosocial, or poetic relationships that were "bred in the west by the conditions of contemporary existence: the death of god, the experience of revolution and repression, the many alienations inherent in the growth of capitalist society, industrialized and urban" (Chambers, 151).

Meller's brand of femininity was a version of vamp, a charged figure of alterity that signified the liminality of being caught between the old and the new Spain. This uncontainable sexuality, haunted as it was by the ghosts of racial and social tensions, was brought into disturbing proximity with other roles that Meller could enter almost too easily—el ángel del hogar and la perfecta casada ("the angel of the home" and "the perfect wife")—both of them necessary kinds of womanhood for keeping order in the home and on the streets.[2] Of course, given the unsettled nature of the times, Catholic morality condemned the influx of malicious and corrupting displays of capitalism, fashion, and frivolous consumerism and, worst of all, those degenerate individuals, movie stars, cupletistas, and showgirls living in sin. Educational and

religious institutions pressured women to imitate *el ángel del hogar,* a late nineteenth-century construct of femininity who safeguarded the timeless spirituality of home against the mutability of the twenties. This paragon was the perfect wife and mother, demure, thrifty, and asexual and the defender of home, *patria,* family values, religion, and patriarchal honor, someone who willfully gave herself up to unpaid work in the home, which was her natural place (Aldaraca, 97; Nash, "Uncontested," 28–30).

In an attempt to counter this angelic, traditional role model, prominent feminists in Spain promoted an image of women more in tune with the discourse of the Nueva Mujer Moderna (New Woman), an idea already common in other Western countries. This gender model challenged both women's restriction to the home and discriminatory practices toward them, allowing women to stake a claim to public space and further the struggle for emancipation. Probably not all the talk of sex and stardom was inspired by the image of the New Woman, though she was emerging triumphantly with the onslaught of modernity. Mary Nash argues that the Nueva Mujer Moderna was ultimately a model of traditional gender identity, due to its emphasis on childbearing and motherhood ("Uncontested," 32). It is likewise risky to collapse the ideology of stardom into the rhetorics and practices of prostitution or the sex philosophy of the anarchists, given their highly marginalized status compared with the mainstream media distribution of cinematic female stardom. More likely, the erotic female sex symbol, star, and/or vamp was constellated with the more consensual, "acceptable" gender models that circulated in cinematic discourse. Benjamin's concept of constellation usefully emphasizes that these combined identities "suggest historical meanings through the way in which they are linked to one another and to the context from which they derive" (McGee, 25). In other words, these imagined conjunctions of different feminine identities seem to have transcended previous categories of subject formation. After 1936 they would be the basis of the folklórica role.

Meller's worrisome blending of female purity and whiteness with the vamp and the Nueva Mujer Moderna rendered her ultimately unknowable. Indeed, many of her filmic characters were described in the press as "strange," "peculiar," or "sublimated." The competing discourses of femininity that circulated in Spain in the 1920s were enacted both in Meller's star text and in the complicated character roles that she played.

If in the nineteenth century "the social individual [was] acquiring a new definition and importance, woman [was] often perceived not as an individual but as a genre or a type" (Aldaraca, 60). The residues of the nineteenth-century idealization of women were not abandoned but folded into a more complex process in which roles such as the fallen woman, the femme fatale, and the girl next door were combined in more ambiguous arrangements of the whore with a golden heart and the not-so-bad woman, who were associated with consumerism and stardom.[3] The first Spanish winner of the Nobel Prize in Literature, Jacinto Benavente, succinctly expressed his perplexity when he was quoted by the newspaper *ABC* as saying, "[Meller's] art always make me think: where could this angel have found such devilry?" (March 3, 1960). A model thus emerged that was dangerous but invoked desire for something beyond what conventional society could offer.

Cinema and Cuplés: Cosmopolitanism versus Castizo Entertainment

Cinema and popular song were welded at their base. From the late 1890s through the 1910s, recorded performances of song, dance, or circus acts were projected in the same theaters and cafés where musical performances, musical theatre (*zarzuelas*), vaudeville variety shows (*espectáculo de variedades*), or revues (*revistas*) were performed (Salaün, *El cuplé*, 142–43). Indeed, cinema constituted a recorded archive of the proliferations, mutations, and mediations of spectacles that combined theatre and dance. These cinematic actualities were interim entertainment for the live acts, mere accoutrements of musical theatre, until filmmakers started recording entire theatrical performances and edited narrative sequences (Salaün, *El cuplé*, 143). The congenital connection between cinema and song performance remains evident in the following statistics: of the 230 feature-length films made in Spain during the twenties, 130 were adaptations (56.5 percent); of these, 21.5 percent were adapted from novels, while 30.5 percent (70 in total) were theatre adaptations from Spanish plays, 34 of them musicals (Sánchez Salas, *Historias*, 48–49).[4] These film adaptations of musicals had live musical accompaniment, and the audience was encouraged to sing lyrics flashed on the screen as subtitles or sung out by a reader or singer. During this time and through the twenties, a form of song enjoying extreme

popularity was the cuplé. A bastardization of the French couplet, the cuplé was a popular narrative song of approximately two to three minutes that most often recounted stories of prostitutes, lost love, sexual escapades, or the trials of a poverty-stricken life. These songs could also satirize politics or romanticize reactionary and patriotic feelings. Their tone was at once provocative, oppositional, and conformist regarding the dominant culture. The cupletista was the female or male transvestite singer who usually performed cuplés in cafés, lyric theaters, and lowbrow theaters.[5] According to Serge Salaün, a cultural historian of the cuplé, the growing vogue for the cuplé in Spain developed alongside, within, and around the star system and, by extension, the cinema (El cuplé, 86, 141–47).

Yet for Salaün combining cinema and popular musical theatre was not an index of modernity but a lowbrow, indecorous (yet profitable) dumbing down of the masses that would ultimately be responsible for the success of Fascism in Spain (El cuplé, 147). Certainly, popular cinema born of musical theatre favored not only foreign stereotypes but also clichéd Andalusian and Madrilenian customs and manners: "sainete [short skits] and zarzuela cinema, the small-time, backward Spain of tin bands and tambourines, facile and frivolous musical comedies, constructed around a name or a title that guaranteed box office sales" (Salaün, El cuplé, 147). For José María García Escudero, the culture of the cuplé was "the most nefarious empire . . . of the most harmful trends of our cinema" (24). In general, the cuplé tradition served as a mere pretext for a parade of chorus girls and naked bodies (Deleito y Piñuela, 19–20).

The ideology underlying the condemnation of the cuplé entails both a rapprochement with and a rejection of European aesthetics. What was beyond Europe's borders was abject. Spain shared the current of European culture, thereby asserting Spanish Europeanness, but at the same time the licentiousness and brazen sexuality of the cuplé was a xenotopia: "what Europe [was] not, the antithesis of bourgeois austerity, respectability, and temperance" (Schick, 59). Sexual explicitness was something outside of the castizo, coming from the exotic east, the savage south, or the wild west. Sexuality was emblematic of the spectacle of "Parisian cabarets, London music halls, New York jazz pavilions, and of course, Argentine tango parlors" (Dougherty, 14). Like the Orient, Spain assumed for Europeans "an ambivalent status in that this orient is perceived as both opposite and contained within

the bourgeois values of western Europe" (Gould, 28). The positive and pleasurable connotations of cosmopolitanism as "social worldliness, sexual toleration and engagement with modernist trends in the arts and fashion" were overshadowed by its antagonistic geopolitical associations and debased body forms and racial degeneration (Walkowitz, 339–40). For Spain itself, cosmopolitanism was associated with the foreign, in particular Paris and Hollywood, in contradistinction to national, castizo themes, a prejudice that dates back to the "unacceptable Frenchification of Spanish society" due to the Borbon monarchy and the widespread embrace of French fashions, customs, and language in the eighteenth century, which were felt to be decadent, frivolous, and rancid (Torrecilla, 4–5).

Even in this pre–National Catholic period, critics arguing that cinema should be more Spanish often employed the terms "racial" or "spiritual" to emphasize their point, as did the executives of Atlántida films in 1919: "The company will inspire itself in accordance with the traditional genius of our race, in order to assist, with the various excellencies of its art, the spiritual elevation of our people, and at the same time procure closer fraternal relations with Spanish America and spread the civilizing relations in North Africa" (Cánovas Belchi, "El cine mudo madrileño," 50). In company with this insistence on excellence of race and spirit was the ever-looming insecurity over hispanidad and the hunger for African colonization. In such times, defining the perceived contours of the nation and race was necessary to any medium that gained enough attention to create an imagined community, but it was then inevitable that the ways in which cinema and the cuplé imagined the "reality" of Spain, its essence or soul, would be thoroughly critiqued and policed.

What had been essentially a healthy genre—the género chico (lesser genre)—had declined into the género ínfimo (least genre), degraded by brash upstarts and its sexually suggestive piernografía ("leggy" or light porn). Álvaro Retana describes the género ínfimo as "invariably a laic procession in which there was no lack of streetwalkers, and cupletistas and dancers executed a noisy-festive (bullicioso) repertory that was catchy, singable, to the delight of an exclusively masculine public, always being interrupted by authorities who defended public morality" (Retana, Historia del arte frívolo, 17).[6] As usual in cinematic stardom narrative, the theaters and cafés where the género ínfimo was performed

were a means of escape from poverty and mediocrity. For cupletis-
tas performing was, if not lucrative, still a way to rise above a dreary,
predictable life. Cuplés and bullfighting were the two fastest ways to
change economic status, and even the singers of zarzuelas sometimes
crossed over into the *género ínfimo*, where higher profits assured a bet-
ter salary.[7] Some saw these possibilities as uplifting; others, including
some leftist intellectuals, thought they were crass.

Missing from Salaün's description of cinema and its links to song,
though amply documented in his book, is the strong erotic and pica-
resque tendency in musical theatre that migrated to cinema, known
as *sicalipsis* (according to Salaün, "the perversion of the género chico
into the género ínfimo" [*El cuplé*, 42]). The origins of the word are
now mythical. One version says that a Barcelonese impresario mis-
spelled *apocalipsis* (apocalypse); another version claims it came from
the misuse of "epileptic" when describing frenetic dancers, most likely
of color (Ramos, 51–52). The first official use of the term appeared
in Gerónimo Jiménez's *Enseñanza libre* (1901). This term was, as Dru
Dougherty explains, "coined to identify plays, and then narratives,
whose sexual appeal approached 'the cheeky impudence of pornogra-
phy'" (22). Juan Carlos De la Madrid, writing about early cinema spec-
tacles in Asturias, confirms that *sicalipsis* was typical of *varieté* shows
combined with cinema shorts (226). Cinema's inheritance of *sicalipsis*
is evident in the few remaining sexually irreverent films of the twenties,
such as *Frivolinas* (dir. Arturo Caballo Alemany, 1926), a filmed musi-
cal review of diverse skits ranging from comedy routines, stripteases,
orientalist morphine and opium routines, homages to Ziegfeld-type
chorus lines, and parodies of prostitution. The fragments of this film
confirm that Spanish silent cinema spectacularized female sexuality in
the same lurid recounting of modernity's social ills that had deliciously
scandalized European and American audiences. The songs in *Frivoli-
nas*, paeans to hedonism, had lyrics such as, "Opium calms and con-
soles the pains of the heart, smoking we are happy because we know
from its dreams, life's best part" (Berritúa, 124). Luciano Berritúa finds
this content unsurprising, since other cuplés had titles like "La cocaína"
(Vidal-Durán) and "Sueño de morfina" (Tenorio and Retana). Main-
stream films such as *La Venenosa* (dir. Roger de Lion, 1928) and *La sin
ventura* (dir. E. B. Donatien and Benito Perojo, 1923) and *La Malvaloca*
(dir. Benito Perojo, 1926)[8] also harbor a rich selection of illicit themes:

drugs, prostitution, white slavery, decadent, cosmopolitan casinos, venereal disease, adultery, and miscegenation. Raquel Meller's star text and vampiness melted effortlessly into this modern, cosmopolitan (above all, Parisian), yet seedy ambiance.

This kind of cinema, its content and aesthetic, was decidedly not Spanish. Nationalist discourse about cinematic production and its promotion of *españolidad* began to appear as early as the mid-1910s in magazines like *El cine* (Barcelona) and continued through the 1920s, climaxing during the integration of sound and film and remaining relevant throughout the Second Republic (García Carrión, 42). But the question over the Spanishness of films produced in Spain traversed political lines and was debated in cinema magazines such as *Pantalla*, in the forums of the Congreso Español, and in the first Congreso Hispanoamericano de Cinematografía in 1928 (organized by *Pantalla*) (García Carrión, 42). In *Pantalla's* March 31, 1929, issue, the renowned cinema director José Buchs declared, "The typical films of customs and situations that are distinctly Spanish . . . are the ones that national production should be making, if it wants to compete in a dignified way with foreign films." To be condemned were "films in the style of the novelistic productions and ambience of cosmopolitan society" (García Carrión, 44n61). *La Venenosa, La sin ventura*, and the film discussed in the next chapter, *El negro que tenía el alma blanca*, were squarely within the purview of cosmopolitan cinema. While national discourse was facing overwhelming competition from Hollywood and struggling to retain its precarious place in global empire through African colonialist enterprises, the Primo de Rivera dictatorship was endeavoring to put a modern face on its regime.[9]

But it was difficult, if not impossible, for silent cinema *not* to be cosmopolitan, in the internationalizing sense of the word: foreign influences, discourses, agents, stars, and directors were part and parcel of moviemaking. And for this reason, attributing silent films a definitive nationality is beset with difficulties. Movie sets were often an amalgamation of nationalities extending not only to the set workers and extras but also to the stars, directors, and producers. Coproductions were the name of the game, given scant material resources such as film stock, camera technology, and technicians. *La sin ventura* was a Spanish-French coproduction. Most of Benito Perojo's early films were made with French capital or in French studios, earning him the scorn

of Spanish film critics eager to promote an autochthonous industry.[10] Critics like Luis Gómez Mesa reproached Perojo's cinema for its impersonal and culturally apatriated cosmopolitanism, or as an anonymous critic in *Popular Film* wrote: "This will never keep us from censoring [Perojo], as gravely as necessary, when we frankly believe that he has behaved unfairly or disdainfully toward national production" (Gubern, *Benito Perojo*, 118–21).

The term "film international," coined by Jacques Feyder, who directed Raquel Meller in *Carmen*, in which Perojo participated, implied the inherent difficulties in making money from films made in only one country (Gubern, *Benito Perojo*, 67). The mere contact of Spaniards with European and Hollywood artists presupposed a creative and collaborative brainstorming of ideas that would echo throughout Spanish silent films, despite critics' claims that Spanish cinema did or should constitute an exclusively national cultural form. Spanish cinema was tied to Hollywood both by its fierce desire to defend its own territory against the onslaught of Hollywood imports and by the inevitable borrowing and cultural transcription that characterized Spanish films. Although folkloric, Andalusian, and Gypsy topics were prevalent (e.g., *La gitana blanca* and *Carmen*), even these plots carefully intercalated traditional manners and customs with modernist, cosmopolitan, and other scandalous discourses. The world of the spectacle and the circles of cosmopolitan society were themes that most easily transcended the national boundaries of this early cinema (Gubern, *Benito Perojo*, 67).

Meller's Star Text

Internationalization also impacted the career and reception of Raquel Meller, despite her frequently quoted line, "I was the most Spanish Spanish woman of all the Spanish women," which appeared in several published interviews and on her albums (Díaz de Quijano, 109). Yet virtually all of her star publicity subverted a nationalist appropriation of Meller. As she demonstrated in *La gitana blanca*, she was quite capable of embodying the stereotype of the white Spanish woman. But Meller's patriotic girl-next-door star persona was energized, if not eclipsed, by the ambivalent dynamic of her other roles as the cosmopolitan vamp and the modern woman, two constructions that were socially a little threatening. Meller claimed, for instance, that Louise

Brooks had copied her hairstyle, giving *her* name to the vamp cut. Meller's kohl-lined eyelids, the exaggerated shadows under her eyes, the powdered white skin, and her pouting look occupied a halfway stance between victim and seductress. Her name was not particularly Castilian—supposedly it had been inspired by a former Dutch lover named Pierre Moeller—but neither was much of her star publicity nor the consumer products that flanked her image, which were celebrated just as much by the foreign press as they were in Spain—e.g., "The Spanish woman from Catalonia (where the language consists of such strange noises)" (*New York Times*, April 18, 1926).

Many historians of the cuplé would concur with Máximo Díaz de Quijano's assessment of Meller's internationalism: "She did not know, in contrast, how to express Spanish graces, so necessary in the majority of song styles in Spain, nor how to portray a racial sensibility, because Meller could be equally Italian, as much as French, Portuguese, or Argentine" (119). Much of her success was enjoyed in New York. Arch Selwin, who had called her "the most marvelous artist I have ever seen" (*New York Times*, July 31, 1923), had contracted her for the revue La Rue de la Paix, to be managed by Florenz Ziegfeld, but she postponed until 1926 for reasons of illness, which made her an even hotter commodity. Her launching from stage to screen was mainly supported by foreign directors and noted in the foreign press by audiences in Paris, Buenos Aires, Lima, and New York. In fact, little has been written or documented about her films except for foreign reviews of *Violetas imperiales* (dir. Henry Roussell, 1923), *La terre promise* (dir. H. Roussell, 1924), *Ronde de nuite* (dir. Marcel Silver, 1925), *Nocturno* (dir. Marcel Silver, 1926), *Carmen*, and *Les opprimés* (dir. Henry Roussell, 1922).[11] Chaplin wanted her to star in *City Lights* (1931), but she fell ill. On another occasion, she had a previous engagement and had already signed a contract when again Chaplin wanted her to star, this time as Joséphine in a film on Napoleon I. In the mid-1920s, William Fox produced musical shorts of her most famous songs, such as "El relicario," "El noi de la mare," and "La mujer del torero," using the Western Electric Movietone sound-on-film system that would soon be used for feature-length films (*New York Times*, September 20, 1928).[12] While in New York, she was part of the social scene, performing at hospital benefits, private parties, and several Broadway theaters (e.g., the Empire Theatre and the Cool Casino).

Meller's interviews reveal the pressure she felt to tailor the facts of her life according to a more Spanish or a more cosmopolitan reading, depending upon her situation. Meller was born Francisca Romana Marqués López in Zaragoza, Spain, in 1888. When she was four years old, her family moved to Tarragona, near Barcelona, and for this reason she remained a Catalan singer and therefore not quite Spanish. Her father, known as El Cojo (The Limper), was a merchant and mechanic, and her mother was a seamstress, known as La Mendarra. At age four she was sent to convent school but soon left to join her family in Barcelona and began to contribute to the family income, working at a women's clothing manufacturing shop whose clientele, apparently, was mainly singers. Her first salary, two pesetas a day, was earned by combing the floors for fallen pins with a magnetized iron tool bound to her belt. After six months of this, she was set to removing tacking from clothes and was then promoted to making hems (*Journal of Contemporary Street Art*, 6–7). These details were ironically obscured by the *New York Times* reporter who writes that "as a little girl she embroidered the robes of priests and bishops." Careful not to dwell on the past, the rest of the article describes in minute detail her dress, jewelry, and other accessories worn at the interview (April 6, 1926).

But the references to the church were made pointedly. Meller's experience with it had become less friendly when the church censored her song "La procesión" (*New York Times*, April 18, 1926). Added to this was her film *Les opprimés*, an acute condemnation of Inquisitorial Spain in Flanders during the reign of Philip II (*New York Times*, July 15, 1929). Here, she plays Concepción, the daughter of Don Ruy, a high constable of the Inquisition. Concepción falls in love with Philip of Horn, a Flemish nobleman who helps lead the revolt against the Duke of Alba. (The *New York Times* unsurprisingly found her performance "inhibited." Clearly, she knew her patriotism would be questioned, and indeed, Spanish censors would cut out parts of the film and rename it *La rosa de Flandes*.) As Meller grew old, she struggled to control the narratives that clung to her life in Franquista Spain, where she eventually settled and died. The public refused to forget her naughty side, as she noted bitterly in late interviews, and her efforts to transcend her status as sex symbol and glamorous Ziegfeld girl did not result in her being remembered as a great actress, as it did with Sarah Bernhardt or María Guerrero.

Yet had it not been for an inchoate stage career, firmly rooted in short, cheap, erotic variety shows and café gigs, Francisca never would have become Raquel Meller. Among those who frequented her family's shop was Marta Oliver, a performance artist from Barcelona's demimonde who convinced Meller that she could become rich by singing cuplés. Changing her name, Meller debuted at around sixteen at La Gran Peña, earning seven pesetas per night. As her fame grew, she transferred to the Salón Madrid, the headquarters of the *género ínfimo*, where she shocked audiences with her sexually suggestive songs and scant clothing. The *género ínfimo* impressed the middle-class mind as a hotbed of prostitution, and the world of varieties undoubtedly served in part as a front for upscale call girls until the sexual revolution in the 1970s (Barreiro, 27). Magazine advertisements for some cupletistas included among their descriptions of merit the qualifier "traveling without mother," effectively announcing hassle-free access to the performers when offstage (Barreiro, 37). Needless to say, Meller traveled without her mother. The pervasiveness of *sicalipsis*, or sexual naughtiness, as critics tended to call it, enhanced business for female artists, businessmen, and authors alike, regardless of actual talent. This minor yet significant detail would also haunt Meller. In the words of a *New York Times* reporter, Meller had "that little touch of art which makes one forgive many other shortcomings" (October 5, 1930). Whereas another reporter wrote, "This singing woman who cannot particularly sing . . . she is only a music hall singer, if you will, and even one who sings badly" (*New York Times*, April 18, 1926). Naturally, this detail was then followed by a lengthy panegyric that elevated her art to legendary status: "She is woman embodied in artist, as only in the very greatest artists she is embodied" (*New York Times*, April 18, 1926). But cupletistas were branded, whether they moved on to be world-famous performers or innocuous folklore interpreters. And so, despite her international star status after her debut in Paris in 1919 and her elite cosmopolitan celebrity standing—throughout the twenties and thirties she would be respectfully known for her commanding stage presence—Meller's star text was inevitably colored by its relationship to the popular *varietés* acts of the late nineteenth and early twentieth centuries and their chorus lines of anxious hopefuls.

As Meller's film career took off, directors sought her not for her dramatic range but because of her "magnetic personality" and her

"comprehensive interpretation of the gypsy vampire," as a critic writes in a *New York Times* review of Jacques Feyder's *Carmen*. He adds that Meller is "admirably suited physically to play the role of Carmen." Her striking appearance was carefully, even minutely, detailed in press eulogies: her rebellious black hair—dramatically contrasting with her white skin—her large, lustrous, black, expressive eyes, and her bold features. These were the classic ingredients of the twenties vamp. Her lurid reputation—temperamental and capable of sadistic cruelty—was embellished by publicity rumors implicating her in the death of the dancer Mata Hari, a former lover of her husband and the subject of his biography. (Parisian society apparently shunned Meller and Enrique Gómez Carrillo when it was reported that she had collaborated with the police in locating the outlawed Mata Hari.)

The cinematic vamp mystique in Hollywood films of the 1910s and 1920s was incarnated by actresses such as Theda Bara (an anagram for "Arab Death"), Nita Naldi, Lya de Putti, and Pola Negri (Negra, 62). Who is the vamp? She is traditionally heartless, calculating, willful, and intelligent. The qualities that most defined film vamps of the twenties, according to Janet Staiger, also threatened white identity, as well as economic and social-class stability: "The vamp was dangerous because she could destroy not only a man's discipline and will by feeding off him, but she could deprive him of his home, financial security, and social status" (150). The vamp was a middle-class figure who symbolized bourgeois aspirations to and complicity with the nobility. As such, she belonged to a broader trend of aristocratic and art deco aesthetics displayed in advertising strategies of the 1920s that reinforced elitism and distinction through their ads for luxury objects and beauty products (Alonso and Conde, 67). Both sides of this persona would obsequiously court the favor of upper-crust Spanish society, either through quasi-celebrity marriages, the conference of noble titles, patronage, or thinly veiled prostitution. Meller in her real life would play on these possibilities, befriending the aristocracy and earning titles of nobility. Her contemporary colleague, La Bella Chelito, was said to have been the sexual initiation of Alfonso XIII (Barreiro, 47), while Pastora Imperio, the Gypsy singer, was a notorious supporter of Alfonso XIII and cherished his photo. In exchange, he "admired" her for her promonarchy sympathies (Moix, 28).

The vamp was the antitype of the folklórica, who wore her heart

on her sleeve, or the white gold digger and working-class girl, the folklórica of the thirties and forties. But folklóricas after Meller would certainly continue this love affair with the aristocracy. Their relationship played into the ideology of charity in Spanish-Catholic thinking, combined with the liberal nineteenth-century idea that the *pueblo*, in the form of the folklórica, had the talent and merit necessary to earn favors with the nobility and, thus, their complicity (Moix, 25). Folklóricas had relations with nobility in many films of the 1940s and 1950s, the genre known as the *orduñada*, since Juan de Orduña directed a large part of these romantic, historical superproductions. Lola Flores is, for example, quoted as saying, "For my part, when I see Don Juan, I burst into tears. Spain should be governed by a *caudillo* or by a monarchy, which is what we are accustomed to because we have the best blue-blooded folk in the world" (Moix, 35). Later, apparently, she was indignant when she was denied the Marquisate of Torres Morenas (Moix, 25). For Meller, winning the favor of the monarchy while passing as patriotic and as royalty herself was achieved by a contradictory mix of subject positions characteristic of cinema in the twenties, for she was also an expert at playing the good country girl, loyal to her country and humanely compassionate, qualities that coalesced nicely with models of the honorable and upright Spanish woman.

Publicity strategies that closed the distance between fans and their stars were evident in Meller's doctored interviews. She offered herself as a simple, loving girlfriend: "What I most love in this world is Spain and its poor ones. I also love my little pets. And my true friends" (Gómez Santos, 58). Meller speaks in simple language and, by referring to her domesticated pets, appeals to her fans as a girlfriend, a neighbor, or someone with whom the average housewife could relate. At the same time, her pack of Pekingese dogs, who always traveled in their own first-class accommodations, conspicuously signaled her eccentric and extravagant taste for luxury (*New York Times*, April 6, 1926). Along the same lines, Meller cast herself as the most Spanish of all Spanish women: "I'm more Spanish than anyone! Because even in my affection for my country I am jealous and selfish and no one can love it as much as me" (Gómez Santos, 55). At a pageant in Paris, upon seeing Miss Spain using the Republican flag, Meller appeared on stage with a Spanish Nationalist flag draped over her chest and exclaimed to the audience, "Señores, esto es España!" (Ladies and Gentleman, this

is Spain!) (*La vanguardia española*, March 22, 1966). Wrapping herself in the Spanish flag on stage or convincing her friends to switch sides during the Spanish Civil War suggest a fanaticism incompatible with the life of an artist, especially in light of the numbers of performers and artists who defected, were exiled from Spain, or, worse, became casualties of the Nationalist purges.

And yet, despite her indisputable cosmopolitanism, Meller did seem well suited to certain kinds of Gypsy roles. This was partly due to her song repertoire, which included pieces such as the cuplé "Mala entraña," better known as "Gitanillo," by the painter Juan Martínez:

> Cuanto triste quedo a solas
> En mi alcoba,
> Le pregunto a la estampita
> De la virgen:
> —Qué hice yo para tú tan mal
> te portes?
> Pues lo que haces tú conmigo
> Es casi un crimen.
> Mira, niño, que la Virgen
> Lo ve todo
> Y que sabe lo malito
> Que tú eres,
> Pues queriéndote yo a ti
> Con fatiguitas
> El amor buscas tú
> De otras mujeres.
>
> [Refrain]
> Serranillo, serranillo,
> No me mates, gitanillo.
> ¡Qué mala entraña tienes pa mí!
> ¿Cómo pues ser así?
>
> When I am sad and alone
> In my room,
> I ask the image

Of the Virgin:
—What did I do for you to
Be so bad with me?
Because what you do to me
Is almost a crime.
Look, little boy, the Virgin
Sees everything
And knows how bad
You are,
So loving you like I do
Till I'm sick,
You look for love
From other women.

[Refrain]
Little lad, little lad,
Don't kill me, little Gypsy.
What ill will you have for me!
How could this be?
(Retana, *Historia de la canción*, 214)

Here began, according to Díaz de Quijano, the unfortunate development of her star persona along racial lines: "Her appearance, admirable for vaudeville, upon becoming more dramatic became infused with similarly excessive traits, and her gypsy attire was the first aberration in the series of which we would see many more: curly, rebellious, dark-brown side locks, a makeshift strip of silk cloth, like a table runner, in lieu of a waist kerchief, and a ruffled dress with an insipid Andalusian flavor" (Díaz de Quijano, 109). The exaggerated Gypsy stereotype and bullfighting cliché would power one of her trademark songs, "El relicario" (written by Armando Oliveros and José Castellví, with music by Montesinos y Padilla).

Ricardo de Baños had wanted her to play the lead role in a cinematic version of the zarzuela *El relicario* but could not afford her (Pineda Novo, 35). Chaplin had offered her the lead in *Napoleon*, which he abandoned, and then used the music of Meller's cuplé "La Violetera" as leitmotif in *City Lights* (Pineda Novo, 35). "La Violetera" was

popular to absurd and perhaps malevolent proportions. After nightly performances of "La Violetera," in which Meller would languidly toss bouquets of violets to the audience, a circus act would emerge in which an elephant imitated her act: "The animal has not yet learned to sing La Violetera, but, while an orchestra plays the famous song, he too distributes bouquets of violets to his audience. Unfortunately the crowd does not always understand; for the people who gain admittance to the circus for a few francs are not those who have listened to the great Spanish artist at four dollars a seat" (*The Living Age*, July 1928).

Díaz de Quijano implies that Meller started off the whole star industry on a bad foot when she began incorrectly incorporating the Gypsy look into her performance repertory. For Pineda Novo she was the first folklórica (32). And whether her histrionic patriotism was based on fear or some other motive is uncertain. But the close-ups in her films revealed an inner, private side of Meller's star character, seemingly implying she had social and personality types that transcended her screen performances. Paula Marantz Cohen notes that "the development of personal information about stars was a gradual movement to narrative form" and that conversely, as film narratives became more complex with the rise of the feature-length film, constructed star personas were better able to convey the intimacy of private life (141). Star texts and narrative form were thus connected, as were the screen and private life. It goes without saying that all of Meller's identities were media constructions designed to sell her image to the broadest possible audience. Nevertheless, these constructed extracinematic identities relied on the actual stage and cinematic performances for their authority. As Marantz Cohen has written, "The star system as it evolved during the silent era was the outgrowth of the films whose moving images flooded the consciousness of their audiences" (14). The extrafilmic star personality was inseparable from the films, although subordinate to the intrafilmic star ontology. And both constructions were powerfully appealing because they were sexually ambiguous—both racy and acceptable to the public. Stars embodied the desires and fears of their audiences: as consensual creations of the audience and the film industry, they mirrored both the ideal and the prurient spectator. Meller's image resonated in the public imagination not because she was a foreign model imposed on a rural Spanish audience but because she constituted an icon of contradictions that made sense to a Spanish spectator.

Stardom, Consumerism, and Orientalism

The explosion of leisure culture after the 1890s and the many forms of mass culture entertainment aroused dismay in petite bourgeois intellectuals and critics who saw high culture struggling to compete with new low forms of entertainment, such as the aforementioned cuplé and *género ínfimo*. The same critics were regular clients of these lower-caste theaters but mocked cupletistas for their ignorance or lack of talent, revealing a love–hate obsession that found its counterpart in the struggles of women to negotiate their own identifications with these female models of being. Ramón María del Valle-Inclán, for instance, an aficionado of theaters like Central Kursaal in Madrid, where cuplés and "frivolities" were performed, wrote about this environment in works like *La pipa de Kif* (Berritúa, 124). Popular novelists and playwrights participated enthusiastically in modernity's craze with the spectacle, and many of their literary creations based on these performances became film adaptations in the 1920s. The majority of folkloric musical comedies of the 1930s and 1940s (and even the 1950s) were adaptations of the less sexually and morally explicit plays by the prolific Quintero brothers—or by tamer writers who nevertheless foregrounded salacious female Gypsies, flamencoized music, and bullfighters—or were similarly loose adaptations of *sainetes* and zarzuelas from the turn of the century.

Many of the films in the 1920s specifically were, however, products of the popular erotic novel. El Caballero Audaz (The Audacious Gentleman), the pseudonym for José María Carretero, the foremost erotic popular writer during the first third of the century, was the author of both *La Venenosa* (1927) and *La sin ventura* (published as *Vida de una pecadora errante*, 1921). Eager for media publicity, Carretero was equally well known for his interviews of celebrities and politicians and for his own fickle political affiliations. An incarnation of the consensual process of subject formation, Carretero vigorously defended licentious customs and was a severe critic of religious orthodoxy (Gubern, *Benito*, 68). His two novels deal with the decadent world of the spectacle and often are more lurid and scandalous than their filmic adaptations. In *La sin ventura*, a biography of the first Spanish cupletista, La Fornarina (Consuelo Bello Cano [1884–1915]), the protagonist commits suicide at the end of the film by ripping off her surgical bandages after an

operation to cure her "sickness," a euphemism for venereal disease. In the film, however, she is the victim of a botched operation, a more "correct" ending that circumvents disease and the mortal sin of suicide. Yet even this "appropriate" plot insertion is rendered ambiguous, darkened by contextual influences within the film and outside it. Women did not, for instance, control these images. Rather, they were bombarded with only slightly more attractive options for shaping their own identities. The producers of these narratives were also consumers— male consumers—and as Bridget Aldaraca writes of male novelists in the nineteenth century, they most likely saw the creation of woman "through the purchase of Rousseau's grown-up doll," who was offered in several kinds of models: "the sweet submissive 'angel del hogar' guaranteed to obey your slightest command; there is the luxury model, the new and improved, educated woman who appears at night in the *tertulias*, and like her French cousin, the *femme savante*, who not only walks but talks; the slightly shop-worn Courtesan is a big seller; and of course, the bargain basement Streetwalker" (Aldaraca, 109–10).

But competing with illustrated novels and erotic fiction were the magazines. As the market flooded with faces of stars—a whole section of *Cinegramas* was named "Rostros" (Faces)—notions of becoming inevitably and simultaneously intertwined with consumerism and shifting identities. Marantz Cohen discusses how the psychological novel of the nineteenth century penetrated a character to reveal an internal life, whereas film had to dramatize inner states of mind. But since psychological processes are not so easily spatialized, silent film minimized what it could say about feeling and thought and concentrated more on action. Thus, the cinematic guide for identity, unlike the novel, emphasized less the idea of "being" than of "becoming," showing that forward-moving action was the crux of film's vitality and power (Marantz Cohen, 42). The notion of a modern self that was more plastic, more adaptable and capable of being transformed into models of glamour and authority, such as the movie star, easily merged with silent film's philosophy of becoming.

Many of Meller's films were screened episodically over a series of nights, which reinforced this flexible notion of the individual as a process. But it also entailed the idea of consumption: to see the finished product of the character, one had to keep paying. *La gitana blanca* and *La sin ventura* share this episode format, *La sin ventura* being available

through the *Novela Semanal Cinematográfica*, which featured photos of the film. Indeed, the ideology of consumerism enhanced the cinematic techniques of suspense and character development, which now required an iconography of the self as a "mutable surface" (Marantz Cohen, 14) or continuing development, to allow for more complex characters and, therefore, more complicated star texts.

Meller's climb to national stardom in the 1910s and international stardom in the 1920s coincided with a period of social upheaval in Spain in which discourses of domesticity, religion, and modernization converged upon the site of the female body. Her stardom was a paradoxical mix of consumption, success, sexuality, patriotism, and ordinariness. Marantz Cohen proposes that cinema played to a new kind of public involved in a consensual process of creating the self by the exercising of consumer power (14–15). While capital remained in the hands of the aristocracy, the bourgeoisie, the petite bourgeoisie, and the merchant classes, the "power" to envision other selves through advertising and new stores was magnified by the explosion of popular theatre entertainment. Films of the 1920s shifted attention away from work and toward the pleasures of consumerism through "cross-class fantasies, stories of interactions and romantic involvements . . . that conveyed an underlying ideology of class harmony and reconciliation," thus erasing class differences (Beach, 8–9). Consumerism thereby fostered access to the public sphere at the same time it promoted the spectacularization of the female body. Women were both looking and being looked at. As consumers they were participating in the regulation of their bodies and identities, and as female entertainers they allowed the paying spectators to gaze upon their fetishized bodies. Consumerist practices such as window shopping and department store browsing offered a space, if only temporary and imaginary, for women to act out alternative identities that challenged more restrictive feminine roles.

In Barcelona during the 1910s, the brand name "Meller" proliferated on objects such as hats, perfumes, ties, fans, and cigarette paper (Amado, 8).[13] Knowledge of Meller as a champion of consumerism reinforced the buying habits of the spectator. Marino Gómez Santos's claim that Meller was the first Spanish actress to appear on stage smoking a cigarette surely had an impact on both male and female audiences, perhaps foreshadowing the publicity myth that equates cigarette smoking with the acquisition or consumption of the sexualized female

body (41). Ads in the *New York Times* for Lord and Taylor department stores advertised dresses that could "bring on a Raquel Meller feeling" (April 4, 1933), while fashion columns talked about the latest fabrics that when worked into "swishing ruffles on a sinuous train," were "as worldly as Raquel Meller" (May 7, 1933). In a similar way, Meller's cosmopolitanism, displayed through her minglings with the international star crowd of the 1920s (Charlie Chaplin, Rudolph Valentino), royalty (Alfonso XIII and several famous aristocrats), and intellectuals (her husband, Gómez Carillo, and Manuel Machado) added sophistication to her star persona.[14] Anecdotes about Meller's vast wealth proliferated and were mythified by interviews and articles in the popular cinema journals of the time. In 1926, Meller's contract with Empire in New York earned her $50,000 (Díaz de Quijano, 129). Inventories of her stock of luxury items were minutely documented in the gossip news: Rodin sculptures, drawings by Matisse, and a piano that supposedly belonged to Mozart (Gómez Santos, 41). This lust for *things*, even though inaccessible to the many, diverted attention from the pervasive lack of material goods and the monotonous world of labor.

Meller was a model for consumers and a fashion leader; the spectacle of her jewels and gowns was fetishized in almost all of her films dealing with narratives of stardom, and it amplified the awe and excitement that energized her performance sequences. In the credit sequence of *La Venenosa*, for instance, the film announces that Meller, who plays the lead character, Liana, will be modeling dresses by the Parisian designer Jeanne Lanvin. The camera interpellates spectators' craving for the wealth represented by Liana's jewels through close-up shots of her bracelets and rings, punctuated by several point-of-view shots that capture the devouring looks of a lumpen bar crowd eyeing her jewel-bedecked body. This sequence foregrounds the protagonist not only as an object of consumption for the audience and the bar clientele but also as a luxury item to be coveted, just as advertisements in the 1920s displayed goods that few could aspire to own.

In *La sin ventura* consumerism is blatantly associated with prostitution and indecorous public identity, while the scopic power of film triggers desire for the product displayed. The orphaned and impoverished protagonist, Margarita (played by the well-known Lucienne Legrand), peers longingly into the window of a shoe store containing those quintessential symbols of commodity fetishism.[15] When a white-bearded

passerby offers to buy her a pair of shoes, Margarita unhesitatingly accepts "the love that offers shoes and silk stockings." From point-of-view close-up shots of the shoes in the window to the medium shot of Margarita's transaction with the old man, the cinema spectator is finally transported to a high-angle close-up of rhinestone-buckled pumps sparkling in the sunlight. The scene's closing shot of this universally desired fetish commodity slyly circumvents uncomfortable connotations of female corruption by degenerate older men. Indeed, throughout the film Margarita benefits from this man's attention and money, indexing a consensual mode of relations. In a later scene, having already triumphed as a star and now searching for solitude and anonymity, Margarita is horrified at finding her photograph reproduced on postcards, proof that the consumption of stardom and mass-produced images of cupletistas and stars was widespread even in the remotest Andalusian village. Such images, circulated not only on postcards but also on the covers of magazines, calendars, matchboxes, chromolithographs, and labels for anís, invaded daily life and consummated the marriage of the spectacle with commodity capitalism.

But beyond the scenes in which spectators are invited to partake of the conspicuous display of luxury, both *La Venenosa* and *La sin ventura* are steeped in an exoticism that manifests itself through an interplay of consumption and references to prostitution or promiscuity. As reflected in their various names—Margarita/La Ambarina/La Sin Ventura and Liana/Liana the Star/La Venenosa—each woman's birth name is shingled with exoticized show names and legends. These names, like brands, sold orientalism, which had been in vogue in the cinema since the enormous success of both vamp films and ethnographic cinema like *Nanook of the North* (1922), *Grass: A Nation's Battle for Life* (1925), *Chang: A Drama of the Wilderness* (1928), *Simba: The King of Beasts* (1927), and *Rango* (1931). Related media like the theatre, the circus, and the illustrated press carried, as studies by Lou Charnon-Deutsch demonstrate, spectators to fantastical xenotopias. In the theatre, Tórtola Valencia debuted in London in 1908 and shared a bill with Maud Allan, who performed as Oscar Wilde's Salomé (Garland, 7). Valencia, who claimed to be the daughter of a Spanish Gypsy and a nobleman, performed orientalist dances such as *La serpiente* ("a dance of the Priestess Ñag—Natha Krishna, Goddess of the Serpents") and *La danza arcaica guerrera del Perú* (The ancient Peruvian warrior's dance)

in costumes that resembled Allan's: beaded, fringed, jeweled, breast-plated, and jangling, where the associations of harem, slave, and princess overlapped (Garland, 12, 14). Although Valencia and Allan were considered serious performers of high modern art, their imitators abounded in the cheaper variety shows and circus acts, and hundreds of photos in the histories of the cuplé show young women posing in this kind of exoticist costume. Magic acts also reveled in this orientalism, regularly featuring white conjurors who, smeared in brown greasepaint, announced themselves as "The Fakir of Ava, Chief of Staff of Conjurors to His Sublime Greatness of the Nanka of Aristaphae!" (Lamont, 30). In films like *La Venenosa*, these disparate strains of orientalist performance would collect and pool in the sequences devoted to the performance life of the female star.

Orientalism clearly sold, but it was also tainted with associations to racial degeneracy and linked to Catholic condemnation of luxury and the consumerist woman. Oriental luxury, pagan self-indulgence, the profane, and fashion embodied the "moral and economical sin of conspicuous female waste, that is, the nonproductive expenditure of male labor" (Aldaraca, 88–89). The vamp flaunted her idle luxury and her ability to deplete a man's wealth; such sloth and leisure were links between sexuality—adultery and prostitution—and consumption. Betraying the husband's pocketbook was the same as engaging in illegitimate sexual activity. Fashion, like cosmopolitanism, threatened the stability of the (white) home because it was marked by "inconstancy, mutability, a lack of stability, reliability or permanence" (Aldaraca, 110). In *La Venenosa* and *La sin ventura*, the mingling of racialized exoticism and cosmopolitanism and religion, bourgeois domesticity, and medicine bore witness to the state of flux in which definitions of womanhood and nation found themselves.

La Venenosa

La Venenosa (The Venomous One) is the stage name of Liana, played by Raquel Meller, the star trapeze artist of the prestigious Paris circus Cirque d'Hiver. Liana has climbed the entertainment ladder of success yet remains unhappy in her stardom due to a curse that gave her the power of fatal seduction over all men. The circus performers who fall in love with her inevitably encounter death, giving Liana the reputation

of a femme fatale and black widow. But through a double plot line, Liana finds true love with Luis Sevilla, a former famous criminal of the Apache crime group who desires to escape infamy, just as Liana longs to flee the media-saturated celebrity world. In a happy but open-ended gesture, the film predicts the couple's move to America.

Liana longs to be free from her indelibly tainted blood. The film's narrative begins with an intertitle explaining the curse of "La Venenosa," the effect of a bite from a sacred serpent that belonged to Liana's mother, "an enchantress of snakes." The bite has condemned Liana as both a fallen woman and a fatal seductress in the sense that she is unable to consummate her love with a man without his becoming bound and endangered in the web of death, as her name suggests. For indeed, all men who love Liana die: her mixed blood dooms her lovers to a variety of fatal accidents. It remains ambiguous throughout the film, however, whether the curse is the result of the actual snakebite or of Liana's mixed-race ancestry (her father was seemingly of Hindu or Indian origin, "a perjured and renegade fakir," and her mother was an even more vaguely racialized "oriental" snake charmer). Both possible origins are, however, equally undesirable. In the vampiristic associations with the bite, there lies the metaphor of the foreign monster who sucks the energy from the body of the nation. Like impure blood (*impureza de sangre*), otherness is the threat that lies both within and outside the body. The diseased fallen woman becomes a racialized social element through the conflation of discourses of medicine (science) and racial purity. In either case, otherness jeopardizes the (national) body and binary notions of identity and thus requires expulsion. The dilemma of Liana's unknowability typology—is she bad, fallen, fatal, or good?—is a problem that climaxes with the deaths of the circus performers who court her, representations of different types of manhood embodied in the clown, the lion tamer, and the prince who watches her perform, and gets resolved through her love for Luis Sevilla, who is Spanish by name but working in the French organized-crime business. The film's tension stems from an opposition between the antimodern curse that marks Liana's blood as racialized and therefore fatal and the medical-scientific view of Liana as a free subject capable of transformation.

Liana's public success and exceptionality is the result of discarding her "natural" and domestic role as a female. The sixteenth-century attitudes about women, which Fray Luis de León published in his 1563

La perfecta casada, were still in robust circulation in nineteenth-century texts, the foundational fictions for silent narrative film: "Women are meant to be secluded . . . should shut themselves inside and hide from the public eye . . . covered up in such a way that men may not look upon them and would he therefore permit that they go wandering at will though the city squares and streets, showing themselves off." Such "shameful and frivolous" behavior destroys the order, peace, and purity of the bosom of the home and can "poison the hearts and weaken the souls of all who look upon them" (quoted in Aldaraca, 29). Stardom is thus an inherently dangerous route to womanhood that threatens to compete with a male-controlled space, and in this way Liana's (and Meller's) legend wields material power over men. In her role as a trapeze artist—practically the whole first third of the film concentrates on her circus career—she is untouchable but certain to enflame male desire. Alone among the electric lights at the top of the black circus tent, with her dazzling costume and pale white skin, she is the embodiment of the celestial star. As both a controller of her spectators' gazes and the subjective focus of their adoring, incredulous up-tilted faces, Liana/Meller complicates any facile notion of the unidirectional gaze. Implicit within this complexity is a displacement from Liana as fallen woman to Liana as bad woman, a feminine model still dangerous but captivating, awe inspiring, titillating, and, perhaps for some, heroic. In this ambivalent commentary on stardom, Liana is both victim of her success, enslaved by rules of stardom that enforce the same kind of confinement as the curse of La Venenosa, and at the same time worshipped and desired.

Because the film medium struggles to simulate live entertainment, in addition to indexing the star's relationship with a cinema audience already familiar with the extracinematic persona, the symbolic and cultural coding of Meller's image must be negotiated both with the character she is playing and with the spectator's previous knowledge of her star iconography and her sexy performances as a cupletista. In this film it is not Meller's singing that becomes the vehicle of her character's success but the spectacle of her body and the low-angle shots of her trapeze tricks, edited so as to conceal Meller's stunt double. The film enacts live performance by intercutting between the audience of the heavily attended Paris circus and the performance of Liana, using long, medium, and close-up shots in both cases. This sequence of multiple point-of-view shots reinforces the extradiegetic spectator's

desire for Liana the acrobat, but more important, it foreshadows the camera work of the later Andalusian musical comedy films that incorporate similar performance modes. These quasi-erotic entertainment sequences evoke the female entertainers of the early theater halls and cabarets, whose performances were really just excuses to display skin. These performances—as they are registered by the condoned narrative—present what is, in effect, a peep show inserted into a "decent" narrative, thereby providing women and audiences with much more than just a morally sanctioned view of womanhood. Needless to say, for Catholic morality "the large crowded salons and places of public entertainment are filled with vice, destructive passions and temptations that provoke impure desires" (Pulido, 30; quoted in Aldaraca, 56).

The film thus accommodates the ideology of domesticity through Liana's noble and saintly qualities and in this way sutures identification with women who publicly performed the role of the saint and devout citizen while acting out star fantasies in a hidden transcript (e.g., the privacy of their minds, in their bedrooms). The filmic narrative is careful, for instance, to mention that Liana is a virgin. Men fall in love with her, but they never get beyond the first kiss before they die from the supposed venom. Nevertheless, the film acquits Liana of the blame for these corpses by having them succumb to occupational hazards: the clown falls off the trapeze, and the lion tamer faces a predictable ending. Indeed, Liana displays a saintly compassion, caring for the wounded criminal Luis Sevilla, who has hijacked her car, accidentally bringing them together. And by generously donating her blood and putting her own life in danger, she breaks the stranglehold of the curse. Her sacrifice could be read as her consent to the authority of medical discourse, the male voice of power that had supplanted that of the clergy after the turn of the century. Fainting and anemic, she returns to the circus that night but is unable to perform her act and is thus forced to descend the ladder amid jeers and taunts from the audience. Liana, like many women of the time, yields herself to the pressure to perform the saintly female role of abnegated sacrifice; "challenging it meant contesting not only the scientific basis for modernity but also traditional religious canons" (Nash, "Un/Contested Identities," 35).

At the same time, the film *La Venenosa* transports us to the Parisian nights of the twenties, to frenzied automobile traffic and city lights, and to a racialized space of luxury, lumpen characters, and the ever-looming

question of tainted blood. One night, we see Liana open the windows of her luxurious hotel room and look out at the night. The intertitle reads, "And the distant voices of the night called to the daughter of mystery." As if the beast within her has responded to this primal calling, the film tells us that Liana gets in her car and drives away in search of tranquility and solitude. The 1920s cinephile would surely see the intertext with early Hollywood films that offered images of New Womanhood through adventurous female drivers—like *Mabel at the Wheel* (1914), which was shown in Spain—suturing Liana as driver to autoeroticism and its masturbatory possibilities, *jouissance*, anarchy, flight from patriarchy, and the galvanizing experience of freedom (see Parchesky). In ways such as these, the vamp-like associations of this driver-car assemblage evoked empowering images of women. But all of a sudden, in a scene that foreshadows the gangster films of the forties, the famed leader of the Apache crime gang forces his way into Liana's automobile, or automobility. Unafraid, she stands up to him, requiring him to plead for compassion: he is wounded and needs her help. Unlike the femme fatale we suppose her to be, Liana agrees to help Luis Sevilla, and after a series of intermediary events, she volunteers to donate her blood to save his life, reversing her stereotyped role as a vampiress.

The car, of course, will transport her to and from the hospital, where myths and legends are destroyed and new, hopeful narratives are created. This apparently incidental round trip in the automobile structures the rest of the film. In the hospital scientific reason and method work to dispel the curse for the doctors, oblivious to the superstitious legend of La Venenosa, who see Liana as an altruistic lover of men. In the expansive spirit of the scientific criminology of the time, they tell the gangster that hopefully Liana's blood will infuse him with good instincts. The insertion of this sequence was consonant with reported developments in technologies of biopower that Spanish scientists were deploying in Equatorial Guinea in the 1910s and 1920s. In 1909, the bacteriologist Gustavo Pittaluga led an expedition to the colony to undertake mass blood screenings (Medina-Doménech, 84). The physician Luis Nájera Angulo, concerned with racial degeneration of indigenous tribes, wrote in the late twenties and early thirties of the importance of the new medical technology of blood testing for extracting information about colonial inhabitants that could prove their evolutionary primitivism and thus control and surveil the indigenous population.

Blood test certificates served as a "medical passport" and sub-
sequently as an identification technology, becoming compul-
sory in Guinea in 1928 as in many other African territories.
Landowners were also legally obliged to send their workers for
blood tests every three months or even monthly when results
seemed to warrant testing. Fines were imposed on landowners
(100 pesetas) for failing to comply with the practice and, from
1932 on, the workers themselves. (Medina-Doménech 84)

Finally, after hours of blood transfusion, Liana realizes she is late
for her nightly circus performance. Fainting and anemic, she rushes
back to the Paris circus in a taxi. Her return to the circus in this fre-
netic cab ride is exceptional for its intercutting between the taxi racing
through the Parisian night and shots of the love-struck circus clown
fatally attempting to perform Liana's trapeze routine. As the clown sus-
pensefully climbs to his death, gets dizzy, and plunges to the ground,
Liana pleads with the taxi driver to drive faster. The car, however,
is incapable of fulfilling its utopian promise: she does not arrive in
time, and ultimately the clown dies. Believing her curse is true, Liana
collapses, pleading, "Virgin of mine, have pity on me." The intertitles
scream, "La Venenosa!!" In this sequence the car is an actant, at first
defusing but finally perpetuating the antimodern myth of racial essen-
tialism—it takes us to the place of science where doctors deconstruct
the myth imprisoning Liana, yet inevitably she remains a killer of men.

Tired of constant scrutiny, Liana retires from show business to a
sumptuous palace in Nice—again, a performative gesture that out-
wardly rejects stardom as unhealthy while basking in luxury on fabu-
lous sets, subtly evoking the lounging flappers in product advertise-
ments. References to star-related gossip of the 1910s are displayed in
the film in ways that mediate the newspaper: images, snippets of news,
and ads are absorbed parallel to the main narrative. Here, the snip-
pet consists of the 1908 celebrity marriage of Spanish Andalusian fla-
menco dancer Anita Delgado to Indian king Maharaja Jagatjit Singh
Bahadur (Sajit). (Evidently, Penélope Cruz attempted to direct a film,
tentatively titled *The Princess of Kapurthala*, based on Javier Moro's
novel *Pasión India* but was prevented from doing so by the heir of the
Kapurthala royal family [Sajit].) Like the dancer Anita Delgado, Liana
is courted throughout the film by Karidjean, the wealthy Indian prince

and former circus fan who asks for her hand but dies in a bizarre plot twist before the wedding is consummated.

The threat of miscegenation is thereby introduced but conveniently resolved, dispersing the shadow of impure blood. Liana then marries Luis Sevilla, who like her, desires a life of anonymity, away from the public eye. Both Luis and Liana gained their social status through money rather than blood and share the desire to move beyond a society that imposes confinement by either domesticity or media scrutiny. Liana wishes to be free from the curse of La Venenosa, while Luis hopes that going to America will allow him to begin a new life as a gentleman, rather than as a criminal. As the couple embraces, the audience is reassured that legends die, since both characters will overcome what fate has carved out for them—including superstition, myths, and the prejudice of small communities. Such an ending provides an ample compromise: Liana turns her back on stardom, and the couple escapes from an oppressive society, while Liana the star lives on in the figure of Raquel Meller.

Figure 7. Liana (Raquel Meller) with a diamond crucifix around her neck and the turbaned prince in La Venenosa (1928)

La sin ventura

The film *La sin ventura* was shot five years before *La Venenosa* but contains more explosive material. While it critiques stardom by associating it with prostitution and sex slavery, it also allows women to identify with a titillating story of sexual scandal and orphaned girls living without the protection of a father. Reviews of the film were highly favorable, proclaiming it the best Spanish film to date (Gubern, *Benito*, 74), but its release also provoked highly polemical debates, given the sexually daring content (Ventajas Dote, 204). On December 12, 1923, *Mundo gráfico*, in issue number 623, noted that each night (the film was shown in serial form) the public anxiously awaited the projection. Such curiosity and expectation was surely not due to any moral proselytizing that the film had to offer.

On the level of diegesis, *La sin ventura* tells the story of Margarita Reyes, a fourteen-year-old Spanish girl from the other side of the tracks forced to serve her physically abusive mother and her good-for-nothing brother. When the latter's hoodlum friend comes to the house with a book containing "sycalyptic details of love and the venom of temptation," the seed of vice is sown, and Margarita falls prey to her precocious nature—the sin of which all women are supposedly capable. This book of knowledge also incites Margarita's desire for freedom, portrayed through frontal medium shots of Margarita longingly looking through a window in which hangs a caged bird. When the hoodlum character rapes Margarita, leaving her sprawled on the kitchen floor, the mother kicks her out of the house. Thus begins her training on the street as a picaresque petty thief and streetwalker. The henceforth recurring paradigm of sex for money subversively conflates patriarchy with pimping, and the lack of positive male images in the film does nothing to reverse that impression. In a similar development, white slavery stories in U.S. films after 1910 exploited audiences' fears of a very real phenomenon, but they also drew massive crowds eager and horrified to view their deep-rooted anxieties on screen. Shelley Stamp writes, "Even as white slave warnings expressed communities' collective fears about their daughters and sisters, the stories imagined independence and prohibited sexual encounters, at the same time rendering their participation involuntary" (51). In 1904, the Spanish supreme court incorporated legislation against white slavery into the penal code according to the

norms established by the international federation against white slavery that met in Paris in 1902 (Scanlon, 114). Although in 1902 Queen María Christina established the Royal Board for the Suppression of White Slavery (Real Patronato para la Represión de la Trata de Blancas), its administration by aristocratic women and the church rendered it virtually ineffectual (Scanlon, 115–16). In 1909, a royal order decreed illegal the employment of performers and waitresses under the age of sixteen in public theaters and entertainment locales, and women younger than twenty-three years old were required to obtain signatures from their parents in order to work (Scanlon, 115). In a gentler form, such plot elements dominated musical comedy films of the 1930s and 1940s. The narrative of *La sin ventura* is permeated with dangerous influences that as in *La Venenosa*, frame themselves within public transcripts that acquiesce to moral societal structures.

Through her sugar daddy, Ricardo España, Margarita meets the man who will be her downfall, Julio Monreal, an elegant con man, business impresario, and pimp who proposes to transform her into a desirable object for consumption, "the most delicious woman on earth." Through dance classes, social etiquette training, new clothes, and exposure to high society, Margarita becomes a fabulous star. Changing her name to La Ambarina, which recalls her exotic amber-colored hair and skin and resonates with the name La Fornarina (on whom the story is based), Margarita begins her career as a dancer and singer. Following her through the sumptuous, expensive sets, the enthralled spectator comes to know the wealth and decadence of the stardom into which Margarita/La Ambarina has been reborn. Demonstrating her jump in economic status, the film fetishizes even her everyday rituals as she dines at the city's fanciest casino. With its choreography of frolicking, naked, diving nymphs and its drugs and hedonism, this sequence metonymically conveys the iconography of the jazz age in Spain: "the lively clamor of the jazz band, the champagne and the craziness that inundated the salons of the fashionable cabaret, the Alhambra Palace" (Umbral, 44).[16] This casino scene was celebrated in the reviews of the time not only for the money that was spent filming it but for its visual extravagance and lush mise-en-scène.[17] For one of the ways that film sold itself was to show spectators fabulous worlds otherwise inaccessible to them, such as dinners in expensive casinos and costly evening spectacles.

But despite her wealth, Ambarina is disconsolate, imprisoned by

her relationship with Julio, the upper-class pimp who controls her life, exploiting her labor on the stage and prostituting her to his wealthy friends to fund his gambling addiction at the racetrack. The culmination of her success is the point at which the film actually begins, while her previous life of subsistence survival is shown as a flashback to "how it all started." As with La Venenosa, although life in the limelight fortunately supplants previous sexual and economic exploitation, it fails to provide happiness. As if she were channeling Fray Luis de León, Ambarina exclaims: "I wish to go where no one knows me, where I could be one among so many other women who live a bit for their soul."

Consequently, Ambarina rebels against Julio, and with the help of her former "protector," Ricardo, she flees to a remote Andalusian village, Valdeflores, a dwelling place for mendicants and lepers. Framed within a religious discourse—the Augustinian commitment to an ascetic life— the action here is motivated by Ricardo, who instructs her to isolate herself, renounce her jewels, furs, and carnal love for men, and assume a new identity. In a sort of temptation in the desert, a young doctor, an appropriate mate from the wealthy landowning aristocracy, falls madly in love with Ambarina. But she sticks to her promise, shunning his attentions; she also fears that he will uncover her sordid past, for as mentioned earlier, postcards and posters bearing her image continue to circulate, making it impossible for her to completely escape her former life. But Ambarina buys all of the postcards in the town and burns the remaining traces of her shame, symbolically purifying herself in the process. In a scene of her leaving the church, point-of-view shots from the perspective of a group of beggars who have gathered frame her walking out in a long black veil. Evoking a sense of the miraculous, the camera dissolves this image of Ambarina while fading into a new image of her in a long *white* veil, a virgin bride apparition that prompts the ragtag crowd to drop to their knees. The metamorphosis from black to white, from whore to virgin, is blatant, and its consequence is the creation of a miracle, a religious star who is the final negotiation of stardom and moral codes. Shortly after this point, the film stock has deteriorated, and we must rely on the synopsis provided by the novel, according to which Julio sequesters Ambarina in the city to revive his failing starlet business, which collapsed after she deserted him. Forced to continue her *mala vida*, Ambarina becomes seriously ill and must undergo an operation, the surgeon being none other than the young doctor who nobly pined for her back in

the village. But Ambarina dies in the hospital from the surgery, and the young doctor goes mad. In the meantime, the town celebrates Ambarina as a saint, and her strange disappearance is pronounced a miracle.

Public Transcripts

The conventional and morally sanctioned endings of both films, which provided familiar public transcripts, or performances, for women, in addition to medical discourse, resolved the lingering question about contaminated, racialized blood. But despite the conventional ending, the open-ended character of death or escape to America leaves more room for affirmation of subject positions. In *La Venenosa*, Liana and Luis transcend their pasts and castes; "America" is the quintessential icon of new beginnings. In *La sin ventura*, Ambarina achieves her long-wished-for freedom—"I need to breathe, be free, and live my life far way from men and toil [i.e., prostitution]"—if only briefly. In both films stardom does not die but lives on forever through the will of the public, who will always create another goddess. Such an interpellation of the active role of the spectator in creating meaning is inscribed into the palimpsest of constantly shifting identities present throughout the film. The complicated mix of types of the fallen, the bad, the vamp, the good, and the saintly woman provided audiences with a variety of positions from which to imagine and embellish the available models for womanhood and thus negotiate not just acceptable but desirable identities.

Although made to look more glamorous in film, in real life these identities were deeply ingrained roles, or scripts that women often had no choice but to adopt. These transcripts were not ambiguous or mixed, as they could be portrayed in film, but rather circumscribed, classified, and fixed. But film and its imaginary possibilities constituted for Spanish spectators in the twenties a domain of popular culture that could propel them into new configurations of knowledge, however temporary and brief. Racialized sexuality, especially Meller's version of the good-girl/bad-girl vamp or the reference to amber and sexuality in Ambarina's character, is an in-between identity that slips out from attempts to signify it. Again, this was film. How could spectators living under censorship and Primo de Rivera's dictatorship access these potentially dangerous images that destabilized white normativity? Gramsci explains that the ruling class must win the consent of subordinate groups in order to

sustain its hegemonic position. Its order is not permanent: the dominated continually pose a threat to its hegemony by the sheer nature of their existence. Racialized and white identity function according to the same logic. At the same time, consent must also inform the actions of subordinated groups, for they have a practical interest in avoiding overt confrontation with institutions of authority. Consequently, a negotiated ideological settlement becomes attractive to both groups, and popular culture plays an important ideological function both in endorsing *and* challenging ideological consensus.

Film's usefulness to the state and its capacity to appease censors were instances of consent. Unresolvable contradictions or gaps in film narratives were most often symptoms of censorship, but filmmakers and filmgoers complied by maintaining an appearance of consent, a fact reflected in film's balancing of sex content with "correct" conclusions. The first censorship law that applied to cinema was enacted in 1912. It was revised in 1913 under a royal order and prohibited minors under ten years old from going to cinemas unattended and even required cinemas to post the titles and premises of films, so that the authorities could determine the presence of pernicious elements (García Fernández, *El cine español*, 276–77). In 1916, films about World War I that could offend allied countries were censored, but in vague terms. It wasn't until after 1921 that censorship was tightened to the extent that it actually endangered the cinema industry (Martínez-Bretón, 113). With the reform of the penal code in 1928, article 618 prohibited and fined the production, distribution, or exhibition of obscene footage (Martínez-Bretón, 114). In light of the irregularity in which censorship was implemented, however, the First Spanish Congress on Cinematography of 1928 prescribed the creation of a new system of censorship governed by regulated norms and an appeals committee for rejected films (Martínez-Bretón, 116). Given these limits, it was in the industry's (stars' and fans') best interests to not discredit hegemony by rebelling against standards, so as to avoid having the film banned. Consent on a larger scale was won by cinema's contributions to the Spanish national economy, which lent credibility to cinema's claim that its existence complemented the common good of the nation. And yet necessary practices such as coproductions and star making threatened to break down the very ideological security that had supposedly been assured by film's acquiescence to state intervention.

From the perspective of hegemony and, thus, the Spanish state, the business of stardom, a pernicious element attacking the wholesomeness and innocence of all Spanish women, was anathema to the implicit patriarchal need to keep women under control. The star system was, however, a vital necessity to fledgling film production companies that relied on star appeal to attract spectators and to compete with other producers. Since it was tied to the economic success of the film industry, the star system also contributed to the national economy and, by extension, the patriarchal system of rule and social order. Despite a certain hegemonic discontent, it therefore was neither possible nor desirable to entirely destroy the semiautonomous discourses of the subordinate groups that made up Spain's small but growing star industry, even if they tended to promote alternative and progressive perspectives. Like the leniency toward prostitution under Primo de Rivera and its near-legal status under Franco—it was authorized until 1956 for the purpose of controlling public health (Roura, 45)—stardom enjoyed the status of a "necessary" industry that patriarchy both persecuted and protected.[18]

Toward the end of her life, Raquel Meller retired to Barcelona, shunning all publicity and interviews. Alone at the top of an eight-story building with no elevator, accompanied by only a horde of cats and dogs, whom she considered her children, and the relics of her stardom (medals of honor, objects, pictures), Meller appeared to be seeking refuge from stardom. Like La Bella Otero and countless others, Meller had either squandered her vast fortune or, as she told it, given it to the poor and needy. She herself had become a *beata* (devout woman), wearing a rosary everywhere and rising daily at dawn to attend Mass. Was this a contrived act of contrition or a genuine effort to escape the residues of vampiness? In Meller's last interview she condemns the journalists who betrayed her and only agrees to be interviewed if she is allowed to tell her own story. Perhaps Meller simply desired to reclaim her life and to control her image. This was, however, outside of the bounds of the consensus that governed stardom. When asked about her reclusive attitude, she defiantly retorted, "Why do people insist on retiring me if I haven't retired?" It seemed that for Meller the process of identity, although an ongoing process of becoming, consent, and negotiation, was a battle she was losing.

Racing for Modernity: From Black Jazz to White Gypsy Folklore

In America, when a Negro is accepted, one often says, in order to separate him from the rest of his race, "He is a Negro, of course, but his soul is white."
— Roger Bastide, "Color, Racism, and Christianity"

T he colonial failure of 1898 and the protracted conflict with Morocco, in particular the Spanish losses in the battle of Annual and the Rif rebellion, played themselves out through popular nostalgia in the mass media of the twenties and thirties, where manufactured notions of biological destiny (and infirmity) justified Spain's need to conquer and black Africa's need to be conquered.[1] Popular theatre spectacle, in tune with the turbulent filmic and literary modernity of the twenties, imagined who performed identity (whiteness or blackness), who *passed*, and who would be successful enough to actually live out the fiction of becoming. Benito Perojo's racially saturated text *El negro que tenía el alma blanca* (1926; The black man with the white soul) contained cosmopolitan (i.e., foreign) performers, objects, and scenarios that uncontrollably leaked into the national culture, potentializing imaginations and polluting cultural purity. By incorporating these fresh discourses into an idiom that made sense for Spanish audiences, *El negro* plunged Spain's racial and colonial history into a modernity symbolized by the stardom narrative. In this collision racialized bodies provided contrast, affirming the bourgeois self as nonracialized, while racial codes and exclusionary cultural principles distinguished those who were worthy of property, citizenship, and dominant subjecthood, thereby mapping the national community along racial criteria.[2] When

black jazz entertainers came from the United States and Latin America, their "return" was not as former colonial subjects but as exuberant bearers of modernity. With talent and tuxedos and being far more educated and worldly than any middle-class Spaniard could hope to be, they created a confusing dilemma: if these performers were modern, wherein lay Spanish modernity, and what did modernity mean?

The both-and identity of these entertainers, both black and white, fit most familiarly with the collective neurosis about Spain's status as both European and other to Europe. In 1927, the film *Del schottis al charlestón* (From the Schottische to the Charleston) was scheduled to go into production under the direction of Ernesto González (Gubern, "Ruido, furia y negritude," 276). Its death before its life on screen indicates how the furor over black jazz was short lived, overshadowed as it was by sound film, which favored folklore as a national idiom. The death of jazz is poignantly told through *El negro que tenía el alma blanca*. In 1926, a year before the release of Alan Crosland's *The Jazz Singer*, Benito Perojo made this silent film melodrama about Pedro Valdés, the grandson of Cuban slaves who works his way from restaurant bellboy to prominence as Peter Wald, internationally celebrated prodigy of the Charleston and the fox-trot. In Madrid, Wald falls in love with the lily-skinned Emma Cortadell, a poor white theatre apprentice who quickly rises to stardom as Peter's dance partner. But wealth and fame pale in comparison to Wald's anxiety about his blackness, an insecurity fueled by repeated rejections from the white women in his life. His powerlessness to overcome Spanish society's racist prohibitions on intermarriage, or Emma's own prejudice—Emma is horrified by Wald's skin color—has a debilitating, consumptive effect: Peter weakens and nobly, romantically dies a saintly death.[3] Transcending his materiality and becoming a soul, he achieves the invisibility that for the living comes with whiteness. For audiences Peter's redemptive martyrdom dissipated anxieties about ambiguous racial identities by reinforcing an essentialist black-and-white color scheme, as opposed to chromatic hybridity. Peter's illness became a metaphor for the memory of Spain's tainted racial origins and its perceived tubercular political impotence.[4]

This chapter discusses the progressive whitening and nationalizing of Spanish stardom and its fabrication of a predominately Andalusian, Gypsified subjectivity via the death of the Afro-Cuban jazz entertainer. A prototype of the later folklórica and an embodiment of

Figure 8. Poster reading, "Goya Films Presents Conchita Piquer in *El negro que tenía el alma blanca*," and featuring a portrait of Peter Wald

Spanish national identity, Emma wins over audiences with her own
surprising interpretation of African American dance, thus symbolizing
the triumph of white Spanish stardom over cosmopolitan and colonial
identity. Emma's fictive trajectory uncannily mirrors the real-life career
path of Concha Piquer, a career that began in New York, where she
performed with Eddie Cantor at Winter Garden in the early twen-
ties, becoming thenceforth known as Queen of the Fox-trot (García
Martínez, 24).[5] El negro would vault Concha Piquer's film career, as
well as launching her on the path to becoming one of Spain's premier
folkloric stage performance artists, starring in folkloric musical films in
the 1940s. Even though in El negro she dances the Charleston, Piquer
was known as an international star who frequently performed in an
Andalusianized folkloric style. An analysis of the context, characteriza-
tion, and registers of meaning in El negro, a silent musical film about
the world of jazz in Spain in the twenties, illustrates how stars like
Piquer became progressively whitened, even though they went on to
perform in Andalusian-based entertainment.

As we saw with Raquel Meller, the simultaneous racialization
and whitening that the Spanish female star underwent showcased an
ambivalent white individualism that proved decisive for later films,
like Filigrana (1949), that treated the performance and embodiment
of stardom. The rags-to-riches story of Filigrana traces the rise of its
lower-class heroine to the status of international performance artist,
much like Piquer's role of Emma in El negro. For modernity means the
ability to generate narratives of stardom in which Spaniards associ-
ated with racial others become producers of modern capitalist culture
who can vie with their counterparts in the other filmmaking capitals of
the world: Paris, Berlin, and Hollywood. Star culture and ambivalent
otherness therefore is modernity. As El negro conveys, the narrative of
the undiscovered but talented underclass girl who only needs groom-
ing to be made into a star develops through her engagement with
modernity. The economically marginalized (and therefore racialized)
Emma, played by Concha Piquer, learns how to perform whiteness in
this film when she becomes a cosmopolitan dancing star.

The triangular relationship among Spain, Cuba, and Africa shad-
ows the triangular relationships of Peter, Emma, and her father, just as
in a larger sense it underlies real-life entertainment and the authorship
of novels and films, with their particular investments in questions of

Figure 9. Poster for *El negro que tenía el alma blanca* (1926) featuring Concha Piquer

nation and identity.[6] Insistence on racial fixity, underscored by Emma's repeated rejections of Peter, is countered by the ambivalence of scenes where Peter and Emma dance together or black-and-white objects mingle in the film's mise-en-scène. More generally, the film's elaboration of dynamic, paradoxical, and indeterminate racial subjectivity is undermined by the ideological trickle-down of medical and anthropological racism—racial categorizing for the purpose of measuring the so-called progress of civilization—and the colonial nostalgia that informed the novel, film, and theatre cycle of El negro.[7] This ambivalence toward race derived not from any diffuse psychologized (and psycho-analytical) notions but specifically from the confused racial thinking that circulated among Arabists, regenerationists, and anthropologists in the mid-nineteenth to early twentieth centuries, who variously cast racial mixing (the result of African colonization and Spain's Muslim and Jewish history or potential mixes with Africans in North or sub-Saharan Africa) as either necessary for strengthening the stock or disadvantageous, for furthering degeneracy (Martin-Márquez, 50–63). Echoing these discourses, El negro's images of the primitive and other ideological taboos mark the black body as irretrievably contaminated, thereby reiterating Peter's inevitable failure as an appropriate subject for Spanish modernity. Nonetheless, these images are held in tension with others that convey Emma's desire for racial crossing with an Afro-Cuban Valentino who is modern yet not modern and, thus, threatening.

Story Cycles

El negro que tenía el alma blanca was closely adapted from the popular novel by Alberto Insúa, a pseudonym for Alberto Galt y Escobar, and published in the weekly magazine La voz in 1922. The second-most republished novel during the period of 1900 to 1936, El negro appeared in more than forty editions, sold over a million copies, and was eventually translated into Portuguese, English, Swedish, French, and German (Fortuño Llorens, "Introducción," 20). In 1930, Federico Oliver's fairly loyal theatrical version of El negro debuted in Madrid, while in 1935 Madrid's weekly Revista literaria novelas y cuentos was reprinting the 1922 novel. In 1937, Insúa published El negro's sequel, La sombra de Peter Wald (The shadow of Peter Wald), in which Peter's specter haunts the

sad romance of Emma Cortadell, destined to marry a white man "too white, of an ivory white" (212). Two film remakes—1934 and 1951—are probably the most lasting legacy of the El negro story cycle, as critics and academics largely dismissed the books as erotic pulp fiction and the only copy of the 1926 silent film remains in Madrid's national film archives. Literacy statistics indicate that the public was 52 percent illiterate in 1920 and 44 percent in 1930, implying that the film reached a broader section of the Spanish public and had more impact than the novel. Because El negro belongs to the modern studio spectacular that, influenced by Hollywood, flourished in French cinema during the second half of the 1920s, it lavished upon its public scenes of cabarets, entertainment spectacles, and elegant, bourgeois locales.

The proliferation of the story cycle of Peter Wald and Emma Cortadell—three film versions, two novels, and a play that were produced over almost thirty years—raises the question of why this narrative remained so popular with Hispanic audiences. The sensibility of the novel El negro derives from a whole tradition of racial melodrama in Spain, which had appeared in literary, dramatic, and visual incarnations, but the core histoire overlaps with forms of racial media and spectacle and with fashionable topics such as miscegenation and the tawdry world of the popular theatre. Fortuño Llorens, one of the few contemporary critics writing about the novel, attributes its success to a heterogeneous public looking for the "distraction, morbidity, eroticism, and sentimentality" to be found in the weekly serial magazines through which El negro and other erotic novels of the day were marketed (29). The novel's particular obsession with race stems, however, from the symbolically threatening nature of Peter's character.

Peter's ambivalent status as both servant and star (ordinary yet extraordinary) and his obsession with reconciling his black skin with his white soul figure the construction of Cuba itself in the Spanish national imaginary. The ideology underlying Peter's attractive yet threatening character can be partly surmised from Insúa's own sociopolitical context and from his 1922 novel. Insúa, born in La Habana in 1883, was born to a Galician father (Waldo Álvarez Insúa—note the similarity with "Peter Wald") and a mother from Camaguey, Cuba. His family left Cuba for Spain in 1898, after the colonial liquidation (Fortuño Llorens, Alberto Insúa, x). In his autobiography, Memorias, Insúa sees Cuba as black anarchy yet, at the same time, as Spain's brother. These analogies

evoke the imperialist rhetoric of hispanidad, a project designed to unite the Hispanic world through Spanish language and culture. This alternative to military colonization carried with it the implicit recognition that while *criollos* (Spaniards born in the Americas) longed to be part of the Madre Patria, black America could destroy this union. In *Memorias* Insúa remarks that Spanish nationalist newspapers portrayed the conflict in Cuba as an encounter of troops against rebels, heroes versus savages. Projecting his desire, he writes that the savages could nevertheless be tamed by white Spaniards: "blacks and mulattos, whose rage always ceded itself to the impulse of the Spanish infantrymen and cavalry" (79–80).[8] This same fearful condescension reveals itself in Insúa's father's political treatise, *El problema cubano*, which calls for Cuba's semiautonomy rather than its independence. Insúa agreed that Cuba's salvation resided in the continuity of the Spanish spirit and its language, religion, and culture presided over by an elite: "Upon the prophesies of a Black Cuba, of an enslaved Cuba, my father's book followed with rosy portraits of a happy Cuba, governed by the best of her sons in the name of the Madre Patria. That was what I liked about his book: that Cuba did not cease to be Spanish" (81).

Such tacit support of Spanish paternalism and colonization, indeed the inability of Peter to rid himself of his past as a house servant for wealthy *criollos*, nevertheless acknowledges Peter and, by extension, Cuba and Africa as competitors but, at the same time, as coveted possessions. Insúa's own conflicted relationship to his character Peter may have stemmed from his sympathy for Peter's doubleness, which was a condition for blacks, *criollos*, and Spaniards alike (in their aspiration and inability to be European and modern). The narrative reveals Peter's mysterious past, the root of his anxiety, as a series of flashbacks linking him indelibly to his Afro-Cuban origins. This plot material is necessary for the star-is-born narrative: Peter's humble beginnings parallel Emma's struggle amid poverty and the degrading theatre life. Yet while Emma longs to preserve her past, Peter endeavors to erase his. The flashbacks signify Peter's inability to repress the circumstances of his birth or his acculturation to Cuban servitude. The flashbacks thus posit history as a problem for the unhistorifiable part of Peter that lies outside the narrative of stardom and, as we have seen, on the margin of the (national) family.[9]

In the novel, Peter, or Pedro Valdés, as he was born, is the son of freed

slaves who remain faithful to their Spanish masters, believing that life is better on the idyllic plantation with their "buenos amos" (good masters) (Insúa, 122). Pedro comes from a family of house servants who are considered an improved stock of Africans, closely associated as they are with the white aristocratic Arencibia family—a "superior race" (123). Pedro's relationships with women reflect his forbidden aspirations and the fatal flaw of his tragic heroism. Pedro's mother, a mammy type—"Eva negra, Cibeles etíope" (a black Eve, an Ethiopian Cybil) (122)—simultaneously suckled Pedro and the marquis's daughter, Piedad. Pedro, accustomed to white wealth and comfort, subsequently acquires a taste for white women: first Piedad, then the loose theatre women, and finally the saintly Emma. Peter's tragedy thus resides in his location within, identification with, and desire for white culture as incarnated in the white woman and in his simultaneous status as a melodramatic victim of a racially divided society. The desire for a white stage sibling was again enacted in 1932, by Josephine Baker in the title role of *Zouzou* (dir. Marc Allegret). Zouzou falls in love with her white stage brother, Jean, who has eyes for only the blond named Claire.

During the Republic, however, the black child was metaphorically embraced in Grigori Aleksandrov's *Tsirk* (1936; El circo or The circus), which was shown in Madrid and, according to the leftist worker's newspaper *Mundo obrero*, received deafening applause because "the people of Madrid understood the value of the heroic Soviet crusade for the equality of race" (quoted in Cabeza, 91). Unheard of for a Soviet film in a Spanish theater, *El circo* was shown seventeen times. The film narrates the story of the American dancer Marion Dixon, who is touring the Soviet Union with her black son. The owner of the circus, jealous of Marion's Russian suitor, makes a spectacle of burning the black boy in the middle of a show. The audience, contrary to the owner's expectations, saves the boy and passes him through the crowd and away from the stage. The theme of mixed-race children continued to fascinate Spanish audiences throughout the Franco regime, even though the vast majority of such films focused on Gypsies played by white folklóricas.

Although Pedro's taste for white women remains repressed, he rebels from his masters. Reaching adulthood, he realizes that Piedad's rejections of even his brotherly love and the increasing threat of his presence to the son of the marquis, the perverted and degenerate Néstor (the embodiment of diseased Spain), have prevented the

fulfillment of his true identity. In a revealing moment Néstor catches Pedro playing with his fencing foils and violently punishes him, recalling the realities of slave owners' fears of rebellion by armed and educated blacks and once again reflecting how *criollos* felt about their own underclass. Pedro's choice is to remain subhuman in the eyes of his paternalistic employers or to leave Cuba and try to fulfill his dream of becoming white. Pedro's black corporeal identity marks him as the lack, yet his soul—a romantic, not modern, concept—and, thus, his spectator identification are in ideological conflict with this Hegelian bias, such that "black" and "white" are synthesized to teleologically lead to an improved subjectivity. Peter is therefore the victim of contesting discourses in an emergent Spain that categorizes him as either irremediably black or impossibly altruistic and devoted.

The specter of Cuba and insecurities about pure-blooded Spanish ancestry are also present in Perojo's biographical relationship to the island. His father, José del Perojo, born in Santiago de Cuba, openly supported Cuban autonomy in his parliamentary speeches as deputy representative and denounced the tyranny of the United States over Cuba (he also supported Catalan regionalism and decentralization) (Gubern, *Benito*, 16–19). José married a white Cuban but left her and lived the rest of his life with Perojo's mother, who was born in the Philippines. Perojo's father, a fervent neo-Kantian—considered heretical by the church—dedicated most of his time to journalism, having founded the weekly graphic magazine *Nuevo mundo* (1894), which became one of the highest-selling papers in Spain and recognized throughout Europe. It is thus no surprise that Perojo felt personal resonance in Insúa's story, as well as compatibility with his cosmopolitan concerns. Perojo's earliest years of filmmaking were as a teenager, in collusion with his slightly older brother, who like him had inherited *Nuevo mundo* upon José's untimely death in 1908. Although the brothers quickly lost the business to unscrupulous business associates and were thus forced to pursue filmmaking as a livelihood, the relationship between the print media, theatre entertainment, and filmmaking had become naturalized for Perojo. Perojo understood audiences and, despite the relentless criticism of his cosmopolitanism, knew that presenting the Spanish spectator with a broader vision of reality was the future of cinema.

The story of Peter merely replicated that of dozens of other Cuban

performers who came to Spain after the midtwenties. Orchestral *danzones* that combined jazz and Caribbean rhythms and instruments were brought over by groups like the Sexteto Nacional de Ignacio Piñeiro Martínez at the Expo Iberoamericano in 1929; Antonio Machín and the Orquestra Plantación of José Valero; Mariano Barreto, aka Blanquita Amaro (star of the 1934 *El negro*), who was famous for balancing on her hands and who apart from introducing modern mambo in Spain, went on to make *Una cubana en España* (dir. Luis Bayón Herrera, 1951). In reverse fashion, Spanish singers such as La Bella Chelito attained whirlwind success in Cuba, adapting Cuban rumba to more stylized routines. The Cuban press named her "The Christopher Columbus of the Antillean Rumba" (García Martínez, 22).

Successful entertainment satisfied the desire for modernity by keeping up with foreign trends, yet initial criticism in Spanish film magazines of Perojo's *El negro* derided the director's cosmopolitanism. Aesthetically, his films were said to lack Spanish personality and to be devoid of nationalist interest. "Cosmopolitanism" contained a variety of meanings—it could refer to the insult of Jewish internationalism or to the extreme Left's condemnation of Perojo's bourgeois themes, as opposed to international proletarianism (Gubern, *Benito Perojo*, 118). But clearly for Spanish critics, Perojo did not demonstrate commitment to what they saw as the project of Spanish national cinema. In effect, Perojo had to choose between artistic integrity and profit, even though his reason for returning continually to foreign studios between 1917 and 1931 was chiefly that Spanish capitalists were unwilling to invest in films. When shooting *El negro*, for example, he resorted to the Joinville studios outside of Paris, which had readily available and up-to-date studios, sets, and lighting, and in the process used foreign technicians and actors (Perojo thought it was virtually impossible to find elegant actors in Spain) (Gubern, *Benito Perojo*, 118). But Perojo's efforts to represent Spain as modern despite its material obstacles led critics to claim his films were not realistic or authentic. Ironically, the Spanish film industry's answer to this cosmopolitanism would be the confabulated Andalusian musical film genre. Perojo's Emma foreshadowed the demise of black jazz and the rise of a more appropriate national symbol—a move that was uncannily associated with the return to Spanish autochthonous studios that Spanish film directors would be forced to make. Certainly, the tawdry *varietés* of popular theatre and

the naughtier versions of the cuplé were also associated with cosmo-
politanism, as was Perojo's demonized internationalism.

> The radical discredit of the category of cosmopolitanism was
> in our century coincidental with the argumentation of the ex-
> treme right, which condemned it as unpatriotic (like Fascism's
> condemning of international Judaism), and of the extreme left,
> that saw strong bourgeois and elitist connotations in such a
> category, opposed to the virtues of proletarian international-
> ism. (Gubern, *Benito Perojo*, 123)

Although *El negro* is not itself a folkloric musical comedy film, its
Spanish rendition of an *A Star Is Born* theme anticipates the plotline
of many folkloric musical films from the 1930s to the 1950s. Indeed,
Peter and Emma, with mantilla and an enormous Andalusian comb,
triumph in the Paris cabaret El Patio, whose interior design simulates
an Andalusian-Moorish palace and in which waiters of African de-
scent pour champagne and African American musicians play jazz. If
Parisians saw no distinction between Spanishness and Andalusian-
ness, then perhaps modernity lay in playing with race while all the while
whitening it.

 El negro capitalized on desire and anxiety about modernity by pre-
senting race in a racy way, that is, through Emma's liaison with Peter, a
bizarre performance of blackface, her contact with jazz dance, and her
metamorphosis into the "real" star of the film. Commotion over the
film was, however, as much a product of audience familiarity with racy
tropes as it was of their ignorance of them. As Luis Quesada states,
the film mixed plantation scenes with the café and cabaret life of Paris,
all novel themes for the unworldly Spaniard, agape at the spectacle of
race (225–27). Although radio and music hall exposed audiences to
various national types and their accents, skin color was not a vision
from daily life but an exotic mirage. To understand the film's impact
as a story of becoming requires an awareness of the racially saturated
popular spectacles available to Spanish audiences of the time. Within
this horizon of expectation, we begin to see what all that excitement
and nervousness about modernity was really about.

 Perojo's *El negro* was certainly not the first instance of blackface per-
formance, referred to in Spanish as *negrito, cara negrita,* or *cara embe-*

Figure 10. Emma (Concha Piquer) and Peter at the Paris cabaret El Patio in *El negro que tenía el alma blanca* (1926)

tunada. In golden age theatre, actors in blackface parodied Africans, and *teatro bufo* lasted well into the twentieth century (García Martínez, 270n13).[10] *Teatro bufo* was principally a preindependence Cuban theatre tradition that parodied esteemed Spanish literary and theatrical traditions, often flaunting the threat that Cubanness represented to Spanish cultural hegemony. This revue-style theatre combined short comic plays, music, dance, and displays of vernacular culture. Although it was later performed in Spain, *teatro bufo* peaked in popularity in the 1860s in Cuba, coinciding with the struggle for independence from Spain. Reinventing the comedy of manners, it developed a repertoire of stock black characters invariably played by white actors in blackface. Jill Meredith Lane argues that the *teatro bufo*'s protagonist, the *negrito* character, performed in blackface by white actors, allowed white *criollos* to indulge themselves in racist spectacles. In so doing, they assuaged racial panic and the general anxiety over the Africanization of Cuba, affirming white status over black in a colonial hierarchy yet reaffirming a nationalist sentiment that celebrated racial diversity. Blackface performance promoted *mestizaje* as a national ideology, projecting Cuban-

ness in opposition to the Spanish peninsular identity (Lane, 3). Cuban patriot-intellectuals such as José Martí recast *mestizaje* to mean not the "emblem of colonial contact, conquest, and violence—the mixed race offspring of a native American and European conqueror"—but rather the "original" American that "embodie[d] both a pre-colonial and post-colonial utopia at once . . . an originary figure for a newly hopeful American nation" and "a trope of national self-invention" (Lane, 6, 9). In the film *El negro*, *mestizaje* constitutes the ebb and flow of Emma and Peter's relationship, conjuring demons of terror and excitement while seeming to reinforce Emma's putatively stable identity.

Combining with the residues of the *teatro bufo*, the influx of black entertainers into Spain that started in the late nineteenth century brought the popular stage and early cinema into a substantially more intimate relationship with black entertainment. As early as 1880, entertainers like the acrobats Paolo and Panlo could be seen in Madrid's Teatro-Circo Price, as well as in other venues for dance and black spiritual song (García Martínez, 17). At the end of the nineteenth century, the owner of Teatro Apolo in Madrid fired an actor from the zarzuela *Cadiz* (1887), who was playing a mulatto, in order to replace him with a black servant who had no theatrical experience. García Martínez does not explain why the white actor was fired, but it seems clear that the public wanted to see a black actor, not a white one with makeup (García Martínez, 17; Gubern, "Ruido, furia y negritude," 278).

The writer and intellectual Gonzalo Torrente Ballester describes the first two decades of the twentieth century as an explosion of jazz venues and the time of the craze for ragtime and the cakewalk, noting the 1905 cakewalk performances of Mister Johnson in Barcelona's Alegría Circus and of black dancers in the 1910 operetta *La niña mimada* (Aurelio González Rendón; The spoiled little girl) (García Martínez, 18). Fox-trots and tango mixed with jazz, and both were performed by cupletistas and associated with black entertainment. The first jazz performance in Madrid was in 1919 at Madrid's El Club Parisiana (García Martínez, 59). From the midtwenties on, the Spanish intelligentsia closely followed the developments of the New Negro movement and the Harlem Renaissance, appropriating (a problematic) *négritude* in a desire to find new inspiration and to keep up with modernity. Federico García Lorca's observations on theatre revealed his fascination with the Parisian *révue nègre*—Josephine Baker had debuted in Madrid in 1925

with Louis Douglas's *La révue nègre*—in which the best actors were black, *mimos insuperables* attesting to how audiences clamored for black theatre over white.[11] In 1929, Ramón Gomez de la Serna, in blackface and a tuxedo, read from his text *Jazzbandismo* for his introduction to the debut of *The Jazz Singer* (Amorós, *Luces de candilejas*, 193; Gubern, "Ruido, furia y negritude," 293).

Such entertainment braved a new world while it begged to be exploited. The attraction of the modern figured largely in popular theater owners' decisions on content, as can be seen in the theatre magazine *Comedias y comediantes* (August 1, 1910), which pretended it had found a recipe for success for cabaret owners: "two drops of the *garrotín* [a popular late nineteenth-century dance], four of *machicha*, three grams of cakewalk, fifty milligrams of a sexy song, and a half dozen cute girls" (García Martínez, 19). In his memoirs César González Ruano describes Maxim's, the first *bar americano* in Madrid in 1919: "Guarding the door was a giant black man dressed in showy livery who sold cocaine in little brown crystal flasks that contained a gram from the Merck company" (Gonzalo Ruano, 66; see also Gubern, "Ruido, furia y negritude," 279–80; and Amorós, 162). This doorman would be the inspiration for Peter's character in Perojo's *El negro* (Gubern, "Ruido, furia y negritude," 280). What can be surmised from histories of entertainment and from theatre and film reviews is that imported entertainment that foregrounded performers of color was fairly accessible to a large percent of the Spanish public.

Raciness was, however, most profitable, exotic, and titillating when it passed white for black and vice versa, radically destabilizing fixed categories of identity. The English adjective "racy" (the *Oxford English Dictionary* gives its early twentieth-century meaning as referring to a "floozy" or "a girl or woman of disreputable character") may have described how some Spaniards felt about stories of the girl seduced into the stage world or, more generally, about mixed-race couples in films and serial novels. The girls in these stories were racy in their open sexuality and their openness toward men of different ethnicities, specifically men of color. They were dangerously naughty, and for moralists and race purists, their stories were hopelessly popular. Narratives about mixed-race couples were certainly not new in Spain—the *cosquilleo interracista* (interracial tickle) was a well-known fad in the twenties (Gubern, "Ruido, furia y negritude," 282). The difference was that in

the context of modern entertainment and stardom, racy female characters could actually compete with men for wealth and fame.

In 1907, for instance, the company Atracciones Internacionales toured Spain with a Barcelonese singer and dancer who performed American songs in blackface. The girl allegedly was Raquel Meller. In 1914, the cupletista Marianela and a black entertainer named Colbert danced the tango in the Trianon Club (López Ruiz, 13). We also know that long before Baker's Madrid debut, the cakewalk and ragtime, originally sung by African American artists, figured in the repertoires of cupletistas and singers of the 1910s and 1920s such as Esperanza Posada, Julieta Fons (The Queen of Sicalipsis), and Adelita Lulú (The Queen of Lighted Photos), bringing these performers fame in the entertainment circuits of large Spanish cities. When first heard in Spain, Duke Ellington's songs were sung by cupletistas (García Martínez, 11); fox-trots were composed by Spaniards, such as "Ritmos del tap," by Orduña, Llorens, and G. de Molina, or "La calle 22," by Raffles y Villacañas (García Martínez, 24). When Concha Piquer returned from New York, where she had purportedly sung in the musical *The Dancing Girl* with Eddie Cantor, she was thenceforth labeled Queen of the Fox-trot (García Martínez, 24). In 1923, the vedette Gloria Guzmán earned the first superhit in the history of recording in Spain with the fox-trot "Yes! We Have No Bananas" (García Martínez, 24). Nevertheless, Álvaro Retana, revealing the racist tendency that underlay the historicization of entertainment, distinguishes between ladylike performance and the "absurdity" of "a Spanish girl imitating an old, pot-bellied black woman, of indescribable ugliness, vociferating as if a group of blacks were hitting her" (García Martínez, 131).

By 1926, when she made her cinematic debut with Perojo, Concha Piquer had already become an internationally famous singer of cuplés. The daughter of a bricklayer and a seamstress, she was a product of the hardy Valencian working class; her parents had already lost four children before she was born. Piquer recalled that her first experiences as a singer were traumatic: the first time was with her dead brother in her arms and another one was with her father dying of cirrhosis (De la Plaza, 22). At eleven years of age, behind her mother's back, she daringly presented herself to the owner of Teatro Sogueros, who then sent her to a music academy. In her first performances she was obliged to wear her first Communion dress. She could neither read nor

write, and the only language she spoke was Valenciano (De la Plaza, 23, 26). At thirteen she met Penella, who would become her benefactor, tutor, song composer, and "sentimental companion" into the late twenties. With Penella in 1922, Piquer and her mother crossed the Atlantic for a debut in New York, where the public was so enthralled by her transvestite performance as El Florero (The Flower Boy) that during the intermission of *El gato montés*, Columbia Records offered her first record contract, which ran from 1922 to 1924. She would later record twenty-two songs for Columbia on eleven gramophone disks (De la Plaza, 29). By the time Piquer returned to Madrid via Paris in 1926, with the wardrobe of a star and 14,000 dollars, she was performing in a wide variety of styles: Charlestons, orientalist pieces, Andalusian songs, and, according to De la Plaza, blackface imitations of Al Jolson singing "Just Singing a Song" (37). Her song by Penella "La maredeueta" (1927), about a sculptor who carves a Virgin to look like his lover, was censored by Catholic groups as a sacrilege. In 1927, she briefly appeared in a scene of the *The Jazz Singer* in which she sits with her back to the camera (with two brief shots of her face in profile) at a café table while listening to Al Jolson sing.

El negro que tenía el alma blanca's spectacular impact upon the popular imaginary becomes clearer when we see that its mechanism of attraction—its raciness—had much in common with other forms of entertainment where black and white formulas mixed with sexual displays of femininity that satisfied the demand for (acceptably) bold and risky situations. Indeed, *El negro* embraces the world of racialized entertainment by displaying blackface on the labels of commodity tie-ins and through the unselfconscious blackface performances of Raymond de Sarka, the Egyptian actor playing Peter. Concha Piquer symbolizes white stardom through the close-ups of her white face, her white, glittery clothes, and bright stage lighting, and she furthers the contrast by putting on and removing blackface in one of the film's most important sequences. Just as she performs raciness by dancing with Peter but then removes it by rejecting his love (sex), Emma performs blackness but then removes it to perform her role as a white star. Those who can choose their color, as opposed to Peter's fixed and antimodern blackness, demonstrate the ability to change, become, and pass—indices of the modern.

From the very beginning, *El negro* foregrounds the performance of

blackface. At the same time, it impresses upon us the value-encoded color scheme and the axiomatic star scheme of good girl/bad girl/good girl needed to read the film. In the first scene a tired Don Mucio returns to his poverty-stricken home in working-class Madrid. As he enters, he surprises his daughter Emma, who is cleaning the chimney stove. Covered in soot, hair uncombed, and with relaxed, even slovenly bodily gestures—all of which function as a performance of stereotyped blackness—Emma looks up at Don Mucio with bulging eyes and blinks several times, opening them widely to show off the whites of her eyes and crossing them several times. Emma's gestures call forth Manthia Diawara's description of the "deceptively dangerous" color white. When used in blackface, white alludes to the rolling eyes of the watermelon and chicken thief surprised in the darkness in Sambo art, the wide-eyed stereotypes of blackness associated with the grimaces of demons, or imposters "trying to usurp the ways and manners of a white lady" (Diawara, under "The Stereotype and the Content of History"). Here, Emma parodies a white lady, since she is not yet one herself. But Don Mucio, concerned that his white property, symbol of his honor, might be contaminated by association with blackness, reprimands Emma for not being more well groomed, as a future star should take better care of herself. The scene ends with a close-up shot of Emma's white hands stroking a white cat and then raising it to her face, now clean and whitened even further with makeup.

Emma's ability to put on and take off blackface foregrounds Peter's inability to change his color. Precisely what had made *The Jazz Singer* potentially contestatory was the self-conscious use of blackface as just another prop that might allow Eddie to pass and identify with another marginalized group like his own. Emma is first presented as black and soiled by the chimney soot on her face, but she will become white, clean, and normatively stable merely by dressing up and applying white powder. Emma's face is central and highly visible as the antonym of Peter's black face; he almost blends into the background in many shots, which illustrates his dilemma. He has a white soul (Emma's face is the reminder of the soul), but as we cannot see his whiteness, it does not exist. Peter's slave past, his skin color, and the further commodification of his skin and body deny him the full expression of his aspiring bourgeois desire to become.[12]

Emma's emergent whiteness is aligned with visual symbols of white

Figure 11. Emma and her father in *El negro que tenía el alma blanca* (1926)

superiority and female purity like the white cat that Emma holds up to her face. In her study of nineteenth-century Spanish illustrated magazines' portrayal of women, Lou Charnon-Deutsch brings to bear abundant evidence to show that domesticated animals were a familiar visual trope that evoked the contradictory status of women as precious and precocious, servile and requiring engagement (see *Fictions of the Feminine* and "Racial Fetishism"). Emma's color and feline traits invoke the popular and racy operas *La gatita negra* and *La gatita blanca* by Vives y Giménez, which were known for "scantily clad tango dancers, whose cast was led by Julita Fons herself, and the trembling cakewalkers that topped it off" (García Martínez, 19). These overtly sexual features of popular erotic theatre bring us back to the theme of race, the daring taboo of white and black sexual contact that was exciting for audiences of both men and women. Yet Emma's white cat also explicitly references D. W. Griffith's shots of white kittens contrasted with black kittens and puppies in *The Birth of a Nation*, where they are visual metaphors for the tension between the genteel white South and the criminalized, lower-class North, which had been further contaminated by its association with former black slaves. Inherent in these examples is

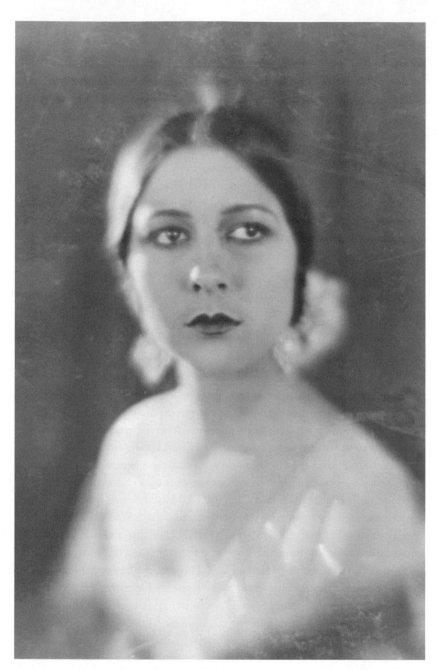

Figure 12. Concha Piquer à la Lillian Gish in *El negro que tenía el alma blanca* (1926)

the mechanism of desire and rejection, offering a profitable release for sexual fantasy but also instating the white woman's privileged role in reproduction and her hierarchical position above the racialized other, while she herself is subordinated to white male power. Emma is the white angel of the home, moving within a glowing incandescent light, à la Lillian Gish, yet simultaneously holding the status of sex symbol through the star text of Concha Piquer. The Spanish film industry nurtured this union in order to compete with Hollywood and, more important, to provide Spanish spectators with a star that they could acceptably idolize. Blatant sexuality was impermissible, but Concha Piquer, skimpily veiled by the discourse of virginity, was titillatingly profitable.

Performing, Mixing, and Monsters

Peter's stellar rise in popularity reflects both the demand for performers of color and Spaniards' simultaneous denigration of entertainment that overshadowed authentic Spanish cinema or theatre (Oliver, 35). His rebellion against the Arencibia family and his steamship journey across the Atlantic to become a new man, first in Paris and then in Madrid, tells the story of so many other artists of color who came to Europe in the 1910s and early 1920s to occupy stages alongside European performers. Although the 1926 film recalls how Spanish and American performers mixed and mingled, it also invests heavily in the visibility of the white female Spanish star, and much of its dramatic tension lies in the fear that Emma, other theatre personalities, and intra-diegetic spectators feel toward Peter.

In the novel Peter's story opens with theater owners' debating the consequences of contracting Peter Wald.[13] Not unlike the minstrelsy of the *bufo theatre*, derided as a facile, contaminating foreign product that caused the decline of Spanish theatre in the nineteenth century (Amorós, 161–62), black jazz dancers were hugely popular, often because of the morbid attraction spectators felt. Praising the Valencian soprano and zarzuela singer Selica Pérez Carpio, Luis Gómez Mesa wrote in the magazine *Popular Film*: "But who is he that suddenly feels he is a baritone or a tenor without other precedents or merits then a detestable voice and a marked taste for tam-tam Africans and Negroid

jazz bands—is he capable of engaging in strength with a starlet of the rank and renown of Selica?" (May 24, 1928).

Peter's triumphant visit to Madrid, when he is at the height of his world fame, exposes the parochial Spanish theatre world as a synecdoche for post-1898 Spain. The economic boom of the twenties, owing to Spain's nonparticipation in World War I, which boosted Spain's markets while other European ports were closed, had not yet seeped into the attitudes of the theatre players, stand-ins for Spanish citizens. *El negro* introduces the character Peter on his arrival at the Madrid theater where Emma works, which bustles with activity as the performers wait anxiously for his entrance, enviously gossiping about his success and wealth. Accompanied by a white chauffeur and his white dance partner, Ginnette, Peter epitomizes cosmopolitan modernity (the mixed-race couple and Ginnette's French identity) in conjunction with the American dream (the Rolls Royce and the money-can-buy-everything motto). Set against previous scenes that highlight Emma's poverty and the lumpen theater conditions, Peter's material extravagance, coupled with the fawning intradiegetic audience of theater workers, destabilizes the notion of blackness as primitive. The anxiety to achieve modernity is conveyed by shots of the curious theater girls, who from behind the bars of a descending stairway gape through fetishized close-ups of Ginnette's satin and diamond shoes. Precisely who is on display in this scene is ambiguous, both for the curious Spaniards behind bars *and* for Peter, who receives and returns their gaze, complicating any facile reading of the look. Later on, Emma and Don Mucio arrive at Paris's Quai d'Orsay train station and step aboard the electric escalator, an emblem of modernity and the rise to stardom. In a slapstick routine they fall all over themselves, annoying the Parisians, who are accustomed to such machines, and parodying the *paletos* (hickish Spaniards who have never been out of Spain).

Anxieties about who would benefit from the cultural onslaught of modernity encouraged Spaniards to pit ethnicities against one another. With the arrival in Spain of Afro-Cuban and African American entertainers such as La Perla Negra and Josephine Baker, white female entertainers, as well as agents and theatres and film directors, felt inadequate knowing that stars like Baker, or the fictional Peter Wald, could request sums of money far beyond those available even to established national stars.[14] Gossip about the salaries of entertainers was

constant in pulp fiction and journalistic coverage of the popular stage (Insúa's novel *El negro* being just one example). Benito Perojo affirmed in an interview, for instance, that Piquer made 12,000 pesetas for three months of work in *El negro*, more than any other Spanish actress of the time (Gubern, *Historia del cine español*, 121). But de Sarka's salary was not mentioned, perhaps implying that Peter Wald symbolized how color and talent endangered the collective drive to succeed in the capitalist project of Spanish modernity. Emma reinforces the white right to economic success and individuality, modeling Spanish audiences' ideal projection of themselves. Wald's ambition and his success in the international entertainment circuit suggest what could happen if former colonial subjects invaded the entertainment market: they could make more money, take the jobs, and in the end perform better. Ultimately, throughout the story cycle of *El negro*, the message is clear: in his monstrosity, Peter would be better off not to compete with whites.

As the filmic narrative progresses, Emma and Peter's dance routine becomes an international hit; intradiegetic audiences flock to see this racy couple, and they become icons of a sort. A point-of-view shot shows a female spectator with opera glasses watching their Charleston and tango routine, suturing intra- and extradiegetic audience desire for both Concha Piquer as Emma and the Valentino-like Peter. Heightening the sensibility of audiences, Peter and Emma's trance-like dance on stage fuels the public's desire to witness their taboo interracial coupling, briefly overriding a fear-induced tension. As the novel describes it, "Certain steps, certain swaying of the hips and contortions were frankly lubricious and tended to evoke images of sexual intimacy" (251).

Temporary excess is then reigned in by scientific discourse. In Federico Oliver's theatrical adaptation, Peter's monstrosity is compared to the spider's fascinating yet terrifying excess. Describing his dancing with Emma, Oliver writes, "Peter notices Emma's invincible repugnance and proceeds to do the same as fascinating insects, to anaesthetize his victim. He wants to wrap her in a thick web of attentions and devotions." Later, he makes another analogy: "Imagine a hippopotamus that wants to be a swan" (Oliver, 59). Among the general public this quasi-anthropological obsession with hybridity manifested itself as "an abhorrence of interracial intercourse and 'blood-mixing'" and in the belief that such mixture produced monsters (Tobing Rony, 162, 163).[15] Furthermore, cannibalistic imagery actually displaced responsibility

for obscene consumption from the white spectator onto the racialized subject. But then in one of the many reversals, the narrator attempts to reimpose disinterested love onto Peter's dancing: "Dancing they were two lines and one sole harmony, the beginning and the end of a beautiful act that stopped when they separated" (Insúa, *El negro*, 288). Peter also endeavors, machine-like, to convert his love-lust for Emma into platonic love, but it only feeds his illness.

Emma's father, Don Mucio, who vicariously lives through Emma's hoped-for stardom, represents both progressive (i.e., eugenicist) race thinking and free-market capitalism veiled in the discourse of rational, economic thinking—the slippery slope of modernity's capitalist enlightenment. His hypocrisy, a willingness to benefit from money whatever its "color," is compounded by his selling his daughter to a former slave, an act that haunts Don Mucio's eugenicist and colonialist conscience. In Frederico Oliver's play, Don Mucio has fought for Spain in Cuba, has killed blacks, and boasts of his knowledge about Afro-Cubans, citing the perverse racial typologies used to distinguish among them (25). His prejudices fit smoothly into a fashionable capitalist logic that flirts with hybridity to the extent that he sees progressive modernity as golden, rather than black or white. Fame is gold, thus modern—so goes the logic. In the novel he repeatedly reminds his daughter: "Well, daughter . . . that is success, and it's not Congo, Mandinga, Christian, or Jewish; success forgets about crime and infamy; success is success, and it always has the same color, that of gold!" (96).[16]

Such facile hybridity is suggested in the film by mixings of black and white images—a series of carefully edited close-ups—produced by intercutting between shots of Peter's welcome reception and Emma's humble preparation of coffee. Medium shots of Peter's servant pouring champagne alternate with takes of Emma mixing the dark coffee with the milk, creating what the spectator imagines to be a caramel-colored *café con leche* for her father. As father and daughter watch the theatre types toasting Peter's success, Peter turns to Emma and raises his glass. Don Mucio immediately starts to toast back with coffee, but Emma hysterically keeps him from speaking, knocking the coffee onto the floor, where the disastrous results of racial mixing are visually foretold in a puddle. Peter returns Emma's stare, having marked his superiority with champagne over the slave crop coffee. He takes these moments to mean that perhaps Emma's attitude toward him has

changed, and he asks for her hand in marriage, giving Emma an engage-
ment bracelet made of black and white pearls. In a trick fade the pearls
all turn to white but then fade back into their original black and white.
The impossibility of Peter's whiteness is thus objectified by the filmic
apparatus.[17]

Recurrently, the possibilities of a utopian melding with the Other
disappear in a series of narrative and ideological closures. Peter be-
comes a doomed figure whose darkness can only reaffirm Emma's
white, Castilian identity, while Emma herself signifies the contradic-
tory fusion of domestic innocence with stardom. The subjectivities
that ideological apparatuses offer rarely include such dangerously am-
biguous both/and identities, and indeed, these spaces are foreclosed by
the filmic reflection of a racially divided society and the insistence on a
biological essentialism in which the black man becomes the epidermal-
ized locus of fear.[18] The title used for distribution in France, *La fatalité
du destin*, and the poster that read "Piel negra–Alma blanca" (Black
skin–White soul) reaffirm this closed-off inevitability of race, as does
one of the first French reviews of the film: "The abyss that separates
two races, the insurmountable revolt of white flesh against dark, such
is the theme of the novel" (*Cinémagazine*, July 28, 1929). Emma's re-
peated rejections of Peter's blackness thus underscore the impossibility
of *mestizaje*, miscegenation, or nuanced tones of skin color.

His efforts to close the distance between them merely catalyze her
feelings of trauma, instigating her desperate appeal to her father to
protect her from Peter's demonized blackness and cancelling any pos-
sible interpretation of her reaction as envy or admiration. As female
victim of the black man's lustful gaze, Emma gains a narrative centrality
in the stardom story of both novel and film, starkly upstaging Peter's
exuberant and transgressive entrance into the theater.

The tension between them climaxes in an oneiric sequence where
Emma imagines that a savage abducts her and takes her to Peter, who
is waiting for her inside gigantic, cannibalistic gorilla fangs. White
paranoia now controls the narrative as anxious looks reveal taboo de-
sire, along with the feelings of incompleteness and lack that plague
white subjecthood. Fanon's interpretation of the white woman's fear
of the black man as a fantasy of rape is thus evoked by Emma's uncon-
scious, perhaps, but certainly by her guilty conscience (Fanon, 63–82).
Contemporary historians have considered this oneiric section of

the film the most important, labeling it avant-garde and surreal for its evocation of the complex world of the libido (see Sánchez Vidal, *El cine de Chomón;* Gubern, *Benito Perojo*). Relevant here are Clyde Taylor's criticisms of productions celebrated for their technical achievements (15). One thinks of Segundo de Chomón, an early auteur Spanish filmmaker and inventor of many special effects (Sánchez Vidal, *El cine de Chomón,* 227), who devised the photographic tricks used in this sequence. Chomón's effects are reminiscent of Taylor's argument that emphasis on pioneer figures of national cinemas and their technical innovations tends to conceal racist national ideologies. For the most technically daring, as well as shockingly racist, scene of *El negro* occurs during Emma's nightmare, provoked by Peter's return of her gaze.

As the title card informs us, "That night, Emma is chased by the piercing gaze of the black man." Distracted by the poster calendar in her room, a blackface advertisement for cigarette papers ("Papel de fumar Bambú"), Emma turns it around to escape the black face and its gaze. Manthia Diawara's comments on the blackface stereotype are again appropriate: "The stereotype's red lips, white eyes, and white teeth both emphasize its deformity and monstrosity.... [The] head is much smaller by analogy to the large face While the top hat and the bow-tie signify modernity, the red lips symbolize cannibalism" (Diawara, under the introductory section). In a series of transition shots, the black face on the calendar fades into a close-up of Peter's distorted face, made globular and balloon-like by a concave lens, and finally the head of a gorilla with an enormously large, fanged mouth, out of which an imaginary black tribal man, naked except for a grass skirt, jumps out into Emma's bedroom. In slow motion the camera "captures" him leaping around the room with springing and crouching gestures, in a style reminiscent of ethnographic documentaries of dark-skinned others, exotic remnants of an age without history, writing, civilization, or technology. Fatimah Tobing Rony argues that cinema has been the site of intersections between anthropology, popular culture, and the constructions of nation and empire (9). Thus, this tribal figure pulls Emma out of bed and then heaves her into the gaping gorilla mouth, where nativist figures orgiastically dance around a fire. Peter, dressed in king of the savages mode, kisses her squarely on the mouth, and the sequence ends when Emma wakes up screaming while her father rushes to comfort her.

Advertisements inside and outside the film—cigarette papers, the

Figure 13. Emma in the dream sequence in *El negro que tenía el alma blanca* (1926)

film poster, product labels—forge a connection between the com-
modified, bestialized black body and the imperial spectacle of race and
domesticity that permeates Emma's eroticized fears that mask her own
potential savagery. Emma's simian perception of Peter, which combines
with the anthropoid image on a bottle of Anís del Mono, is framed by
the dreams of Peter had by the members of the theatre company and
by her nightmare in particular: "What a nightmare! Peter and she were
alone in the theatre, among screens and curtains, which formed a laby-
rinth. Jumping in the most terrible way he pursued her. Upon feeling
the black man's hands upon her shoulders, enormous and hot hands,
she screamed." Emma exclaims, "Ay papá, you can not imagine . . . ! It
was a monkey, very big, like the one on the anis bottle . . . Ay papaíto!
Ay papá!" (Insúa, *El Negro*, 98). What comes to mind is Fanon's famous
case of the boy who becomes fearful upon seeing a black man and so
appeals to his mother. Here, the monkey on the Spanish anís bottle
is eloquent of consumerism and the scientific racism of primatology,
which Anne McClintock has called "a theatre for negotiating the peril-
ous boundaries between the family (as natural and female) and power

(as political and male)" (216). Reproduced in the film's publicity posters, with its unusual similarity to the future star of *King Kong* (1933), this highly recognizable simian artifact connects the consumption of alcohol with sexual fantasies involving racialized others. As Agustín Sánchez Vidal points out, canvas paintings by Picasso and Juan Gris had glossed this image of the gorilla, deepening its effect on the national imaginary (*El cine de Chomón,* 227).[19] But the image of the monkey on the anís bottle and its reproduction on publicity posters by Juan Bosch now serve as collectibles. In these posters a white woman in fashionable dress is accompanied by an infantilized monkey either holding or serving her the bottle of anís. The ambivalent symbol of the monkey—captive ape, child, and index of women's uncontrollable sexuality or sociality—was also seen in other corners of empire, specifically in English Victorian soap ads. McClintock has noted that "the soap-monkey became the emblem of industrial progress and imperial evolution, embodying the double promise that nature could be redeemed by consumer capital and that consumer capital could be guaranteed by natural law" (217). Race and gender thinking are thus displaced onto the terrain of domestic commodities: the increasing visibility of women's sexuality in the public sphere and the fear of either urban militancy or colonial misrule are implicitly constrained by the promise of progress and the satisfaction of need represented by consumerism.

Similarly, the ad for Bambú cigarette papers with a Sambo face mimics the strategy used to sell Gitanes cigarettes by linking phallic cigarettes to a racialized, exoticized female icon.[20] The actual promotion of smoking accoutrements, alcohol, and beauty products—luxury items for the majority of

Figure 14. Mouth of the gorilla in *El negro que tenía el alma blanca* (1926)

Figure 15. Emma at Peter's death bed in *El negro que tenía el alma blanca* (1926)

Spaniards—borrowed cosmopolitan aesthetics (vampy, sleek art deco looks) but often added racialized others to suggest an exotic escape from mundane industrialized life. Such product placement trained spectators to aspire to middle-class materiality, even if such aspirations would only be fulfilled three decades later.

Consciousness of hybridity, the root of Emma's antagonism, is nevertheless interrupted by an asexual, spiritual register. The novel refers to Peter's dancing with Emma as disinterested: far from bestializing the modern dances, they spiritualized them (251). In terms used by Susan Sontag to describe tuberculosis as the "disease of the soul" (18), Peter becomes a metaphor for superior virtue, a higher moral sensibility, too good to be sexual and more soulful (Sontag, 17–20). Having become more soulful, his choreography evoked martyrdom and ecstasy. The couple's dynamic is an expression of platonic love, which dispels the sexual excitement and prepares for a scenario in which Peter ascends, or descends, into enlightened white subjecthood and death. But first, in step with the somatic nervousness of the colonized, Peter deteriorates to a mere specter of his former self. The title card assures the

audience that Peter's soul is now as white as snow, permitting Emma to declare her love and kiss Peter. In his last sighs, Emma sees in his face, consumed by fever, a "splendor that transfigured it, making his face whiter, more noble, and pure" (Insúa, *El negro*, 293). But just before the filmic kiss, Emma sees Peter's white servant observing the scene from behind a door, so she kisses Peter's forehead instead of his lips. The climactic moment of forbidden desire is denied by the intrusion of a third element, Peter's butler, Rolovitch, who absorbs the surplus of the moment, that is, the unorthodox pleasure framed in the mise-en-scène of Peter and Emma's embrace, and causes Emma to once again recognize her fear of difference. She cannot intimately face the Other, because that would require commitment, complicity, and identification.

Inherent in Peter's ironic trajectory toward the sublime, drawn by his desire to transcend materiality, is the uncomfortable awareness that overcoming the body, even the racially marked body, leaves one with nothing. To prevent disappearing into nothingness, one must retain the body, but this means incorporating the racialized body into the social body. Emma's identification with Peter implies her willingness to transcend the body's passions, to pursue to infinite heights a disembodied spiritual love. But on film, as in life, without the exposure that produces a black mark on an otherwise clear celluloid, there is only whiteness, which is nothingness. Thus it is that mixing, which is always more interesting, permeates the register of film and its casting practices.

Mixing, Passing, and Casting

For those would-be moderns who came into direct competition with performers like Peter Wald, Peter's blackness was a convenient buffer. Because of it, he remained safely fixed in the class hierarchy, so that his blackface in the 1926 film was a counterpoint to Emma's ability to pass. The parodic *teatro bufo*'s blackface had ultimately retreated before the grim obsession with blood purity that had justified centuries of terror in Spain. The motives for choosing the Egyptian actor Raymond de Sarka for the role of Peter in Perojo's 1926 film are a case in point. Peter's role was unique in Spanish cinema—not only a black character but an Egyptian actor in blackface—and the astonished spectators might not have known that de Sarka was not black. As a French critic

noted, because Sarka's skin was white he had to endure a thick coat of makeup during the shooting; he did not know how to dance, but he was chosen for his "grand ability to emote" (*Cinémagazine*, June 28, 1937; quoted in Gubern, *Benito*, 137).

Film reviews that remarked upon his ethnic identity were also ambiguous, like the interview in *El cine* that describes de Sarka as the son of a *pacha*, which in Spanish denotes a racially indeterminate man who lives "in great wealth or opulence" (*El cine*, November 17, 1927; quoted in Gubern, *Benito*, 128). Others noted his discovery on a beach by the cinema director Marcel Vandal and his star appearance in three films, *La menace* (dir. Henri Pouctal, 1915), *Lady Harrington* (dir. Maurice Level, 1926), and *L'eau du nil* (dir. Marcel Vandal, 1928). When Perojo saw de Sarka's photo in a magazine, he hired him on the spot as a Valentino figure who would appeal to the growing female cinema audience.[21] Such industry gossip elevated de Sarka to the status of a sexual icon that was sutured to intradiegetic audience desire; his purported aristocracy gained extradiegetic audience support for a noble character.

More important, audiences were taking unorthodox pleasure in the dancing (mixing) of Peter and Emma, whose ambivalence undermines the essentialist color rules. Alternating scenarios of attraction and repulsion create an ambiguity that urges mixing and exacerbates the hysteria that both Emma and Peter feel. But in this impassioned narrative, it is Peter who emerges as the object of desire—like Rudolph Valentino, who died the same year that *El negro* was released and whose posthumous film *The Son of the Sheik* was also released in 1926. Peter, like Valentino, is talented, svelte, darkly foreign, and erotically effeminate. In Madrid, as in the United States, the afternoon salons—which were called "tea time" (*la hora del té*) or, at the Ritz, "tea dances" (García Martínez, 39, 43)—were linked to the black wave of tango and jazz entertainment and were held responsible for unleashing unhealthy desires in young well-bred women and New Women who were easily seduced by young men of suspect lower-class backgrounds or by foreign performers in town for a gig—the *pollo-peras* or *niños frutícola* (García Martínez, 38). Tango debuted in Barcelona in 1912 in the Thés Tango, later known as the Thés Dansants (Gubern, "Ruido, furia y negritude," 277). In 1914 when Pious X condemned tango, the blond Marianela and the black Colbert exhibited mixed tango performances (Retana, *Historia del arte frívolo*, 81). The push and pull of identity and difference

entered the experience of Spanish spectators, who riveted by the per-
formances of fictional entertainers like Peter Wald, were led to think
about their own modernness or antimodernness and to project their
longing/loathing onto the racialized performer.

Miriam Hansen reads Valentino's figure as a "fire and function of
female spectatorship" that "gave public expression to a force specific to
relations among women" for a specifically female subculture of con-
sumption (Hansen, 260). I would argue that as with Valentino, the star
text of Raymond de Sarka's playing the character of Peter Wald situ-
ated itself within "cinema's massive solicitation of the female consumer
and women's increased presence in the public sphere" (Hansen, 254),
thereby triggering white/castizo male anxiety. The uproar about Peter
among the intrafilmic audience not only excluded men but made it clear
that the site of Peter's body embodied mixtures and "conflicts between
the forces of consumerism and ideologically entrenched discourses of
ethnicity and sexuality" (Hansen, 267).

Spoiled females' whims for men of color were made classic in "Porque
era negro," by Vidal Tragán, a popular tango that insinuated itself into
the spaces of everyday life in the 1920s.

Porque era negro
Le engañaba;
Porque era negro
Le despreciaba.
Pobre negrito,
Muere de amor
Por la desdicha de su color.

Because he was black
He betrayed her;
Because he was black
She disdained him.
Poor little black man,
He dies of love
Because of the misfortune of his color.

A complex range of meanings surface through the lyrics of this song:
the white male song writer's desire to appear cosmopolitan and bo-

hemian, his resentment toward white women who prefer black as opposed to white males, but also, on some level, his recognition that white women could recklessly treat black men as toys. The Spanish composer credited with bringing the Charleston to Spain, Ángel Ortiz de Villajos Cano, composed "¡Cómprame un negro!" (Buy me a black man) (1926) after coming into contact with African American rhythms during his travels in the Americas and the African American entertainers who came to Spain to teach these new dances and rhythms.

Mamá,
Cómprame un negro
En el bazar.
Cómprame un negro
Que baile el charleston.

Mama,
Buy me a black man
In the bazaar.
Buy me a black man
Who dances the Charleston.
(quoted in Gubern, Benito, 127)

One of the song's most famous versions was sung by the cupletista La Yankee, aka Reyes Castizo, in the midtwenties.[22] Another version boasted the line, "So many are the black men who have come to teach us the Charleston" (García Martínez, 38).

Peter's skin color contributed as much to his role as did Raymond de Sarka. The search for an actor whose skin color would convincingly fulfill the requirements of Peter's blackness became an issue that outflanked the film, both at the level of textual meaning and at the level of production. According to an article in Cámara about the making of the 1950 El negro (dir. Hugo del Carril), finding the right black man to portray Peter was not easy:

What was not so easy to find was the handful of blacks necessary. . . . The recruiting from all of Madrid's neighborhoods produced a whole host of individuals aspiring to prickliness, with the appropriate physiognomy, but not with the

bituminous blackness it required: tanned ones, Berbers, blacks from Guinea, grayish Saharans, and one or another compatriot of theirs with wooly hair and a flat nose. . . . In the end there is now a group of first-rate blacks. We don't know if they are authentic or not; that is a matter of décor. What is more important is that they seem black, and for that they have been bathed in a viscous mixture. (November 1, 1950)[23]

The photo caption referring to these anonymous individuals states simply, "negros." The racism, with its fussy affect of having searched the entire city, is less relevant for its explicit content—that there are no suitable people of color to play a man so black—than for its search for a black man black enough to be desirable to white females. In fact, the necessary darkening, or lightening, of skin resonated with the notion of becoming, a concept that was impressed upon women by the media and the cosmetics industry. In the February 20, 1930, issue of *Popular Film*, in the section titled "Feminine Mail" (a compendium of news facts suitable for women readers), is an item entitled a "marvelous invention." A doctor from Tokyo has invented a method by which "a child physically malconstituted can become normal, a person can grow taller or shorter, fatter or thinner; be blond or brunette, and finally, and this is the most extraordinary, it can change, for example, a black person into a white person or an Asian into a red skin." (10).

De Sarka's blackface acting is not grossly overdone, as is the blackface in American films of the 1910s and the 1920s. His blackface is neither parodic nor self-conscious, as it was in *teatro bufo*, yet his blackness is emphasized by makeup, lighting, the frequent use of white gloves, and black-and-white clothing such as tuxedos. The film subjects de Sarka as Peter to a politics of color that precludes intermediate skin tones and disciplines ambivalent elements that slip through the cracks of the imperialist machinery. De Sarka's Egyptian identity was outshined by his cosmopolitan stardom, so like Peter, his skin had to be colored darker and aligned with a colonial identity in which North Africa substituted for Latin America (Cuba). In its allegorical way, Peter's story evokes Spain's history of racial confrontation—the Arab invasion of 711 and the fifteenth-century arrival of the first Roma and expulsion of the Jews and Muslims—safely diffusing the feared return

of the racialized/ethnic other and reinforcing Spain's imaginary status as emissary rather than receiver.

In contrast to *La gitana blanca*, *El negro* offers a more profitable and desirable version of stardom and racial identity, since it cast a "real" racialized other in the starring role instead of a case of mistaken identity. Spectators' desire for the body of the star, rather than their being drawn to a character later revealed to be aristocratic or non-Gypsy, is captured by the camera's fetishization of Peter's black face and handsomely dressed figure. Orientalist motifs abound in films such as *La Venenosa*, but there the heroine is more eroticized than racialized; race is controllable because it is assimilable, feminized, and pacified, as in *Morena Clara*. Except for Pastora Imperio, Carmen Amaya, and, later, Lola Flores, who was only one-quarter Gypsy and thus passed to a large degree, the musical film genre was dominated by white women who passed as Gypsies or indigenous-looking extras.

The progressive lightening of the musical film genre was played out on a smaller scale in the *El negro* film cycle, in which blackface is displaced onto Nonell, the bootblack character who is then whitewashed in the 1934 version. Perojo's 1934 film starred the Cuban mulatto Marino Barreto. Marino Barreto does not appear to wear makeup, but he is also shot with light that makes his skin appear whiter in the film. Associated with the wave of black jazz singers who came to Madrid, Barreto was the first "Spanish crooner" (García Martínez, 130). Important to note, Barreto was not a dancer but a singer—a reflection of the new sound possibility in film but also a clear distancing from the erotically charged dancer figure capable of enacting "ritualized extremes of sexual domination and submission" with a white woman (Studlar, 160). Commenting upon his film's cast, Perojo said of Barreto, "He is a photogenic black who sings, talks, dances. . . . I would say that he were a rare white blackbird if the color of his skin didn't oblige me to use another term" (*Popular Film*, July 19, 1934).

Nonell the bootblack is a central character who appears in all versions of the film.[24] Significant for the unbiased friendship he offers Peter and his symbolic characterization as the poor, white version of Peter, Nonell's skin is literally blackened by the labor of his profession, his lower-caste status, and his Catalan identity. "He was a small, pale, wrinkled chap. He had a look of hunger about him. He kneeled on the

sidewalk in front of Pedro and began service in a natural way, as if the color of his face and the color of his shoes were all the same. . . . 'I am blacker than you . . . look at my paws . . . I've been the servant of a Japanese man . . . But I'm taking off, you aren't rich'" (Insúa, *El negro*, 136–37). Nonell's character offsets the biological determinism that categorizes Peter as Afro-Cuban and irremediably black, since Nonell is *blacker* than Peter. Having served a Japanese man, a racist allusion to the supposed feminine passivity of Asians—echoed by the enigmatic, smiling Chinese man in Ortega y Gasset's "Teoría de Andalucía" (113)—Nonell is not only effeminate (the novel reveals that he prostitutes himself to pay for the transatlantic voyage with Peter) but, like the Catalan nation, weak and sickly (see Sontag, 76). Establishing the theme of illness and its link with racial degeneracy, Nonell dies of consumption during their boat trip to America.

When Nonell's character is revived in Perojo's 1934 remake, however, he is played by Angelillo, a popular idol of the flamenco *copla* and song (*copla andaluza* and *canción andaluza*). As Manuel Román characterizes it, Angelillo excelled in "Spanish song with Andalusian and flamenco trimmings" (84). By 1934, however, Angelillo had started to mix what were considered purist guitar-accompanied flamenco pieces with Andalusian song (fandangos, for example) and sometimes added orchestral accompaniment, becoming one of the first practitioners of flamenco opera (Román, 87). Like many entertainers, Angelillo's role as a bootblack echoed his adolescence, when he too worked as a shoe shiner, in the Hotel Palace in Madrid (Román, 88). Angelillo would go on to star in two more films, *La hija de Juan Simón* (1935) and *¡Centinela, alerta!* (Grémillon, 1936), in which his songs were central features, before his Republican ideas and failed marriage—giving rise to false rumors about his purported homosexuality—led him to exile in Mexico and Argentina until 1954, just three years before the white Argentine Hugo del Carril directed and starred in brownface as Peter in the last and whitest remake.

In this 1934 version, Emma is played by Antoñita Colomé, who debuted on the Madrilenian stage in 1927 and whose career trajectory from cosmopolitanism through folklore mirrored that of Concha Piquer. Colomé, a heavily accented Sevillian singer (and a quarter Korean) performed both the cuplé and comic folklore roles. Discovered by a Paramount talent scout, her first films were Spanish versions

of Franco-American films made in Joinville.[25] In 1932, upon return-ing to Spain, Perojo starred her in his *El hombre que se reía del amor* (1932), and during the Second Republic she continued to star in vari-ous films.[26] Beginning in the forties, her filmic and performance reper-toire adopted the obligatory folkloric hue with Gypsy and Andalusian roles in *La danza del fuego*, aka *La sévillane* (dir. Hugón and Salviche, 1942); *El frente de los suspiros* (dir. Orduña, 1943); *Forja de almas* (dir. Fernández Ardavín, 1944); *La gitana y el rey* (dir. Bengoa, 1945); *María Antonia 'La caramba'* (dir. Ruiz del Castillo, 1951); and *Tercio de Quites* (dir. Gómez Muriel, 1951) (*Primer plano*, September 9, 1945).[27] In the fifties she joined the Andalusian folkloric company El Príncipe Gitano, inserting herself, according to Pinedo Novo, in the tradition of Estrel-lita Castro. For Álvaro Retana, Colomé was a "very funny Andalusian woman . . . a Gypsy doll in deluxe edition with her pale golden hair and her little mouth painted like a heart—she would disdain innumerable suitors—and her figure like a palm tree in an oasis. She didn't sing like some folklórica stars, with shouts like an ostrich in the desert, but with a delightful voice" (174).

Concha Piquer and National Folklore

Surveying the films that Concha Piquer starred in, particularly those during Francoism, shows how Piquer was marketed as a folklórica. From this point on and throughout the rest of her career, like other cupletistas of the time, she made Andalusian folklore styles part of her repertoire.[28] The Andalusian motif in no way dominated her repertoire or personal style, but she is included in histories of folklóricas because of the popularity of Andalusian folklore, her intimate professional relationship with El Maestro Quiroga, which began in 1930, and her lead role in the Andalusian folkloric films that would frame her career: *La bodega* (dir. Benito Perojo, 1929), written by the Valencian Vicente Blasco Ibáñez but set in Andalusia; the Aragonese tale *La Dolores* (dir. Florián Rey, 1939); and *Filigrana* (dir. Luis Marquina, 1949). Further-ing her Andalusianification, in 1927 she had a publicized affair with the already married bullfighter Antonio Márquez, who would after his retirement in 1933 become her manager.

Sound film allowed Spanish national cinema to capture nationalist sentiment through language, which was more powerful than subtitles,

and songs sung by cupletistas, like Piquer, who responded to the de-
mand for folkloric repertoires. As in the United States with *The Jazz
Singer*, Spanish blackface died with *El negro*, its most celebrated role.[29]
But on its coattails rode the Andalusian musical comedy film starring
white actresses who in effect performed Gypsy-face, although without
the use of makeup. Replacing the international cosmopolitan ambi-
ence of the silent film with an authentically perceived yet in actuality
stereotypical Andalusian backdrop, directors and producers retained
the formulas that had proved so successful in *El negro* while avoiding
the criticisms launched at Perojo for making what looked like a "foreign
film."[30] In Piquer's sparse but significant cinematic career, she played a
non-Andalusian folkloric singer only in *Yo canto para ti* (1933), based
on the life of La Fornarina (Perojo's *La sin ventura* also portrayed her
life [see chapter 2]); *La Dolores* (dir. Florián Rey, 1939), an Aragonese
folkloric film; and *Me casé con una estrella* (dir. Luis César Amadori,
1951), based on the Argentine stage scene. It is important to note, how-
ever, that these films underscore the gradual whitening of both popular
stars who did folklore and the musical film genre. *Filigrana* shows how
in the forties Piquer's whitening continued, while she paradoxically and
simultaneously became almost exclusively associated with the Anda-
lusian performance.

Piquer's legendary popularity constituted its own text, one in which
spectator-fans became coprotagonists in the creation of her stardom.
Now referred to as "Doña Concha," even in the early part of her career
crowds flocked en masse to see her. Her records topped the charts,
were reedited for new albums, and were constantly broadcast through
Radio Nacional, the dominant Spanish state radio station of the 1940s,
which broadcasted throughout the whole territory. In several issues of
Popular Film during 1928, the Contest of Literary Look-a-Likes invited
fans to write a winning panegyric on their favorite star, to be published
in an upcoming issue. Fans were thus collectively courted, and their
involvement bound them to the star texts in ways both personal and
public. According to many critics, Piquer's stage reputation was irre-
producible on the screen; she was less a cinema star than the prima
donna of the "Spanish music spectacle" (Moix, 44). Excelling in Span-
ish song, the "culture of the masses" that Vázquez Montalbán considers
part of every Spaniard's sentimental education, Piquer's galvanizing

performances on stage and her professional demeanor encouraged many imitators: Jaime Chávarri's *Las cosas del querer* (1989) attests to the continuity of the myth of Piquer, as does Pedro Almodóvar's *Tacones Lejanos* (1991), where Marisa Paredes's dynamism recalls Piquer's absolute command of her audience.

Piquer's complicity with and mastery over her audience resided in the importance that Piquer herself recognized in preserving the memory of the original, transgressive lyrics of the songs. According to Carmen Martín-Gaite, Piquer knew that the tragic stories of cuplés were meaningless if key words or phrases were censored.[31] Piquer would thus find a way to mend the gaps, hanging on to the lost words by turning their silence into intense feeling through her hieratic pose, her lost gaze into emptiness ("Cuarto," 36). It was in this solemn, otherworldly moment that rapt spectators would be transported to the memory of the original words of devastating stories about fallen women who transgressed the limits of accepted morality, usually for love (Moix, 53). One of Piquer's most famous songs, "Ojos verdes," sung in *Filigrana*, represents the bitterness buried under the guise of normality worn by a rigidly hierarchical society bound to strict Catholic postwar morality. Silvia Bermúdez sees Piquer's song "Tatuaje" as "an oppositional gesture" that triggered memories of the oppositional culture of the twenties while "unmaking the cultural nationalism promoted by Franco's regime" (33).

Filigrana begins in 1927, the date flashing onto the screen prior to a curtain's opening, with Concha Piquer singing. The curtain opens onto an unselfconsciously stereotypical Andalusian set in which Filigrana, dressed in full flamenco garb, descends the steps of a white adobe house. She is singing to a man who has betrayed her:

Por la gloria de la madre,
Miénteme por caridad
Para que yo me lo crea
Como si fuera verdad.

For the glory of the Virgin,
Lie to me for pity's sake
So that I believe it
As if it were true.

The late twenties also were when Andalusian folkloric genres emerged to dominate the theatre and cinema. Manuel Román locates the replacement of the cuplé with the Andalusian copla, or the Andalusian or Spanish song, with the 1929 debut of "The Andalusian Copla," by Guillén and Quintero, a staged Andalusian costumes and manners comedy with flamencoized songs, in which incidentally, Angelillo replaced the lead, Pepe Marchena, after four days (16). For Román, Piquer was one of the "authentic pioneers" of this shift to the copla that made the cuplé more respectable. The term "Andalusian revue," which debuted in 1942 with *Ropa tendida*, by Quintero, León, and Quiroga and starring Piquer, was changed to "folkloric spectacle" precisely to avoid associations with the déclassé cuplé (Román, 17, 19). In 1927, Piquer had just returned to Spain after living abroad for several years, and in *Filigrana* there is a conscious effort to fuse the life of the real star with that of the fictional star character, who is, significantly, an Andalusian-style folklórica. It is little wonder that spectators tended to associate Piquer's real life with the life of her character.

The camera then cuts to the dressing room, focusing in on the wealth of flowers provided by suitors and admirers, a representational wink at the real life that Piquer led. An exchange with her stage manager adds to the construction, assuring the spectator that this is indeed the story of a big star. Filigrana decides to accept the invitation of Guillermo Harrison, puzzling the manager (she could have so many other men). With the bitterness of experience, she responds that the only thing left for her in life is to play with men's feelings. Her pain, she says, can only be cured by revenge for the abuse she suffered by a former lover. When the millionaire Harrison offers her his hand in marriage, she reveals to him the traumatic event that marked her life and forced her to flee Spain.

Filigrana's story of seduction by the Count of Montepalma constitutes a long flashback—or digression—that ends with a choreographed musical montage sequence that returns the narrative to the diegetic present. In this digressive flashback, we view the story of María Paz (Filigrana), an Andalusian girl who falls in love with the count, a typical *señorito* (wealthy playboy) who dishonors and then further humiliates her. The seduction consists of a series of shots on location in the Sevillian countryside, overlaid with the nonsynchronous recording of Piquer's "Ojos verdes." This dreamlike, Lorquian sequence (Lorca

was a major influence on the song's composer, Rafael de León) intensi-
fies the transgression of the lyrics, even though its key words have been
substituted by the censors in order to tame the references to prostitu-
tion and adultery.[32] In the original lyrics a prostitute standing outside a
brothel meets a man and has the "most beautiful" night of her life. She
never sees this anonymous lover again, but his green eyes haunt the
narrative, giving "light" to the woman's dark and miserable existence.

When the count marries a woman of higher social standing, a blond
from Madrid, Filigrana swears revenge, "Arrieros somos y tarde o tem-
prano en el caminito nos encontraremos" (We are mule drivers, and
sooner or later we'll wind up on the same path). She then leaves the
count's palace and Andalusia to pursue her singing career in the major
capitals of Europe and then in the Americas. Harrison is so moved by
her story that he proposes to her on the spot, partially completing her
vindication.

Immediately after this flashback, the camera cuts to an out-of-time,
out-of-place montage that bridges the time gap, eliding Filigrana's wed-
ding and move to Argentina and symbolizing her change in fortune
with the kind of mythmaking that Andalusian musical comedies weave
into their structure. Containing seven parts, each segment features *sevil-
lanas* (flamenco-styled dancing), progressing from younger dancers to
older ones, with more complicated dance routines each time. Alternat-
ing male and female voices resemble a "passed along song," even though
we do not see the song passed from singer to singer. The anonymous
singers and dancers performing to the recorded lyrics about Filigrana
constitute a kind of proto–music video that elevates her story to the
status of popular-mythic icon. The marketing of *Filigrana* was like
that of *María de la O* (dir. Francisco Elías, 1936). An already popu-
lar song, "María de la O" became the theme song of the film, which
in turn inspired a series of new recordings. *Filigrana* also echoes the
earlier intermission-montage sequence in *María de la O*, where the
theme song is passed along in a similar way. As the film later reveals,
the copla recounting the story of Filigrana and the count circulates
around Seville in the bars, taverns, and popular venues, representing
popular mythmaking in process.

The narrative then leaps to the diegetic present, where the married
Filigrana, settled in Argentina, is mother to a grown son who wants
to experience the excitement of Andalusian bullfighting. In Seville,

Filigrana's son falls in love with the daughter of the count, played by the up-and-coming Carmen Sevilla, a folklórica whose career would dominate the media landscape of the fifties, sixties, and beyond. Sevilla would push the whitening of the folklórica the furthest with her glam look, particularly in *El caballero andaluz* (see chapter 4), a film that emblematizes the increasingly saccharine portrayal of folklóricas that became standard in the fifties and sixties. The daughter-and-son match justifies a reencounter between Filigrana and the count, who through mismanagement and irresponsibility now finds himself deep in debt. Filigrana, now widowed, arranges to buy his mansion so as to become the owner of the same house in which she was seduced and betrayed. Compounding this poetic justice, her son successfully woos the count's daughter.

Unlike the vampy narratives of the twenties, with their upper-class figures, Filigrana's acquisition of the count's mansion and her song about the count's despicable behavior can be read either as a symbolic echo of the atrocities carried out by the victors of the war or as a class critique. Though during most of the film Filigrana wears fashionable and elegant dresses, here she wears the traditional flamenco performance outfit, the striking sheath dress with its ruffles and polka dots, and all the combs and jewelry and other stylistically excessive details. The final song provides the missing coda to "Ojos verdes," creating a triumphant ending to Filigrana's adventures. In *Filigrana* is the fate of Emma and Peter's mixing, that transgression will be subsumed by Andalusian settings.

Remarkably, *El negro que tenía el alma blanca* brings eighteenth-century natural science and nineteenth-century classification of difference into an engagement with the new and daring interpretations of racial difference, sex, and gender roles that infiltrated 1920s Spain under the labels of "négritude," "the New Woman," and "cosmopolitanism." Science and spectacle are captured within a melodramatic, crowd-pleasing narrative. By incorporating foreign and racialized entertainment discourses in a cosmopolitan idiom that made sense for Spanish audiences, *El negro* plunged Spain's racial and colonial history into a modernity symbolized by the stardom narrative. In this collision racialized bodies affirmed the bourgeois self as nonracialized, while racial codes and exclusionary cultural principles marked out those who were worthy of property, citizenship, and dominant subjecthood, thereby mapping the

national community along racial criteria. In this sense, the symbolic death of the film's black entertainer unwittingly secured a safe route for the progressive whitening and nationalizing of Spanish stardom and its fabrication of subjectivity.

In later folkloric musical comedy films, Jo Labanyi argues, the projection of racial others and the insistence on skin color evoked nostalgia for lost empire and was the basis for a model of nationhood established along colonial lines (see "Raza Género" and "Miscegenation" or *Gender and Modernization*). The same paradigm drives *El negro's* story cycle, where Peter crystallizes Spaniards' deep desire and disgust for an Other who is colonial, foreign, and gendered, and also drives films such as *Morena Clara; María de la O; Carmen, la de Triana;* and *Mariquilla Terremoto,* where the female Gypsy and her skin color are Andalusian and both are seen as deeply in need of assimilation.

As for Emma, the shift in visual and narrative codes that showcases her brand of white individualism and success will shape the performance and embodiment of stardom. As *El negro's* perspective shifts from Peter to Emma, it registers her difference from the dark, foreign, anarchic jazz that appeals to her so seductively. In the death of Peter and the birth of Emma (played by the singer Concha Piquer), we see the demise of the silent-screen actors and the rise of musical film, the launching pad for national cinema.

The Gypsy Problem: Law and Spatial Assimilation

With the gypsies the case is quite different. They are the
living example of a whole race of criminals, and have all the
passions and all the vices of criminals.

— Cesare Lombroso, *Crime, Its Causes and Remedies*

Soy de la raza Calé
Que al mundo dicta sus leyes
Y llevo sangre de Reyes
En la palma de la mano

I am from the Gypsy race
That dictates its laws to the world
And I carry the blood of Kings
In the palm of my hand

— From the copla "Gypsy Heritage"

From the 1930s until the 1950s, law and otherness were mediated
by the spatiality and comedic language of Andalusian musical
comedy. This chapter analyzes three films in which white Gypsies rep-
resent the assimilation of Spain's racial internal Other by a legitimate
national visual idiom: *Morena Clara* (dir. Florián Rey, 1936), *Canelita
en rama* (dir. Eduardo García Maroto, 1943), and *El caballero anda-
luz* (dir. Luis Lucía, 1954).[1] The stories of these folklóricas parallel the
legal narrative used to validate the real political regime. The Gypsies'
position within the Spanish legal framework—outside the law yet

perpetually breaking that law—is reflected in the films' simultaneous legitimization and criminalization of Gypsiness.

Filmic fantasies of Andalusian Gypsies and popularized flamenco had saturated the Spanish national film market since the dawn of narrative film in the early 1910s. Crowding the background of these films is, however, the obsession with legality: the films abound in imaginary legal situations filled with legal icons, spaces, and discourses. Gypsies, these films assume, are naturally linked to the law because they are naturally born into roguery. As the first line of Cervantes's novella *The Little Gypsy Girl* reads, "It would almost seem that the Gitanos and Gitanas, or male and female gipsies, had been sent into the world for the sole purpose of thieving" (The Literature Network, http://www.online-literature.com/cervantes/exemplary-novels/5). In the early twentieth century, little had changed regarding such attitudes, and the stories of Carmen and little Gypsy girls were as popular as ever. In fact, at the dawn of feature-length film production, *Carmen* (dir. Doria and Turqui, 1914) and *La gitanilla* (dir. Adriá Gual, 1914) were among the first stories to be adapted. And like *Carmen* and *La gitanilla*, themes of mistaken identity and Gypsy lawlessness buttressed many film narratives in the Andalusian musical comedy genre.[2]

Populating the narratives of these Andalusian españoladas are *fiscales* (prosecutors), *guardia civil* (police), and the owners and administrators of cortijos (country estates mostly left uncultivated by absentee landowners), while the spaces of these legal agents—jails, cortijo settings, and court rooms—shape their mise-en-scène. These legal spaces and "border agents" encourage the conformity of the Gypsy or half-Gypsy characters and in the process educate the extrafilmic audience about the state's behavioral norms, interpellating spectators into uniform national fantasies. Just as the law shapes modernity by encouraging conformity, law in these films is a structuring device that propels the narrative in a certain direction—i.e., Gypsies are caught performing illegal activities that require their punishment and ultimately their assimilation. The drive to relocate and acculturate Gypsies creates a Pygmalion-style narrative that merges racial integration with the successful production of modern citizens and subjects, which was also the goal of legislation that wrote the citizen subject into existence (Labanyi, *Gender and Modernization*, 22).

The law—both in its written statues and in filmic and literary

representations—defines who is legitimate and, thus, who is an appropriate subject for modernity. Modernity in Spain, Labanyi argues, existed primarily on paper, in the economic reforms designed in post-1868 Spain "to bring the whole of the national territory under State jurisdiction and into a single market economy. . . . Further legislation was aimed at constituting the nation's amorphous inhabitants as individualized but standardized citizens" (*Gender and Modernization*, 24). The law, both in film and in reality, regulates the assimilation of the Other. Legal procedures construct whiteness as a fact, so that the aims of racial integration seem self-evident. The films studied in this chapter subsume racial otherness into a seemingly a priori homogenous whole, thereby contributing to the ideology of social progress.[3]

Labanyi has argued that the Gypsy heroines in these films—most often white folklóricas playing Gypsies—represent "the need to eliminate difference through the incorporation of the subaltern into dominant culture" ("Miscegenation, nation formation and cross-racial identifications," 57). In these legal scenarios the folklórica star/entertainer is sustained by the law: she will civilize her untamed Gypsy side and help to assimilate others like her. As she moves from the margins of the cortijo to the central house of the *terrateniente* (landowner), her backward manner of speaking and her Gypsy dress gradually disappear and, with them, the proverbial maladies of premodern Spain. She moves from primitive to civilized, from polka dots and ruffles to elegant dresses, evoking the classic dichotomy of Europe and its Other and reflecting the ideology of social progress based on racial integration (Peller, 131). In effect, the racialized narrative of economic progress is mapped onto the narrative of stardom: the ambitious folklórica's road to fame and wealth is seen through the lens of her de-Gypsification. The male protagonist meanwhile undergoes a process of Gypsification or Andalusianification. His transformation is, however, merely a bohemian, cross-dressing moment (Charnon-Deutsch, *Imaginary*, 228–29), not subversive of structural norms, and the dominant assimilation of otherness remains that of the female, as in *Morena Clara, Suspiros de España, Torbellino, Canelita en rama*, and *La Lola se va a los puertos*.

The racial ambiguity of these films appears as Gypsies playfully sneak across racial and class boundaries and provide pleasureful identification for spectators without disrupting the status quo. Passing, mocking the law, and delightfully intermingling in spaces of dominant

culture, Miguel Ligero in *Morena Clara* plays a loafing Gypsy who bar-
rages his civil guard detractors with double entendres—a profoundly
gratifying performance for spectators who might be killed if they be-
haved that way with the police. Spectators must have also enjoyed
identifying with Gypsy folklóricas who successfully integrated, since
it allowed them to imagine lives different from their own, immobilized
as they were by a lack of education and social mobility and by material
scarcity.[4] The irony was that Gypsies did not fit into any societal space.
The blind spots of these humorous legal scenarios were the reality of
unequal land distribution, the lack of access to the formal economy,
and Spaniard's racialized relationship to space.

But in these optimistic musical comedies, law holds out promises of
fairness and neutrality. In this sense, law retains an aspect of utopian
fantasy, complementing melodrama by offering "temporary answers to
the inadequacies of the society which is being escaped from" (Dyer,
Only Entertainment, 23).[5] Added to this utopian appeal is the bour-
geois view of the world inherent to both institutions and discourses of
cinema and law and the subjectivities they produce (Gaines, *Contested
Culture*, 30). Thus, the law and the cinema "anticipate hypothetical sub-
jects" and assume particular kinds of social engagement and participa-
tion (Gaines, *Contested Culture*, 31–32). Like the law, visual melodrama
divides subjects into abstract categories—citizens are either criminal-
ized or law abiding—thereby shaping the lived reality of its culture.
Moreover, practitioners of law (students, attorneys, judges) were both
spectators and subjects of cinematic culture; they participated in the
narratives that characterized both the legal process and the cinema
(Black, 34). The reciprocity and mutual influence of these two "most
important and prolific narrative regimes" justify studying them together
(Black, 1). In effect, melodrama helps make sense of legal issues and
even animates the law.

The female folklórica in these films—heroine, rogue, and girl next
door—combines white glamour and stardom with comic and colorful
Gypsiness as she reworks the reality of the law, healing national divides
and reforming bourgeois pettiness. Not unlike the colonial administra-
tor, the folklórica Gypsy stands between the colonizer and the colo-
nized, animating other Gypsies and teaching them how to be of service
to bourgeois property owners and, thence, to the state. These films
applaud her integration into white capitalist society, encouraging her

success if and when she might ascend to normative Spanish identity. Each film's representation of law, no matter how parodic, homogenizes any difference, assuring the spectator that cultural uniformity can accommodate difference.

In films such as *Morena Clara, Canelita en rama, El caballero andaluz,* and *La Lola se va a los puertos* (dir. Juan de Orduña, 1947), the folklórica models a paradigm of controlled success, harmonizing the Gypsy problem and the irremediable gaps between wealth and poverty, race and class. In these films, an economic, reality-based undercurrent of anxiety pervades the cortijo setting, where the type characters play out various conflicts over land, space, and belonging. The folklórica, straddling two cultures, enables the symbolic assimilation of all misfits, marginals, and outcasts, even though the rough crew of Gypsies that make up her entourage are undesirable, lazy, impertinent, and, of course, inefficient. She gives us the utopian vision of the assimilation of otherness through efficiency and order, thus demonstrating the union of law and melodrama.

During the Second Republic a film like *Morena Clara* (1936)—an apolitical folkloric musical comedy film, according to historians critical of the genre—offered a Gypsy protagonist who worked out formulas for Spanishness (with their necessary correlates of otherness) while displacing the anxieties that radical legal reforms had generated among spectator-citizens onto figures of whitewashed yet racialized otherness. *Morena Clara* focuses not on divorce and land reform, the legal issues being debated in the political sphere, but on racial identity, uplifting populist narratives, and the containment of undesirable elements of society—issues ignored by Republican legislation because they seemed to transcend the law. Legal film fantasy brought race, social mobility, and assimilation back into the sphere of the law, performing work that the legal system was too overburdened or perhaps simply not prepared to address. Similarly, law, in particular civil, family, and penal law, was reflected in the lyrics of coplas that were broadcast on the radio from the 1920s through to the 1960s, just as it was in the musical film genre. At the same time that Francoist ideology appropriated the copla as an "official aesthetic," there wasn't a norm of family law that did not appear in the copla (Peñasco, 15, 56). Like the copla, cinema was a cultural reserve of the mentality, values, and norms of Spanish society.

Under Francoism and especially in the early forties, films about law

(*cine jurídico*) that questioned authority or, worse, defended principles of democracy were virtually impossible to make, despite the proliferation of courtroom dramas in American and European film (González Romero, 16).[6] But censorship did not preclude the ubiquity of law in comedies and musical films with Gypsy characters. At times, a populist vein seeped through state ideology, rendered by comic lawbreaking Gypsy troublemakers, as in *Canelita en rama*. This parodic thread culminated in Luis Lucía's 1954 remake of *Morena Clara*, where the exaggerated Gypsiness of Lola Flores and the castizo Fernando Fernán Gómez brought the blistering satire of Luis García Berlanga's *¡Bienvenido, Mister Marshall!* (1952) into the framework of the Andalusian musical comedy film.[7]

The point is not that in the midfifties the Andalusian musical film genre reached its zenith as a fearless critic of the regime and its rule of law. The issue is rather that in spite of the parody in *Morena Clara*, Spain's relationship with its internal other had barely evolved between the thirties and the fifties.[8] The reason was that modernization was more plausible in the fifties, and the control and assimilation of filmic Gypsies seemed to promise stability for capitalist modernity.

The Gypsy Question and Its Story Cycles

Through the law, an unimpeachable repository of truth, the ruling classes in Spain had established their power and identity as unquestionable fact. Thus law was itself a narrative regime imagining the lived existence of Roma and, through that image, directly affecting their lives. Cinema, reflecting and producing the mentality, values, and norms of Spanish society, capitalized on images of lawless Gypsies that had circulated since the publication of the first laws about Roma in the fifteenth century and, indeed, since the first references to Gypsies in Cervantes.

The law has had very real consequences for the livelihood of Roma. So it behooves us to view representations of Roma and the law against the background of actual historical persecutions of Roma. For centuries little was known about the arrival of the Roma in the fifteenth century to the cluster of kingdoms known as Spain. Various myths about their origins circulated, the most-lasting that they had come from Egypt, thus the misnomer "Gypsy," from "Egyptians."[9] Historians,

Figure 16. Enrique's mother, the lawyer, Enrique Baena, Trini (Lola Flores), and Regalito in *Morena Clara* (1954)

linguists, and then anthropologists studied the Roma using the legal proclamations and decrees that the monarchy and later government used to control the Roma population. From the fifteenth through the eighteenth centuries, harsh legislation forbade Roma language and their traditional mode of dress and enslaved them in agricultural labor for nonconformity. Regardless, as Richard Pym argues, legislation was erratically enforced, thus exposing the legal system as a failure, provoking even more anti-Roma lawmaking. In 1783, Carlos III, remembered as a progressively minded monarch, recognized the freedom of work and domicile of the Roma. Nevertheless, they continued to be persecuted for their dress, language, and itinerant lifestyle (see San Román, 1–73).

The liberal constitutions written between 1812 and 1936 formally guaranteed the Roma equality, but the state was incapable of translating law into practice (San Román, 69). Its laws protected the economic interests of the very classes who considered Roma little better than a nuisance if they were not working for slave wages. In 1933, the Second Republic passed La Ley de los Vagabundos (The Vagrancy Law),

which could be applied arbitrarily to anyone without a fixed habitation and was thus the primary tool for prosecuting Roma.

The Second Republic was remarkable in its efforts to ameliorate centuries of socioeconomic injustice through a legal framework, yet an overabundance of new laws that could not be applied during the Second Republic had produced anxiety. During the Great Depression and the advance of Fascism in western and central Europe, the democratically elected Second Republic flooded its courts with radical legislation that would change the face of Spain. Like the lawmaking fever of the nineteenth century that generated legislation aimed at centralizing and standardizing the state (Labanyi, *Gender and Modernization*, 24–25), Republican legal reforms of both public and private domains attempted to reorganize laws governing issues of divorce, abortion (legalized in 1936 by Fedrica Montseny, the minister of health and social welfare in Catalonia), women's suffrage, land (*latifundios*), and education (secularization).[10] Indeed, the Second Republic issued its bold legal decrees because it knew that creating a new Spain required changing the legal structure. In this lawmaking frenzy—an ultimately unsuccessful campaign—there seemed to be an implicit faith in the power of law to fashion national identity and to encourage individuals to identify with the nation. Nevertheless, enlightened benevolence toward Gypsies echoed in Republican reforms was accompanied by a paternalistic and bourgeois view of how the internal other could arrive at subjecthood, a point underscored in the film *El gato montés* (dir. Rosario Pi, 1936; Wildcat) (Martin-Márquez, *Feminist*, 55, 70–79).

The government and its intellectual leaders were keenly aware of the need for a sense of nation at this moment of inchoate democracy. The coalition of political parties and liberal intellectuals that comprised the Second Republic "shared the belief that the success of democratic government would depend on the ability of Spaniards to adopt unfamiliar political values and behaviors. . . . Educating Spaniards in the values appropriate to a republican civic culture was the bedrock on which the Republic must be erected." (Boyd, 194). Values and subjectivity were to be molded through legal discourse and practice, both of them forms of control. It seemed to be understood that law could impose order across stark divisions within society, uniting people who did not share class, racial, nor gender affinities by making them all anonymous before legal discourse. Such laws defined these individuals but did little to

merge their divisions. Instead, as politicians, lawmakers, and intellectuals seemed to agree, law fashioned identity, imposed uniformity, and promoted "national fantasies of homogeneity" (Goldberg, 139–40, 146). These changes in the legal landscape provoked anxieties in different sections of Spain's political spectrum. Leveling the social hierarchies directly challenged the status quo—the church, the monarchists, the oligarchy—who immediately began to prepare their offensive. At the same time, urban and rural working classes, especially in the militant areas of Andalusia and Asturias, viewed the legislation as not far-reaching enough and in the end incapable of producing actual social change. Both the Right and the Left remained unsatisfied if not belligerent in regard to the Republic. For its part, the bourgeoisie was thoroughly divided on the question of how to reform. Bourgeois belief in private property was irreconcilable, for instance, with the demands of social justice and land redistribution (Esdaile, 314). An unbridgeable political fissure thus characterized the period's political landscape. Not only the economic structure but the ruling class ideology that buttressed it was threatened by the proliferation of discourses—regional identity, political, legal, literary, and filmic—that sought to create Spanishness in a way remarkably different from traditional notions of Castilian identity.

Despite the tendency of the literary bourgeoisie to promote Gypsy motifs and Deep Song from the late twenties forward and the paternalism of Republican attitudes toward Gypsies, their socioeconomic reality remained fixed in abject poverty and discrimination. Under Franco no specific laws pertained to the Roma, but they were subject to loose interpretations of laws directed at vagabonds and undocumented persons (See Santaolalla). The fourth and fifth articles of the Civil Guard Statute of 1943, for example, entrusted the corps with special vigilance over the Roma (San Román, 71). Lou Charnon-Deutsch argues that beyond this law, the Franco regime avoided seeking solutions to the Gypsy question: "The prejudice against the Roma was largely discouraged, for it would have required an admission of entrenched class inequities and racism" (*Spanish*, 233).[11] Nevertheless, there were nightly raids on Gypsy communities, who lived in constant fear of Franco's *guardia civil*.[12]

During the Franco regime, draconian justice provoked a rather different collective neurosis. Nocturnal police raids and media censorship

ensured that such operations were not made public. Spaniards were therefore able to imagine that the carefree, laughing filmic Gypsy was very like the Roma with whom they might come in contact, sometimes on a daily basis. Suspecting a raid or hearing about one were more residual than conscious thought processes. Watching a film, of course, spectators might think about the negative urban legends concerning the Roma who lived at the edge of town. After all, these "trash-dump Gypsies" living in the urban detritus of a bombed-out postwar Spain were a daily sight, pressing into their peripheral vision. This constant reminder of racialized criminality could make Francoist citizens feel anxious over their own precarious economic status and what they too could become. But the enduring poverty of the Roma assured them that non-Roma would always be somewhat better off. It is precisely this feeling of relief that someone else can be blamed for social instability that drives the production of stereotypes, those "coping devices" that "relieve anxiety about the instabilities in our perception of order of the world" (Gilman, 18–19).

Popular films synthesized notions of racial uplift and law enforcement into narratives that transferred the oft-repeated encounter between the law and Gypsies into models by which spectators could work through their economic and class anxieties (Labanyi, "Miscegenation," 61–62). Us/them thinking was reinforced by Spanish legal institutions that categorized individuals as either legitimate or illegitimate (or winners or losers, in the context of the civil war), triggering anxiety about the loss of control, be it political, legal, or familial. "Difference is that which threatens order and control; it is the polar opposite to our group. This mental representation of difference is but the projection of the tension between control and its loss present within each individual in every group. That tension produces an anxiety that is given shape as the other" (Gilman, 21).[13] The physical presence of the Roma must have reminded even those who were on the "right side" that the racial situation was inherently unbalanced, if not unjust. But since this lack of balance or wholeness could not be openly acknowledged, it expressed itself in the drama of lawfulness and unlawfulness. In these popular narratives about Gypsies, the goal was to entertain through a flirtation with an attractive difference that then justified the cleansing of all foreign elements and their incorporation into the body.[14] In reality assimilation was rarely successful. The state's efforts to assimilate

others are a history of failure. But the melodramatic scenarios reenact-
ing stories of legality, law, and Gypsies continued to assert an imagi-
nary in which these legal measures were successful. The underclass,
ethnic female married a bourgeois white professional, a cortijo owner,
or a nobleman, or through her legitimately paid labor of singing and
dancing, she integrated herself into Spain's formal (and ultimately
tourist) economy.

Controlling the Roma, the attempt to impose stability on an inher-
ently unstable society, worked in tandem with controlling the imaginary
Gypsies by corralling them into scripts about Gypsy fortune-tellers,
singers, magicians, dancers, petty thieves, horse traders, highway rob-
bers, and baby snatchers (Charnon-Deutsch, *Spanish*, 18). Following
the last expulsions, from 1609 to 1614, of *moriscos* and *conversos* (those
already converted in either 1502 in Castille or 1528 in Aragón but sus-
pected of still having contaminated blood and of secretly practicing
Islam and Judaism), Cervantes crafted a tale about mistaken identity
in *La gitanilla*. Cervantes was writing in a moment of massive identity
confusion. The *conversos* and *moriscos* were viewed as distinct ethnic
groups, but Roma, because they "did not covet land" and "claimed to
be sincere Christians," did not constitute a "persecutorial priority"
(Mitchell, *Flamenco*, 56). The expansion of the Roma population after
the last expulsion has been attributed to the mixing of *moriscos*, *quin-
quis* (a self-identified ethnic group bound by the trade of metal and
hardware who was, like the Roma, often criminalized), and possibly
even Jews within Roma bands, the implication being that the purity
of Roma ethnogenesis has always been a myth (Mitchell, 51–61). Yet
one thing was for sure, Roma were clearly identified with delinquency.
As Cervantes writes in *The Little Gypsy Girl*: "Born of parents who
are thieves, reared among thieves, and educated as thieves, [Gypsies]
finally go forth perfected in their vocation, accomplished at all points,
and ready for every species of roguery. In them the love of thieving, and
the ability to exercise it, are qualities inseparable from their existence,
and never lost until the hour of their death." It is thus unsurprising
that the female protagonist, Preciosa the Gypsy, turns out to be an
aristocrat, switched at birth with a Gypsy baby. Cervantes's ambivalent
attitude toward race actually insists on "both a recognition of Gypsy
racial difference and a disavowal of that difference through a linking of
Gypsies with other nonracially differentiated groups." Racial alterity

thus plays a crucial role in Cervantes's creation of white Gypsy glamour: an exceptionally good and beautiful woman contrasts sharply with the common run of scoundrels and thieves (Charnon-Deutsch, *Spanish*, 18). Cervantes writes:

> Little Preciosa became the most admired dancer in all the tribes of Gipsydom; she was the most beautiful and discreet of all their maidens; nay she shone conspicuous not only among the gipsies, but even as compared with the most lovely and accomplished damsels whose praises were at that time sounded forth by the voice of fame. Neither sun, nor wind, nor all those vicissitudes of weather, to which the gipsies are more constantly exposed than any other people, could impair the bloom of her complexion or embrown her hands; and what is more remarkable, the rude manner in which she was reared only served to reveal that she must have sprung from something better than the Gitano stock.

Preciosa prefigures the exceptionality of the folklórica: "[Precious] is more beautiful than the rest, . . . earns more money, dances and sings better, and loves more honestly and deeply" (Charnon-Deutsch, *Spanish*, 19). Like so many folklóricas and cupletistas—in particular Raquel Meller (*La gitana blanca*), Estrellita Castro (*Suspiros de España* and *Mariquilla Terremoto*), Concha Piquer (*Filigrana*), and Carmen Amaya (*María de la O*)—who were taken to the city to be presented to society, Preciosa, well aware of her worth, is taken to Madrid by the old Gypsy woman who raised her, "but in her sixteenth year her grandmother brought her to Madrid, to the usual camping-ground of the gipsies, in the fields of Santa Barbara. Madrid seemed to her the most likely place to find customers; for there everything is bought and sold" (see also Resina, 261).

From the seventeenth to the nineteenth centuries, negative Gypsy stereotypes were the norm in fiction and drama, as they had been in *La gitanilla*; later, they would form part of folkloric cinema's filmic imaginary. In nineteenth-century Spanish literature with Prosper Mérimée's *Carmen* (1845), however, the image becomes more complex.[15] Other interpretations of Carmen that go beyond the femme fatale image envision her as the siren who is also a worker, rebel,

and revolutionary.[16] Resisting integration and social regulation, she proudly rebels against state law, mocking those who pander to it. Mérimée's tale resonates with social preoccupations as Carmen edges against the modernizing nineteenth-century government of Spain, whose actions include the control and reform of delinquent sectors of the population, as in the creation of the civil guard in 1844, who patrolled national highways and policed bandits and was associated in Spanish cinema and the popular imagination with Gypsies (Labanyi, "Miscegenation," 60).[17] Nevertheless, although Carmen's romantic figure of the female Gypsy broadens the possibilities of the Gypsy icon, she remains captive to fate, destiny, primitivism, and racism. For Sander Gilman, Carmen is "the quintessential Other—female, a gypsy possessing all language and yet native only in her mother tongue, proletarian, and black [skinned]" (30).

The *Carmen* remakes in prose, drama, and film demonstrate its status as *the* foundational fiction for most of the filmic narratives studied in this book.[18] But its plot is also inherently concerned with law. The central tension is between Carmen and her Gypsy highway robbers and black marketers and the state, the symbol of civilization, which is represented by José, the soldier who falls in love with her and is subsequently punished. The problem with Carmen is that she cannot be assimilated. By luring potentially good citizens, even those charged with enforcing the law, away from society, she effectively unassimilates them, converting them into criminals and members of fringe society. Carmen poses such a threat to the teleology of enlightened modernity that she must be eliminated. To reassert his masculinity, José, castrated by his illness and Carmen's rejection, stabs her before being executed as a collaborator.

The impact that such a violent and lawless Carmen might have on the public was softened by kinder portraits of Carmen or by Carmen-derived stories that appeared in Spanish-produced films. Segundo de Chomón's film *Amor gitano* (1910; Gypsy love) was, according to Moix, a film that dealt with the "racial problem" of relations between *payos* [non-Roma] and *gitanos* with integrity and with openness and is thus a logical precursor to *Morena Clara* (Moix, 106). In other words, *Amor gitano's* representation of a mixed-race relationship that ended in consummation and a child—the ultimate symbol of racial and class reconciliation—was a positive sign.

Morena Clara and Spatial Boundaries

Though the Second Republic may have gestured toward a more progressive stance on the Roma problem—one of its presidents, Manuel Azaña, felt the Gypsies preserved Spain's national roots in the purest form (Charnon-Deutsch, *Spanish*, 176)—playwrights and musical composers of the late twenties onward (e.g., the Álvarez Quintero brothers, Guillén, Rafael de León, and Manuel Quiroga) repeatedly offered a successful formula designed to exploit the Carmen theme without dangerous references to lawlessness and "black" Spain: the crossing of a Gypsy with a non-Gypsy, the ultimate symbol of reconciliation (Sánchez Vidal, *El cine de Florián Rey*, 220).

The folklórica Gypsy was concocted by film directors eager to adapt Andalusian theatre comedies to the screen. Staging a model of national unity and family, the folklórica represented fantasies of cultural inclusion rather than exotic others wholly incapable of assimilation (Vernon, "Culture and Cinema," 254). *Morena Clara*, a foundational Andalusian musical comedy film, is emblematic of such a shift toward an inclusive yet paternalistic (and imperialistic) legal and political view of the Gypsy as a celebration of racial assimilation. Symptomatic of the growth and consolidation of the 1930s, a short period of precarious democracy framed by two dictatorships, the film casts a progressive light on Gypsies and the law. Film historians like Manuel Rotellar encourage this liberal thinking, noting that *Morena Clara* and the character of Trini build a "bridge of understanding" between the Gypsies and the non-Gypsies (139). And Caparrós Lera goes so far as to write that the "atmosphere of the Popular Front period comes through in [*Morena Clara*]" ("Feature Films," 68). But the film's Republican-style compromise of racism and liberal ideology diffuses any potential radicalism.[19] The film's permissiveness, embodied in the laughter and coquetry of Trini and Regalito's (the male Gypsy in *Morena Clara's*) relentless Andalusian wisecracks, smooths over Enrique's racial hatred, proffering a fantasy of mutual need during the tense prewar situation. Female Gypsies here are keen to assimilate and move their lazy male counterparts into line. They constitute ideal romantic partners for the uptight white male Spaniard. Most important, they are recognized as white female stars, despite the hybridity that their character signifies.

Morena Clara opens the so-called golden age of Spanish filmmaking,

becoming one of the biggest box office successes in Spanish cinema history. Debuting on April 11, 1936, it stayed in theaters until March 1937, showing in all capitals except for Cadiz, and was a hit in Havana, Cuba. As a testament to its malleability, the film continued to be shown at intervals on both sides of the war front until 1939 (Sánchez Vidal, *El cine de Florián Rey*, 219–20). Román Gubern testifies to *Morena Clara*'s ability to bridge political boundaries after the start of the war through its popularity on both sides, remarking that it was only until the Republican government supposedly became aware of Florián Rey's, Imperio Argentina's, and Cifesa's (the production company's) "Francoist sympathies" that screenings of the film were discontinued (*La guerra*, 36). Word had circulated among the press that Rey and Argentina were off to Nazi Berlin to film *Carmen, la de Triana*, thereby provoking a furor among liberals and cineastes eager to condemn Rey for his populist tastes. The Republican government's censorship of *Morena Clara* probably contributed to an even greater interest in the film within the Nationalist zone (Gubern, *La guerra*, 36). Caparrós Lera adds that this film was the first one shown when Barcelona fell to the Nationalists (*El cine*, 159).

Nevertheless, however potentially subversive *Morena Clara* was to the middle-class mentality, its comedy functions to emphasize how in the end, no matter how whitened, the Gypsy will lapse back into her natural state, confirming what the audience already knew to be true. The gesture toward assimilation thus actually reasserts the need to exclude the Roma or exploit these artificially efficient, utilitarian Gypsies who were "therapeutic antidotes" (Charnon-Deutsch, *Spanish*, 226) to an incompetent bourgeoisie. Never mind that Regalito's exaggerated sloth and thievery not only undermine the capitalist work ethic but also expose profit for the robbery that it is. If Gypsies and their potential labor could be incorporated into the working class, as the film strives to imagine, the middle class could invest in them as a financial product, or a property whose boundaries were carefully controlled.

If it is true, as David Harvey writes, that "social space is a way of thinking" and determines to a large degree the way we think about our social imaginary (23), then discussing how bodies get racialized and occupy space and how that space is policed and regulated are central issues when looking at filmic Gypsiness. This overdetermined Gypsiness is born of North–South thinking and colonial–imperial

paradigms—spatial binaries that determine the scale of otherness—
that are sustained by and worked through the "truth" of the law. The
logic underwriting the ideology of folkloric films in the first decade of
Francoism imagined Madrid as the imperial center and the region of
Andalusia as the periphery, the colonized territory. Assisted by "the
occupying army," the Francoist state constructed the nation on "impe-
rial pillars," submitting inferior regions to central power in that same
way that Franco, as commander of the Spanish legion in Morocco,
subjugated native tribes (Labanyi, *Gender and Modernization*, 23). By
symbolically privileging the culturally marginalized, however, the cen-
ter is able to assure itself and its marginalized other that a consensual
unity binds them together. This is why spectators could derive pleasure
from the North–South axis displaced onto a romantic relationship,
even though they were participating in imperialist and racist think-
ing. Interdependence is, according to this logic, both a necessity and
a desired state; it affirms the South's symbolic importance despite its
economic inferiority, forcing it into a position of objectification by the
centralizing North. In the state as in the films, Andalusia is spatialized
as a colonized periphery, or a vestigial "memory" of the Spanish past,
while the Gypsy is spatialized as the margin of this periphery.

The Gypsy question and its relation to law is, at its most material
level, an issue of space. Throughout the twentieth century geographical
proximity and physical contact between the Roma and Spanish citizens
were of great concern to communities barely subsisting on the scarce
resources so unevenly distributed by the state.[20] To keep extreme pov-
erty out of sight while simultaneously encouraging a controlled assimi-
lation, borders—both invisible and visible and maintained through
prisons, ghettos, and schools—were designed to separate Roma and
non-Roma. In the films access to and blockage from borders are con-
stantly raised by the dialogues and characterization, foregrounding the
question of the appropriate space for Gypsies.

The Industrial Revolution and later the Spanish Civil War caused
two major displacements of the Roma population in Spain.[21] The
mechanization of the countryside and urbanization left many job-
less, since their professions relied on services to and trade with agri-
cultural communities (San Román, 66, 212). The invention of plastic
supplanted the need for the tin and aluminum gadgetry they tradition-
ally traded, while radio and cinema reduced the demand for Roma

ambulatory theaters, puppet shows, and circuses. After the civil war the massive dispersion and redistribution of Roma populations gave rise to shanty towns in bombed-out buildings or in trash dumps on the urban limits (San Román, 213–14). In Andalusia the permanently settled communities of Spanish Roma lived in the impoverished places vacated by non-Roma emigrants who had left to seek industrial jobs in the urban centers (San Román, 67), and thus were not included in this process of proletarianization (San Román, 68). As late as the 1950s and 1960s, however, a majority of Spanish Roma were still nomadic even if associated with more-settled communities (see Martín Fernandez). Dispersion and resettlement—in short, the spatial reality of the displaced Roma population and the problems they posed for those controlling space—manifest themselves in the setting and action of films such as *Morena Clara, Canelita en rama,* and *El caballero andaluz.*

In *Morena Clara* the division of space works variously, establishing difference but also demonstrating the assimilative potential of a modern state. From the beginning of the film, the narrative and the transparent editing structurally and visually reinforce the film's message that differences might exist within the unity of family or nation but they must be made whole. Throughout the film medium shots and dollies alternating with exterior long shots stress the inherent distance between Gypsies, Roma, and non-Roma. *Morena Clara's* establishing shot displays the peaceful roadside inn that will soon be invaded by the conniving yet endearing and ever comical pair of Gypsies Trini and Regalito. Within this legitimized interior lengthy dolly shots track forward through the inn, positioning the spectator as part of this coherent, sanctioned space.

During the succession of shots, a contrast emerges between the roadside inn, a refuge of legitimate business, and the Gypsies who came in from the road, symbolizing migratory, dislocated wanderers. In the next scene an exterior long shot of Trini and Regalito walking down the road distances spectators, who have just identified with the interior opening shots. This same extreme long shot is repeated after Trini and Regalito leave the courtroom where they are prosecuted. Shot as two small figures against the sky at the bottom of the frame, their marginal status is vividly revealed by the empty space that oppressively surrounds them.

Yet the rest of the film appears to contest their marginalization to

Figure 17. Regalito and Trini (Imperio Argentina) in *Morena Clara* (1936)

the extent that the eventual assimilation of the Gypsy appears not only justified but the ultimate gesture of justice. From this point on, the film intercuts between public and private space—from the court, to the Baena household, to exterior spaces—mimicking the state's and the law's infiltration into all of these spaces.

Space, Don Foster argues, "embraces both material and discursive dimensions," and "boundaries and exclusions may be both symbolic and physical" (20). The family home is a discursive construction, just as nations are imagined communities, and both are geographically bounded entities. But discourse is not just representation; it "does things." Laws, regulations, and language codes comprise boundaries that mark divisions within space, whether that space is discursive or physical. *Morena Clara*, made before Franco took power, cannot be said to reflect National Catholic ideology per se, but neither National Catholicism nor liberalism began or ended with the Spanish Civil War. Through the family setting, the need to merge with the other is spliced onto the terrain of the national family, whether conceived of in terms of Republicanism or Francoism.

Clear parallels can be seen with the nineteenth-century lawmaking fever, which also infused the family space with legality in an attempt to counteract the effects that modernization had on the integrity and stability of the bourgeois family home. Nineteenth-century modernizing legislation sought to centralize state functions, increase the numbers of property holders and thus citizens, and finally extend a firm hold over the private sphere of the family. The 1889 Civil Code marked the culmination of this activity, laying down norms that governed private property, marriage, and the family (Labanyi, *Gender and Modernization*, 26).

In *Morena Clara* a utilitarian idea of the Gypsy as a facilitator of the national family simultaneously functions in a nostalgic way. The ambivalent non-Gypsy folklórica, Imperio Argentina, who plays a Gypsy character, implies that racial unity in Spain is a potential reality, thus affirming a subliminal message inherent in all folkloric films that Spain needs to be reunited (Labanyi, *Gender and Modernization*, 33). Such a textual resolution of fratricide and class anxiety is accomplished in *Morena Clara* by presenting the Gypsies as augmenting daily family life and their absence as diminishing the chances that all of Spain could be like a cheerful Andalusia.

Dichotomies of difference, in particular spatial boundaries, can benefit hegemonic power if the outsider is a guest and not an intruder. The first musical sequence of the film occurs when Trini and Regalito visit the Sevillian mansion of the Baena family, hoping that Enrique Baena, the attorney who prosecuted them for stealing hams, will take

them in, as he had promised to do in court. The Baenas happen to be hosting a party for the social elite and have provided *sevillanas* (flamenco-styled dancing) as entertainment. The scene opens on the image of a cross reflected in the rectangular pool within the lavishly decorated Islamic interior patio. Accompanied by nondiegetic orchestral music, the camera moves around the patio's arches and filigreed gratings, capturing the stylized chorus of female *sevillanas* dancers. Critics have noted the Busby Berkeley influence that appears in the extreme high-angle shots of the circle of dancers (Sánchez Vidal, *El cine de Florián Rey*, 223) and in the intradiegetic audience composed of the party guests. More interesting is the pointed visual reference to Islamic/Arabic architectural style. Both the patio and the flamenco-inflected *sevillanas* dancing are apparent proof that Roma and Arab can be successfully integrated into the Spanish family/nation. Here, the two ethnicities exist in their fetishized and petrified form. The eruption of Trini and Regalito, essentially guest workers who crash the party, momentarily subverts the order of things. But as we will see, Trini's success lies not in overturning the status quo but in successfully installing herself within it.

At this party Trini and Regalito, the uninvited guests (i.e., immigrants), displace the legitimate entertainment from the party space with their popular song duet "Échale guindas al pavo" (Stuff the turkey with cherries).[22] The song celebrates the cleverness of a pair of Gypsies who steal a pair of turkeys but who know that since the *guardia civil* will inevitably arrive, they may as well roast and dress the birds so that the *guardia civil* will be more likely to sit down to eat than take them to prison. Trini and Regalito dance and sing for both the interior audience and the film spectator, and there is a general feeling of attending an intimate live performance. Their song wins over the audience and distracts them from the *sevillanas* dancers, in part because of the subversive nature of the lyrics:

> Huyendo de los civiles, un gitano de perchel,
> Sin cálculo y sin combina, ¡que donde vino a caer!
> En un corral de gallinas, ¿y qué es lo que allí encontró?,
> Pues una pavita fina que a un pavo le hacía el amor.
> Saltó la tapia el gitano, con muchísimo talento
> Y cuando se vino a dar cuenta, con un saco estaba dentro.

A los dos los cogió, con los dos se najó,
Y el gitano a su gitana de esta manera le habló:
"Échale guindas al pavo, échale guindas al pavo,
Que yo le echaré a la pava azucar, canela, y clavo." [repeat]
Estaba ya el pavo asao, la pava en el asador
Y llamaron a la puerta, verá usted lo que pasó:
Entró un civil con bigote, ¡Ozú, que miedo, chavo!
Se echó el fusil a la cara y de esta manero habló:
"A ver dónde está ese pavo, porque tiene mucha guasa
Que yo no pruebe ni un ala."

Fleeing from the civil guards, a Gypsy loafer,
unwittingly and without having planned it, look what he fell into!
In a hen coop, and what did he find there
But a fine little turkey hen wooing a turkey.
The Gypsy jumped the fence with great skill,
And before realizing it, he was inside a sack.
He caught both of them, and with both of them he disappeared,
And the Gypsy to his wife spoke thus:
"Stuff the turkey with cherries, stuff the turkey with cherries,
And I'll add to the turkey hen the sugar, cinnamon, and clove."
 [repeat]
The turkey was already roasted, and the female turkey in the oven
When there was a knock at the door, and look what happened:
A mustached civil guard came in, geez, how frightening, boy!
He put his rifle to his face and in this manner said:
"Let's see where that turkey is, because it would be pretty fun
If I couldn't even try a wing."

The double entendres of the song—*guindillas* (red chili) is similar in
form to *guinda*, a colloquial term for stealing. While "échale guindas al
pavo" is an exclamatory phrase expressing admiration for the theft, it
literally means "stuff the turkey with cherries"—suggesting how these
subaltern Gypsies outwit their oppressors. By cooking the evidence of
their theft, they hide the loot from the *guardia civil*, whose desire to eat
turkey points to the collusion of petty crime and the law, a relation-
ship that allows for the Gypsies' survival but continues their marginal-
ization. The song is performed when Trini and Regalito entertain the

invitees and the homeowners, slipping into the space of the bourgeoi-
sie, mingling and slyly passing through borders while demonstrating
their utility.

Trini proves to be indispensable to each member of the Baena fam-
ily. Cleverly, she maintains the family's unity and honor in the face of
legal threats, whereas Enrique's enlightenment reason and faith in the
power of the state provide no answers to the family's problems. Indeed,
Trini rescues Enrique's father, Don Elías, from a scandal that could
have destroyed his marriage: this from an old lover, Juanita Cespedes,
who bore his child out of wedlock. Over the years, he has supported
Juanita and her daughter with hidden money, but now Juanita wants
revenge. She and her daughter arrive with a letter from Don Elías that
she threatens to give to Doña Teresa. But Trini, the faithful servant,
disarms the letter by "foretelling" its contents as it sits in Juanita's purse.
Thus, the letter becomes a fantasy product of her supernatural powers
rather than solid evidence of adultery. By this parody of Gypsy sorcery,
Trini foils the blackmail but also secures the trust of the family and her
subordinate position within it.

Now a part of the Baena household, Trini finds a stash of money
that a shady character, Pepe Rosales, has left on Enrique's desk. Rosales,
an old law school acquaintance of Enrique's, is now the agent of a
morphine trafficker prosecuted by Enrique. His attempt to discredit
Enrique will test Trini's faithfulness to the Baena family. Tempted to
pocket the money, Trini debates with herself, decides she will prove
worthy of her race, and so places the money in Don Elías's pocket
when he's not looking, reversing the Gypsy stereotype of pickpock-
eting. When Enrique's good-for-nothing brother, Rafael, comes ask-
ing for a loan, Trini intervenes, boasting that she can make the money
magically appear. Performing a nonsensical incantation, she retrieves
the bills from the father's pocket. The family is bewildered, but be-
cause Trini saves the situation *as a Gypsy*, she reinforces the stereotype
of the cunning Gypsy who dupes non-Gypsies but also demonstrates
that within the home space, otherness can safely coexist, as long as it
is useful. By restoring honor to the philandering father and the ruined
playboy Rafael, both stand-ins for Andalusian *señoritos*, Trini averts
the family tragedy that in real life was about to sever Republican and
Nationalist Spain.

The interplay between Trini and Enrique's mother offers another

take on otherness inside the home space. When Trini first comes to live at the house, the mother is charmed by her stereotypical jokes, clever rhymes, and, of course, songs. But the mother is conflicted. She wishes her Andalusian-identified son Rafael could be more responsible, like his brother Enrique, and that Enrique could be as fun loving and easygoing as Rafael. Giving money to Rafael behind the father's back, she functions like the liberal state that complained about the ineffective Andalusian landowning classes while protecting them. As Trini and the mother grow closer scenes of Trini cleaning the house or wandering through it, marveling at the material wealth, mark her as the internal laboring other. At such times, Trini shows almost religious adoration for the mother. In several scenes the mother is the center point in the mise-en-scène or is seated or standing in a higher place than Trini, emphasizing her white matriarchal and domestic authority.

As a go-between, Trini negotiates the home space under controlled conditions, dependent on the family but never becoming part of the family, the ultimate legitimate subject.[23] As a Gypsy, she remains exploitable labor, which in effect instrumentalizes her (Goldberg, *The Racial State*, 51); the mother sees Trini as a positive influence on Enrique and allows her to stay in the house in exchange for domestic labor. As a maid, Trini makes domestic servitude a comedy: she competes with the other maid, ingratiates herself with the family, entertains, distracts, and even solves the family's problems. Her ineptitude at the tasks of modernity, such as answering the phone, guarantees her status as an acceptable yet inferior internal other. Still, her otherness is necessary to the proper functioning of the home. In a larger metaphoric sense, her guest worker status enables the economy while excluding her from the full benefits of citizenry. The in-between and the marginal are crucial to the dominant economy, as seen in the space of the cortijo.

Canelita en rama, *El caballero andaluz*, and the Space of the Cortijo

The Andalusian cortijo, the large ranch or hacienda, haunts Gypsy folklórica film.[24] It is the space of the antimodern. As the landowner in *Canelita en rama* describes his estate to Canelita, "Progress stops here. The auto has never passed this boundary. From here on, tradition, and mule-drawn carriages." Presenting the cortijo as the guardian of

tradition, he continues, "The people of my lands feel affection for my traditions, and I've never wanted to defraud them with modernisms." The paternalistic will to suppress modern influences that might alter economic hierarchies is justified by the peasants' supposed complicity in this social structure. The cortijo motif was a product of respectable bourgeois cultural production, as well as lowbrow live entertainment. In José Cadalso's epistolary fiction *Cartas marruecas* (1789), the author describes a Gypsy *juerga* in Tío Gregorio's cortijo. Flamencologists have often used this reference to confirm the existence of flamenco music in Andalusia in the eighteenth century. The Andalusian musical comedy film aspires to a similar authenticity. Despite their blunt exploitation of massified flamencoized music, these films develop the same connection between the cortijo and flamenco.

In the nineteenth century an increased interest in regionalism and *costumbrismo* had found its home in a spate of novels and plays with much to say both idealistically and critically about Andalusia's millions of landless, illiterate peasants, the Roma, and the wealthy landowners.[25] In the popular oral tradition *juegos de cortijo*, farcical and slapstick minidramas or skits were performed on the premises of cortijos for peasant and rural laborers. Stanley Brandes has shown that these spontaneous and improvised skits were acted out exclusively for "working people of the countryside" and were integral to all customary celebrations, such as baptisms, weddings, family pig slaughters, and the final day of the olive harvest (239–40).[26] In a more poetic way *Canelita en rama* dedicates several musical sequences to the celebration that marks the end of the vintage season, but the *juegos de cortijo* insertion within this comical film cancels out any serious portrayal of Andalusian landscapes and cities.

For the most part the cortijo world in these films is idyllic and disconnected from the realities that faced Andalusia, in particular the tensions that would explode during the civil war. Traditionally, the cortijo was protected by the state and allowed to function as a semiautonomous entity with its own unwritten laws. The state had an interest in sustaining the owners of cortijos, who were often local *caciques* (political bosses). During the nineteenth-century restoration of the monarchy, *caciquismo* was an efficient tool for incorporating the rural majority into the nation (Labanyi, *Gender and Modernization*, 268).[27] Its authority was transcendent and natural, sustaining the bourgeois family

and, by default, property and territorial interests. A guardian of private property and the uncontested power of the landlords, the cortijo also promoted landlessness, poverty, and itinerant others on its margins. In these film versions of cortijo politics, the public legal sphere disappears and private property goes unquestioned, despite the recent war fought largely over property rights. Whereas the private lawmaking function of the cortijo remains intact, autonomous Roma lawmaking is, as it is made clear, invalid according to state law.

The unwritten rules of cortijo law were tolerated because the laws of the state usually shared an interest with landowners in controlling the land and population, specifically a restless and racialized population. The cortijo, through its *cacique,* "served the state by ensuring that the central government authority was enforced (Labanyi, *Gender and Modernization,* 269). The world of playboy *señoritos* and the wretched hunger and unemployment endured by the working poor are nevertheless harmonized in the Andalusian musical film's illusionary symbiosis of legitimate and illegitimate subjects—those occupying the cortijo and those at its margins. In these films law is, in a general sense, more credible than the state because it connotes abstract qualities such as justice and truth. It reinforces a good stereotype (the landed, propertied self) and is counterposed to the bad stereotype (the Other, i.e., the landless Gypsy), which is always against and outside the law. The cortijo largely symbolizes the quasi-feudal agrarian culture underwritten by a thoroughly modern, centralized administrative apparatus in its drive toward internal pacification. On its stage—both on film and in fact—the fictive harmony of illegitimacy/legitimacy and the assimilation of otherness played out.

Racialized fantasies of harmony distracted audiences from the reality of failure. Attempts to restructure society had revealed a loss of control over the social realm, including an inability to contain the disenfranchised majority's seething anger, which frequently leaked out in riots in the early 1910s (see Díaz del Moral). Florencia Zoido Naranjo and Juan Francisco Ojeda Rivera point out that historically, efforts to aid the rural Andalusian poor by redistributing land had not succeeded and had resulted in a mass exodus to the cities (777). Such attempts were undermined by the weaknesses of the Central Junta of Colonization and Repopulation of the Interior (between 1907 and 1923) and later by the failure of the Republican agrarian reforms, the general devastation caused by the

Spanish Civil War (1936–39), the decrease in levels of productivity dur-
ing the first decade of Francoism (up to 50 percent in the primary sec-
tor), which was due to the internal blockage against imports, and finally
the greater attraction of the urban centers (777; see also Payne, 112–22).
The widespread migration to urban areas left large numbers of
Roma without their traditional means of earning a living, and their
consequent settlement in outer-city slums only exacerbated their
plight. So while Spain moved toward economic recovery, xenophobia
toward ethnic minorities increased, as reflected by the forced resettle-
ments and raids of Roma communities. After World War II, the state
went to the extreme of initiating a formal politics of assimilation (San
Román, 71, 212). The intent was to incorporate the Roma despite the
resistance and the explicit racism of the communities where Roma
were forced to settle.

In all of these films, Gypsies hover at the margins of a wealthy estate
in the Andalusian countryside. *Canelita en rama* stars Juanita Reina,
an up-and-coming folklórica of the early 1940s. Canelita's Gypsy fam-
ily is composed of three comic characters who raised her: Tarantos,
Cayetano, and Tía Consolación, played by Pastora Imperio, a folklórica
stage dancer "with Gypsy airs" who was touted as "la más cañí" (the
most Gypsy) in her dances and songs (*El cine*, January 11, 1919). Pastora
Imperio's status was such that Manuel de Falla commissioned her to
premiere his Gypsy ballet *El amor brujo* (1914–15). She had also played
the mother of Carmen Amaya in *María de la O*. In the hierarchical
world of folklórica star culture, it was common practice to compare
younger stars, like Juanita Reina, with older ones, both out of respect
for the elder star's experience and as a way of perpetuating discourse
about the business by constant allusions to its own performance prac-
tices and genealogies. Here, Pastora Imperio, not only older but more
Gypsified, cedes the spotlight, in terms of both narrative and perfor-
mance time, to the younger and whiter folklórica.

In order to raise Canelita properly and to educate her as a *señorita*,
Don Juan, a cortijo owner who thinks he is her biological father, sends
her to a convent in northern Spain, thinking that there she will be free
from the pernicious influence of her mother's Gypsy family. But the
clever Gypsies follow her north to continue her flamenco education
from outside the school's iron bars. Rather than seeing themselves as
locked out of the school, they ask what she did to find herself between

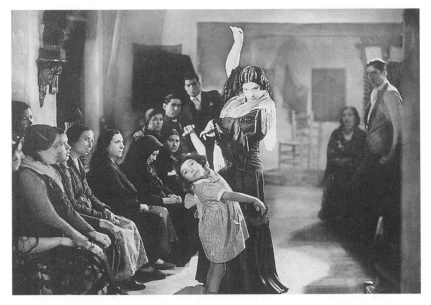

Figure 18. Pastora Imperio's trademark serpentine arms looming over María (Carmen Amaya) in *María de la O* (1936)

bars: "What have you done, my love, to get yourself behind bars?" Canelita, at this point in the film, identifies more with her Gypsy heritage. When she dances for her relatives, who are urging her on from the other side of the convent gate, the nun scolds her: "Castanets are not necessary; what is needed is application." But Canelita protests: "I'm a Gypsy, I'm a Gypsy, and I like castanets!" At which the nun refers her to the white cherubs of the pervasive Catholic school imagery: "Come on, don't cry. The little angels are always happy and they don't use castanets, you'll see."

Fifteen years later Canelita graduates from school. In the ensuing mixture of nature/nurture arguments, both the nun and the count are convinced that she has had no contact with her Gypsy family for fifteen years, while the audience knows that they have seen each other all but three days. Throughout her schooling, it is clear that the Gypsies' transgression of space has been a cogent critique of the church and its arrogant pretensions to omniscience. Moreover, the folklórica has aided the spatial assimilation of the Gypsies, first by securing their place on the cortijo grounds and then by mediating with the landowner.

The biopower of the cortijo is temporarily undermined when Canel-ita's threat to leave keeps Don Juan from sending the Gypsies back to Czechoslovakia; cortijo ideology might have colonized the mind of its peripheral subjects, but it needs these subjects to remain on its margin in order to function.[28] Her threat to leave is not in the film, but in the original script Tía Consolación affirms that "the girl won 'er case." The disciplining of others, more covert than coercive, gets played out when Canelita intervenes so that the Gypsies can enter into the interior of the cortijo in exchange for menial jobs. Pastora Imperio, one of the most respected dancers of flamenco of the early part of the twentieth century, but much more Gypsy than Canelita, ironically becomes the maid of the cortijo. In effect, the white folklórica stands in for the cor-tijo administrator (a colonialist middleman) and maintains the private police and the disciplinary system of the cortijo. She performs Don Joaquín's (the administrator of the cortijo's) duty, keeping the Gypsies at bay and ensuring the profitability of the estate, and when mortified by her relatives' behavior, she is the heroine who scolds Cayetano and Tarantos for stealing and chides Don Joaquín for his naiveté about Gypsies' potential for honest work.

Whereas the cortijo functions as a disciplinary extension of the state and a model of integration in *Canelita en rama*, the film *Un caballero andaluz* hails law and assimilation by transforming the space of the cortijo. Like *Morena Clara* and *Canelita en rama*, the film delights in showing how Gypsy misfits somehow manage to cross property lines. They invade the cortijo mansion itself, which gives them a taste for a better life, smoothing their transition from abject marginality to a sta-tus as acceptable, if racialized, subjects. Carmen Sevilla, who belonged to what Terenci Moix calls the second wave of folklóricas, stars in this film, sporting a slight tan in order to be more convincing as Colorín (Little Colored One). Colorín is blind and a surrogate mother for her *hermanillos* (little brothers), some from different fathers and others simply orphaned Gypsy boys. Also known as "La gitana ciega de las cuevas del remedio" (The blind Gypsy of the caves of the [virgin of] remedies), Colorín lives with this ragtag bunch on the fringes of the cortijo owned by the wealthy Don Juan Manuel de Almodóvar.

Don Juan Manuel's voice-over narration at the beginning of the film tells us that he is very proud of his cortijo, with its extensive and productive lands. Bragging about how he dominates his horses and

raises the best-quality bulls, Don Juan Manuel celebrates the most traditional, masculinist ideals of cortijo life. His attitude toward the Gypsies, unsurprisingly, is condescending: "That's the Calé race: all day long drinking and dancing so they can then come to our doors asking for money." His son, José Luis, the product of a boarding school in England and thus liberal in his thinking, tries to convince him otherwise, reminding him that Colorín is different, an exemplary (i.e., token) other: "But papa, Colorín is different, she works all day in order to feed her brothers."

In a quick turn of events, José Luis is gored trying to save his show-off father while taming bulls, and even though Colorín gives a blood transfusion (a remarkable link with the 1928 *La Venenosa*), it fails to save his life. In other words, despite Colorín's or, for that matter, Carmen Sevilla's exceptionalism, the film remains consistent with historical blood taboos. It is not until Colorín's transformation later in the film that she fully assimilates. On his death bed José Luis asks his father if, given the space and abundance of the cortijo, they couldn't make room for Colorín and her cold, hungry, fatherless *hermanillos*. José Luis's good intentions are the backbone of assimilationist discourse: the white landowning family is the ideal nuclear family and the model the Gypsies must emulate.

When José Luis dies, Juan Manuel undergoes a complete transformation and decides to fulfill his son's wishes. Inspired by the blind Colorín, he becomes a visionary and decides to regenerate the race, to instill in them the ideals and work ethic of the white Spaniards. In a frenzy of do-gooding, he renames the cortijo Casa-Hogar José Luis de Almodóvar. On the commemorative bust of José Luis at the entrance, he engraves, "For all orphaned children who live without shelter."

Don Juan Manuel's philanthropy consists in giving shelter and education to all Gypsies of the neighboring area and granting the priest the directorship of the school, so that it can be run as "military quarters," justifying this comparison by adding, "He is a knowing observer of your virtues and your defects."

This project, parodic and utopian at the same time, resonates with Michel Foucault's later description of how since the eighteenth century, schools were the locus of the project of docility, employing disciplinary methods that meticulously controlled the body and made subject its forces (137–38). As Juan Manuel describes his vision of the reform

Figure 19. Colorín (Carmen Sevilla) pinching the nose of the commemorative bust in *Un caballero andaluz* (1954)

school the camera cuts to various rooms transformed into ideal dormitories, eating areas, and classrooms, each of them arranged with the appropriate objects, beds, tables, and desks, in neat, orderly rows. One thinks of Foucault's description of disciplinary institutions, where objects are distributed in a functional and serialized fashion. The schedules of the boys are regimented: "Five minutes of showering: apart from waking them up, this will make them forget that Gypsies can only wash themselves with wine." The insistent inculcation of ideology also presages Foucault: "And before three months are up these Gypsies that only knew how to read the lines on their palms will know how to read regular books."

Colorín and Don Juan Manuel fantasize together about the reformist and assimilationist future of the school. Colorín predicts, for instance, that the school will regenerate the Roma race ("the regeneration of the Gypsy race") and will remove the vices from Gypsiness ("eliminate the bad habits from Gypsydom"). Within a few years, she says dreamily, there will be Gypsy doctors, prosecutors, and lawyers, but definitely no Gypsy *guardia civil*, and she reproves Don Juan Manuel for mentioning it. Noteworthy, however, is the boys' actual transformation: we see

shots of them welding, doing carpentry, making metal instruments, and working the fields, but not practicing law or medicine.

After a year of running the reform school, Don Manuel's finances are drained, obliging him to return to bullfighting. But now he fights as an Iberian macho who is also an enlightened reformer and successful businessman, somewhat along the lines of García Morente's *caballero cristiano*. The traditional ideals of the cortijo, which were always paired with those of the church, are now joined by the ambitions of a new bedfellow, the regenerationist state. Don Juan Manuel and Colorín, the metaphorical father and mother of these orphans, celebrate their triumph as they walk hand in hand out of the church, serenaded by the reformed Gypsy boys and flanked by the priest, all headed for a wedding that we will never see. This trinity is sustained, reaching its maximum expression at the end of the film when Don Manuel has just married Colorín and pays for surgery to restore her sight. No longer wearing her traditional Gypsy-beggar-maid clothes, Colorín is now dressed in fashionable evening wear, with a glittery blouse and diamond earrings. This upward mobility, from polka dots and aprons to the solid white wedding gown, marks her transformation from a Gypsy to a cosmopolitan, white glamour icon. Both are commodified, but the white woman is more desirable, especially when she can be white *and* Gypsy. The doctors of Western medical science remove her bandage, and she rises up in her chair, ascending into the world of those who can see. The dichotomies of light and dark, wisdom and ignorance, enlightenment and progress, and primitiveness and savageness that the film maintains throughout its entirety are finally wiped away, to the relief of the intended spectator. If Colorín was originally blind to the benefits of Western society, the metamorphic removal of the bandage allows her to see Don Manuel and the priest Don Elías, the cortijo and the church, as one and the same. Never having seen and having only heard either one, she rushes to embrace Don Elías, mistaking him for Don Manuel in an uncanny gesture toward a ménage à trois.

Natural Law, Comedic Language, and Truth

The flurry of legal changes during the Republic coincided with sound film's expansion of comedy from slapstick and mere iconographic symbols to a genre that could exploit dialogue and spoken language (see

Figure 20. Don Elías, the seated Colorín, and Don Manuel in *Un caballero andaluz* (1954)

Beach, 1–2). Spoken comic interactions were microcosms for conflicts in the social structure, and so law enforcement became another target of comedy, given the law's ubiquity.[29] Like the law, moreover, comedy opens up spaces of subversion.[30] As Stuart Hall would argue, comedy provides social critique, exploring the nuances of class-based relationships and subtle differences in gender, ethnicity, education, or geographical background, yet as a form of mass entertainment, it also confirms status quo ideology. Through song or comic dialogue, the Gypsy has a temporary voice (a subjectivity) that rebels against the establishment, whether in Castilian Spanish, legal discourse, or Latin. These speech acts are highly performative, exposing the constructed nature of identity—the idea that the Gypsy is fixed in the past and by nature deceitful, lazy, etc.—and contradicting the static and universalist character of Spanish law. The language of the Gypsy characters in these films subverts the educated parlance of the non-Gypsy characters, including the legal discourse of the lawyers and cortijo overseers. Indeed, the constant foregrounding of language, whether comedic or of the penal code, becomes a presence in itself.

But such debates take place on the slippery slope of law, which like the folklórica, symbolizes both modernity and otherness, both just and unjust. In these contests, passing and mimicry, which imply that identity may be unstable, alternate with the notion of static identity. Such ambiguity sustains doubt about Gypsies' "natural" tendency toward anarchism and their inability to assimilate, their innate illiteracy. Yet the broad appeal of the folklórica icon is a result of that very ambiguity. Through her stardom, her capacity for successful assimilation, she signifies the modern ideal, Spain's "coming out" as a Western nation, which disavows the Gypsy/Other and affirms Spain's advancement under capitalism.[31] Of course, the Gypsy has a voice exclusively on the comic register, and the audience pays for exactly this kind of entertainment. Comedy elides, then, the injustice of the Roma reality, downplaying the fact that the Roma have neither voice nor property nor citizenship. In the actual debates on land reform and the Gypsy question, Gypsies were never participants but rather the collateral damage of economic strife. Under land reform many Gypsies did see changes in their situations. But because of their lack of property, which defines citizenship, they were denied the possibility of civil speech, the supposed reward of society to its citizens (Goldberg, *The Racial State*, 144).

Certainly, a rebellious Gypsy voice commands attention in the film's comic register. But the rhetoric of liberalism carries more weight in what could be considered its register of truth. Similarly, the church may have the last word, but throughout these films progressive (as opposed to conservative or radical) discourse dominates, celebrating the Gypsy's dexterity with language, his or her ability to outwit the non-Gypsy, and the carnivalesque critique of the law. Illegality, deviance, and dishonesty are comically rendered by the dialogue. Therefore, when in *Morena Clara* Regalito and Trini mastermind a plot to finagle hams from an innkeeper, we side with Trini, who distracts the inn workers with lively conversation while Regalito throws the hams out the window. We laugh at the gullibility of the men who succumb to Trini's charming sweet talk. When it appears that Trini and Regalito will succeed in their deception, we side with them, hoping that they will escape before they are caught. We applaud Regalito's ludic appropriation of language and see the illegal actions from their perspective. Just before Trini and Regalito take the hams, Trini, who will later become the "model Gypsy," questions their actions:

TRINI: Because what we are going to do is a robbery, right dear?

REGALITO: Why put an ugly name to things? Call it substraction [*sic*].

In this verbal and visual gag, Regalito assimilates "robbery" to Gypsy culture. The crime itself is not what we think about as the *guardia civil* lead the handcuffed Regalito to jail; rather, we imagine ourselves rebuffing the law. At the same time, Regalito's arrest only reinforces the reality that Gypsies steal, fill up the prisons, and live under another code of law, not out of necessity but out of unwillingness to comply with the official order.

In all of the films studied in this chapter, the characters' language depends upon where they stand in regard to polarities such as North versus South, oral versus written, and official codified legal language versus broken Spanish or colloquial slang peppered with Caló and malapropisms. In *Canelita en rama* the language of Roman law is parodied through the administrator of the cortijo, Don Joaquín. He accuses the Gypsies of being "heroclíticos" (deviating, irregular), a term no one understands, which reveals him as a pedantic buffoon. When Don Juan orders the expulsion of the Gypsies from the cortijo, Don Joaquín confronts the Gypsies with the Latin expression, "Dura lex, sed lex!" The Gypsies play along, answering him in an equally incomprehensible fashion, supposedly a form of Caló:

TARANTAS: "Menda chingaripén chincarelar"
CAYETANO: "Camelar gacharadi de curripén"
CONSOLACIÓN: "Bomboy dililó"

When Don Joaquín explains his Latin—"The law is harsh, but it is still the law"[32]—he adds that his purpose is to invite the Gypsies to abandon the cortijo, to which Consolación replies, "You invite us and you throw us out? That's like having to honor a wedding invitation and then having to pay for the dessert."

Worse than a Gypsy are, of course, the elitist pretensions of those who uphold the system but scorn the common folk—that is, Europeanized Spaniards who salt their speech with Anglicisms. When the landowner's son, Rafael, expresses his affinity with Anglo culture and

flaunts his English education, Don Joaquín replies, "I'll tell you something: Oxford, with all its doctors, knows less than one Gypsy about Triana." But if the foreign is threatening to national unity, the speech of the Gypsy seems even more insidious. The law favors the well educated and well spoken at the same time that the film pokes fun at pedants.

One of the most important scenes in *Morena Clara* takes place in the courtroom (the theatrical version of the film, written by playwrights Quintero and Guillén, was subtitled *Comedia en tres actos y un juicio oral* [Comedy in three acts and an oral trial]). In the courtroom scene Enrique prosecutes Trini and Regalito for stealing the hams, and Trini and Regalito are defended by a female attorney.[33] As Trini and Regalito walk into the courtroom, they greet others cheerfully, as if attending a social event. They proceed to entertain the whole court despite being threatened with life imprisonment (e.g., Regalito jesting, "Girl, they should've bought 'em a ticket"). Throughout the scene their speech acts underscore the constructedness of ideology, as opposed to more fundamental and stable notions of identity. Their disregard for social norms destabilizes the legal stereotype ("they are thieves") only to replace it with another stereotype, that of the Gypsy as the eternal performer, the Gypsy's rightful, acceptable social function.

During the court proceedings, the Gypsies dodge volleys of questions and frustrate the prosecutor's abrasive attempts to interrogate them. The language—what Goldberg calls "Administrology"—used by the court authorities asserts the power of the state and excludes the marginal subject. But Trini and Regalito's transgressive comebacks derail the interrogation, and communication suffers a comic breakdown. Trini ignores her fines, persists in flirting, and disingenuously fails to understand what is being asked of her. The camera's gaze remains on Trini for most of this banter, giving her our approving attention while she manipulates the Gypsy stereotype. Nevertheless, in the debate between Enrique and the female defense attorney, Trini's transgression is overshadowed: this exchange passes as truth because it is robed in law and liberalism. Enrique represents, on the one hand, logos, reason, history, the exemplary citizen of the modern state, and the law of the father. His Castilian accent affirms his laconic and pragmatic speech style. Through his legal profession and his bourgeois family origins, he stands for an enlightenment system of values that upholds notions of truth and coherent subjectivity. The judge responds that Gypsies

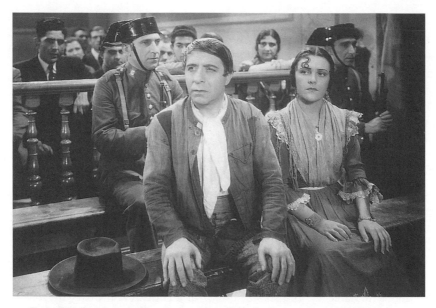

Figure 21. Trini (Imperio Argentina) and Regalito in the first row in court in *Morena Clara* (1936)

live in constant war with society and recommends a prison sentence of six months. The female defense attorney represents, on the other hand, the very best democratic Republican tradition and is a progressive champion of Gypsy rights. Even under the Republic, women were barred from being judges, but the film does grant authority to women by including a female legal professional, in this debate on the legal status of individuals, when hardly any such women existed at the time. Attacking Enrique as a property-owning citizen who enjoys full privileges yet denies them to others, the defense attorney directly poses the question: "Would you be capable of opening the doors of your house to any of these people who came to you shouting, 'Shelter me, give me refuge, because I don't want to 'delinque.'" And when Enrique asserts the fixed nature of the Gypsy, the female defense attorney confronts the crucial issue of nature versus nurture, "It's our fault and that of industrialists without a conscience," not nature, in other words, but capitalism's role in the creation of an underclass.

After her condemnation of oppression, however, the defense attor-

ney admits her pleased acceptance of the essentialized Gypsy: that is how Gypsies are; "Enrique doesn't find them funny, but I do." Appealing to sweet charity and the realm of the maternal, she cites the "goodness" of the Gypsies, claiming that they never stole even a needle from her, "not even the equivalent of a needle." Like the paternalistic state, the feminine version of the law would provide, it seems, Gypsies with shelter and protection, acknowledging them as one would children, for "they mean no harm." At the end of the scene, the public leaves the courtroom laughing as if they had witnessed a comedic performance. And they did. For as Romero points out, the coat of arms behind the magistrates in the courtroom is in actuality the logotype of the production company Compañia Industrial Film Español SA (Cifesa), the leading Spanish distribution and production company.

Finally, at the end of *Morena Clara*, Trini has a kind of success: she Andalusianifies Enrique. The Europeanized man of Castile becomes a relaxed and humorous Southern sympathizer.[34] But the change is superficial, and therein lies the humor. We also laugh at the outrageousness of a female Gypsy's trying to pass as a respectable bourgeois and talking back to a judge.[35] Trini may learn the ways of the civilized while in the Baena household, shedding her Gypsy outfit and successfully performing modernity, but her sidekick, Regalito, never stops being the Gypsy, even when his comic presentation undermines the disciplinary regime.

Although virtually every film of this genre refers to assimilation, the plot of *Canelita en rama* illustrates the point especially well. The mixed-blood Canelita is the daughter of a Gypsy dancer and one of the famous Gypsophile painters of the early twentieth century, Romero de Torres.[36] Like Morena Clara, played by Imperio Argentina, Canelita is supposed to be, as suggested by her name, which means "little cinnamon," dusky in color, which is laughable given Juanita Reina's milky-white skin. The theme song (copla) explains this to the spectator:

Vas derramando, serrana,
Esencia de limonero,
Y eres morena y gitana.
Por eso canela en rama,
Entre todas te prefiero.

You go dripping, maiden,
Essence of the lemon tree,
And you are brown and Gypsy.
Because of this cinnamon on the tree,
Among all I prefer you.

A product of Southeast Asia, "cinnamon" refers not only to her cinnamon-colored skin but also to her Gypsy identity and the origins of the Roma diaspora. The uncut, uncultivated cinnamon flower, which can be made into a fine, exotic spice, signals her ability to pass and her later transformation: this rough-edged Gypsy will become a *señorita* eligible for marriage to the son of the cortijo owner. This hybridity is, of course, the trademark of the folklórica, who can embody the comic Gypsy while being courted by politicians, wealthy landowners, and even intellectuals.

As the movie begins, the Gypsy Canelita is a case of mistaken identity. Except for the Gypsies who raised her, no one, not even she, knows that she is not the daughter of the count but instead the product of a flamenco dancer and one of her lovers. Unfortunately, the count's son—Canelita's romantic interest—believes the Gypsies are incapable of assimilation. They lack work ethic, and they are buffoons, disorderly, irregularly employed liars who ignore honor and formality. In sum, they do not deserve to be subjects of capitalist modernity. Canelita, echoing the court debate in *Morena Clara*, attacks Rafael's judgment. In defense of her family, she lashes out against Rafael's Gypsyphobia and Anglophilia by fortune-telling, thereby "revealing" that his greed and aspirations to white European culture (that is, blonds and suffragette tennis players with freckles) will be his downfall.[37]

But Canelita's mix of common sense and magical Gypsy intuition merely reinforce the racial hierarchy of power. Her convent education having failed to eliminate her Gypsiness, the film turns to her budding romance with Rafael and the viability of this interracial, interclass relationship. Whether her differences are inherent or socially learned, Tía Consolación invokes Gypsy law: "Don't ever forget, child: neither convents nor education can separate you from us, who are your family. A Gypsy never denies her race." But Tía Consolación reveals a long-kept secret: Don Juan's baby was switched at birth with Canelita (a reference to Cervantes's *La gitanilla*), so no incest is involved. For Don

Juan, however, the church is the only authority that can resolve this identity dilemma, and he travels to Seville to consult the ecclesiastical archives, the bastion of truth and law. In this silent scene, accompanied only by music, we see the detail of a hand paging through folios of a book. The camera recedes to a medium shot of a priest with a book and Don Juan standing beside him. The church, overseeing the inscription of citizenry into legal existence, determines that birth constitutes truth (nature) and not upbringing (nurture). In other words, the church validates state law, which masked as liberal, nevertheless adheres to an antimodern concept of race. Such a formulation requires the state to assimilate racial and cultural difference while cordoning off space (ghettos, projects, jails, or films about Gypsies) so as to manage the surplus—the antagonistic elements of society that cannot in fact be integrated into the national family. This society, as discussed in the next chapter, cannot see that the antagonistic elements continually reproduced within it are due not to racialized others but to the internal contradictions of capitalism that structure this very society.

The Spanish Solution: The Folklórica and the Führer

On 8 December 1938, Himmler's circular on the "Struggle against the Gypsy Nuisance" called for "the racial affinity" of all Gypsies to be established and distinctions to be made "between pure and part-Gypsies in the final solution of the gypsy question."

— Michael Burleigh and Wolfgang Wippermann,
The Racial State: Germany 1933–1945

Ith the full collaboration of Spanish Nationalists, Florián Rey and Benito Perojo made five films in Nazi Germany's UFA studios between 1937 and 1939: *Carmen, la de Triana* (Rey, 1938), *El barbero de Sevilla* (Perojo, 1938), *Suspiros de España* (Perojo, 1938), *La canción de Aixa* (Rey, 1939), and *Mariquilla Terremoto* (Perojo, 1939). With the exception of *La canción de Aixa*, an orientalist musical comedy starring Imperio Argentina and set in Morocco, the films provide thoroughly Andalusian folkloric fare.[1] This Berlinesque intermission in the careers of Rey and Perojo, which cemented the Spanish–German venture Hispano-Film-Produktion (HFP) and produced a series of Andalusian musical comedy films, exposed the dangerous compatibility between Fascism, sound film spectacle, and liberal ideology's union with stardom. Race was the fulcrum for this balancing act.

A dark period that would haunt the musical folkloric genre and the deployment of Gypsiness for decades to come, the Spanish–German relationship of 1936–39 has long been a topic of both popular and scholarly interest (See Muñoz Aunión; Gubern, *Benito*; Sánchez Vidal, *El cine de Florián Rey*; Díez). Film histories and romanticized or vilified versions of the collaboration in the press have seen Hitler's infatuation

with Imperio Argentina as providing the catalyst for Goebbels's invitation to Florián Rey. In 1938, when newspapers announced that Rey and Argentina had visited Hitler, both *Carmen, la de Triana* and *Morena Clara* were taken out of theaters in the Republican zone, the latter promoted in Nationalist territory as "the movie that the reds prohibited" (Víllora, 94). After the war, as late as 1952, protesters with posters stating that Argentina had been Hitler's lover would try to boycott her performances at New York's Carnegie Hall (Román, 71; Sánchez Vidal, *El cine de Florián Rey*, 229). Today, film historians and critics continue to ponder the purported attraction between the folklórica and the Führer, often with ambiguous assumptions or conclusions.

An analysis of the conditions and relations of production of Rey's *Carmen, la de Triana* and Perojo's *Suspiros de España* does more than bring into focus the affinity and difference between National Socialism and Spain's inchoate National Catholicism—the platform for Franco's union of Fascism and religion. It reveals how the two different strains of Andalusian folkloric film that had and would continue to characterize it—the emphasis on stardom and on Gypsified, racial identity—were not contradictory but congruous with both Fascism and liberal-capitalist ideology. In these two films both liberal and right-wing ideas about the treatment of Gypsies (paternalist tolerance of model minorities or forcible assimilation) were models for the global marketing of Spanish-language films.

Song and sound film were powerful vehicles for evolving notions of race and nationalism. The union of song and film promoted the concept of a national cinema, but it also cemented the dominance of the Andalusian musical style in Spanish popular culture. Regional (non-Castilian) accents enabled by sound films boosted the possibilities for comedic dialogue that could explore romance and class in ways unimaginable in the internationalist style of silent film (Beach, 1–2). Greater intimacy between spectator, film content, and social reality could now be achieved through accent, vocabulary, grammar, and linguistic proficiency that registered what before had been imperceptible differences in class, education, and regional background. Songs from the films that were broadcasted on the radio strengthened even further the capacity of cinema to interpellate spectators on a variety of different registers. While ideology comprises both the articulation of political doctrine and, on a second level, its materialization in institutions

such as film, a third and most crucial level constitutes the interaction between spectator and the filmic sound-image. In this moment ideology becomes internalized, and subjects can imagine and experience themselves as "free subjects" (Spector, 470). Through Andalusian music and dialogue spoken with an Andalusian accent and peppered with localist expressions and even Caló words, Spaniards were being hailed as *Spanish* national citizens, as *consumers* of popular culture, and as *witnesses* to the modern cinema spectacle that showed Spain on the cusp of modernity. The fantasy through which modernity would be imaged was the white Gypsy.

"Che Vuoi?" (What Do You Want?)

Slavoj Žižek's examination of the role of the Jew in Nazi discourse and aesthetics provides a reference point for looking at the image of the Gypsy in Spanish folkloric film. Both films examined in this chapter are steeped in nostalgia for a harmonious, homogenous society that never existed (in a process similar to fetishism), and both frame the racialized other as a necessary condition for securing a stable meaning of "homeland" (*patria, Heimat*). This tension is a mechanism of racism. Žižek argues that social-ideological fantasies, those that made the Jew the problem of German society, override the fundamental antagonisms inherent in the structure of society. Not only was the Gypsy used in a similar way, but the Roma were one of the ethnic groups the Nazi regime had targeted for total annihilation. Considered racially alien according to laws that required their forcible sterilization, they were castrated, prohibited from marrying Aryans, and banished from Germany (Pine, 115).[2] The half million Roma that perished in concentration camps and gas chambers constituted one-quarter to one-third of the total European Roma population, a proportion allegedly similar to the Jewish extermination. The journey to this hoped-for *Heimat* began, however, with the nationless figure whom German nationalism attempted to obliterate and whom Spain had historically criminalized and forcibly (although unsuccessfully) assimilated.[3]

Žižek's analysis aptly describes the ideological imaginary of Fascism in mid-1930s Spain, according to which the Roma constituted a certain blockage that prevented Spanish society from achieving its full identity as a self-contained totality. It follows that ideological fantasies,

such as folkloric films, mask an inconsistency, the fact that an organically unified society, like self-contained and coherent *Volkish* ideology, does not exist. Marketing a Gypsy icon that displaces racial tension in favor of some past time of harmony perhaps persuaded audiences to ignore the Gypsy (or Jew) of the traumatic present.

The major difference between Nazism and Spanish Fascism was the latter's emphasis on the incorporation of the female other, which pulled it closer to Italian, rather than German, Fascism, which argued for the extermination of racial others (Labanyi, "Race, Gender," 220; "Internalisations," 29).[4] But since Andalusia had been historically associated with the racially alien because of its Arab and Jewish past and Roma presence, it functioned as an internal "colonial other which confirmed the identity of the colonizing metropolis (centralized Spain): it was precisely Andalusia's 'foreignness' that enabled it to figure 'Spanishness'"(Labanyi, "Race, Gender," 216). Nevertheless, although "Spanish thinkers were not direct imitators of their Nazi colleagues," the efforts, for example, of Spanish medical professionals practicing eugenics or, in this case, filmmakers existed "on a continuum of eugenic and racial thought" in which the concept of mixture underlay the base of racial formations (Goode, 142).

In Žižek's explanation of racism, the Lacanian question, "Che vuoi?" (literally, "What do you want from me?"), can also be interpreted as, "What does the Other want from me?" Here, "the Other" refers to the symbolic order or to another subject representative of the symbolic, such as a woman or a Gypsy. For Žižek this question is most clearly exemplified by anti-Semitism: "In the anti-Semitic perspective, the Jew is precisely a person about whom it is never clear 'what he really wants' " (*The Sublime Object*, 114). The Jew is suspected, Tony Myers explains, because we are unclear as to his intentions: "We thus create our own scenario, explaining the Jew's actions in terms of a hidden agenda— 'This is what he really wants (to get all our money, to take over the world, etc.)'" (94). What does the Other want? The fantasy, the filmic Gypsy, the novella *Carmen*, each gives an answer (Žižek, *The Sublime Object*, 114, 118).

As discussed in chapter 1, the social fantasy of Gypsies as baby stealers or as thieves in general is a necessary narrative in that it masks "the antagonistic fissure [of society]; it is the means for an ideology to take its own failure into account in advance" (Žižek, *The Sublime Object*,

126). Through the Gypsy, society hides its failure to be a homogenous totality—to inhabit the space of *jouissance*—the fullness, coherency, and pleasure that exists before the subject has split itself in order to enter the symbolic order of language and ideology. Society is not prevented, however, from achieving its full identity because of the Roma but "by its own antagonistic nature, by its own immanent blockage" (Žižek, *The Sublime Object*, 127). Society thus projects its lack onto the figure of the Gypsy. The Roma is not what antagonizes society, yet society sees Roma as embodying this blockage.[5]

If only one out of the five films that Perojo and Rey made were not about Gypsies—as mentioned, it was an orientalist fantasy-scape—then what kind of desire was being displaced onto these imaginary Gypsies by liberals like Perojo; "liberal" Fascists like Rey and Imperio Argentina, who became Falangists just before leaving for Germany; and hard-core ideologues of the Falange who would attempt to influence cinema policy, like Manuel Augusto García Viñolas, editor of *Primer plano?* Complicating this question is the ambivalent desire that had constructed Spanish nationalism: Spaniards who looked to foreign-influenced identity but deployed Andalusian Gypsiness to embody this modernity. Of course, it seems contradictory that Gypsiness could be employed for Fascist (whether Spanish or German) race thinking. The contradiction makes sense only because for the German or Spanish racists, there was no contradiction. As Žižek explains, racism is not about the (Gypsy) Other but about the (Fascist) subject who displaces his or her desire onto the Other. Thus, for the Fascist, "The question of desire is therefore never directly a matter of what I want, but what the Other wants from me" (Žižek, *The Plague*, 8–9).

Throughout the twenties the representation of Spain in foreign imports—e.g., in Feyder's *Carmen* (1926) or Raoul Walsh's *The Loves of Carmen* (1927)—was criticized as false but tolerated. But when Josef Von Sternberg's *The Devil Is a Woman* (*Capricho español*), another *Carmen* remake, debuted in Spain in 1935, Spaniards were indignant. José María Gil Robles, the minister of war and the founder of the center-Right coalition CEDS, "instigated a series of protests via the Spanish Ambassador in Washington" (Loyo, 86). In Madrid, student groups chanted in front of Paramount's Spanish headquarters, "Long live Spain! Down with Paramount!" and in Santiago de Compostela protesters threw smoke bombs to block entry into a theater where the

film was being shown. Finally, the Spanish government threatened to shut down Paramount's offices and rights of distribution if the film was not immediately withdrawn from theaters and its negative burned (Cabeza, 36). *The Devil Is a Woman* showed how major Hollywood studios started to encounter obstacles to marketing their films abroad in an era of rampant nationalism, protectionist measures, dubbing, quotas, and censorship: "Governments wanted control over the films that their citizens viewed" (Cabeza, 38). Marlene Dietrich's version of Carmen is the epitome of surplus meaning out of control, analogous to the *jouissance* that defines Mérimée's *Carmen*—while the drunk *guardia civil* in the film ridicules Spain's legal authority. Yet when *Morena Clara* was released in 1936, it was a huge success with Spaniards, despite its folkloric topic. *Morena Clara* passed because it represented the possibility for Spanish competition in the U.S.-dominated world cinema market, and it was a clear sign of a Spanish star system, another indicator of a modernized film industry. *Morena Clara* also proved that stereotypes, when produced in Spain, were better than foreign representations of Spanish Gypsies. Most important, Imperio Argentina's white Gypsy was the ideal assimilable other, a cute, sexy, but not too sexy female who could add a touch of gregariousness to the austere castizo male. The *morena clara* was entirely knowable. What she wanted was clear, to marry a *payo* and improve the races, while fully aware of her second-class status. Whatever the *real* Roma subject was hardly mattered.

The control and assimilation of unpredictable meanings was crucial to both liberal and Fascist interests, despite the impossibility of attaining them. In both *Carmen, la de Triana* and *Suspiros de España*, light-skinned folklóricas—Imperio Argentina and Estrellita Castro—play Andalusian Gypsies or Gypsified singers, and whether they were reworking the Carmen model or triumphing as stars in Latin America, they enabled the national project and mollified class tensions through their interracial appeal, which was less a promiscegenation platform than it was a strategy to avoid discussing the acute class tensions that exploded in the thirties in Spain and beyond. In neither film is the folklórica's Spanishness fanatically castizo nor racially abject—although the ghosts of Roma pariahs haunt the margins—for again, the point was not to reference the reality of racial minorities but to contain this reality so as to subsume it completely or, in the case of the Germans, obliterate it.

Yet hard-core Falangists abhorred Andalusian Gypsy synecdoches for Spain and would have preferred no mention of them at all, for Gypsies did not represent the spiritual Spanishness, based on the values of the Christian knight, for which the Falangists longingly searched. Hard propaganda was, they believed, more suited to their ideological mission. In the December 1, 1940, *Primer plano*, a critic lamenting the ills of Spanish cinema describes the frustration of Falangist supporters who see expensive film stock used to represent ideologies anathema to them. The critic's list of images—mainly those that counter Falangist dogma—is worth quoting in its entirety:

to present to us that Spain of "generous bandits" constantly fighting against the law and all that signifies authority and discipline . . . to attempt, in a pathetic exploitation of tenderness, to give us the truculent serial story of the child abandoned in a hospice that then comes to be, who knows how, a famous bull-fighter, indefatigably in love with a dark and robust woman . . . in order to portray the poor life of those individuals on the verge of misery, so as to entertain the placid bourgeoisie and foment the resentment of those for whom life is nothing but a constant fight against adversity . . . in order to ridicule us and our customs, under the pretense of humor, when there is so much beauty to be praised that is yet unfilmed . . . in order to tell us the stupid jokes of a gang of vagrants exalting filth and the Popular Front, against everything that means authority, norm and measure.

In Fascist thinking, vagrancy, lawlessness, and lowbrow humor were associated with Communism, Masonry, and corrupted thinking. Thus for Falangist critics, Spanish cinema should be "the mirror of the race and not an exhibition of tin bands and tambourines (*pandereta)*" (Taibo I, 16). The problem was that not everyone agreed on the definition of *pandereta*. For the Falangists it was a racialized, Gypsified reminder of poverty and backwardness, whereas for Rey and the fans of his films, it was a fairly authentic representation of their hometown life, or what they remembered of it. The irony was that the German Fascists, who clearly saw Spain as not only backward but sickly, found no contradiction in the *pandereta* vision of Andalusia in the films and their own

vision of it. Given creative license, the Germans would push *pandereta* to its limit: "They had a vision of Andalusia as black houses populated by crippled, mangled, and cross-eyed [Spaniards]" (Sánchez Vidal, *El cine de Florián Rey*, 231). The location of production (Nazi Berlin) did not necessarily mean that the Falangists controlled either the content or the import of these films. First, they capitulated to the German filmmakers and technicians, who argued for the effectiveness of these faux-Gypsy stars (Sánchez Vidal, *El cine de Florián Rey*, 231). Although Goebbels argued for españolada or folkloric films' potential for dominating the world market (the drive for capitalist domination is always latent if not explicit in stardom films), he was more interested in *The Barber of Seville*, for example, than in Gypsy films, although separating folklore from Gypsy stereotypes was virtually impossible. Then there was giving in to Perojo's cosmopolitan and liberal star narrative. But beyond this acquiescence, and despite their efforts to control the cinema, Spanish Fascism could neither capitalize on the cinema nor enforce a complementarity between its politics and the populist ideology of the films, not even in Nationalist Spain before 1939 (Font, 50). As has been argued in relation to cinema under Franco, films made in the Nationalist camp before 1939 or those made after the regime takeover were not exclusively seen as products of a homogenous political machine: "In cinema policy as elsewhere, Franco behaved like an old soldier. His strategy was not to interfere in the workings of the industry, but merely to ensure the established order. The cinema was farmed out among the victors in the war. The Church took charge of its morality; the state unions got its administration, racketeers and the rich the chance to make a buck" (Besas, 37). Far from uniform, the agglomeration of forces working on products destined for the screen and the medium itself were inherently collaborative forms of cultural production. Cinema's collectivity, in conjunction with the postwar conflicts in which the Falange vied with Francoist forces, reveals the instability and insecurity of the project to crush resistance. Marsha Kinder points out the contradictory nature of Catholic and Fascist discourses: "Even within a hermetically sealed culture such as Francoist Spain, the dominant ideology could never be totally monolithic; its hegemony was always being contested and negotiated by conflicting historical forces and by alternative ideologies" (20).[6]

Another weakness plaguing the Falange's ideological control over cinema was the lack of overtly right-wing politics on the part of the

"cinematographic lumpen-burguesía," as Font describes filmmakers like Perojo, Marquina, de Orduña, and many others of the forties who jumped at the chance of winning the cash prizes awarded to films of national interest. Though the Falange could not control ideological content, it did control the cinema in Nationalist territory (Font, 51) and was interested in "a cinematic thinking" that recuperated high–culture cinema, as opposed to frivolous and commercial visions (Minguet Batllori, "La regeneración," 2). Such directors were not deeply committed to promoting Falangist ideology, except to the extent that it would get their film funded. Oddly, the ideology of the Falange was markedly anticapitalist, a contradictory stance in light of their drive to expand the cinema's market to Spanish America (where a market already existed), which would supposedly return Spain to its position of imperial and colonial supremacy. For this drive was nothing other than a capitalistic venture motivated by the fear that the United States would take over the market before Spain could invade it. As Labanyi describes it, Spanish Fascism "repudiated capitalist modernity but was born of it" and appropriated it for its own interests ("Internalisations," 27).

The inability of Fascist discourse to contain the leakage of meanings, compelling it to negate or ignore this surplus, is echoed by the assimilation of the folklórica figure into the story lines of Andalusian musical comedy films. The society imagined in these films is, as in all melodrama, a corporate body that when confronted with a foreign body that threatens to corrupt it, strives to assimilate this antagonistic element. So when film historians associate folkloric comedies only with "reactionary agrarian cinema" or vehicles for the politics of the financial bourgeoisie and landowning aristocracy, they ignore not only the films' usefulness to liberal ideology (social mobility through stardom) but also their inappropriateness for Falange cinemagoers.

From this assimilationist point of view, it makes little sense for historians to associate folkloric films with Fascism, despite Florián Rey's conservative politics. For the mission of Hispano-Film-Produktion (HFP) and even of Goebbels, who ultimately supervised everything made in Berlin, was not necessarily akin to that of the Spanish Falange film directive, the National Department of Cinematography, established in 1938. Indeed, the Spanish branch of HFP in Burgos feared that German interests would dominate, and the Falangist film directive already felt their position to be marginalized. The paranoia was so pronounced

that the Burgos directive admitted their insecurity and defensiveness by ordering an agent from the Subdelegation of Press and Propaganda to oversee all film shoots, in addition to sending the department proof of the "meters of film shot" (Álvarez and Sala Noguer, 228).

Folklóricas: Emissaries of Empire

The paranoia of Nationalists back in Spain is telling. Goebbels's designs for producing appealing entertainment were allowing the image of Spain to slip into dangerous territory. Perhaps, though, Goebbels knew better what the Falangists needed, because the folklórica was quite useful to their project of constructing a unified national culture. Folklóricas could assimilate otherness, mirroring the national need to incorporate as many citizen soldiers and laborers as possible in order to compete in capitalist modernity. At the same time, they projected a vision of a homeland desirable enough that these same citizens would be willing to die for it. The hybrid Gypsy was the perfect solution for acknowledging otherness in terms that did not include Jews or Arabs. In addition, the new sound technology meant that Spanish audiences could identify with a German production (dubbed in Spanish), and even Germans could identify with a Spanish star who did a German-language version of a Spanish film. Given that national collectivity is experienced preeminently through mass commodity spectacle (McClintock, 374), a folklórica Gypsy cinematically performing for a large invented community provided fetishized visions of desirable alterity.

When Rey and Perojo and their most valuable stars, Imperio Argentina and Estrellita Castro, arrived to Berlin, it was neither their first foray into star-related narratives (Perojo had made *La sin ventura* in 1923, *El negro que tenía el alma blanca* in 1926 and 1934, and *El hombre que se reía del amor* in 1932) nor the first time that Spain and Germany had collaborated on filmic enterprises. In 1926, Saturnino Ulargui Moreno served as the Universum Film AG (UFA) representative in Spain, while in 1928 Cifesa explored the possibility of making *El barbero de Sevilla* in Germany. In 1936, Cifesa created its own producer and distributor in Berlin, Cifesa Film Produktions und Vertriebs GMBH (Gubern, *Benito Perojo*, 309). The administrative structures were therefore in place for a continued interaction between the two countries.

In line with Spanish national interests, HFP had been founded to create new studios in Madrid and Barcelona to compensate for the failure of private capitalists to invest in cinema and for the lack of access to Cifesa due to opposition from Republican studios. Johann Ther, a member of the Nazi party, claimed to be the founder of Cifesa in Berlin (Norberto Soliño, Cifesa's representative in Cuba, is said to be the actual originator of the Berlin-Cifesa connection). Ther, who was in any case Cifesa's main contact in Berlin, arranged an agreement in which the Germans would provide the capital and control the studios, which belonged to UFA; the technicians; and, most important, the final product, whereas the Spaniards would contribute the directors, actors, and scripts (Álvarez and Sala Noguer, 217). In the end, Cifesa recognized its intervention in only two films, *La canción de Aixa* and *Mariquilla Terremoto* (in addition to the documentary *España Heroica/Helden in Spanien*, directed by Joaquín Reig in 1937, the brother of the creator of the NO-DO (Noticiarios y Documentales), the state-controlled series of cinema newsreels). Saturnino Ulargui did distribute and maintain rights to *Carmen, la de Triana*, *El barbero de Sevilla*, and *Mariquilla Terremoto* (Gubern, *Benito Perojo*, 292). But HFP was neither successful nor profitable for the Germans: Spain had no money and contributed only actors and directors, whereas Germany had to front all of the studios, equipment, and personnel. The German decision to proceed regardless demonstrated the money and power they were willing to invest in this joint German-Spanish nationalist project.

The clearly defined goal of the Spanish faction of HFP, to produce top-quality patriotic cinema, i.e., propagandistic films favorable to the Nationalist cause (Díez, 38), was acknowledged in the contracting of Florián Rey and Imperio Argentina, who were then Spain's most prominent exponents of the españolada and Spanishness on celluloid. To assure that Spanish interests would be represented, Rey even formed a separate company, Cinematográfica Español SA (CINA), which would work in conjunction with HFP to produce *Carmen* (1938) and *Goyescas* (postponed until 1942) (Díez, 38). Marta Muñoz Aunión argues that Goebbels saw this collaboration as a means for justifying the Spanish Civil War to German audiences (32). According to Goebbels, a fictional exotic story with Spanish actors would be more effective than a propagandist documentary for gaining German support for the Spanish Nationalist fight against Red Spain, the aspect of the Spanish

conflict that most concerned the Reich. Thus, in part, the company was launching a restorative mission led by female Spanish stars described as "well inclined to value Spanish art and reveal the virtues of the Race and spread the Castilian language" (Álvarez and Sala Noguer, 230).

The Second Hispanoamerican Cinematographic Congress, held in 1948, openly deployed hispanidad both as a vehicle of nationalist foreign policy in Latin America and an economic strategy against Hollywood's hegemony (Díaz López, 142, 144). The justifying slogan was "sister industries, a common language, and customs which have their roots in identical traditions" (*Radiocinema*, August 1948). The goal of the first meeting, held in 1931, was to combat the U.S. versions of Spanish films, which were made in the big studios of Hollywood or Joinville, so that the same countries that consumed these films could have a better foothold in the Spanish market (Díaz López, 144). The renovation of Spain's image in Latin America was reported optimistically in cinema magazines in an effort to restore pride in their weak national cinema and to prevent hard feelings about weakened empire from clouding Spain's relationship to its former colonies.[7]

The actual result was that a large number of Andalusian musical comedy films were shown in both Spain and Latin America.[8] Thirty-five Spanish films were imported to Argentina between 1936 and 1939, and twenty-three, between 1946 and 1949. But these patronizing strategies of sponsorship were ultimately ineffectual, being rejected by Latin American nationalists, who "showed little or no enthusiasm in the matter, deeming such politics a right-wing ideology, based on upholding Spanish interests and subsuming Latin America within them" (Grugel and Rees, 164). Hispanidad was acceptable only to conservative, generally racist antidemocrats in the region: "Given that Spain could offer no economic benefits to Latin America, there was little incentive for Latin American states to enter into an alliance" (Grugel and Rees, 164). Notwithstanding, this probably did not stop lower-class audiences from not only viewing them assiduously but enjoying them.

One of the main ingredients of hispanidad was a myth of national unity supported by a spiritual and material resurgence of images of empire, the Reconquest, and the Counter-Reformation. Pan-Hispanism is, for Alfonso Botti, linked to the general tendency to make alliances against an expanding North American hegemony. Like

Pan-Germanism, Pan-Slavism, and Pan-Africanism, Pan-Latinism was integrated into "the baggage of National Catholicism as an ideal of hispanidad" (53–54). The Fiesta de la Raza, which celebrated Columbus's discovery of America on October 12, 1492, become a national holiday by royal decree in 1917, and Franco would later entitle it the Fiesta de la Raza y Día de la Hispanidad. Spain's policy of hispanidad remained strong throughout the forties and beyond. Most notably, its strength fed the initiative that created the Council of Hispanidad in 1940, whose function was to make Spain an imperial power once again. After the Axis had been defeated, the possibility of constructing a cultural and spiritual empire in North Africa was less likely, so Spain turned its sights toward Latin America (Martin-Márquez, 49). Presenting Spain as a unified nation, despite its constant peripheral pull, the discourse of hispanidad sublimated racial difference through the terminology of "brotherhood," which emphasized commonalities of language, history, and religion (Martin-Márquez, 49). However, "even when 'spiritual' formulations of race appeared to dominate in Spain, they never managed to dislodge biological understandings; from the early modern era on, notions of blood legacies have always circulated throughout Spanish cultural discourse" (Martin-Márquez, 50).

The second main goal of HFP was to produce films in Spanish that would give the company a foothold on the lucrative Latin American film market currently dominated by American films (Díez, 38). For Goebbels effectiveness outweighed exclusiveness. From his perspective Estrellita Castro and Imperio Argentina together could anchor the female cast of superstars who enabled Germany and, to a lesser degree, Spain (although Spain was certainly convinced it could participate in this world conquest) to conquer the cinema market and propagate the International Fascist cause. Goebbels was more drawn to creating a cinema that could win over the world market than he was to merely producing Fascist propaganda:

> Goebbels admired less the strident voices of the fanatical propagandists (thus his reservations concerning Karl Ritter) than the capacity to attract people to the North American box offices; and nationality or the adhesion to national socialism mattered less than the magnetism of a star, as the Swedish actress Zarah

Leander seemed to confirm. Goebbels had said that, with the
UFA in power, Germany could rise to become the greatest com-
pany in the world. (Álvarez and Sala Noguer, 216)[9]

It is hard to say whether Goebbels's ambition to conquer the Latin
American market was successful. Meanwhile, the German-language
versions were unconvincing to the Germans, who expected Imperio
Argentina's voice to compare with that of Zarah Leander. Although
they clashed in all other respects, here we see how closely Benito
Perojo's thinking resembled that of Goebbels. For both of them, cre-
ating effective entertainment was more important than assuring the
purity of the Castilian image and Catholic morals, which were in fact
the concerns of the Falangists and the Spanish Falange film directive.
Therefore, although Perojo did not sympathize with the Nazis, he was
willing, with Goebbels's support, to direct cinema in which he could be
in control of the artistic decisions.

It is useful to see Rey's and Perojo's activities in Berlin not as the
result of a dictator's whim but as part of what Paul Starr has called a
series of constitutive choices and moments—not just individual de-
cisions but larger political and economic contexts, constellations of
power, preexisting institutional legacies, and the ideas and cultural
forms that circulated at the time (1–2). Even though there might have
been force in the dictators' whims, the institutional structures that had
permitted German-Spanish collaboration on cinema had existed since
the 1920s. It is within this context that Román Gubern argues rightly
that *Suspiros de España* and *Mariquilla Terremoto* were transitional
cinematic works in which Republican populism and artistic freedom
intermingled with Francoist sentimentalism and aesthetics (*Benito*,
306–7). Given his filmic résumé of progressive and clearly Republican
ideas and aesthetics, it is probable that Perojo left for Germany more
for the extensive materials offered by German studios than for the
chance to collaborate with the German film industry to produce pro-
pagandist fiction films for the Nationalist cause (Muñoz Aunión, 27).

Yet despite the attraction that Germany's material resources held
for directors aspiring to glossier film products, a certain Germanophilia,
shared by intellectuals, politicos, and the military, cannot be over-
looked. Paul Preston documents Francisco Franco's love affair with

Germany, which began in 1929 with an invitation to visit the German army's general infantry academy in Dresden:

> [Franco] had been especially impressed by the Academy's cult of reverence for the regiments which had achieved the great German military triumph of the recent past. He was particularly sympathetic to German efforts to break free of the shackles of the Versailles Treaty. It was the beginning of a love affair which would intensify during the civil war, reach its peak in 1940, and not begin to die until 1945. (*Franco*, 61)

In the mid-1930s, moreover, Germany was highly regarded by even progressive Spaniards, such as Perojo. Perojo had also worked in the German studios in Munich on *Corazones sin rumbo* (1928) and then in Neubabelsberg (Berlin) in 1930 to produce a German and French version of *El embrujo de Sevilla* (an Andalusian españolada adapted from the Urugayan Carlos Reyles's 1922 novel of the same name) (Gubern, *Benito Perojo*, 191–94).

Folklóricas and the Führer

The first film made in Berlin in 1937/38 was *Carmen, la de Triana*, tellingly entitled *Andalusische Nächte* in the German-language version (dir. Herbert Maisch). The background of this film is significant. Hitler, apparently obsessed with Lola Montes, had wanted to make a biopic of the beautiful Irish woman who danced in a Spanish style—and a celebrity figure of the mid-nineteenth century—thereby bringing attention to the German-Spanish friendship (Muñoz Aunión, 29). Goebbels wanted to modernize the story of this mixed-race lover of Franz Liszt and Louis II of Bavaria by setting it in contemporary Berlin and making the former 1848 revolutionary part of the Hitler Youth. Although Argentina was perfect for the role, as she herself not only resembled Montes but was also a mix of English and Malguenian, she said that she stoutly refused and implied that it was for this reason that the film was never made (Sánchez Vidal, *El cine de Florián Rey*, 228). But perhaps because he had saturated himself with nightly images of Imperio Argentina during 1937—Hitler and Goebbels reportedly watched her

in *Nobleza baturra* (dir. Rey, 1935; Noble peasantry) every night after dinner for months—Hitler asked Goebbels to do everything possible to add her to the cast of actresses that UFA and the Ministry of Propaganda were organizing to conquer Latin American markets. Within a month Imperio Argentina and her husband, Florián Rey, were on a boat to Germany to arrange a film contract with UFA studios, their expenses paid not by UFA but by the Imperial Chancellorship by direct order of Hitler.[10]

Defending herself to the post-1992 liberal media—she would be called upon many times in the future to defend this visit—Imperio Argentina stated that "Hitler wanted to be my lover, but I refused. I like saying that I think only about art. I understand politics, but I keep quiet about them. But when I saw what Hitler was capable of . . . that was frightening" ("Mi único y verdadero amor siempre fue el escenario: Por eso estoy tan sola," *El país digital*, November 9, 2000). Argentina writes something quite different, however, in her 2001 memoir:

> It was at that time that Florían and I joined the Spanish Falangist party. I didn't understand anything about politics, nor could I comprehend what was happening in Spain, nor how it was possible for [Spanish] brothers to be waging war against one another. Nevertheless, I admired Juan Antonio Primo de Rivera as a poet and most of all I sympathized with his innocent flirtation with youthfulness. (Víllora, 102)

Berlin was, she remarks, a comfortable, friendly place where she and Rey could never have suspected the tragedy that would transpire (112). But Argentina does not stop with friendly admiration for a Fascist leader; with mounting praise, she audaciously and disturbingly scrutinizes Hitler's face, surpassing mere description and wading into the deeper waters of extreme close-up:

> Adolf Hitler was a very attractive man. The image we have of him today is that of a dictator with a ridiculous mustache, and that's true, but it doesn't resemble his actual face. We refuse to see it as it was, preferring to think of him as a monster. He was, but that wasn't how he appeared. The Hitler I saw was an athletic man, muscular, fit, dressed in a uniform. He was

tall, I suppose a little under six feet, and looked like he played sports. His face was regular, symmetrical, virtually flawless and very handsome; the only thing that spoiled it was that French mustache that looked like a fly stuck to his lips and made me wonder whether it hid a scar. His eyes, on the other hand, were very beautiful, profound—most unusual; they were gray but with a touch of blue and a greenish border; I was reminded of the gaze of panthers, it was that striking. Also, his manner was entirely cordial, well bred, and this contributed to making him more attractive yet. . . . You have to imagine that in that moment we hadn't yet thought of the horrors that would be known about later. For then there was already political controversy, but no proof of his crimes had yet come to light. To the contrary, the Adolf Hitler of that time was simply one of the most powerful men in the world, and about this there was no argument. And also, although it's painful to remember, he was a leader with enormous charisma; otherwise he wouldn't have been able to mobilize the German masses as he did, nor would he have been capable of causing millions of normal people to become his accomplices and participants in his ideas and actions. Hitler had magnetism, he cast a spell. (109)

Argentina's evocation of Hitler's controversial charisma, which could be (and often was) read as exonerating the agents of the Holocaust, performs a double function as it turns our gaze toward a resurrected ghost of Fascism.

This interaction between Hitler and Imperio Argentina joins the many times that this North–South cultural and racial hierarchy has been resurrected and, as here, displaced onto a gendered and sexualized fantasy. There was significant German precedent for this infatuation. In his tirade against Wagner, Nietzsche gushes about Bizet's opera *Carmen* (1875):

I heard yesterday—will you believe it?—the masterpiece of Bizet for the twentieth time. . . . How such a work perfects one! One becomes a "masterpiece" one's self by its influence.—And really, I have appeared to myself, every time I have heard Carmen, to be more of a philosopher, a better philosopher than at

other times: I have become so patient, so happy, so Indian, so
sedate . . . Five hours sitting: the first stage of holiness! (5)

It would be hard to better represent Žižek's idea of the subject attaining
the feeling of *jouissance* through exoticist fantasy, for Nietzsche clearly
expresses how *Carmen* fills his feelings of emptiness and soothes his
anxiety. He becomes a richer, fuller being, "a better philosopher." One
must at least give Nietzsche credit for realizing that Bizet's *Carmen*
had nothing to do with *Carmen* but with Nietzsche's own desire for
philosophical enlightenment.

Carmen would become "one of the most popular operas ever com-
posed, canonizing the cliché espagnolade on a global scale" (Colmeiro,
"Exorcising," 143). The plethora of international filmic remakes of *Car-
men* (nearly eighty in total throughout the twentieth century) are tes-
tament to its adaptability to different historical and cultural contexts.
All of these versions constitute iterations of Spanishness, implying as
a whole the mingled pride and anxiety of Spaniards who have striven
to control that image. Yet the negative images embedded in the icon of
Carmen as a symbol of Andalusia, in Mérimée for example, were, from
the perspective of most Spanish intellectuals since the mid-nineteenth
century, unacceptable as a narration of the nation; the figure of Car-
men did not project a noble, cultured image of Spain.

For those concerned with regenerating Spain, these images were
not authentic representations of either Spain or Andalusia, much less
of the possibility of a modern Spain. Rather, they constituted an impo-
sition of northern European nostalgic fantasies. The task imposed on
Spanish filmmakers therefore was to correct this unrealistic vision by
providing an authentic and, as José Colmeiro terms it, re-Hispanicized
version (93). The Spanish redressing of Carmen would supposedly
adjust what was seen as antimodern in Mérimée's text, while provid-
ing a more realistic view of Andalusia and the relationships between
Spain's Gypsies and its white majority. This impulse to Hispanicize
Mérimée's Carmen grew into a massive, repetitive insistence on as-
similating Carmen into Spanish texts. As European identified, Spain
constructed its Spanishness by absorbing the foreign orientalist per-
spective, privileging the Gypsy as a symbolic representation of national
culture (Colmeiro, 92).[11]

Yet despite the condemnations, Mérimée's *Carmen* is quite modern

in that it embodies the split between the modern subject and modern consciousness, torn asunder by modernization and its nostalgic desire for a premodern past that symbolizes a nonantagonistic, precapitalist, and supposedly harmonious society. Carmen belongs to the incipient urban proletariat in the Seville cigar factory—historically the site of worker rebellions and food strikes led by fearless female workers. These half-naked, sweaty women roll cigars and chop off their ends, withering the manliness of the soldiers that guard the factory doors. In this feminist reading, Carmen blazes with romantic fervor in her individualism and determination to defy at any cost the chains of white patriarchal law.[12] Her hedonistic drive for immediate consumption and multiple sexual relationships with men satisfies her and her alone. Seduction for Carmen is an egotistical compulsion for material gain and personal satisfaction that keeps her independent and helps her influence the events in her life (Woodhull, 47; González Troyano, 43–44). Such pleasureful consumption—a premonition of consumer capitalism—was directly opposed to casticismo's affirmation of asceticism, delayed gratification, and sacrifice of pleasure leading to spiritual gain.

In a postcolonial reading, even the antimodernness of Mérimée's Carmen—her mystery, her belief in destiny, her dallying in superstitious practices of fortune-telling, and her unquestioning adherence to Gypsy law—belonged to a dichotomy of atavism versus modernity whose ambiguity was modern. Even the unapologetic racism toward Gypsies and the pseudoethnographic chapter that Mérimée added after the first publication, which identified the Roma and their educational customs as the reason for their pariah status, was also a form of nineteenth-century modernity. What offended Spaniards the most was, however, the pompous and paternalistic attitude of the narrator toward Spaniards in general that implied that like José, Spanish men were naïve, unworldly, and simple and that Spanish woman were promiscuous and tragic.

Carmen's and, indeed, José's behavior had been associated with Andalusia by bohemian European travelers who ventured to Spain in the second half of the nineteenth century. The Carmen, or *mala mujer* [bad woman], type was fetishized by these Europeans, kept mysterious, and thus re-created as a romantic icon. Their mysticism answered a need to deliberately regress through the aestheticization of the female racial other (Mitchell, *Flamenco*, 163–77). In the hands of Spanish

intellectuals, playwrights, and cineastes, what had been sublime and even a little dangerous would be converted into something immanently knowable and controllable. A national, exportable, and marketable Carmen was necessarily a domesticated commodity: a good, even honorable woman who is not murdered in the end but remains to mourn her dead lovers.

Consequently, Rey's *Carmen* avoids ambiguity, redefining Carmen as a Gypsified white woman who functions as a medium for the discourse of casticismo. As Colmeiro points out, this "language of exoticism—safely removed from reality—did not pose any real threats to Fascist ideology" (94). Rey demystified Carmen by excising the real Andalusian background of anarchy, food strikes, and political discontent in order to serve a nationalist agenda that valued women for reproduction and for their domestic role as a repository for national values. Other differences between Mérimée's *Carmen* and the Spanish and German filmic versions of 1938 lie in the films' subtle attack on peripheral Basque nationalism, in addition to the domestication and whitewashing of Carmen. From the beginning of the film, Carmen lives to love men, not to be free. Imperio Argentina's star persona radiates this attitude: she doesn't drink, as she admits at the tavern, nor does she seduce. Hardly a femme fatale, Argentina is more the flirtatious girl next door. Never is she the capricious, unpredictable, or impetuous Carmen of Mérimée. The poignancy of Mérimée's Carmen is her rejection of and scorn for the morality and laws of Spanish society. In the novel José is initially drawn to Carmen's independence but spends the entire novel insisting that she fit the mold of a traditional wife—an insult to Carmen and a reproof to her modernness. In the film José also sees Carmen as a woman to be respected, reprimanding the soldiers for mistreating her—"You cannot mistreat a woman. Even if she is a Gypsy she is still a woman"—and the filmic Carmen proves worthy of his respect. But José's reprimand does not represent acceptance of the *equality* of women and Gypsies but merely his respect for the star of the film and a nod to Imperio Argentina's star power.

It is because Carmen is Imperio Argentina that she cannot be treated like a Gypsy. In addition, Argentina has whiter skin than does Rafael Rivelles, the Valencian actor playing Don José, which complicates the reading of her Gypsiness. Indeed, Argentina's smiling Carmen comes closer to the angel of the home—the pale, domesticated

mother and wife of nineteenth-century Spanish literature—than she does to the proud, dark-skinned, sensuous heroine of Mérimée's novel. This filmic Carmen, a white Gypsy, fears the Gypsy witch in the film who foretells her fated relationship with José and fears even the idea of that fate, hysterically denying the truth and screaming as she runs out of the Gypsy's home. Hitler was probably right that Imperio Argentina should have played Lola Montes, the Irish-Spanish singer, and not a Gypsy. Mérimée's Carmen is sublime, ripe with *jouissance*. For Žižek "it is precisely nature in its most chaotic, boundless, terrifying dimension which is best qualified to awaken in us the feeling of the Sublime"— such is the kernel of enjoyment (*The Sublime Object*, 68–69).[13]

In the film's first musical scene, Carmen finagles her way into the prison to visit Antonio Vargas, the Gypsy bullfighter. The scene more evokes, in fact, a star's providing entertainment for the troops— something a folklórica would be called upon to do—than it does a furtive tryst between two Gypsies. Yet Carmen's visit is not a caprice but a sign of true love, and her singing melts the hearts of the prisoners. The spectator identifies with them because they, too, are receiving the compassionate look of Carmen, who seems to be performing charity work rather than surreptitious activities. Gradually, the shot-reverse-shots between Carmen and the love-stricken prisoners suture the filmic spectator into a fan relationship with Carmen. The camerawork reinforces this relationship through its complex shifts among the cells, the bars, and the characters' faces, ultimately confusing the cells' interiors and exteriors. Close-ups of Carmen's face framed between the bars provide fetishistic, static moments—in the tradition of Laura Mulvey's masochistic camera gaze—while the bars emphasize the similarity between Carmen and the prisoners. Far from free, she is bound by law and hardly the rebel.

The famous *reyerta* (fight) that ensues in the cigar factory is replaced, in the film, by an acrobatic wrestling match between Carmen and a female rival.[14] Carmen is not a factory worker but a performer in this version, and her work/performance is mainly a gesture of whatever emotion she is feeling in that moment, which most of the time happens to be possessive love. The fight is not for saving Carmen's honor, but rather, it is about her jealousy over her rival's attempts to seduce Don José. Moreover, the fight contains more slapstick comedy than it does drama. Argentina herself notes that the German acrobat who played Carmen's opponent took the fight seriously and that both

she and Argentina ended the scene with bruises (Argentina and Víl-lora, 117). Rather than the age-old antagonism that pits families or so-cial groups against each other, we have a peep show residue of females homoerotically wrestling on stage.

Rey's Carmen is not meant to transcend nation, religion, or lan-guage but to affirm them. Mérimée's novel emphasizes Carmen's multi-lingual abilities—talents she applies in deceiving strangers and for-eigners—as well as her exclusive loyalty to no nation or religion but to the Roma tribe and its beliefs. In the film, however, Carmen has sentimental ties to Seville and particularly its neighborhood of Tri-ana. After the fight in the tavern, Carmen realizes that she is in love with José. Forebodingly, she tells José that the *payos* say Seville is in love with Triana and asks, "Is it possible that people can love like cities do?" At that she begins to sing, "Triana, mi Triana." As she sings under the moonlight the camera shifts from shots of her and José to their reflection in the Guadalquivir river. Through this series of shots, the camera compares her face to the moon from an angle slightly above the pensive Don José. The association softens Carmen, recalling the traditional images of passive women who wait for something better to come, visually foreshadowing the resignation of Isabel in *Calle mayor* (dir. Juan Antonio Bardem, 1956). This nostalgia for place, strikingly absent from Mérimée's novel, assumes that Carmen is not a wandering but a sedentary Gypsy, a claim that is somewhat acceptable given that Spain has one of the few sedentary Roma populations in Europe (their actual population was often exaggerated to imply that Spain's Roma were not oppressed) (San Román, 247).

The most significant difference between the novel and the film is the film's ending. Carmen not only lives but is melodramatically transformed into a guilty and religious character who weeps over the death of her two lovers. After Antonio Vargas is gored by a bull (he had thrown Carmen a flower and dropped his guard), Carmen kneels before a crucifix and, bereft, sings, "Before my cross, let me cry. Let me suffer for your pain and your suffering, Antonio Vargas Heredia, flower of the Calé race; you stole my heart." After José dies, Carmen, as a saintly widow draped in a black veil, views his coffin through the bars of the garrison. In the reverse shot, her face is framed once again by bars. Imprisoned by guilt, she sighs, "José." Mérimée's Carmen remains proud of her difference until the end. Here, Carmen's sexual *jouissance*

is resignified as an angel of the home, converted into the female body of National Catholicism.

The conclusion of *Carmen, la de Triana* clearly reflects the role of women envisioned by Spanish nationalists, but the linear narrative privileges the role of Don José, the brigade soldier, focusing on military and disciplinary aesthetics and the struggle with the contrabandists. Don José's Basque nationality, rendered as weak and naïve, allows him to succumb to the wiles of Carmen, while his clumsiness in military matters leaves him vulnerable and incapable of recognizing the danger to him or the military community. In this way, Muñoz Aunión argues, spectators are led to question the integrity of the Basques and their resistance to the Spanish troops in the Spanish Civil War (43). José openly rejects his Basque identity in Rey's version, affirming, "I'm not Basque; I am from Navarre," thus providing a more appropriate nationalist hero (Colmeiro, 95). The film strengthens this impression. Instead of killing Carmen and dying by military execution, as in the novel's fatalistic ending, Don José has his honor restored by dying while alerting soldiers to an impending bandit attack. In Mérimée's *Carmen*, Don José's Basque identity is seen as foreign to both the French and the Spanish, despite his blond hair, blue eyes, and old Christian (*cristiano viejo*) background.

Muñoz Aunión claims that in Rey's version, Don José's identifying with Navarre rather than the Basque Country indexes the propaganda the Third Reich launched to justify the Condor Legion's role in the Spanish Civil War and, specifically, their shock-and-awe bombing of the Republican-held Basque town of Gernika (Guernica).[15] The German office of censorship rated the film as "serious entertainment," a grade unknown at the time. Such a rating conceals the notoriety of the Condor Legion in the wake of its civilian massacre at Gernika on April 26, 1937.[16] The Nazi regime needed to justify their support of Franco amid the international outpouring of sympathy for the massacred Basque civilians. Of course, the Francoist cause was illegal; the Nationalist uprising in Spain had violated the constitutional sovereignty of the Second Republic, and this illegitimacy was a polemical topic even in Nazi Germany, since the Nazi fantasy of their rise to power was premised upon gaining power through democratic elections. German leaders had to present the peninsular conflict in a light that justified their support of the Nationalist cause, whether in Spain

or in Germany (Muñoz Aunión, 45–46). Carmen, the former rebel, surrenders in resignation to the body of Don José, much as the Spanish Nationalists expected the losing side to kneel down in front of crosses, or their own tombs.

Song and Nation

Like *Carmen*, *Suspiros de España* is an ideological balancing act that keeps in tension strains of National Catholicism, the world of the copla, the star text of Estrellita Castro, and Benito Perojo's cosmopolitan liberalism. *Suspiros de España* was the second film Perojo directed in Berlin (the first being *El barbero de Sevilla* in 1938) and the third film made during these Berlin years. On a superficial level the central themes of *Suspiros de España* coincided with the main tenets of the Falangist conception of the state, which was based on the complementary and "natural" units of family, community, and *patria* (Enders, 376). When it was produced by HFP in 1938, along with a German version appropriately titled *Nostalgia*, its associations with Nazism and Spanish Fascism and their search for the racialized other who could fetishistically supplement the antagonism of the homeland seemed even more obvious.

Román Gubern not only claims that the overt nationalistic and patriotic elements of *Suspiros de España* and, especially, its *pasodoble* "Suspiros de España" were provoked by the successes of the two previous HFP productions, *Carmen, la de Triana* and *El barbero de Sevilla*, but also suggests that the touches of nationalism in the film were due to the intervention of the National Department of Cinematography and to the cooperation of Norberto Soliño, a Cuban Galician who was one of the founders of HFP and the representative of Cifesa in Havana who oversaw Castro's contract. Soliño's connection with Cuba explains, according to Gubern, the expectation that the film would succeed in the Cuban market and with the Spanish emigrants in Latin America. Gubern suggests that *Suspiros de España*'s Republican elements came from the writer and director Perojo, whereas the Nationalist flourishes were due to the official overseeing of the film. Scenes that do not fit into one mold or another, such as the drinking scene between Relámpago and Carlos Cuesta, which uses distancing techniques and highly formalistic aesthetics, symbolize the transition between "the old formal liberty and the new aesthetic order" that was

configuring itself in Spanish cinema (Gubern, *Benito Perojo*, 306). *Suspiros de España*'s rags-to-riches love story was undeniably a star vehicle for Estrellita Castro, and true to stardom narratives, Castro's real-life biography was mirrored in the plot. The film remains bound, however, by the ideological discourses of nationalism, Fascism, and Catholicism that were already present before Franco took power and which certainly complemented German interests. Such ambivalence is the effect of overdetermination by conservative ideologies, as well as by those that distort and caricature such models. Superficially, *Suspiros de España* subscribes to Nationalist ideology in that its female protagonist travels to Cuba to sing Spanish songs and sigh nostalgically for Spain (Castro's eponymous pasodoble) and then returns to Spain having triumphed in its former colony. But the syntax of the film demonstrates that scenes such as the public washing place (*lavadero público*) and the boat scene, which might initially be interpreted as reinforcing Nationalist propaganda, prove instead to be contortions and displacements of its ideological discourse.

The song "Suspiros de España" could, for example, also be read as an ode to emigrants who fled Spain after the war or, simply, as a longing for a better place, one not associated with the reality of war-torn Spain or the immediate postwar.[17] Despite Castro's plastered-on smile—she was rarely photographed without it—Castro's life, like those of so many other folklóricas, hid an underbelly of economic marginalization, child labor, and brushes with prostitution. Castro began working at six years of age as a beggar to help support her twelve siblings, and by the age of twelve, she was already a child star and commonly sought as entertainment for the parties of the Sevillian upper crust (Román, 39). It was at this age, in 1927, that authorities prohibited her from performing, as she was in violation of child labor laws (Román, 40). Castro would continue to send money home throughout her life, and when in Berlin, she claims she received a sum of German marks directly from the Führer. She also managed to convince Hitler to intervene on behalf of one of her brothers, who was in jail in Germany (Román, 47). Though we know that she did have a private interview with Hitler, we can only speculate as to how these favors came about. But with her hardwired memory of abject poverty, Castro would squander every last penny of the fortune she made throughout her years of touring the Americas and Europe (when she received the contract for *Suspiros de*

España, she was performing in Cuba), and when she died in 1983, she had virtually nothing left. Although Castro is recognized as emblematizing the transition from the saucier, bawdier cuplé to the Andalusian copla, one wonders whether her premature entry into entertainment was not lived out on the edges of prostitution, as so often was the unspoken case with female entertainers. Castro's innocent *castiza* smile was perhaps her only guard against being eternally trapped in the stigma of the cuplé, as was Raquel Meller. As Román notes, "Estrellita didn't perhaps have the spicy impact of those who cultivated the so-called least genre [*género ínfimo*], but she did have natural grace, along with the force of her voice and her dance" (41).

Beyond love, romance, religious feeling, and even legal angst, *coplas*, *canciones*, *cuplés*, and *pasodobles* have reflected political and social events, mobilized citizens through patriotic lyrics and rhythms, retold history, and expressed feelings of solidarity with fellow countrymen. Since 1898, beginning with the conflict in Morocco and continuing through the Spanish Civil War, Spanish nationalism and its relationship to Spanish imperialism were primarily experienced through music and film. Even earlier, in the late nineteenth century, the "martial virtues of the Spanish character and the coming victory of the Americas" had been reinforced in popular songs, *género chico* plays, and zarzuelas (Balfour, 110). Like any medium, however, songs in themselves are not politically and morally neutral; it is the context they bear, their means of transmission, the uses for which they are employed, and meanings associated with them that determine their political character. After the Spanish Civil War, songs like "Que viva España" (Long live Spain), "Carmen de España" (Carmen of Spain), "Cántame un pasodoble español" (Leblanc and Lember; Sing me a Spanish pasodoble), "Españolear" (Lisart and Espeita; Spanishizing), and "Soldadito español" (Little Spanish soldier) inundated the Spanish radio and recording industries. Manuel Quiroga, one of the most famous Andalusian song writers, churned out more than five thousand songs, becoming a millionaire from sales and rights (Román, 30). The pasodoble "Suspiros de España" (Sighs of Spain) deals yearningly with nostalgia for the homeland and was consequently written off as a product of Fascist ideology. The pasodoble is the Spanish version of the salon dance, that is, danceable music with or without lyrics. Heard all over Spain but most often associated with bullfights and fiestas, the rhythm is similar to that of a military march. Its

undeniably patriotic and nationalistic connotations associate it with the military, and the homogenous, imaginary Spain that it invokes provides its listeners with the experience of "unisonance," "the echoed physical realization of the imagined community" (Anderson, 145). "Suspiros de España," arguably the most famous patriotic pasodoble, was originally composed in 1902 by Antonio Álvarez (Román, 46), but when Perojo was choosing music for *Suspiros de España*, he selected lyrics written by the Andalusian Antonio Quintero, whose version then became the most well known. The song's nostalgic sentimentality displaces patriotism onto the intimate gendered relationship:

Me voy sufriendo lejos de ti,
Y se desgarra mi corazón . . .
Dentro del alma te llevaré,
España, y nunca más te he de ver.
De pena suspira mi corazón.

I go on suffering far from you,
And my heart is torn in two . . .
I'll carry you within my soul,
Spain, and never more will I see you.
My heart in sorrow breathes a sigh.

The song genre of the copla, to which "Suspiros de España" belongs, became the artistic emblem of the Franco regime, the mascot of its ideology, and its official aesthetic (Peñasco, 16). The regime sanctified and protected the copla, promoting its creators and interpreters, including folklóricas such as Imperio Argentina, Estrellita Castro, Raquel Meller, Concha Piquer, and, later, Carmen Sevilla and Lola Flores. Performing the copla brought social prestige and official recognition in the form of visits to the Pardo, Franco's Galician residence; accolades such as medals, ribbons, and jewels; and even titles of nobility (Peñasco, 16). In this way, folklóricas and, by extension, Andalusian musical comedy films became unconditionally associated with Francoism as a medium for advancing a political cause.

Whether the Andalusianification of Spanish culture subscribed to a liberal or a Fascist agenda is a more complex question. Andalusia as a scenic topos and a musical style dominated popular theatre starting in

the late nineteenth century and peaked in the twenties. It was especial-
ly prominent in the plays of the Álvarez Quintero brothers. Sound film
came to Spain in 1927, coinciding with the peak of Andalusian fashion,
and enabled a more complete experience of Andalusian-style music,
since audiences could now both see and hear performances. Film di-
rectors felt pressure to respond to the demand, and folklóricas had to
mold their repertoires and persona to fit the Gypsified model. Castro
was a master of performing Gypsiness, or at least what audiences took
to mean Gypsiness—a composite of aesthetic, linguistic, and affective
traits that had come to stand-in for a racial Andalusian personality.
The *quita y pon* (removable buns), painted-on moles, *caracolillos* (curly
sideburns), and Andalusian *salero* (salty humor) were just some of the
racialized prostheses marketed to young women throughout the twen-
tieth century—painted-on moles being fashionable as late as the 1970s.

Casticismo might still have been the dominant discourse and an
ideological tool of the ruling class, but as Jesús Torrecilla notes, since the
late eighteenth century, racialized and stylized Andalusianism had been
subsumed into the discursive styles and practices of casticismo. Gypsi-
ness as a fashion was promoted by both popular culture and petite bour-
geoisie intellectuals. In much the same way that Federico García Lorca
used Gypsies as a backdrop, the lyrics of songs, the plots of films, and
the folklórica look all depended upon incorporating Gypsy elements,
passing as Gypsy, or even wearing Gypsy-face. Estrellita Castro spent
her life trying to project a convincing Gypsiness, requesting that she be
buried with her *caracolillo* on her forehead. She exaggerated, as Moix
explains, the ethnic characteristics of her characters and stubbornly in-
sisted on a triumphant localism of Seville and Andalusia. Her mantra,
"¡Viva Cartagena!" "became consistently racial, and of course, musical"
(82). Like many of the Hollywood stars, Castro used to tell stories about
her childhood, some of them most likely fabrications that supported her
career as a hyper-*andaluza*. Although her father was from Galicia, she
explained that he was "the most flamenco *gallego* who ever lived in the
shadow of the Giralda: it's to him that I owe all my *flamenquería*" (Moix,
82). In order to fill in the ethnic gap apparent in her family background,
she would tell reporters that when she was six years old,

> Some Gypsies passed through Sevilla with their bears and
> their "typical Spanish" routines, their dances and their songs;

I was just overwhelmed, watching them for hours and hours, and later I gave them a demonstration of my talents. When they saw how I sang and danced, they asked me if I wanted to go with them, and I, without thinking twice, told them yes. And for three months I was travelling with them from town to town. Finally, after three months, the civil guard found me and took me back to my parents. Well, I certainly didn't take any joy in that! I was enchanted with my beggar's performance of passing the plate, in exchange for living a life according to my own desires: singing, dancing, getting applause. (82–84)

Her Madrid debut in the twenties advertised her as "Estrellita Castro: The Soul of Gypsy Art." Castro's Gypsiness perhaps became "innate," but only through her consistent repetition of enacting it through dress and language. Yet it is precisely because of this ambiguous relationship to Gypsiness—of being a Gypsy without really being one—that Castro and Argentina make the perfect folklóricas for bringing Spanishness to the world. The identificatory paradigm that sees the racialized representation as both similar and different, "like us and not like us," was at the heart of the French espagnolade, Carmen, and the folklórica (Colmeiro, "Exorcising," 132).

Thus, while regime-sanctioned folklore churned out white Gypsies, Falangists expressed contempt for the Gypsified Andalusians of Suspiros de España, who were dangerously misrepresenting Spanishness (Arráiz). For Falangists Suspiros de España's characters were Gypsified because of their associations with poverty and petty criminality. The logic was that they were like Gypsies because they were dishonest and poor and sang all the time. The review of Suspiros de España by the Falangist cinema magazine Radiocinema illustrates their discomfort with a Gypsiness that is not peacefully assimilable but rather a reminder of excess and jouissance: The film caricatures the Spanish race as "Gypsified Andalusians among which one finds a dissolute kleptomaniac and an old woman who acts like a harpy, disheveled and spoiling for a fight." The scenes were "so disturbing and unaesthetic, like the ones of the argument in the washing place, which present us with neighbors who insult each other, grab each other's hair, and mutually deal out blows, slaps, and bites" (Arráiz).

Ironically, this ultra-Spanish cinema presented neither a pure warrior

Figure 22. A slapstick fight scene from *Suspiros de España* (1938)

race fulfilling their destiny nor a modest or submissive female role model. Herein lies one of the differences between the Spanish and German takes on Gypsiness. For Nazis, who had no intention of incorporating the Gypsy into their societal vision, *jouissance* was welcome as it better supplemented their fantasies, but for Spaniards the Gypsy was a permanent problem, and the solution needed to be conversion and incorporation in the same pattern as the religious and military colonization of the Americas. Gypsy excess and *jouissance* were thus obstacles to assimilation, creating grotesque stereotypes of the Spanish race. They were not material that would sell: Gypsified cupletistas playing out the rise-to-stardom theme to the massified music of the *canción andaluza-española*.

Promoting Spain through a female Andalusia is precisely how *Suspiros de España* begins. The young Gypsy Sole (i.e., Soledad) wins a beauty contest sponsored by a Cuban radio station. After many slapstick obstacles, Sole, her domineering mother, and her loafing godfather-uncle (played by Miguel Ligero in the same vein as his good-for-nothing comic Gypsy character, Regalito, in *Morena Clara*) travel to Cuba with Carlos Cuesta, the agent of the Cuban radio station, who is instantaneously

in romantic pursuit of Sole. The film ends with Sole making an outrageously lucrative deal that promises lifetime stardom and wealth for her and her family.

After the initial establishing shot of Sole's singing in the contest, the camera zooms back in; the photo beneath the headline comes to life; and it zooms out once again to the public washing space in Seville, where Sole is surrounded by singing washerwomen. At first this scene looks like the cliché of smiling, submissive female slaves at their domestic chores. The parodic nature of the scene becomes apparent, however, when a fight erupts between Sole's mother, Dolores, and another washerwoman who has taken her place at the washstand. Intended for comedic effect, the fight is surprisingly brutal and carnivalesque, with the women pulling and ripping each other's hair and clothing, and as other women get involved, one is even thrown into the pool in the style of the Hollywood Western bar brawl scene. Two municipal guards appear to check out the ruckus, but the women pretend nothing has happened, and Sole launches into "A mí me gusta, a mí me gusta que los hombres se mueran por ti" (I like it, I like it when men die for you). The guards think the song is for them and are dumbfounded by the beautiful singing. Thus, the city folk seem much smarter than the officers. Sole's flirtatious yet cunning and mischievous attitude adds to the self-consciousness of this scene as she glances from side to side, inviting complicity from the film spectator in making fun of the guards, who are still blissfully ignorant of the situation. Because the spectator is privy to the same knowledge as the washerwomen, an ironic distance opens up between the women and the civil guards.

The scene at the public washing square illustrates several points about song, nation, and consensus. First, Sole is shown in the public sphere working as a washerwoman but not raising children or even married. When this film was produced in 1938, the Nationalists were already developing a program to control attitudes toward working women. Even before the end of the war, work restrictions forced women into the role of a crutch for the rebuilding of the nation—ideal Catholic mothers, that is, whose only proper places were at home or in church. One of the first major pieces of legislation was the 1938 Labor Charter. Motivated by the fear of an independent and organized working class, it brought workers and employers together under a system of official unions (Spanish Syndical Organizations) directed by the state. It also

prohibited night work by women, regulated work at home, and "liberated" the woman from the factory and workplace (Brooksbank Jones, 75). The Labor Charter mandated the family as the natural nucleus and foundation of society, a moral institution that was above all secular law.

As noted by Anny Brooksbank Jones, Francoism was unable to realize its professed goal of emancipating women from the workplace in order to remobilize them in the home (114). The best example of how the regime slit its own throat is in the political mobilization of women, especially middle-class women, through the Fascist organization for women, the Sección Feminina (SF). Imposing traditional gender roles on a society bewildered by the onslaught of modernity and the supposed need for stability, the SF provided an optimistic assurance that things could be turned back towards the nostalgic days when women knew their place. Yet the women put in charge were thus given a taste for power, and once having experienced this semiautonomy, they were reluctant to return to their earlier states of subjugation. Brooksbank Jones also remarks that during the years of hunger, women played a key role in agricultural production. Many women had to take over the responsibilities for their husbands or fathers who had died in the war; other women worked as low-paid seasonal day laborers or *ayudas familiares* (family helpers). Agricultural work declined with the economic depression of the rural areas, and these women tended to move toward the cities, where they found jobs in construction, metalwork, textiles, domestic service, and/or prostitution (74).

Scenes in *Suspiros* in which the mise-en-scène is framed through female labor or dysfunctional nonpatriarchal family relations thus unwittingly corroborated the reality that Brooksbank Jones describes. This contradiction is enacted, however, at the same time that another, racial dynamic is in process, one in which race gets subsumed, fused, and dissipated into the idea of a white Gypsy. As the film rolls, Sole will, despite her Gypsy background, progressively differentiate herself from her parents as someone useful to and successful within society.

In the next scene Sole's mother is hard at work washing other people's clothes, while her uncle, Relámpago, spends most of his time getting into trouble and causing problems. In a carnivalesque skit Relámpago unknowingly retrieves underwear from a laundry basket belonging to Carlos Cuesta. The ensuing mix-up enables a playful change of identity as Relámpago flaunts his new underpants. When all is

resolved, the domineering Dolores scolds Relámpago in the tradition of The Three Stooges. Ridiculing and bullying the surrogate father both physically and by will and temperament, she subverts the paradigm of the patriarchal family. But because the uncle is not the father, he symbolizes the artificiality and the fantasy of patriarchal authority. Finding that Relámpago has entered Sole in a contest, she pitches into him for going behind her back, again demonstrating her greater authority in the family hierarchy, in flagrant disregard of the sacred microcosmic model of family that anchored National Catholicism.

When Relámpago relates the story of how he sent Sole's portrait to Havana, speculating on the money that the family could possibly make, a fight erupts with Dolores. The fight, although comic and carnivalesque, is incredibly violent, exposing the dysfunctionality that lies at the core of the institution of the family. Tearing hair, hitting, and throwing and breaking furniture, the couple destroys the house, the locus of family unity. At the end of the fight, they lie on the floor, panting for breath, wearing the furniture they have smashed on each other. Carmen Martín-Gaite discusses the correlation between the fear of anarchy and the ways women were encouraged to keep order in the domestic sphere. In fact, they were lectured on the evils that an unorganized home could create (unhappiness, misunderstandings, incompetence, bad hygiene, rebellion, and a lack of discipline) and told they were responsible for maintaining this sphere, despite the lack of participation by the husband (118–19). The family, the primary building unit of Falange and, later, Francoist ideology, as well as a metaphor for Spain and the trinity, was an inseparable unity but, like racial purity or a nonantagonistic society, an impossibility. During the Francoist regime, protonatalist policies would support not only a stable Catholic family but also the reuniting of the patriarchal unit that forced women into a subordinate place. For spectators who saw the inevitable rescreenings of *Suspiros de España* (films from the late 1930s and 1940s were redistributed in Spain and in Latin America whenever there existed a shortage of films), the domestic displaced the center of rational authority from the parents onto the child. Sole, who defiantly runs away to catch the boat to Cuba, is followed by her childish parents, who scramble to keep up with her.

During the family's steamship trip to Cuba, Sole and her family travel third class, the lowest level on the boat, where they are thrown

together with the other foreigners and emigrants hoping for a better life in the Americas. It is on this crowded deck of lumpen passengers that Sole/Castro performs the nostalgic pasodoble "Suspiros de España." The mise-en-scène and editing around the song create an ambiguous cluster of meanings. The performance sequence begins with a shot of the covered upper deck, where first-class passengers have gathered to watch the more colorful scene developing on the unsheltered third-class deck. The background music is a nostalgic Italian song accompanied by only a guitar, in front of which the camera settles, capturing in a medium shot a group of Italians listening to this music, setting the mood for the Spanish pasodoble. The Italian emigrants recall not only the massive flight of peasants from southern Italy to the Americas, especially Argentina, at the turn of the century but also the exodus of Italians escaping Fascism. A right pan over the deck scans the emigrants and the three Spaniards, broadening the take to include all foreigners, who necessarily must leave their mother countries. The parallel between the Spaniards and these other emigrants inevitably calls to mind the civil war, where some Spaniards fought alongside foreigners from the International Brigades and others were either exiled or imposed it on themselves. The camera then pans right, across the crowded floor of the deck to where Sole, Relámpago, and Dolores are muttering scattered lyric phrases: "But mothers never abandon their children. Spain goes with us and will live with us in our hearts in the form of memories, hopes, coplas and longing sighs." With this coda Sole/Castro leads directly into the pasodoble, with the off-screen accompaniment of an orchestra. Throughout the performance of this song, close-ups of Sole's face are intercut with medium to close-up pans of the emigrants or of Dolores's and Relámpago's faces. The emigrants divert meaning from an exclusively Spanish context to a more international one. The quasi-poetic realist shots of the anonymous emigrants' faces gain surprising force in this sequence, lending an almost populist feel to the scene, a touch of realism that defies the logic of escapist, apolitical entertainment.[18]

By the time Sole finishes her performance of "Suspiros de España," various wealthier passengers have gathered on the deck above to watch the performance. Relámpago, faithful to the spirit of entertainment, is aware of the need to entertain both classes and thus join them through entertainment—an unwitting wink to the consensus that

was negotiated under Francoism—so he suggests switching to a song that will lift everyone's mood. The next song is, however, a call to a racialized Spain, "María, la gitanilla," which moves us from nostalgia for homogenous *patria* to the idea of Spain as ethnic, Gypsified, and diverse. The mood has also switched from sentimental to a sensibility conscious of and open to song's capacity for entertainment. In effect, the nostalgia is kept alive by continually remystifying entertainment and its sentimental and emotional hold upon us.

So once again with an invisible orchestra, which secures a sense of folk community, Sole launches into song while Relámpago comically dances alongside. In medium and long shots, the pair moves through the crowd as it closes in around them, as if they were at a nightclub. Using the boat as a stage so that the different decks resemble a theater draws on the modus operandi of the backstage musical, which bridges the barrier between the world and the stage (Feuer, *The Hollywood Musical*, 24). Sole and Relámpago's performance references other folkloric scenes, like the duet by Imperio Argentina and Miguel Ligero in *Morena Clara*, and it wins the applause of the boat passengers, underscoring the show-within-a-show nature of this scene. The ideological message is not, then, strongly conservative, nationalist, and imperialist, nor is it deeply radical. It is pure capitalist consumerism combined with star appeal, the kind that drives the escapist movie industry, the liberal solution to the Spanish movie industry, with a racialization that will be sufficiently digestible to audiences who can better imagine themselves through otherness.

Imperialism through Traveling Folklóricas

The scene of Sole going to Cuba and her exhilarating climb to fame is replayed in many other films that like *Suspiros de España*, combine an Andalusian Gypsified folklórica with a cosmopolitan stardom plot. In *La hija de Juan Simón* (starring the male flamenco singer Angelillo), *Mariquilla Terremoto* (starring Estrellita Castro), *La patria chica* (starring Castro), *Filigrana* (starring Concha Piquer), and *Embrujo* (starring Lola Flores), the assimilation of Spain's Gypsy other as a national idiom and the assimilation of Latin America into the brotherhood of hispanidad are accomplished by the diplomatic mimicking of the folklórica. In *Suspiros de España* and *Mariquilla Terremoto*, the

folklórica boosts her career in the Americas before returning to Spain, metaphorically reenacting the cultural and economic fraternity of hispanidad. As ambassadors of Spanishness, folklóricas symbolized the corporate interests of Spanish capital in Latin America; indeed, they prefigured the neoimperialistic takeovers of Latin America's largest national industries.

Spaniards were for the most part unable to travel until the midfifties. Many of them could not even leave town, because the authorities demanded a certificate of safe passage to travel from one city to another, and passports were the privilege of a fortunate minority. Forced immobility was defended by the well-orchestrated psychological campaign that guarded against noxious foreign influences (Goytisolo, 133). During this period the use of foreign names for stores, cinemas, or bars was officially prohibited, while the press was a constant reminder of the differences between Spain and the rest of the world. But the plotline of traveling folklóricas had its autobiographical counterpoint in reality. Many of these films were loosely based on the memoirs of real Spanish stars.

From cinema's inception, as Isabel Santaolalla argues, America was figured as a destination, thus the origin of ambivalence for immigrants, fugitives, or adventurers in films such as *Regeneración* (dir. Domenec Ceret, 1916), *La loca de la casa* (dir. Luis R. Alonso, 1926), and *El mayorazgo de Basterretxe* (dir. Mauro Azcona, 1928) (28). That folklóricas in real life and on screen could travel to America implied that these women had realized their desires and were successful and rich. "Going to America" meant leaving behind the old and embracing the new, with its risks and adventures. The Indianos, destitute Spaniards who had traveled to Latin America, made a fortune, and returned to Spain to build sumptuous homes or monuments, were one example of the possibilities open to lower-class sectors of Spanish society. Of course, the Spanish nationalist cinema also attempted to reach Latin American cinemas and spectators, or *any* spectators. But mainly these films were seen in Spain. Their stars provided progressive role models for women in an oppressive and depressed society or, at least, provided visions of more complex styles of life. That a performance artist, a profession almost equivalent to prostitution, was the focus of these films, and not the female models offered by Fascism or Catholicism, is a point that must have occurred to many. *Suspiros de España* demonstrates the

possibility of alternative readings when stardom and nationalism converge in an ambivalent narrative.

Traveling to the Americas was a fundamental plot element in several Andalusian musical comedy films, but for almost all folklóricas it was a reality. Earning a fortune through these American and Latin American tours was necessary for returning to Spain with the accoutrements of stardom: a wardrobe, a car, jewels, a house, and cash for a lavish lifestyle in Madrid. Unless you could live like a star, you were not one. And in Spain that kind of capital simply was not available if one worked only in Spanish films. Castro's starring role in *Rosario, la cortijera* (dir. León Artola, 1935) proffered her a miserable 1,000 pesetas (less than ten dollars by today's standards), and her role in *Mariquilla Terremoto* offered her 5,000 pesetas, far less than what Imperio Argentina had been offered for her role in *La hermana San Sulpicio* (Román, 45). Stage performances were still necessary, as they brought in a more consistent income. Such economic considerations are also important in terms of understanding these individual's willingness, even enthusiasm, to work in German studios. Most or all of the folklóricas who became internationally famous—Piquer, Castro, Argentina, Flores, Montiel, and Sevilla—traveled through Latin America and the United States chasing money and stardom. That a star's real life might be mirrored in film plots even more confirmed the idea that dreams could come true for women in Spain of the 1940s and 1950s. Both *Suspiros de España* and *Mariquilla Terremoto* were, for example, remarkably autobiographical in regard to Estrellita Castro's life, even though identification with movie stars was probably not what censors in the late 1930s or during Francoism had in mind.

Suspiros de España could interpellate, with its social mobility, stardom, and travel to the Americas, spectators who identified with a higher economic class and with a female profession in direct contradiction to Catholic morality. It parodies the sacred institutions of family and fatherhood. Because *Suspiros de España* underscores capitalist success, images a New Woman who pursues a career outside of the home, and subtly undermines the mainstays of Nationalist and Falangist ideology, it might not seem a coherent reflection of official dogma. Yet neither would it be correct to assume that *Suspiros de España* unproblematically subverts the ideological stance of Burgos or Berlin or that the vision of this film advocates true economic and social change. In fact, it

restores family values, peace, and happiness to the social order. Through the performance of the pasodoble "Suspiros de España," nationalism is actually invented on the screen. Given Spain's deficient nationalism (the idea that Spain lacked an adequate repertoire of nationalist symbols), the ideological melding of nationalism and folklórica stardom was the key to these films' endurance and the answer to Spain's perceived shortage of icons. What could not be guaranteed was whether Spanish spectators would identify with these images in the way that Falangist and, later, Francoist ideology had instructed them.

Recycling Folklóricas: A Queer Spain

As we have seen, a defining feature of Andalusian folkloric films is their simultaneous emphasis on stories of progress (stardom) embedded within heteronormative romance and an exclusionary racial discourse that haunts their utopian elements. Those who have condemned these films as Fascist preindustrial comedies fail to recognize narrative elements that contradict Fascism, National Catholicism, and the notion of a precapitalist Spain. For these films celebrate the world of the stage, referencing a cosmopolitan lifestyle instead of the nuclear family, and showcase female roles that were anathema to Francoist womanhood. They favor secular romance, not religious matrimony, and laud capitalist ambition and social mobility in place of class hierarchy.

Yet while historians might have attended to the ambivalent gender issues at play in the Andalusian musical comedy film, they have not connected this ambivalence to the general instability created by modernity's narration as a raceless enterprise. Despite their themes of progress, capitalism, mobility, and secular romance, these films are most often driven by a push-pull dynamic of sexualized racialization. As Alberto Mira reminds us, folklóricas became the standard-bearers of racial virtues and chastity. Softening their hard-core sexuality of the twenties, cupletistas like Concha Piquer reinvented themselves in the wake of the Spanish Civil War and became the superstars of the Francoist version of the copla (*De Sodoma*, 343). Of course "racial" meant castizo purity and whiteness, but it was adorned with Andalusianness, which made it more exotic and, of course, sexy.

Vested with this de rigueur Andalusianness, sex was marketable whether it prudishly teased the spectator (folklóricas such as Juanita Reina and Lola Flores were strict Catholics) or provoked masturbatory fantasies (Sara Montiel's devastatingly sensual performance in *El último cuplé* is brilliantly replayed in Almodóvar's *La mala educación*

[2004] to two gawking schoolboys, one of whom is destined to become a drag queen). Indeed, the entire world of the cuplé theatre spectacle and the films that depict this ambience harbored gay audiences and performers throughout the twentieth century, even during censorship. An insistence on seeing the world of the cuplé and the folklórica as racialized must also acknowledge, however, its germane connection with gay camp. Spanish gay camp and the cuplé and later musical film engendered one another. Yet a gay camp optic was not an essential element of, say, folklóricas' performances, even though Juanita Reina or Sara Montiel bragged about how often they were imitated (Mira, *De Sodoma*, 441). Let it be clear that these female stars were not in the least bit queer. What *was* queer was the complicity between gay performers and the audiences who shared (secret) knowledge about the act of imitating a folklórica, an imitation that was not meant to offer a perfect copy of the original but to expose the imitation as a construction of gender and to underscore gender as a performance. As Mira puts it, what became queer was the imitation of the imitation (*De Sodoma*, 439). It is this distance between the object imitated and the imitation that creates irony, a necessary ingredient in the act of critical appropriation and recycling.

Thus, the focus of this chapter is not how much or to what extent the Andalusian musical comedy film was successfully recycled after Franco but rather how race and queer thinking intersected in the critical recycling of folklórica and cuplé aesthetics during the cataclysmic changes of the transition to democracy, in particular the moment of 1978. This chapter examines the confluence of race and queerness by examining the documentary *Ocaña: Retrat intermitent* (dir. Ventura Pons, 1978) and, to a lesser extent, the fictional film *Un hombre llamado Flor de Otoño* (dir. Pedro Olea, 1978). Both films appropriate structural and narrative elements from the folkloric musical comedy films not as a nostalgic return to the Franco years but to revisit their cosmopolitan origins in the cuplé and *sicalipsis* (sexy, erotic) popular theatre of the *varietés* at the beginning of the twentieth century (see chapters 1–3). Ocaña and Lluís Serrancant, the protagonist of *Un hombre llamado Flor de Otoño*, perform cupletista and folklórica aesthetics and demolish bourgeois heteronormative capitalism and religion. Recycling these performative modes, these films redeploy the constructed rural community, intermittent performances, and utopian sensibility of the folkloric

musicals within a new queer landscape in which a radically racialized and sexualized otherness speaks truth to power. My focus on these films concludes my discussion of folklóricas and race—Franco does not have the last word—and serves as a point of entry into dialogues about how to think of queer desire as "not peripheral but central to the narration of race, modernity and the politics of history" (Eng, 1483).

Just prior and soon after the transition, roughly 1974–85, musical film genres either reacted to or remade folkloric musical comedies. While the folkloric film remained popular beyond the fifties, the sixties ushered in a craze for what song historians have called *la canción moderna* (modern song), sung by *los chicos yé-yé* (the yeah-yeah boys/girls) or, as Terenci Moix has coined it, "La flamenquilla de la Coca-Cola." Marisol and Joselito, the "prodigious" child stars of song and cinema, were the poster children for modern Spain who brought much of the musical world from folklore to modern song:

> Marisol was never a *folklórica* in the strict sense of the word, but she came to occupy the same place in the public's heart as did the *folklóricas* of the fifties. She was the petit-bourgeois response, the modern version, the jingle of economic development, who instead of achieving fame in the radio studio, did it in the television studio. What's more, she had an advantage over her predecessors: a physique more in line with a Nordic virgin than with the conventional Malaguenian girl. She was the little blond and blue-eyed flamenco singer/dancer, who when she could, would do the yeah-yeah thing and later the twist, as the newest generation demanded. (Moix, 278)

Whiteness, embodied in this mix of Shirley Temple and the blond-haired child folklórica, complemented the other comedic film genres coming to the fore in the sixties and early seventies, like the *comedia desarrollista* (comedy of development); *la comedia celtibérica* (Celtiberian comedy), aka *el cine de reprimidos* (cinema of the repressed); and *comedias de conquistadores y paletos* (comedies of country bumpkins and conquistadors). The premise of these comedies is usually the reaction of a caricatured Spanish male (*macho ibérico*) who is blinded by (the whiteness of) Swedish female tourists and, as a result, either comes to accept his Spanish culture or feverishly consumes the northern

European fare advertised to him. The actor Alfredo Landa, whose corpus is affectionately termed "Landismo," was the prototypical *macho ibérico*, whose insecurity about his own modernity was humorously combined with a will to planetary conquest, hilariously played out in *Los nuevos españoles* (dir. Roberto Bodegas, 1974).

In the eighties the international success of Carlos Saura's Flamenco Trilogy—*Bodas de sangre* (1981), *Carmen* (1983), and *El amor brujo* (1986)—revitalized the film musical with Andalusian trappings (Riambau, 441). Saura's glossy takes on age-old *sexismo* are revised in a critically queer vein, however, in *Las cosas del querer* (dir. Jaime Chávarri, 1989) and in its 1995 sequel.[1] *La corte del faraón*, José Luis García Sánchez's adaptation of the eponymous zarzuela, parodies the orientalist gay camp tradition, while Josefina Molina also revisits the genre, with a feminist gaze, in *La Lola se va a los puertos* (1993). Nevertheless, attempts to reproduce uncritical yet "authentic" Andalusian folklore (as we have already seen, an oxymoronic concept) still tempted producers like Luis Sanz, who gave the singer Isabel Pantoja the lead roles in *Yo soy ésa* (1990) and *El día que nací yo* (1991), mere nostalgic visions of the folkloric films of the thirties and forties. The much-written-about *La niña de tus ojos* (dir. Fernando Trueba, 1998), a re-creation of Florián Rey and Imperio Argentina's experience making *Carmen, la de Triana*, did little to push the envelope.

Instead of dwelling on the more recognizable re-creations of folklórica film of the nineties, I conclude with 1978, three years after the death of Franco and the year Spaniards inaugurated their new constitution. At this moment a radical political potential was being imagined on the political and audiovisual front. Yet hindering this potentiality was not only the continuation of Francoist structures in the new democracy but also the ferrous strictures of a racialized vision, bound with sexual and class discourses, that plagued the political and cultural public spheres. As Silvia Bermúdez has studied, alongside the creation of title XIII of the constitution—which established a nation of autonomies—rhetoric flourished about "the being of Spain" that openly referenced imperial discourse (350). Spain's essence resides, according to this rhetoric, in the colonial enterprise (350, 353), while racial descriptors like "the black beast" refer to peripheral national identities (Basque, Catalan, Galician) (348, 350). Postcolonial Spain's responsibility to Africa was being downplayed if not ignored, and race

consciousness was deflected to the issue of the Autonomous Communities and their struggle for self-determination. The recognition of autonomy meant access to modernity, and it served to distinguish those more European than the rest (Delgado, "La nación," 211–12). A specter of race thus undergirds most accounts of the transition, including those that present the first world's rediscovery of Spain as curing Spanish inferiority: "Spain was as European as any other country belonging to that common market from the midsixties through the seventies" (Vilarós, 5), with the purpose of "forgetting forever the tin band and tambourine Spain" (Vilarós, 26). The emphasis on difference and Europeanness was especially acute in the case of Catalonia, which was "strongly pro-Europe in the transition to democracy" because European ideals provided "a new space in which to advance nationality claims" (Keating, 30–31). The nationalist claims of Catalonia, like all nationalist claims, were tied to race. As José Álvarez Junco reminds us, "From the late nineteenth century on, the 'national problem' was posed in racial terms" (455). While other European nations had rushed to demonstrate their racial superiority by colonizing Africa and the Far East, Spaniards were forced to negotiate their own position within hierarchies of race (Martin-Márquez, 175).[2] These racial hierarchies in turn played into the struggles over peripheral nationalism. Despite its reputation as being the heart of the transition, 1978 therefore was the launching pad for renewed colonialist rhetoric, making it clear that Spain remained beleaguered by Franco's ghosts and, according to many intellectuals, was rebuilt upon the rancid structures and institutions of Francoism (Pavlovic, 101). While championing democracy in 1978, Spanish intellectuals overtly distanced themselves from Francoist conceptualizations of raza—considered by now old fashioned. Yet race thinking remained residual and wholly unexamined in the period after Franco's death.

Race was the blind spot of this transition to democracy, which media and intellectuals have described as the definitive arrival of modernity to Spain, as witnessed by the welcoming of transnational corporations, the liberalization of the economy, integration with the European Community, new media and communication technologies, and new relationships to consumerism (Vilarós, 4). According to this narrative, Spain's long-awaited entrance into modernity commenced in 1975, when the death of Francisco Franco allowed for the uncovering (destape) and, as

we shall see, stripping of the repressed civic body. For Teresa Vilarós
the transitional period constitutes a gap between the official imposition
of an imperialist casticismo and the immigration of the 1990s: "a space/
time hung between two historical paradigms" (20). And so it has been
historicized by peninsularist scholars. Vilarós notes that these econom-
ic and cultural changes resulted in a rise of racism (12), but as Cristina
Moreiras Menor has shown, this ultranationalism supposedly was not
related to the continuities of racial thinking in Spain but rather was a
foreign element that corrupted the intrinsically benevolent core of the
transition (19). Indeed, during the transition discussion of racial other-
ness was framed by Spain's insecurity about its Europeanness (now vin-
dicated), while its shared coloniality with Africa or Latin America was
downplayed, despite Spain's increasing role in U.S.-led neoimperialism
in the Middle East and Latin America (which would culminate with
José María Aznar's support of the Iraq War). Only in 1992, when Spain
becomes undeniably modern, hosting the quincentennial celebrations
of 1492, the World Expo in Seville, and Barcelona's Olympic Games,
does race become the unavoidable topic, pushed to the forefront by
massive demonstrations of indignant postcolonial subjects around the
Spanish-speaking world (see Graham and Labanyi; Vilarós; Flesler).

Although scholars have abused metaphors of rupture and trans-
formation to describe the cultural production of the transition, they
are partly right. True to transitional aesthetics, in the late sixties and
early seventies Marisol broke from her "tutors" and became a commit-
ted leftist, while Pérez Ocaña, a painter with indeterminate sexuality
and anarchist beliefs, performed in the street, dressing alternatively as
a cupletista or a folklórica. Ocaña summarizes Francoism as dirty rags
or clothing: "La represión me ha puesto cuatro trapos sucios" (The re-
pression has given me four dirty rags). At the end of Ventura Pons's
documentary *Ocaña: Retrat intermitent,* Ocaña hurls his flamenco
dress into the audience and launches into a furious *tapateo* (tapping
of feet), letting his flailing naked body bring home the point that the
body itself is the locus of the revolt of pent-up emotions.[3] But from
frequent performances such as this one, the early transition, or what
was called the *destape,* literally became associated with taking it all off,
drug use, polysexuality, and the general breaking of norms that focused
on the body.

Although the ludic hedonism of the *destape* was not new—Spanish

traditions of corporeal celebration were as old as the Arcipreste de Hita and the Celestina—Ocaña's and Lluís's performances, while referencing the scandalous sexuality of the late nineteenth century and the first third of the twentieth century, could now openly introduce a political potential into the conversation about folklóricas.[4] Of course, the practice of exploiting transvestitism and transsexualism as a vehicle for carrying the symbolic burden of either the transition or postmodernity and modernity has become another blind spot in scholarship on the aesthetic movement known as the *movida* that took place in Madrid, Barcelona, and other cities (Pavlovic, 98). But different from the trans individual and celebrity Bibi Andersson, the historic individual Ocaña and the character Lluís Serrancant actively assume the task of redefining the body politic and rupturing normalizing myths (Pavlovic, 98).

To the intellectuals from his hometown, Ocaña's vindication of Andalusian town life smacked of antimodernism, as did his partially ironic, naïve-folk attempts to re-create colorful, "surreal" (his term) displays of baroque mysticism and small-town Spanish kitsch. Unlike *España oculta*, Cristina García Rodero's book of surreal black-and-white photos, many taken during the same period, Pons's documentary about Ocaña unapologetically juxtaposes scenes of the most excruciatingly backward popular religious culture with others that represent his bohemian camp and radically leftist beliefs. Likewise, for Catalan modernists Ocaña's insistence on the most wretched and unworthy elements of inner-city Barcelona disrupted the forward-looking gaze of Catalan–European regionalism. Similarly, his folklórica aesthetics were, for most, retrograde throwbacks to Francoism and the Right's definition of *raza*. Yet as this chapter attempts to show, both Ocaña's strategy, as laid out in Pons's documentary, and the story of Lluís Serrancant in Olea's film, in terms both visually and graphically riveting, acknowledge how economic marginalization becomes both sexualized and racialized and, more important, how we can think our way out of this association.

Queer

The term "queer" is fraught with potential snares. The word derives from both Anglo-American critical theory and activism, and attempts to use it outside this Anglo-American sphere have been questioned.

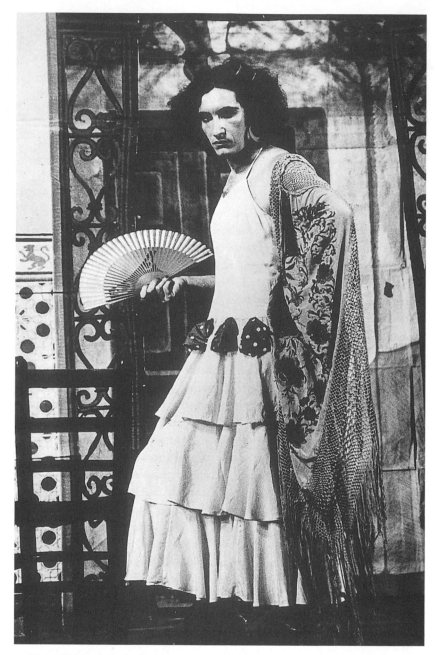

Figure 23. Ocaña in *Ocaña: Retrat intermitent* (1978)

Still, it seems preferable to more autochthonous terms such as *pluma* (literally, "feather"), which is not a gay-positive term and is often used as an insult (Mira, "After Wilde," 45n1). And despite the word's origin in an Anglo-American context, queer theory inherently critiques all notions of normative centeredness, in particular that of Western capitalist modernity. In this sense, the performance text of *Ocaña: Retrat intermitent* and the politics of Lluís Serrancant are queer critiques, for they extend the critique of heterosexuality to include class, race, and the relationship between religion and the normative investments of nation-states in capitalism, turning all of these on their heads (Villarejo, 70, 72). Queer desire speaks to the in-between, as opposed to the binary terms upon which modernity is constructed (Eng, 1488). This queerness is neither articulated nor understood according to its contemporary definition but rather is a sensibility or a structure of feeling that emanates from sex and gender ambiguity in (supporting) film characters or from the aesthetics of a folklórica's performance when performed by and/or for gay performers and spectators. In this sense of queer, the term "camp" emerges not only as an indicator of parody, double entendre, humor, irony, self-deprecation, sexual jokes, excess, and wit but also as "the moment at which a consumer of culture makes the wild surmise, 'What if whoever made this was gay too?'" (Sedgwick, 156).

Characters of indefinite gender punctuate the geography of these musical and folkloric films between the twenties and fifties. In the iterations of *El negro que tenía el alma blanca*, as a novel, a play, and three films, a significant portion of the text is usually devoted to the effeminate and boyish Nonell, a Catalan lumpen bootblack—literally as black as Peter—and sometime male prostitute. Nonell becomes best friends with the Afro-Cuban jazz dancer Peter Wald, hero of the story, serving him both as butler and manager as Peter climbs to success. In fact, Peter's initial voyage to Paris is enabled by the money Nonell receives from a night of prostitution. When Nonell dies from tuberculosis—perhaps a veiled reference to his degenerate sexuality— Peter is bereft: no one will care for and befriend him in the same way. His relationship with Nonell was the true love that Peter sought in the white woman who spurned him. Peter and Nonell's cosmopolitan friendship resembles queer desire in its mobility among "multiple social antagonisms"—race, class, nationality, and sexuality (Eng, Halberstam, and Muñoz, 1). This emotionally intense but ambiguous

Figure 24. Poster for *Un hombre llamado Flor de Otoño* (1978)

friendship between two men also figures in Ocaña's friendships. As he states, his relationships with gay men, artists, prostitutes, and outcasts were spiritual (yet embodied) and were strictly distinguishable from the sexual. In fact, he rejects the term "homosexual" and claims he was unaware of its existence until he came to Barcelona (the symbol of modernity and the categorization of sexuality). Ocaña's emphasis on friendship refers, then, less to a sexual or a possessive desire (although he certainly does not deny that he loves or even likes to make love) than to a way of being in the world, an outlook, and a philosophy.

Looking back at the spectral, queer presences in the Andalusian folkloric genre, other examples of queerish characters emerge as satellites around the display of folklóricas. We see queer butlers and *mayordomos* (*El negro que tenía el alma blanca* and *Canelita en rama*), doormen (*Torbellino*), and stage managers (*Bienvenido*), as well as asexual, comic "uncles" (*Morena Clara*), playboy brothers (*Suspiros de España* and *Morena Clara*), and even loafing Gypsies (Miguel Ligero in several roles). These are odd chaps whose sexuality is ambiguous and who act as counterweights to the main male love interest of the folklórica, thus strengthening her association with heteronormativity. Neither these quasi-queer figures nor the films in which they appear belong to a consciously camp aesthetic that hailed fellow travelers in the know. The intended audiences of these films were not to laugh with these characters but at them. An example of a film that displays an ambivalent relationship to queerness is José Luis García Sánchez's *La corte del faraón* (1985), a remake of the zarzuela of the same title by Vicente Lleó (1910). The zarzuela has been touted as a "blend of biblical pastiche, luscious vaudeville and Art Deco Egyptian chic, . . . one of their most sophisticated and audacious conceptions. The smuttiness of its *double-entendres* was so evident, indeed, that public performance of the work was banned by the Franco regime until as late as 1975!" (Webber, "La corte de faraón," first paragraph). In *La corte del faraón* Ana Belén, who sings and is the protagonist in both the film and the zarzuela within the film, is continuously surrounded by queer characters. These character stereotypes and their aesthetic modalities resemble recognizable forms such as the "loca afeminada" (effeminate queen) or "la mascarada, la bufonada folklórica, y el histrionismo" (the masquerade, the folkloric parody, and histrionics) (Ballesteros, *Cine ins)urgente*, 92). Never leads and always destined for supportive or sidekick roles, these second-rate characters—*transformistas aflamencadas*

(flamencoized cross-dressers)—are remarkably similar to the laughing and happy Gypsies that performed for *payo* audiences in folkloric musical films. Only, here, their destiny was to perform for predominantly heterosexual audiences.

The draw that the folklórica had for gay audiences is archived in Terenci Moix's *Suspiros de España: La copla y el cine de nuestro recuerdo*, both a paean to folklóricas and an index of what that world signified for gay, bisexual, and trans people. Moix's book houses a tradition of gay iconography—drawing on folklóricas from Concha Piquer to Sara Montiel—that nurtures a small but significant cluster of gay critics, novelists of erotic literature, and theatre and song experts. Conceived more broadly, as Chris Perriam notes, the "dilemmas of the female protagonists of the coplas, by way of 'hints and codes,' have served as a 'refuge' for the expression of passion and desire for men" ("*Las cosas del querer*," 261). Like Moix, popular cinema gurus like Álvaro Retana and others could openly express queer tastes by commenting on the world of cuplé songs, popular folkloric entertainment, and generally campy pop culture. Retana perhaps was best known as a writer who belonged to what Mira calls the "emergent homosexual reading community" or the "lost" generation of Spanish literature (Mira, "After Wilde," 31). Situated between two canonical literary movements, the generations of 1898 and 1927, Retana helped to create an erotic, pulpy prose explosion, along with writers such as Eduardo Zamacois, Joaquín Belda, Antonio de Hoyos, and José María Carretero.[5] For Mira these novelists constitute a visible, clearly defined group of producers of gay camp who were conscious and ironic about their marginality yet found expression through references to the gay icons of classical, decadent, mannerist, and popular entertainment art—the cupletista Celia Gámez and the ritual of bullfighting being two of the most important specifically Spanish signs of this tradition.[6] *Imitadoras de estrellas* (imitators of stars), banned in but still surviving through the twenties, occasionally resurfaced in the thirties but definitively fled underground after the establishment of the Franco regime, at which point many were imprisoned (Retana, *Historia de la canción*, 178). Like Insúa, Perojo, and Rey, Retana and most of the erotic writers were branded as Francophiles, which double-referenced their ambiguous sexuality and cosmopolitan tastes.[7]

Retana prided himself on his knowledge of the *género frívolo*, or the *género ínfimo*, wrote songs, "studied the psychology as much as the

environment" of the stars of the variety shows, and referred to this world in his novels (Retana, *Historia del arte frívolo*, 22). Apart from his novelistic endeavors, Retana was also known as a major costume and set designer for *varietés*, from which he gained a reputation for being outrageous (Jo Labanyi, pers. comm.). Ramón Gómez de la Serna described Retana as "a witch in a trench coat who, with exultant probing, is capable of slipping through dungeons and dressing rooms in order to reveal the best-kept secrets of the stars" (Ramos, 126). Retana's histories of song are anecdotal but comprehensive albums of singers, folklóricas, and *imitadoras de estrellas* (or male transvestite artists) of the twenties and thirties. These accounts vividly remember the lives of people who had been all but obliterated by either censorship or critical opprobrium.[8] Many of their own books and essays had preserved the memory of *sicalipsis* and the *imitadoras de estrellas* who mimicked the likes of Concha Piquer, women cross-dressers such as Teresita Saavedra or Perlita Greco, who starred as the male *protagonista* in José Juan Cardenas's review *El príncipe Carnaval*, and even the lesser-known folklóricas who never made it to the screen. Fortunately, writer-historians like Retana also documented the emergence of lowbrow media (circus, popular theatre, cinema) as demonstrated by the *imitadora de estrellas* Monsieur Bertín (1908), who apparently was inspired by the Italian Leopoldo Frégoli, a quick-change artist and master of impersonations (Retana, *Historia del arte frívolo*, 137). Cross-dressing as a circus act (*transformismo*) was also an attempt to shield transvestite performers from official scrutiny. They remained obscure, despite the imagination, originality, and talent of performers like Edmond de Bries, who designed his own extravagant costumes and repertoires and managed his own career (Ramos, 118–19). In a world apart, sheltered from the vicious homophobic prejudice that marked the writing of most cultural critics, these *imitadoras de estrellas* that Retana recalls—entertainers such as Derkas, Edmond de Bries, Luisito Carbonell, Freddy, and Mirko—were not very different from other performers.[9]

Derkas was in fact a possible model for Lluís Serrancant, the protagonist of *Un hombre llamado Flor de Otoño*. Like Retana, Derkas (born Manuel Izquierdo) was born in the Philippines to a prominent Spanish functionary, although unlike Retana, his mother was not Spanish but Filipina (Retana, *Historia del arte frívolo*, 140). Although nothing is ever made of Derkas's Philippine heritage, we can only assume that

this fact marked him. When Derkas was five, his father became a magistrate in Barcelona, where he learned to sing and play the piano, and when he was barely fifteen years old, he debuted as a baritone in a zarzuela company. His "coming out" occurred when he spontaneously volunteered to replace an indisposed lead female singer; the result was so successful that the director, as well as members of the cast, advised him to dedicate himself to the imitation of female stars.[10] His father threw him out, but he disguised himself as a woman and moved to Berlin, where he won first prize in a beauty contest (Retana, *Historia del arte frívolo*, 140).

In *Ocaña: Retrat intermitent* and *Un hombre llamado Flor de Otoño*, José Pérez Ocaña and Lluís Serrancant recuperate the lost history of the *imitadoras de estrellas*, encouraging spectators to imagine how these figures of the twenties might have lived had they known the freedom of the transition. An important facet of *Un hombre llamado Flor de Otoño* is its commentary—situated in the twenties yet applicable to 1978—on the marginalization of homosexuals by not only acceptable society but also fringe society (anarchist groups and gay vaudeville). Indeed, this film has been described as a "splendid gallery of losers, of beings crushed by History, of individuals who only with difficulty can maintain their identity while surrounded by collective injustice, intolerance, coercion, and even forced sacrifice of their lives, which are unusable for anything that does not correspond to the modest aspirations to happiness" (Monterde, 50).[11] Based on the play *Flor de Otoño*, written by José María Rodríguez Méndez in 1972 and published in the theatre journal *Primer acto*, Olea's film, shown in Catalan, was prohibited in the theaters before 1975 (Casas and Torreiro, 99).[12] It recounts the life of Lluís Serrancant (played by José Sacristán), son of a Catalan bourgeois family that owned a factory. Lluís lives a double, if not triple, life. By day he is a lawyer and semiclandestine anarchist; by night he is the transvestite performer Flor de Otoño (Autumn Flower) at the Bataclán club in Barcelona's Barrio Chino. Embroiled in political, professional, and domestic tangles with his fellow anarchists, cabaret colleagues, and doting mother, Lluís struggles to assert himself against the rejection he suffers in each of these spheres. The climax of the film comes with his confessing his "true" identity to his mother, his failed attempt to blow up a train carrying the dictator Primo de Rivera, and

his inability to unite the anarchists, who shun his homosexual life-style.[13] Ultimately, Lluís, his lover, and an anarchist friend are jailed, condemned to death, and shot by firing squad for their homosexuality and anarcho-syndicalist terrorism.[14]

Pedro Olea was wary, however, of making a "melodrama with a desperate gay man" or a tragic homosexual (Casas and Torreiro, 100). Working in the shadow of the well-received *Cabaret* (dir. Bob Fosse, 1972), he asked the scriptwriter Rafael Azcona to create a sense of *esperpento* (frightful absurdity) (Monterde, 46) and inflected Méndez Rodríguez's exclusive focus on aggressive destruction of social norms with several song-and-dance sequences in which Lluís as Flor de Otoño performs at the Bataclán. These full-length song sequences transport the film spectator back to the culture of the cuplé and its themes of prostitution, exploitation, and fallen women. The lyrics of the first song, "Flor de mal," which was originally sung by Raquel Meller, manifest themselves in Lluís's performance as both ironic (as he flirts with the audience) and evocative of the painful memory of fallen women and *imitadoras* whose lives have ended in destitution:

Abandoned by all,
Unprotected since I was a girl,
My road was a deep and inevitable rut of perdition.
Poor me!

[Refrain]
And because of my eternal sadness,
Because of my fatal destiny,
I was a flower without aroma,
Fleur de mal![15]

The second song delves even further, however, into the piquant double-entendre sensibility of the cuplé:

In the hands of a love-struck girlfriend,
The parasol is an expert language.
It says, "Don't come near," when closed
And says, "Come on over," when open.

For some critics this increased focus on the entertainment world was to the detriment of the film: "[The film] does not go beyond one of those serials of the time that Luis César Amadori would film to better glorify Zully Moreno or Sara Montiel, substituted by José Sacristán" (*Arriba*, October 10, 1978).

From the border of civilized society, Lluís declares war on repressive bourgeois structures (Losilla, 62), and the film clearly vindicates the sex and politics that had previously been censored on screen. Lluís is Catalan but a champion of the working class, and radical Left politics were associated by the Right with homosexuality and cosmopolitanism. Like Nonell in *El negro que tenía el alma blanca*, Lluís is simultaneously racialized and sexualized. His transgression is waged in not only the political but also the aesthetic and affective realm of his queerness, the world symbolized by the Bataclán and by the tenderness and mutual comprehension that Lluís shares with his mother. Lluís's queerness is more than just a transvestism understood as a faithful copy of authentic femininity, a potentially politically vacuous escape valve for heterosexual panic that turns homosexuality into mere representation and feminization (Ballesteros, 109), and he is more than a political martyr whose homosexuality can thus be forgiven. As Lluís is sentenced to death, his mother gives him her lipstick case, acknowledging his right to live the gender he chooses instead of acquiescing to his mother's family—the capitalist bourgeoisie—and hiding it. Lluís's transvestism, which exposes the constructedness of gender, is a multifaceted, uncompromising conjunction of politics, affect, aesthetics, and sexuality that defies facile labels and explanations.

Like Lluís, Ocaña represents a protoqueer individual who insists on sexual and gender ambiguity, refusing any heteronormative definitions imposed by family, police, political parties, or the state. He categorically rejects the term *transvestite*, seeing it as a surrogate for cheapened art or imitation: "I like to cross-dress, but I'm not a transvestite."[16] At the same time, he evokes the Rafael de León song performed by so many folklóricas, "Yo soy esa" (I am her), whose lyrics, "yo soy la que no tiene nombre, yo soy esa" (I am that woman who has no name, I am her), he explains in the film, prefiguring a core tenet of queer theory: "[The woman who has no name] is not an essence, but something that lacks essence, because in fixed categories those women were neither

women, nor virgin, nor whore, but otherness." Like the phrase "that woman who has no name" or the word "queer," which was established to replace "gay" and "lesbian," Ocaña's defiance of definitions challenges the "normalizing mechanisms of state power to name its sexual subjects" (Eng, Halberstam, and Muñoz, 1). Ocaña's reliance on Rafael de León was also part of a long tradition of transvestite song repertory:

> The flamencoist songs of Rafael de León are a constant in the repertory of transvestite artists, but in addition, the relationship between these songs and homosexuality is inscribed in these very texts, and it is this mode of transvestite representation that permits gay identification. (De Mateo, 308)

It is in this context that we should recall how Miguel de Molina, one of the most prominent performers of the *canción andaluza* and openly gay in a severely homophobic society, claimed that Rafael de León and Lorca wrote "Ojos verdes" expressly for him and not for Piquer.

Like Molina's outspoken affront to Franco's enforced heterosexual society, the social processes that produce and recognize homosexuality are blunted by Ocaña's description of his emergent sexuality in his boyhood. Describing how he thought of his relationships with other young men while growing up in his hometown, he states, "To me it seemed normal to be either macho or gay." His first contact with the word "homosexual" was when he arrived in Barcelona: before that "what we did back then were 'erotic games.'" Ocaña advocates a queerness whose "fluid, indeterminate sexuality [is] predicated upon a proliferation of sexual acts and fantasies that defy definition through strict gender binaries" (Pérez-Sánchez, 192). He describes himself from a politically anarchic position, seeing politics as a struggle for identity, selfhood, and idiosyncrasy: "What I fight for is being me and being a person. And I don't care if I dress as a chick, dress as a nun, or dress as whatever, as long as I can be what I want." Matter-of-factly (and understandably) he rejects labels such as "homosexual," which he sees as mechanisms of control. Far from a philosophy of liberal individualism, however, Ocaña demands a collective struggle against oppression, and despite his complaints about the homophobia of the anarcho-syndicalist National Confederation of Workers (CNT) or his memories of working-class

bullies, his politics link him with other marginalized groups. Ocaña's individualism is a strategy to contain the drive that would annihilate him and all other subject positions considered deviant.

Fusing the sacred and the profane—collapsing the fallen woman and abject mother into virgin iconography—Ocaña dismantles Francoist heteronormativity in a Buñuelian critique of religion, which exposes its hypocrisy and turns its imagery on its head. True virgins are not the domestic angels of the home but whores of the street—"María de las Ramblas"—or the mothers whose children have been taken from them; women institutionalized, incarcerated in insane asylums; or women crying at the prison gates for the release of their sons. Here lies the double oppression of female Andalusian subjects: victims of cyclical abuse by their fathers or husbands, they are further violated by armed civil guards: "Up to her comes a policeman with a gun. I don't know; it's Andalusia, and Andalusia is like a surrealist painting" (from *Ocaña: Retrat intermitent*). In an intermittent sequence of one of Ocaña's staged minimalist tableaus, tragedy is not the fallen soldier but the "hysterical" and existentially lonely woman. Wearing a thick black veil, Ocaña invokes her by cradling a papier-mâché child and recounting the dark secrets of her family, her incarceration, and the lies about her child's suspicious illness.

Dressed in full-fledged flamenco dress and heavily made-up, Ocaña sings in a cemetery, effectively replacing the funeral dirge of an asexualized widow with a sexually vibrant young woman who channels her painful, burning memory of bodily ecstasy with her dead lover through *cante jondo*. Lorquian poetry inspires Ocaña's lyrics:

> Lo que vale son tus brazos cuando de noche me abrazan.
> ¿Lorca, gitano moreno de verde luna, dónde está tu cuerpo santo?
> ¿Dónde está la gente que por la noche vinieron a adorarte?
> What matters are your arms that embraced me at night.
> Lorca, dark Gypsy of the green moon, where is your sacred body?
> Where are those who came at night to adore you?

By taking his performances "beyond the workings of gender and sex to the realm of 'aesthetic performativity,'" as Gema Pérez-Sánchez writes of queer performativity, Ocaña grounds high cultural norms with elemental cultural allusions (Pérez-Sánchez, 192).

Catholicism's domestic ideal of woman and the home is recycled into Ocaña's aesthetics. This world comes to us via a traveling camera that moves not only through his paintings but also through his home, destabilizing the boundary between public and private and affirming the feminine domestic space as revolutionary, visionary, and structured by feeling. In contrast to the provocative street performances of other intermittent sequences, the camera shows us Ocaña dressed in casual, modern women's clothing and shopping for food in the street market while pedestrians notice his dress, wondering if this is performance, ideology, or mere documentation of the quotidian.

The sacred sites of Catholicism—cemeteries, tombs, coffins, religious statues—are objects of meditation, fascination, and imagined ecstasy that merge with Ocaña's memories of euphoric sexual awakening and innocence and then become superimposed upon the bacchanalian street rites of the transition: "All of that is poetry, superstitious tradition, and it all gets mixed up in my painting; I have all these memories of the fiestas, weddings, baptisms, drunken fests, pilgrimages, folklore." Ocaña's staging of the Feast of the Assumption reconstructs his hometown's surreally baroque aesthetics—"Fellini would be astonished by it"—which includes satin gowns, gold cloth, feathers falling from the sky onto three hundred little girls dressed as doves, and women wailing. The performance filmed in this sequence features altar boys "whipping" child penitents in a nod to S and M, while on a balcony above he parodies the gossipy, catty señorita who delights in the gazes directed at her. These religious fetishes are, he says, residues of his Catholic education, but at the same time, he uses them to undermine church structures: "The church is getting better, but it will be even better when we get rid of capitalism."

This cornucopia of antimodernity and surrealism is, as Ocaña recalls, what modernizing intellectuals wanted to take away from the *pueblo* and, especially, from the old women. And as presently discussed, this is the impulse that refuses recognition of camp's potential to subvert Francoist folklore aesthetics or to revive cuplé culture. But for Ocaña these seemingly disparate elements fit together perfectly within his queer logic, becoming a historical, visual idiom. He makes the connection that many spectators always felt was there just beyond the horizon, blended together but never articulated: the shared visual idiom in which virgins and saints dwell in bliss with cupletistas, folklóricas, and

prostitutes.[17] For Ocaña and Lluís/Flor de Otoño, the critique of capitalist modernity and heteronormativity is compatible with an aesthetic
that embraces otherness in all of its forms. In an intimate close-up,
Ocaña as "himself"—no makeup, in his uniform of black Andalusian
hat, white shirt, and black trousers—tells the camera, "I am marginalized. Like the prostitutes, like the gigolos, like the fags, like the thieves
who steal motorcycles, even though I am a painter I can put myself in
that World; I feel identified with those people; I love them, and they
fascinate me." Queer here is gay, but it is also understanding one's identity in relation to the state as a dissident.

Rupture versus Recycling

The transition to democracy has been widely understood as having provoked deep epistemological and phenomenological changes in Spanish society. The transition has been seen, written about, and probably
felt as a deep and permanent rupture with the past. Cristina Moreiras
Menor describes the years following Franco's death (1975–79) as a celebratory ecstasy and an exaltation of novelty. Euphoric anarchy, revolt
against dictatorship and religion, and ludic sexual transgression (as
featured in *Ocaña* and *Un hombre*) powered the previously illegal gay
marches, anarcho-syndicalist demonstrations, and uninhibited, public
heroin shooting—a street culture at which half (or more) of Spain was
left to gawk, scandalized and shocked.[18]

Both *Ocaña* and *Un hombre* endorsed this jubilee. Abandoning the
austere Francoist body and emphasizing bodily pleasure and desire encouraged Spaniards to understand the transition as a break, a fissure,
or what Vilarós calls "a fissure and a rupture" from the linear narrative
of Francoist historiography (13, 14, 20, 22).[19] Movie reviews of the time
claimed that *Ocaña* marked the death of Francoism, both through its
spirit of freedom and its appropriation of Andalusian popular culture
as subculture and camp, parodying the conservative, regime-endorsed
version of folklore (see Moix). For Vilarós, Ocaña's happenings gave
form to the new social body of the postdictatorship, capable of violent,
spectacular displacements of traditional modes of being (183). Here,
film broke with the Francoist past while reviving the past cultures of
subversion in which sexually and politically marginal individuals were
openly defended.

Undermining the Francoist protocol of realism, Ocaña operates with experimental forms and structures, confirming the idea of transition as a break. In this sense, Pons's visual biography of Ocaña organically mirrors his life, work, and the philosophy expressed by his acts of filmmaking. The interaction of content and form constitutes a meditation on the metonymic quality of knowledge—we can only focus on a part, which is always linked to a larger context. Live performance footage from stage and street acts alternates with sections of an interview with Ocaña on his bed at home or pans of his paintings and exhibits. Each performance appears, in its partial form, to emulate Lorquian theatre, cuplé culture of the *cafés cantantes*, popular theatre of the Hermanos Álvarez Quintero, or punk flamenco. In one of the brief sequences, Ocaña is performing on stage to rock 'n' roll, swaying his hips in rock dance fashion but dressed up in a pink flamenco dress with red ribbons and a matching red shawl. The breakdown and fusion of generic codes is a constant in this documentary/performance, and the lack of explanation or commentary about this decision quietly yet defiantly reinforces the deconstruction of normalized genre. The digressions of earlier entertainment have been greatly extended; the content here is fully located in the intermittent sequence of the digression. There is no longer a difference between the main narrative and the intermittent sequence; everything is in-between.

Many of Ocaña's gems of wisdom reinforce the idea of breakage but are spoken in a relaxed, colloquial, commonsense Spanish, in medium or intimate close-ups, during the interviews when he plays "himself," simply another character in this assemblage of hybrid identity. In a tone whose naturalness and frankness about sexuality might seem an impertinent assault on Francoist morality, Ocaña says: "You were asking me why I strip on the street." He answers, "Well, I would like to know why people wear clothes. . . . I think, why not walk naked down the street. It's like breaking something, and well, I like to break things." Here, the idea of tearing off clothing that represses the body takes on a meaning of breaking away ("It's like breaking something, and well, I like to break things"), both metaphorically and literally. The actual body is liberated from the trappings of heteronormative culture and from the Francoist body but not completely disassociated, however, from the past. The new body contains a synthesis of residues from the past, but of traditions that were repressed and cut off from the Francoist social body.

Ocaña thus breaks from the past by remaining linked to a more distant past. And the roaring twenties' bawdy cuplé culture erupts into the interview, much like the distracting digressions of early cinema. In this intermittent performance Ocaña wears a flimsy pastel dress, a wide and floppy-rimmed sun hat topped by a feather, and movie star glasses. Swaggering down the Ramblas he ostentatiously fans himself, effeminately arm in arm with a *chulo* (his friend Camilo) and the graphic artist Nazario (the creator of *Anarcoma*). In the manner of striptease acts of the risqué pre-1936 variety shows, he gracefully lifts his dress, flashing us his naked body, and then in a queeny display of affected modesty, he pats his crotch, unconvincingly trying to veil his exposed member.

Excising race from the understanding of the transition encourages seeing it as a time-out from the larger narrative of capitalist modernity. The leftist intellectuals, in their disenchantment (*el desencanto*) with the missed opportunities of 1975 and then 1978, bitterly mourned the revolution they had hoped for ever since 1968, while their certainty of a constitutional monarchy and an electoral, parliamentary politics precluded their focusing on any ideological flaws in liberal capitalism. Around the world revolutionary fervor was rising, and with the momentum came profound changes. But in Spain the Left was forced to bide its time until 1975—at which point the Socialist Party, it was felt, betrayed the Left by compromising with the Right and foreclosing any possibility for radical change. Both the Left and the Right agreed on a politics of consensus, a pacted rupture (*ruptura pactada*) in which "both sides shared power and responsibility for overturning the Francoist politics, as a way to ameliorate the differences between them and to secure their place in the fledgling democracy" (Garlinger, 7). Cristina Moreiras Menor describes *el desencanto* as a disillusionment resulting from the uncertain possibility of democracy and the "crisis of affect" in placing such high hopes in democratic gains when what really occurred was a diminution of democracy. As both Ocaña and intellectuals hoping for revolution quickly realized, the death of Franco might have allowed for naked bodies, but it didn't change the class structure or the social injustice caused by centuries of petrified socioeconomic relations. Wishing the past dead but having to concede to its terms unbearably weighted the present and inhibited a hopeful future (15–17).

Trying to forget the failure of revolution resembled the historical

surgery Francoist historiographers performed on the history of the radical Left in Spain prior to 1939. But *Ocaña* is a film that documents the past and the present (of 1978) as linked scenarios. The continuity between Francoism and post-1975 is envisioned as a haunting in which ghosts of the past live on residually in textual and material violence. *Ocaña* and *Un hombre* and their protagonists—"refugees from history" (Labanyi, "Hauntology," 73)—confront the past while using it to reconstruct a present and future that are just as much memory as they are actuality.

The way critics framed their reviews of the films in 1978 and the more recent attempts of Spanish queer theorists to frame these films as queer and Catalan, as opposed to Andalusian or anything else that might smack of race, reveals a deep, perhaps unconscious bias in the way queerness, peripheral national identity, and a racialized Andalusia get mapped onto the Spanish collective imaginary. Scholars like Josep-Anton Fernández are quick to point out that *Ocaña* "must be hailed as a pioneering work in Catalan culture because of its attempt to integrate both homosexuality and the culture of the Andalusian diaspora into the discourses on national and cultural identity in Catalonia" (92). He nevertheless reverses himself on this very point, arguing that Ocaña's sexual discourse might be subversive but his nationalism is patently not: "For we know that much of the film is Andalusian, but what is really Catalan about it?" He laments that *Ocaña's* marketing slogan, rather than extolling Catalan culture, pitches the film as "a Catalan film spoken in Andalusian" (91).

Despite Ocaña's explicit references to Andalusian resistance to state oppression and the violent repression of Andalusian workers by police, Fernández claims that the anarchist ideas in the film were "linked to a certain Barcelonese tradition." Ocaña's "(micro)political endeavor" to politicize his marginality is taken by Fernández to mean his homosexuality and his domicile (Catalonia), as opposed to any possibility of Andalusian self-determination (90). Ocaña's parody of Andalusian popular culture and his recalling of the Andalusian diaspora ignores, according to Fernández, the Catalan forced migration under Francoism and reeks with nostalgia for the antimodern past of a fetishized popular Andalusian religious culture. Any intelligent parody or camp aesthetics is attributed by Fernández to the director, Ventura Pons, who has thankfully, Fernández implies, since focused his energies on building a

more prestigious and marketable Catalan star system (98). In passing, Fernández blames Labanyi's supposed postmodernist orientation for her failure to mention the Catalan origin of the film, complaining that she overemphasizes the film's postmodern hybridity, "as if the presence of an Andalusian drag queen in Catalonia were 'the most natural thing in the world.'" In his final indictment of the film, he states:

> We are confronted here with a case of misrecognition: Ocaña personally might be in a marginal position, but his culture [Andalusian popular culture] is not. Quite the opposite: legitimated by the state, delegitimated by its Francoist appropriation, and relegitimated by a discourse on marginality and gender subversion, it is universally known and recognized, and its legitimate and representative character is misrecognized precisely as an effect of that discourse. Ocaña's misrecognition takes place at the expense of the Catalan dimension of the film, which is relegated to a position of invisibility.[20] (Fernández, 92)

The basis of Fernández's argument is that Ocaña's performance of Andalusianness, despite its catastrophic critique of religion, police, and Francoist sexual politics, usurps attention from Catalonia's status as marginalized internal other. Yet Catalonia's Europeanist stance reinforced the politics of difference in Spain, which tended to be seen as "different," atavistic, antidemocratic, and antimodern (Flesler, 37). From this latter perspective, it would follow that Spain was characterized by autonomous communities like Andalusia, whose proximity to and historical ties with Africa increased its potential to contaminate and, at its most threatening, to obliterate the boundary between Spain and Africa. On a symbolic, essentialist level, this enforcement of hierarchies, evoking the phrase "Who is on top?" reveals the links between race, (homo) sexuality, and the nation's place in empire and returns us to the issue of racialized vision and empire that introduced this book.

Race, Sex, and Paranoid Empire

Gay anarchists and the historical figures of Lluís and Ocaña, as well as Lluís the filmic character and Ocaña's artistic projections of himself, were out to turn on their heads the very foundations of Western

capitalist modernity. The intersection of their political aims and their deviant sexuality boldly confronted the state's historical and discursive mechanisms that have sexualized the race and racialized the sex of so-called deviant individuals. Criminalization was one way to control this extreme otherness, and legal control was necessary because race and homosexuality were not outside but inside the national body. Race was written into the state and its laws not only during the period of Jewish-Muslim-Christian coexistence but also during the centuries that followed, when inquisitorial laws enforced mass expulsion, genocide, or conversion of Muslims, Jews, and Gypsies (Mariscal, 15–19). As discussed in chapter 5, laws pertaining to the Roma came long before literature about them, and some of these old laws remained, in altered forms, until the 1970s. The Law of Vagrants and Thugs (Ley Relativa a Vagos y Maleantes), passed in 1933, was commonly used to round up Roma. In 1954, Spanish jurists modified articles two and six of the law to ensure that homosexuals were subject to security measures such as labor camps, surveillance, and prohibition from certain spaces (Pérez-Sánchez, 25, 28). The same law that had criminalized racial others now codified sexual others as criminals.[21] In 1970, Franco passed the Law of Social Danger and Rehabilitation, a revision and reinforcement of the 1954 Law of Vagrants and Thugs (Pérez-Sánchez, 28) and, in 1971, established institutions like the Center in Huelva for the incarceration of "dangerous" homosexuals, whose reeducation treatments included "electroshock, aversion therapy, attacks and sexual abuse from other inmates and guards" (Pérez-Sánchez, 30). For Pérez-Sánchez, Spain's "obsession" with codifying homosexuality was produced by an "anxiety at perceiving its own position within the western International community as one of [effeminized] marginality and [unmasculine] deviance" (Pérez-Sánchez, 8). In Gamberros, homosexuales, vagos y maleantes: Estudio jurídico-sociológico (1962), the Francoist judge Julio Antonio Sabater, an avid promoter of these laws, portrayed homosexuals as transgressors of family, gender norms, and, thus, the regime itself. Psychopaths, deviants, and anomalies, homosexuals were for Sabater primitive beings "with an intense instinctual life that has no room in civilization" who must be domesticated because they are "dangerous to the progress of humanity" (Pérez-Sánchez, 30). Like antiterrorist rhetoric, this legal language criminalized political prisoners because they threatened the national family.

Francoist laws persecuting homosexual practices lasted until 1981, buttressed by ideologies of empire and the national family. Homophobia was, like other aesthetic and ideological elements of Francoism, tied to sixteenth-century fears of Arab and Muslim otherness, stemming from anxiety about the growing Muslim population. And early tourist guides—basically advertisements for gay sex and transvestites—strengthened the "association between Muslims and sexual perversion" (Boone 181–82). The racialized and sodomite Arab reemerged in the nineteenth-century militarism that coincided with the explosion of discourses on sexuality (Boone 181–82). Internalized homophobia and homosexual self-loathing complemented an idea of military power as manly and youthful and bonded with itself against racial degeneracy. Male homosocial bonding easily slipped, however, into homoeroticism and homosexuality (Martin-Márquez, 188). Such a "racially homosocial if not homosexual ethic [was] sometimes filtered through the aesthetic homoeroticism of Orientalism" in Fascist literature like Franco's *Diary of a Battalion* (1939), in which Franco

> attempts to revamp the sexuality of his troops onto a more "normative grid," in which relations between Spanish and Moroccan men in particular [were] carefully regulated. But this [was] evidently a 'panicky' response to the behavior of any number of soldiers who [might] have eschewed the straight and narrow in their preference for going native, sexually speaking, that is, for "going queer." (Martin-Márquez, 191)

More insidious than the actual act, which certainly took place among Spanish troops, were, however, the ideas that Spanish soldiers had about themselves: Were they on top or on bottom? And wherein lay the Spanish nation vis-à-vis Europe in this sexualized and racialized paradigm (Martin-Márquez, 191; Pérez-Sánchez, 187)? The *árabe malo* (bad Arab), the mongrel Andalusian, women, Gypsies, and indigenous people—these members of a decadent, feminized race—had to be colonized before they too served as a colonizing force (Martin-Márquez, 192). Total submission—a rape in which "anal penetration produces an erasure of the boundaries of the self, 'a shattering of the male ego that is tantamount to psychic death'"—was necessary in order to sustain the fantasy of domination (Boone, 60).

Throughout the late nineteenth and early to mid-twentieth centuries, the image of the Arab in the Spanish national imaginary alternated between what Martín Corrales calls "the good, idealized, and orientalized moor and the bad invader moor." Civil war rhetoric by Africanist officers, such as Juan Yague in 1938, asserted that "the 'savage reds' needed to be civilized in the same way as the Moors had been." Yet Arab enemies needed to be reclassified as Arab friends by Spanish Africanists employing North African troops against leftist rebels on the peninsula (Martin-Márquez, 203). Thus, one heard that "Spanish leftists were racially inferior to Moroccans" and that "Moroccan soldiers would serve as a model of virility for the effeminate 'reds of Spain,'" who were "as much a threat to the future of Islam as to Christian Spain" (Martin-Márquez, 203–5). Like the discourse of hispanidad that Spain extended to Latin America, Moroccans became brothers, united with Spaniards against the common enemy of atheist Communism (Martin-Márquez, 206).

As discussed in the introduction, the same kind of representational mode engulfed views of the Roma throughout the history of Spanish film culture. Fictional Gypsies were either idealized and romanticized or bestialized and demonized. The demand for Gypsies who were symbolically central yet socially marginal parallels how women and gay men have been charged, despite their secondary status, with symbolizing the zeitgeist of the transition (the transvestite as embodiment of rupture with dictatorship), the nation's ideals (women as a signifier for whiteness), and collective fears of racial otherness. And as I have shown, the conjoined racialization and sexualization of these three different identity groups was central to the deployment of both local attempts to contain and assimilate sexual–racial external otherness and global strategies of conquest and colonial policing. That this racialized vision of the folkloric films took place, in its totality, within an entertaining, comedic spectacle speaks to its persuasiveness. More than any other Spanish film genre, the folkloric film musical became the institutionalized battleground for winning over the public (Labanyi, "Musical Battles"). Of the 109 feature films made between 1932 and 1936, 21 were musical films and 18 were españoladas (Gubern, El cine, 156); between 1939 and 1950, 22 musicals and 21 folklórica musicals were produced (Monterde, 238). Although ideological slippage is inevitable in

comedy's tactics of distance and parody, Ocaña and gay camp reminds us that unless there is complicity somewhere in the communicative and hermeneutical process, subversion cannot exist. Those who are represented in images they do not recognize are "those who have known in their bodies the violence of the system [and] are less inclined to be deluded by its idealizations and rationalizations" (Shohat and Stam, 359). If this book has any effect, I hope it will be to encourage future research on the uncountable images that remain to be acknowledged from this critical perspective and that are testimony of the history of racialized vision in Spain.

Acknowledgments

I am grateful for support from the Program for Cultural Coopera-
tion between Spain's Ministry of Education and Culture and U.S.
Universities, the American Association of University Women Summer
Publication Grant, and especially Vassar College, my home institution,
whose nearly continuous summer travel grants (Emily Floyd Fund,
Salmon Fund, and the Dean of the Faculty) have made possible the
archival and film research for this book.

Certain individuals at Vassar are indelibly linked to this project:
my student research assistants, Emma Lowe, Lydia Mendoza, Elisa-
beth Johnson, Raluca Besliu, and Cynthia Borja; my sage and support-
ive colleagues in Hispanic studies, many of whom have read several
versions of this manuscript, Andrew Bush, Michael Aronna, Mario
Cesario, Mihai Grunfeld, and especially Lisa Paravisini-Gebert; those
friends whose presence is manifest in many of the pages of this book,
whether through lending a hand, listening and consoling, or babysitting:
Barbara Olsen, Shona Tucker, Dorothy Kim, Gunnar Danell, Jenny
Magnes, Peggy Piesche, Colette Cann, Linta Varghese, Quincy Mills,
Ivette Romero, Mia Mask, Kathleen Man, Eve Dunbar, Pepa Hernán-
dez and family, Heesok Chang, Angela Smith, Rick Jones, James
Olson, and Mary Griffith. Finally and most important, I acknowledge
my brilliant and generous writing group colleagues, Jeffrey Schneider,
Susan Hiner, and Joshua Schreier (and of course Elliot, Jamie, and
Ellen), who critiqued these and so many other chapters that were not
included here.

Sincerest appreciation goes to colleagues at the Filmoteca Nacional
de Madrid, most significantly Margarita Lobo, my now friend and men-
tor, but also Trini, Miguel, and Javier Herrera; to Rosa Saz Alpuente at
the Filmoteca de Cataluña; and to Josie Walters-Johnston at the Library
of Congress. Deepest affection and thanks goes to Román Gubern for
friendship, conversations, and generous readings. I am very grateful to

Mike Hanson and Wendy Holdman for the attention and expertise spent on copyediting and production. And special thanks to Minnesota's editor, Jason Weidemann.

I owe a debt of gratitude to the mentors, professors, and friends who have believed in me over these twenty years, Roberta Johnson, Sharon Feldman, Celia Weller, Judy Liskin Gasparro, Lou Charnon-Deutsch, E. Ann Kaplan, Tom Lewis, Malcolm Reade, and especially my dear friend and dissertation advisor, Kathleen Vernon, for her unending support, and to those beyond grad school, among them Susan Martin-Márquez, Susan Larson, Daniela Flesler, Leigh Mercer, Bradley Epps, George Soros, Alberto Elena, Fran Zurián, Josetxo Cerdán, Marina Díaz, Rosa Medina-Doménech, and Manuel Palacios. I owe Jo Labanyi more drinks than anyone else for her meticulous and thorough critiques of this manuscript.

Thanks goes to those friends who have taken me into their arms in times of need, and all the other times: Michelle Archange, Lonnie Lee Clark, Deborah Paredez, Susan Larson, Anja Behm, Susanne Leisy, Isolina Ballesteros, Chandra Balkaran, Mindy Daeschner, Ester Lomas Sampedro, Jonathan Wright, Harold Aram Veeser, Coco Baran, Katie Halper, Nora Eisenberg and Jimmy Halper, and Maria Alba Fisch. Special thanks goes to Jonás de León and Inés de León.

And finally, I thank my mother, María Carmen Peiró Vitoria, who did not live to see this book; my family in Spain, María Luisa, Carmelo, tío Ramón, María José, Luis, Pilar, Miguel Ángel, Eva and Ramón; my family in the United States, Sara, for her steadfast loyalty and love, my beautiful Sebastián, for teaching me the meaning of the present, Annie, who helped me to heal and grow, and my father, William F. Woods, for everything—this book is for you, Dad.

Notes

Preface

1. Throughout, all translations of Spanish-language sources are mine.

2. See "Comienza el año europeo de lucha contra la pobreza y la exclusión social," http://www.gitanos.org/index.html, February 2, 2010.

3. Spain's constitution does not recognize or define ethnic minorities. Although there is emphasis on the protection of the individual, this individual is positioned as a white European. In statistical terms, then, Roma are not distinguished from the rest of Spaniards but are considered citizens equal to all other citizens under the law. Since the law does not allow for the gathering of disaggregated census data based on race, sex, or gender, theorizing or quantifying the historical and present condition of Roma as minorities thus is not possible. As a result existing data on groups such as the Roma is primarily secured by sociological research in universities and in private studies (see the Council of Europe's Framework Convention for the Protection of National Minorities, Article 3, http://conventions.coe.int/treaty/en/treaties/html/157.htm), while official governmental organizations such as Spain's National Institute of Statistics and NGOs are incapacitated when collecting official statistical data on Spanish Roma.

4. According to Humberto García González-Gordon from the Fundación Secretariado Gitano, *gitano* is the term used today by most Roma and non-Roma Spaniards, while Roma is employed by organs of the European Union. Yet because Gypsy has negative connotations in North American English, as well as among North American Roma, I have opted to retain the term Roma for the historical people and Gypsy for the stereotype.

Introduction

1. See Hernández Eguiluz, "Definición y tipología de la 'españolada,'" in *Testimonios en huecograbado*, 181–93, for a summary of definitions of and debates about the españolada.

2. When interviewed by the researchers of the Oral History Project of Spanish Cinemagoing, fans of folkloric musical film were almost exclusively women. Regarding the symbolically central yet socially marginal identity of the Roma, Lou Charnon-Deutsch writes: "Their symbolic role grew and formed part of the contradictory vision of the nation's internal other who was variously seen as resourceful materialist or useless idler, accomplished entertainer or primitive bivouacker, beautiful girl or evil horse thief. These stereotypical attributes allowed the dominant classes . . . to define themselves as the only legitimate race [for citizenship], in contrast to those groups that did not belong on the nation's soil and had no 'natural' right to be there" (*The Spanish Gypsy*, 43).

3. According to Sevilla Guzmán and González de Molina, even Andalusians of "Aryan" descent were conflated with Arabs and people from Turkey in expressions like "Andalusian Moors" or "Andalusia is Spanish Morocco" or the "stigma and shame of Europe" (90).

4. Cited in *Spain and the Jews*, 13.

5. For David Theo Golberg race must be seen through the lens of the modern state. Racial distinctions and exclusions get converted, because of prior circulation, into the fabric of state definition and practice. After colonialism race is cast as being outside of Europe; the state must turn into itself in order to deal with its internal others, control its population in the urban centers, and keep out undesirables. It needs to create a new exteriority so as to secure containability (*The Racial State*, 161).

6. "White identity loses its transparency and the easy elision with 'racelessness' that accompanies racial domination. 'Whiteness' becomes a matter of anxiety and concern" (Winant, 187).

7. Taken from the 1674 edition (with Noydens's additions) of Sebastián de Covarrubias's *Tesoro de la lengua castellana o española* (142r). In the 1729 edition are the following definitions: "Fue efta biena virgen purifisima y caftifisima" (This good virgin was most pure and chaste) and "fin mezcla de voces extrañas" (without mixture of foreign tongues) (see www.rae.es and http://bib.cervantesvirtual.com/Buscar.html?texto=tesoro+de+la+lengua+castellana).

8. "During World War II the Spanish government issued passports to more than ten thousand Sephardic Jews in Nazi-occupied Europe. A further forty thousand were permitted to pass through Spain to other destinations." At the same time, Nazi collaborators were provided shelter in Spain after the war, in which Spain had been for some time a passive ally of Germany" (Perednik, under "The Ambivalent Rediscovery of Jews").

9. On May 5, 1941, José Finat, Count of Mayalde, initiated a census

to locate all Jews living or finding refuge in Spain. According to Reverte, the real danger was not the refugees but the "dangerous" Jews of Sephardic origin, who were better able to "pass unnoticed" because they had acquired a Spanish "temperament" from having lived so long on the peninsula.

10. Note the Moroccan-Jewish character Mordejai-Almudena from Galdós's 1897 novel *Misericordia*, as well as the character of the English Daniel Morton in Galdós's *Gloria* (1876–77). Vernon Chamberlin writes, "In *Aita Tetauen* and *Carlos VI, en la Rápita*—both 1905—Galdós clearly rejects the anti-Jewish bias of Pedro Antonio de Alarcón's *Diario de un testigo de la guerra de África* and writes key passages of these *Episodios nacionales* from the Jewish point of view, utilizing the Hebrew calendar and even inventing his own brand of Judeo-Spanish" (105–6). Chamberlin draws heavily from Rodrigo Soriano's book *Moros y cristianos: Notas de viaje, 1893–94* (Madrid, Spain: Librería de Fernando Fe, 1895).

11. In 1930, Giménez Caballero returned from Paris concerned about France's "ascendancy over the Sephardim" and argued that Spain repeal its 1492 expulsion ban. He nevertheless was still in line with Falangist politics, as he saw this as completing the Reconquest "because the Sephardic Jews were Spain's last recovered province" (Rohr, 30).

12. Román Gubern, "El ciclo antisemita del cine español de posguerra" (unpublished conference paper, Simposio Internacional Cine Iberoamericano, Harvard University, May 8, 2010).

13. An amalgamation of beliefs, *nacionalcatolicismo* was articulated by various ideologues and philosophers, ranging from the liberal Right (Ortega y Gasset and Joaquín Costa) to the extreme Right (Falangist ideology). Even before the late thirties, a nationalist ideology assembled itself from scraps of religion, history, and culture, bound together by Falangist elements of militancy and authoritarianism. Carolyn P. Boyd emphasizes the continuity of the coalescence of nationalism, religion, and political domination from the time of the Catholic kings to Franco's regime: "The defining principle of National Catholic discourse was its claim that Spanish nationality had been definitively determined in the sixteenth-century fusion of the 'Catholic ideal' with the 'military monarchy.'" The icons of this cultural model were Castilian ethnicity, Catholicism, ruralism, and, in the first phases of the dictatorship, imperialism (235).

14. "El caballero cristiano no podrá jamás comprender la idea del contrato social, ni la lista de los derechos del hombre y del cuidadano" (The Christian knight could never understand the idea of a social contract or the list of the rights of man or the citizen) (García Morente, 109).

15. "It is undeniable that the cinema exercises great influence upon the diffusion of thought and on the education of the masses; it is thus indispensable that the state be vigilant over all of its areas." (Minguet Batllori, "La regeneración," 3).

16. The Oral History Project of Spanish Cinemagoing documents many cases in which spectators remembered this enforced practice.

17. "Race is integral to, a central feature—indeed, an obsession—of, the historical development of European-influenced and inflected modernity" (Goldberg, *The Racial State*, 50).

18. If as Theodore Allen contends, "the privileging of one race over another occurs in organized ways . . . and becomes effective through particular social establishments," (35) then we should probe the dominant way of projecting race and Spanishness in mid-twentieth-century Spain: the popular cinema. The study of this cinema can provide a form of knowledge about Spain's past and present realities.

19. See Jesús Torrecilla for a comprehensive study of both foreign views and the Spanish internalization of them.

20. In her discussion of gender ideology under Franco, Aurora Morcillo claims that the 1950s ushered in a transition from autarchy to capitalism (34). Pointing out contradictions in advertisements for makeup, perfume, and luxury products that appeared in magazines in the late 1950s, Morcillo notes that this midcentury consumerism was categorically different from that of the forties. Ads in Spanish cinema magazines for Spanish beauty products were, however, commonplace from the 1920s on, and both Spanish and Hollywood stars were featured promoting these products.

21. See Malcolm Read's analysis of Cristóbal de Villón. For Read capitalism in the form of mercantilism was functioning as early as the 1500s. Carlos Lerena argues, however, that the absolutist state was the first capitalist state because of the relative independence with which the bureaucracy functioned economically in regard to the aristocracy (226). For Tom Lewis the notion of an uneven or late modernity fails to consider how a bourgeoisie in Spain was already raising itself up in the wake of the political struggles of the Carlist wars (1835–43). By the early twentieth century this bourgeoisie was not only emergent but firmly established (Lewis, "Structures and Agents," 7, 14). Both Lewis and Lerena point to the French Revolution and its effect on the rest of Europe's expansion of the capitalist mode of production in its competitive phase and its squelching of the feudal mode as evidence for the existence of a full-functioning bourgeoisie in the 1800s (Lewis, "Structures and Agents," 9;

Lerena, 142–43). Although it did not dominate, it coexisted in hegemonic struggle with a landowning aristocracy and a petite bourgeoisie.

22. Translated from the original Spanish: "La civilización musulmana no es originaria del pueblo árabe: los árabes la fueron tomando de los pueblos sometidos por ellos. Refiriéndonos a nuestra Patria, es muy cierto que los invasores aprendieron en ella, entre otras cosas, los cultivos agrícolas. Españoles fueron, en muchos casos, los directores de las grandes obras arquitectónicas musulmanas" (*Historia de España*, 65).

23. Historical films include *Inés de Castro* (1944), *Reina Santa* (1946), *La princesa de los ursinos* (1947), *Eugenia de Montijo* (1948), *Locura de amor* (1948), *La duquesa de Benamejí* (1949), *Augustina de Aragón* (1950), *El correo del rey* (1950), *La Leona de Castilla* (1951), and *Alba de América* (1951). Military and missionary films include *¡Harka!* (1941), *Raza* (1942), *Los últimos de Filipinas* (1945), and *La misión blanca* (1946).

24. According to the Framework Convention on Minority Rights, the Roma comprised 1.6 percent of Spain's total population of 46,157,822 as of January 2009.

25. Bureau of Democracy, Human Rights, and Labor 2000, "Country Reports on Human Rights Practices: Spain," U.S. Department of State, February 23, 2001, http://www.state.gov/g/drl/rls/hrrpt/2000/eur/875.htm.

26. "Psychologically Unfit: The U.S. Can't Handle the Death Penalty," The Black Commentator, April 5, 2002, http://www.blackcommentator.com/death_penalty.html.

27. Alexandre Dumas's statement about Spain and Africa reads differently under the lens of his Afro-Caribbean identity (very likely it was more nuanced than has been understood).

28. *La Negra's* Spanish subtitles differ little from the original English ones. The only surviving copy was found in Madrid in 1990 and sent back to the United States. Its English subtitles were reconstructed on the basis of Kathleen Newman's translation of the Spanish titles and extracts taken from dialogue from some of Micheaux's novels in which the dialect could be imitated.

29. According to Marvin D'Lugo, Spaniards were impelled to imitate foreign models of romantic Spain, "seduced by this falsification of their own cultural past" (203).

30. See Staiger for how the topic of white slavery was explosive during the first decade of U.S. film.

31. Even earlier, in 1545, Luigi Giancarli did the same in *La zingana* (The Gypsy woman), and Lope de Rueda adapted it to his 1567 *Comedia*

llamada Medora (A comedy called Medora). Cervantes also used it in "The Illustrious Scrub Woman" (Charnon-Deutsch, *Spanish*, 35).

32. *The Hunchback of Notre-Dame*, in which a Gypsy child is stolen; Joseph Kane's *The Melody Trail* (1935); and *Morena Clara* (1936) helped debunk this stereotype. The press did its part to disseminate it, however: the children's periodical *Gente menuda* (vol. 3, no. 21 [1908]), carried a story, titled "Dos hombrecitos," in which Miguelito is grabbed by Gypsies. On October 30, 1914, the *Heraldo de Madrid* published "Los ladrones de niños: Unos gitanos se apoderan de dos y huyen con ellos" (Child stealers: Gypsies take advantage of and flee with two children), and on July 13, 1927, they published "Una joven es raptada por dos gitanos que se la llevan apaleándola" (Young girl abducted by two Gypsies, beaten, and carried off) (Morris, 227).

33. The formulaic rags-to-riches arc of the idealized female Gypsies (folklóricas) in these films mirror the aspirations of working- and middle-class people who wanted quick success and financial gains in a hierarchical society where the only careers offering such mobility were singing, dancing, and bullfighting. As Juan Goytisolo wrote after his and Hemingway's conversations with aspiring bullfighters in the Malaguenian mines in 1959, beneath the ideology of stardom and the self-made man lies the gritty reality of southern Spain's misery. With the exception of Dominguín, these young men chose this career not because of the supposed metaphysicality of the bullfight—"they chose it with perfect heedlessness"—but because of gross individualism that sought the sordid profits of cattle ranching and the *latifundia* system that kept thousands of peasants in servitude (Goytisolo, 106–7).

34. Like W. E. B. Du Bois's notion of "double consciousness" or a "second sight," the "sense of always looking at oneself through the eyes of others, of measuring one's soul by the tape of a world that looks in amused contempt and pity" (Du Bois, 3), she is both a Gypsy and a European Spaniard. Richard Wright took the Nietzschian idea of perspectival ways of knowing and referred to it as "double vision rather than double consciousness, . . . something internal to the West's hybrid and split subjectivity (Gilroy, 162).

35. Translated from the Spanish: "Spagna, sempre tormentata dalla sua doppia natura Latina e saracena, sempre in continuo travaglio, dovrà senza dubbio svolgere un ruolo importante nell'evoluzione del mondo latino, anzi del mondo intero."

36. The term "1940's cornball flamenco movies" was used by *New York Times* reporter Barbara Probst Soloman, January 15, 1984.

1. Time, Racial Otherness, and Digressions in Silent Films of the 1920s

1. According to Giddens, for Marx capitalism is the irrational monster, functioning according to market whims, like a juggernaut, "a runaway engine of enormous power ... that threatens to rush out of our control ... erratically in directions we cannot foresee. The ride is by no means wholly unpleasant or unrewarding; it can often be exhilarating and charged with hopeful anticipation In turn, we shall never be able to feel entirely secure, because the terrain across which it runs is fraught with risks of high consequence. Feelings of ontological security and existential anxiety will coexist in ambivalence" (Giddens, 138–39).

2. Cinema produced in Spain or by Spanish directors was no different from other cinema of this period in terms of its necessarily cosmopolitan nature. This was due to a lack of resources, which required practitioners to cross borders; a paucity of state interest in promoting cinema through either economic or legislative means; and the reality that cosmopolitan themes were in demand, spurred on by popular erotic pulp fiction published in the weeklies. Spanish cinema thus needs to be seen as part of a larger historical and geographical phenomenon that shaped Western practices of seeing.

3. See Ginger, "Space, Time, and Desire," on the establishing of national boundaries in the face of the increased dominance of Hollywood film and the corresponding notions of space and time.

4. "The intensification of interest in dissecting and reunifying time in the nineteenth century, in manipulating it in order to produce both the possibility of its record/representation and the opportunity to construct alternative temporalities, is not some reflection of a perennial psychical order, but a reflection of a quite precise historical trauma. The subject is no longer immersed in time, no longer experiences it as an enveloping medium. Through its rationalization and abstraction, its externalization and reification in the form of pocket watches, standardized schedules, the organization of the work day, and industrialization in general, time becomes other, alienated" (Doane, *The Emergence*, 221).

5. For Román Gubern the patchwork structure of *La gitana blanca* is due to the literary genre in which the film's writer, Josep Amich i Bert, based himself, a genre influenced by the music hall theatre of Barcelona's Paralelo (pers. comm.).

6. In many ways, *Carmen o la hija del bandido* (1911) foreshadowed Baños's later work in *La gitana blanca* (1919), by which time he had left

Hispano Films and established Royal Films, which produced at least 10 films between 1916 and 1921.

7. But even the scenes of the Carlist wars were filmed in Morocco, according to Jesus Alsina, "Aportación marroquí a la España fílmica," *Primer plano*, November 1, 1942.

8. For Andrew Ginger the film's conceit is a mix of the quixotic dreamer and the Calderonian life as a dream. Ginger analyzes, along with *Don Juan Tenorio* (dir. Ricardo Baños, 1922) and *El sexto sentido* (dir. Nemesio Sobrevila, 1929), how the fusion of Hollywood and European cultures were "rendered compatible with the delimitation of Spanish national space and time." He argues that the emulation of Hollywood depictions of space, time, and desire reoriented Spanish culture's Atlantic dimensions (70).

9. Daniel Sánchez Salas argues that these sequences are less like documentaries and more like Hollywood films. I would argue that documentaries, war, and fiction film all informed each other (*Historias de Luz y Papel*, 338).

10. Films that offer similar presentations of troops in northern Morocco are *Desembarco en Alhucemas* (dir. Estado Mayor del Ejército, 1925), *España en Marruecos* (dir. Estado Mayor del Ejército, 1925), and Florián Rey's *Águilas de acero* (1927). This list does not include the numerous Spanish documentaries filmed in Morocco between 1909 and 1927. For an excellent and exhaustive treatment of scenes filmed in Africa or about Africa or Africans, see Alberto Elena, *La llamada de África*.

11. In 1954, Miguel M. Delgado directed a Mexican production entitled *La gitana blanca*, starring Rosa Arenas, but with no plot relationship to Baños's *La gitana blanca*.

12. The idea of an orphan's becoming a bullfighting star was expanded in *Currito de la Cruz* (dir. Alejandro Pérez Lugín, 1925). The film obtained remarkable success in both Spain and Latin America, grossing 150,000 pesetas. It was remade in 1948 by Luis Lucía (See del Rey Regillo).

13. The coming together of two free souls, unique selves who enter into contract, belongs to animism, the ideological optic of bourgeois mercantilism and, subsequently, capitalism (Read, "Racism and Commodity Structure," 69–71).

14. For more on the different temporality of the Gypsy, see Trumpener.

15. In 1928, the National Board of Tourism was created to coordinate preparations for the Seville Iberoamerican Expo and the Universal Expo in Barcelona in 1929. España Films, a production company that came out of the board, charged a group of filmmakers with the assignment

of filming various documentaries on the geography of Andalusia. These films fit into the larger project, sponsored by Primo de Rivera's regime, of works glorifying the beauty of the landscape, art, and monuments of Spain in order to foment a positive image of the country and its dictatorship abroad, using the celebration of the two expos as an excuse. The only surviving documentary is *Viaje en tren a Andalucía* (12 min.), which centers on the train route from Ronda to Granada. Interestingly, the titles appear over the image of a train with a steam locomotive: passengers mount wagons, exit the station, view the cultivated land from the train, and gaze around the interiors of the wagons filled with passengers (Ventajas Dote, 222).

16. I rely on Martín Corrales's analysis of these events; see "El traidor enemigo (1909–1927)," in *La imagen del magrebí en España*. For more on masculinity in the Spanish army in Morocco, see Martin-Márquez.

17. See Martin-Márquez, 184–92, for her reading of the merging of race and homosociality in the context of the Spanish military in Morocco.

18. An absurd scene that never made it onto the newsreels can easily be pictured: The landing craft runs aground just before the shore. The high command orders the crafts' commander to withdraw, but Franco ignores the order. He and his men leap into the water up to their necks, holding their arms above their heads, and, like the troops that had launched the first military action of the war in 1908, wade to the beach under heavy fire (Balfour 111). This was far from the military efficiency depicted in cinematic renditions of troops running down the ramp of a K-boat onto the beach.

19. Mustard gas, a weapon used by the Spanish in Morocco, is invisible.

2. Female Spectacle in the Display Case of the Roaring Twenties

1. The rates of production in 1929 were not superseded until well into the 1950s. Despite some economic lag, compared with the rest of Europe, Spain built an infrastructure that helped it move beyond its former characterization as an undeveloped country and offered a reasonable basis for a future economic takeoff. In 1930, economists document a fairly well-developed economy, with well-defined industrial zones in the north and the northeast, and although the south still maintained an immobilized agrarian structure, its transportation and distribution network, while deficient, was real (Goytisolo, 102).

2. See chapters 1–3 of Bridget A. Aldaraca's study *El Ángel del Hogar*, in which she interlays bourgeois ideology in the eighteenth and nineteenth centuries with Fray Luis de León's perfect wife and the Victorian

domestic angel, both of which are counterposed to the frivolous, public, urban, spendthrift, gossiping woman who contaminates men.

3. By "femme fatale" I mean an independent female protagonist capable of undermining male identity by manipulation and seductive prowess. The star La Chelito (Consuelo Portella) was known, for instance, as "una devoradora de hombres" (Díaz de Quijano, 82; see also Posadas).

4. These films include *Maruxa* (1923), *La reina mora* (1923), *Curro Vargas* (1923), *El pobre Valbuena* (1923), *Doloretes* (1925), *Alma de dios* (1925), *Gigantes y cabezudos* (1925), *La revoltosa* (1925), *La casa de Troya* (1925), *La sobrina del cura* (1925), *Cabrita que tira al monte* (1926), *La Bejarana* (1926), *Es mi hombre* (1927), *Del schottis al charlestón* (1927), and *La verbena de la paloma* (1921/1935).

5. For more on the cuplé, see Salaün, *El cuplé*, 14–32.

6. The origin of the *género ínfimo* is generally accepted to be the musical play *El género ínfimo*, composed by the Álvarez Quintero brothers in 1901 (de la Madrid, 225). The work that actually became the standard symbol of the genre was, however, *La corte del faraón*, composed in 1910 by Vicent Lleó and brought to the screen in 1985 by José Luis García Sánchez. The term *ínfimo* has, as defined by the Real Academia Española, two different denotations. One refers to its quantitative aspects (inferior in size and quantity), whereas the other takes into account qualitative traits (inferior in moral capacity). Serge Salaün categorizes the genres and periods as follows: *género chico* (1880–1910), *género ínfimo* (1895–1910), *cuplé-varieté* (1900–1935), *revista de visualidad* (1920–36) (*El cuplé*, 56).

7. Performance artists, bullfighters, and writers published their earnings in the press during the 1910s and the 1920s, and their success thus can be accurately measured.

8. *Malvaloca* was remade in 1942 by Luis Marquina and in 1954 by Ramón Torrado. Its extended life is attributable not only to its fallen woman theme but also to the script's adaptability to the different political climate.

9. According to statistics compiled by Emilio C. García Fernández, Madrid in 1928 had 29 Spanish productions (out of which only 16 were shown that year), whereas 112 foreign productions were screened. In Segovia in 1929, out of the total number of films screened (371), 116 were Russian, French, German, and North American (*El cine*, 164). During the Spanish Civil War, Hollywood dominance remained constant: almost 60.8 percent of the fictional films were Hollywood productions (Cabeza, 31).

10. Perojo officially was the producer of *La sin ventura*, but many accounts attest to his extensive role as the project's artistic director, one of its collaborators, or its initiator (Gubern, *Benito Perojo*, 67). Nevertheless, it was considered Spanish because of its adaptation from a Spanish novel, its Spanish actors, and its Spanish setting. According to a *gacetilla* from the sixth day of its debut in Spanish theaters, "es la mejor película española" (Gubern, *Benito Perojo*, 74).

11. *Bella Raquel* (*Raquel Meller*), a documentary written and edited by Enrique Amat Alfonso in Madrid and registered with the Biblioteca Nacional in 1972, contains a section with footage from her films.

12. Howard Hawkes's film *The Air Circus* is advertised as featuring a Fox Movietone with Meller on the program.

13. In the town of Villefranche on the French Riviera, the Avenue Raquel Meller attests to her international name.

14. Meller's relationships with other celebrities are highlighted in virtually every biography. The technique of cross-referencing stars seems to cement a biography within the specific genre of the exceptional star biography.

15. The French actress Lucienne Legrand remarkably is still active, appearing most recently in a minor role in *L'extraterrestre* (dir. Didier Bourdon, 2000). Her films from the 1920s include *Bonheur conjugal* (dir. Robert Saidreau, 1922), *Le chateau de la morte lente* (dir. Donatien, 1925), *Au revoir et merci* (dir. Pierre Colombier and Donatien, 1926), *Le martyre de Sainte-Maxeuse* (dir. Donatien, 1927), *Miss Edith* (dir. Donatien, 1928), and *L'arpète* (dir. Donatien, 1929).

16. Umbral also notes that "the postwar brought us jazz, stage girls with cocaine, cocaine without stage girls, [and] a few French whores" (Umbral, 44).

17. In *Benito Perojo*, Gubern documents and quotes several French and Spanish film magazines that featured stories on *La sin ventura* between 1923 and 1924: *La cinématographie française*, *Hebdo-film*, *Cinémagazine*, and *Ciné-journal*.

18. See Scanlon, 114–21, on prostitution in the early twentieth century.

3. Racing for Modernity

1. The pressure to assert a Spanish peninsular and neoimperialist identity was keenly felt by the intellectuals and writers of the generations of 1898 and 1914. In *El porvenir de España* (The future of Spain), Ángel Ganivet claims Africa as the new economic future for Spain, not

only to vindicate the embarrassing loss of Cuba and to stay abreast of the concurrent European colonization of Africa but also to revive Spain's languishing economy, which despite growth at the turn of the century, was far behind other European nations (164–67; see also Aronna, *Pueblos enfermos*). Related to this was the fetishization of both Andalusia (on the part of northern European–identified Spanish artists and intellectuals) and North Africa, as a symptom of "deliberate aesthetic regression," that is, the felt need to replenish the alienating experience of industrial modernity by fleeing from history into a fantasy of primitivism and the eroticized exotic (Mitchell, *Flamenco*, 169). Isaac Muñoz argued, drawing upon degeneration theory to prove the "exhaustion of the Spanish race," for colonizing Morocco in order to inject "new blood into both the Spanish and the Moroccan races, which are already kindred" (quoted in Martin-Márquez, 196).

2. Ann Laura Stoler reminds us how "the discursive and practical field upon which bourgeois [subjectivity] emerged was situated on an imperial landscape where the cultural accoutrements of bourgeois distinction were partially shaped through contrasts forged in the politics and language of race" (5).

3. In nineteenth-century medical manuals, sections devoted to demography and race suggested that "inferior races were best adapted to healthy reproduction, and recommend[ed] miscegenation in the colonies as a way of 'improving the stock.' . . . This colonial concept of miscegenation, being based on the white man's coupling with the native female, supposes that female 'others' can be incorporated into the nation, but the reverse—the 'incorporation' of the native male via his coupling with the white woman—is unthinkable" (Labanyi, *Gender and Modernization*, 192). Susan Martin-Márquez notes that the DAI (Delegation of Indigenous Affairs) instituted laws against miscegenation between white Spanish women and African colonials as early as 1938 (261–62, 269). Before this time, however, "strict laws and social norms conspired to regulate liaisons between Spaniards and Guineans" (279).

4. See Susan Sontag's *Illness as Metaphor* for more on the metaphors of tuberculosis.

5. See also "Falleció Concha Piquer a los 82 años Se callaron las coplas," *El tiempo*, December 13, 1990.

6. Paul Gilroy's critique of national ethnocentric analyses of culture (culture seen from within the borders of a particular nation-state) and his appeal to approach the Atlantic "as one single complex unit of analysis" illustrate the possibility of such a transnational perspective (7, 15).

7. Jo Labanyi studies Bénédict Augustine Morel's *Traité des dégénérescences physiques, intellectulles et morales de léspece humaine* (1857) as having impacted much cultural discourse in Spain after 1860 (*Gender*, 28, 125)

8. In *Memorias* Insúa's brother, Waldo, is uncannily similar in name to Peter Wald. Waldo ironically was the one to punish black servants for referring to separatism: "One of the maids, the black Salomé, one afternoon dared to hum the reply sung by the separatist plebs to the famous song, 'Suck the grape / Drop the cane / Get your suitcase / And go to Spain!' And what Waldo got was a broom to give the blackie a beating" (1:133).

9. In Fatimah Tobing Rony's discussion of the origins of ethnographic cinema, she paraphrases Michele Duchet's description of how physical and cultural anthropology arose from the eighteenth-century natural history that characterized indigenous people as "ethnographiable," as opposed to "historifiable" (Tobing Rony, 8).

10. "Regarding our country, it was not an uncommon custom to parody on stage the customs of individuals of the black race, and in Lope de Vega's time it was a fairly extensive practice. This custom lasted well into our century, fundamentally in the *género bufo* and the *alhambresco*. One can trace this custom in the character of the blackened clown Emig, of the trio Tehdy, Emig, and Pompoff" (García Martínez, 270n13).

11. "When an actor wants to capture the public's attention, he paints himself black, Al Sonson [Jolson]. The great North American burst of laughter—a violent, tearing laugh, almost Iberian—is always ripped out by the black actor" (Laffranque, 264).

12. "For it remains a key feature of substantialist doctrine that the appearances which distinguish people in this life define their very nature, which is to say that, rather than being born free, they become free at death, a death that levels all men, as individual souls, in the eyes of God" (Read, "Racism," 68). Read later concludes, "The Greek concept of eleutheria or freedom, of the independent peasant producer, may have preceded, but came to define itself in opposition to, the 'natural slave,' as defined by Aristotle. Likewise, the 'beautiful soul' of the mercantilist trader stood opposed to the bonded serf or natural slave, and the black slave, in the context of post-Enlightenment slavery, to the 'free subject' of capitalism. In this way, conflicts that had once been enacted upon a cosmic stage came to be reduced to the dimensions of the closed-in, solipsistic monad of modern capitalist society" (83).

13. "I know that neither Don Luis nor anyone finds it funny that I'm contracting the black Peter and that my system of comedies and attraction gets critiqued a lot. But what do I care? If I have to, I'll convert the

Sainete theater into a music hall, and no one will see anything here but movies and variety shows" (Insúa, *El negro*, 61).

14. Cuban songs, icons, and fantasies populated Spanish popular entertainment, galvanizing the connection between early jazz, negritude, and Cuba. Spaniards bought Josephine Baker's *Cancionero popular* with rumbas and Cuban songs. As Andres Amorós describes it, "For Spaniards it offered the attractiveness of discovering another world: in the lyrics, in the music, in the dance, in the spectacle. . . . The initial commentary of *Cancionero* highlighted that it dealt with a new discovery of America or the conquest of Europe" (165). Early jazz and the emergence of negritude were indebted to Cuban rumbas and *habaneras* and the *colombiana* and the tango, all massively popular during the interwar period. Female performers of color were mainly from Cuba, like María la Cubana, Lola Montiel, Mercedes Blanco, Perla Etíope, Herminia La Negrita, and Rumba Chamelona. Cuba's eruption onto the Spanish entertainment scene occurred with sensuality and exotica: "'The rumba, a languid, unhealthy, and voluptuous dance,' in its primogenital incarnation as *chuchumbé*, was condemned by the Holy Office for infringing upon moral standards and corrupting damsels" (García Martínez, 20).

15. Labanyi writes that "anthropology and social control has [sic] always been connected. Spain's early history shows this particularly well, for anthropology was effectively invented by the Inquisition's probing and recording of the most intimate details of private life, repeated in the New World by the Spanish friars who got the natives they were forcibly converting to document meticulously their customs and beliefs. In both cases, the anthropological impulse served as a tool of homogenization . . . " (*Gender and Modernization*, 76–77). Indeed, "in late nineteenth-century Spain, as elsewhere, discussion of social problems frequently incorporated the vocabulary of contemporary anthropology, whose aim was to survey, classify, and thus control 'other', primitive races" (77). On the link between anthropology and technologies of vision, Labanyi notes that the "nineteenth-century is inextricably linked with the development of photography (a key element in forensic science) and of the museum, since both document, classify, and contain. The pioneers of anthropology in late nineteenth-century Spain were doctors who saw the discipline as an instrument in their regulatory programme [in particular, female hygiene]" (79).

16. Don Mucio does everything he can to keep Peter from dying not because of the injustice of it all but because "it would have been absurd to conclude the business 'in that way.' . . . The contract with the Follies Bergères was magnificent" (279).

17. In the novel they are negated by descriptions of Emma's death-like faintings and seizures when Peter makes advances (285).

18. Kobena Mercer's reaction to Robert Mapplethorpe's photographs of nude men of color refers to the same tension between fear and desire and could be extended to this film. Franz Fanon asserts that sexual stereotypes born of white fear of blacks necessarily re-create the black man as an "epidermalized" locus of fear.

19. As Moix affirms: "Nothing could have been more natural, for the image had steeped so deeply in the national subconscious through the pro-Darwinist brand Anis del Mono. This brand had been visually glossed by Picasso, Juan Gris, and Barradas in well-known canvasses, and it was logical for cinema to incorporate this tendency" (227).

20. Similarly, Eloy Martín Corrales catalogues the commodification of the Arab body.

21. Among the few male sex symbols who sang or were fetishized in the forties and early fifties, only Angelillo, until his exile; the Mexican Jorge Negrete; and Jorge Mistral, who also occasionally sang, as he did in *La Duquesa de Benamejí* (dir. Luis Lucía, 1949), were able to counter the effeminate male singer stereotype.

22. Álvaro Retana writes of Castizo that she often dressed in menswear—"You didn't see it, but you could see it." Apparently, she sang "Madre, cómprame un negro." She also starred in *Aventura oriental* (dir. Max Nosseck, 1935) (*Historia del arte frívolo*, 249).

23. Thanks to Susan Mártin-Márquez for proffering these notes.

24. Nonell the bootblack was in the original Spanish version of the film, which was three hours long. It was cut from the shorter, French version, which is the only surviving copy (Gubern, *Benito*, 133).

25. *La pura verdad* (dir. Florián Rey and Manuel Romero, 1931), *Un caballero de frac* (dir. Roger Capellani and Carlos San Martín, 1931), and *Las luces de Buenos Aires* (dir. Adelqui Migliar, 1931).

26. *Merecedes* (dir. José María Catellví and Francisco Elías, 1932), *Alalá* or *El hijo del misterio* (dir. Adolf Trotz, 1933), *Dale betún* (dir. Raymond Chevalier, 1934), *Rataplán* (dir. Francisco Elías, 1935), *El malvado Carabel* (dir. Edgar Neville, 1935), *Una mujer en peligro* (dir. José Santugini, 1936), *La señorita de Trévelez* (dir. Edgar Neville, 1936), *El bailarín y el trabajador* (dir. Luis Marquina, 1936), and *Héroe a la fuerza* (dir. Benito Perojo, 1941).

27. Fernando Méndez-Leite lambasted *El frente* as an "outrageous Andalusianified apology for the most abominable kind of hillbilly film" (1:378–79). For Colomé's performance biography, see Pineda Novo, 91–100.

28. "Conchita tiene sensibilidad suficiente para papeles de todas clases;

pero le va mejor también lo típico. Y esto es lo que, según manifiesta, le gustaría encarnar ante la cámara: Un tipo simpático, castizo y genuinamente español ..." (*Cámara*, May 15, 1944).

29. *The Jazz Singer* was distributed in Spain under the title *El cantor de jazz* (see Baena, 59).

30. The majority of articles launched against Perojo in cinema magazines appeared after *El negro que tenía el alma blanca* was filmed, throughout the spring and summer of 1927 (Gubern, *Benito Perojo*, 118–23). The most vociferous critic of Perojo was *Popular Film*, which continued its criticism of him throughout the sound era. Juan Piqueras, in *Nuestro cinema*, wrote of *El negro:* "What is more, the issue was frankly something international, and there was not one mention of anything Hispanic. Nevertheless, it obtained a magnificent result, which was the opening of new horizons for our cinema" (quoted in de la Plaza, 218).

31. Carmen Martín-Gaite loved playing Concha Piquer herself, as Andrew Bush has informed me regarding her Distinguished Visiting Professorship at Vassar College in 1985.

32. Daniel Pineda Novo claims that Rafael de León "boasted of knowing Seville well and of being directly influenced by Dostoyevsky, Lorca, and Antonio Machado" (104).

4. The Gypsy Problem

1. Although many more films could be discussed, I focus on these, as they were some of the more frequently seen and shown films. Other films of the period that portray the encounter between law and otherness and/or that begin with an infringement of the law include *La hija de Juan Simón* (dir. Sáenz de Heredia, 1935), *El gato montés* (dir. Rosario Pi, 1936), *La blanca paloma* (dir. Claudio de la Torre, 1942), *Macarena* (dir. Antonio Guzmán Merino, 1944), *La gitana y el rey* (dir. Manuel Bengoa, 1945), *María de la O* (dir. Francisco Elías, 1936/38), *Embrujo* (dir. Carlos Serrano de Osma, 1946), *Oro y márfil* (dir. Gonzalo Delgrás, 1947), *La niña de la venta* (dir. Ramón Torrado, 1950), *Cuentos de la Alhambra* (dir. Florián Rey, 1950), *Debla, la virgen gitana* (dir. Ramón Torrado, 1951), *La alegre caravana* (dir. Ramón Torrado, 1953), and *Polvorilla* (dir. Florián Rey, 1956).

2. *La gitanilla* was remade in 1923 by André Hugón in France and in 1940 by Fernando Delgado, this latter version starring Estrellita Castro.

3. As Homi K. Bhabha reminds us, law constructs whiteness "as an objective fact, although in reality it is an ideological proposition imposed through subordination" (83).

4. Fran Gómez and José Luis Navarrete write the following about spectator identification with the folklórica stars: "They were a mirror for many women of the time who wanted to be like them. Of course, we are referring to an identification between female spectators and the condition of stardom of these actresses, not an identification between female spectators and the actress in which the former wish to be gypsies involved in stormy love affairs (identifications that become united when the reality of the actress's life and her character get confused)" (20).

5. For Thomas Elsaesser, in melodramatic structures of experience such as suffering, social change is understood not in the abstract but through emotional and personal contexts. Despite happy endings and the conformism implied by stereotypical plots, "the actual working out of the scenes could nonetheless present fundamental social evils," thus exhibiting a "radical ambiguity" that was later echoed in film melodrama (47). As Marsha Kinder shows, the strict division of reactionary versus subversive melodrama breaks down when we acknowledge the popularity of melodrama with both the Left and the Right—*Morena Clara* is a case in point—and how both viewed the family as a microcosm of political and class debates. To function subversively, Kinder says, "melodrama would have to push these local Spanish traditions associated with the *españolada* and *zarzuela* to the point of parody where they would reveal their ideological implications" (71). ¡*Bienvenido, Mister Marshall!*, as Kinder rightly notes, exemplifies such a parody of the españolada.

6. *El clavo* (dir. Rafael Gil, 1944) is an exception to this.

7. After the release of ¡*Bienvenido, Mister Marshall!* (1951), a brilliant parody of massified folklore and the Francoist national tradition, naïve approaches to the folklore industry seemed less tolerated. The utilization of excessive parody to comment on the genre became a way to critique the established tradition while still continuing to profit from it. Juan Goytisolo writes of *Bienvenido*: "On its exterior the appearances have not changed, and the attributes of the 'Spanish soul' fascinate and will continue to fascinate our visitors: bullfights, flamenco song, religious ceremonies, Donjuanism, etc. But let us not be deceived. Obligated to maintain and exhibit these attributes for the necessities of tourism, Spaniards harbor hidden doubts. In the film *Bienvenido* the inhabitants of a Castilian town dress up like Andalusians in order to receive the Americans and obtain their currency. Today, this disguise is a reality: from Galicia to the Basque Country, from Navarre to Catalonia, 'Andalusian' style and folklore do as they please, offering the tourist the typical and conventional image of Spain to draw them in" (136).

8. Lou Charnon-Deutsch notes that a new wave of sociological and

anthropological thinking in the mid- to late fifties attempted to re-vise thought on the Roma. Nevertheless, its effect on legislation was negligible.

9. For histories of the Roma exodus from India and subsequent mi-grations, see Fraser. For histories on the arrival to Spain and the Roma experience in Spain from the fifteenth century on, see Charnon-Deutsch, *Spanish*; and San Román, 1–73. By the seventeenth century, "the word *gi-tano* came to be applied not just to the *egipcianos* (gypsies who apparently passed through Egypt and northwestern Africa before reaching Iberia) but also to their fellow travelers. In other words, the original gitano bands that came to Spain (from either the south or north) grew larger through the assimilation of other marginal group: runaway slaves, Moorish peas-ants fearful of expulsion, Jews or their offspring running from the Inquisi-tion, bohemian rogues known as *pícaros*, smugglers, vagabonds, and other varieties of outcasts and outlaws" (Mitchell, *Flamenco*, 51).

10. The remolding of society under the Second Republic "involved the separation of church and state and a severe restriction on Catholicism in order to refashion national character, a broad expansion of educa-tion, reform and modernization of the armed forces, regional autonomy, far-reaching labor reforms, intensification of public works, and a basic agrarian reform to benefit shareholders and landless farm laborers" (Payne, *Spain's First Democracy*, 81). See Scanlon for legal reforms affect-ing women.

11. Teresa de San Román claims a lack of historical materials to prop-erly analyze this period. She suggests, however, that there are unstudied sources of data that should be examined by historians, such as the ar-chives of the Fuerzas de Seguridad, the courts, the prisons, and the town halls and the ecclesiastical records (63).

12. The oral histories that San Román examines, which cover the pe-riod of 1936–67, detail the extreme duress of the Roma communities at the hands of the Francoist *guardia civil* (66, 222–23).

13. Not until the 1978 constitution did the state abolish all anti-Roma legislation and grant Gypsies full equality by the law and full citizenship, while making racial discrimination a crime against the constitution.

14. Roman law, upon which Spain's legal system is modeled, incor-porates all elements. After the Arab occupation, Roman Catholic law was built upon the elimination of difference through its incorporation (conversion).

15. Evelyn Gould notes that Mérimée's *Carmen* "refines our interpre-tation of the 'Carmen myth' as either a reversal or a passive agent of the values of Western cultural and sexuality. . . . Carmen neither reverses

nor promotes these values but rather dramatizes their ambivalence" (6). Gould clarifies that Pushkin's 1827 epic poem "The Gypsies" "may well be the origin of the story of the Gypsy woman for whom living is fatal, even if Mérimée himself always maintained that the origin of the anecdotes was Eugénie de Montijo" (179n).

16. See González Troyano for more on this reading.

17. Rebellion can be seen as a "private mode of expressing individuality and responding to an existing state of affairs or the status quo" (Loizidou, 45). By telling of an act of rebellion, *Carmen* explains the story of citizenship. Rebel status thus is another kind of citizenship.

18. The list of film adaptations of *Carmen* is exhaustive. They were made not only in Spain but also in the United States, France, Germany, Mexico, Italy, England, Russia, Argentina, and the Philippines. See also Vernon, "Remaking Spain," and Colmeiro. Additionally, see Navarrete.

19. For a discussion of the failed rhetoric of the Second Republic, see Pingree.

20. Relevant is David Harvey's description of capital as a "spatial fix": "The accumulation of capital has always been a profoundly geographical affair. Without the possibilities inherent in geographical expansion, spatial reorganization, and uneven geographical development, capitalism would long ago have ceased to function as a political-economic system" (23).

21. This movement was coupled with the influx of eastern European Gypsies escaping the world wars, the upheavals of post-1917 Russia, and the emancipation of Roma slavery in Romania.

22. The song was originally composed by Rafael Perelló and S. Cantabrana. As María Jesús Ruiz Muñoz notes, this song appeared on the Odéon record label in 1936 and was covered several times after (39).

23. See Goldberg on internal otherness and labor (*The Racial State*, 48–51).

24. Spanish film history is teeming with what we could call a cortijo genre: *Rosario la cortijera* (dir. José Buchs, 1923; dir. León Artola, 1935), *La sobrina del cura* (dir. Luis Alonso, 1925; dir. Juan Bustillo Oro, 1954), *Malvaloca* (dir. Benito Perojo, 1926; dir. Luis Marquina, 1942; dir. Ramon Torrado, 1954), *La dolorosa* (dir. Jean Grèmillon, 1934, starring Rosita Díaz Gimeno), *La hija de Juan Simón* (dir. Sáenz de Heredia, 1935; dir. Gonzalo Delgras, 1957), *El gato montés* (dir. Rosario Pi, 1936), *El genio alegre* (dir. Fernando Delgado, 1939, 1957), *Pepe Conde* (dir. José López Rubio, 1941), *La blanca paloma* (dir. Claudio de la Torre, 1942), *Un caballero famoso* (dir. José Buchs, 1942), *Misterio en la marisma* (dir. Claudio de la Torre, 1943), *Macarena* (dir. Antonio Guzman Merino, 1944), *Castañuela* (dir. Ramón Torrado, 1945), *El centauro* (dir. Antonio

Guzmán Merino, 1946), *La mentira de la Gloria* (dir. Julio Fleischner, 1946), *La Lola se va a los puertos* (dir. Juan de Orduna, 1947; dir. Josefina Molina, 1992), *Oro y márfil* (dir. Gonzalo Pardo Delgrás, 1947), *Currito de la cruz* (dir. Luis Lucía, 1948), *La fiesta sigue* (dir. Enrique Gómez, 1948), *Olé torero* (dir. Benito Perojo, 1948) *Jalisco canta en Sevilla* (dir. Fernando de Fuerntes, 1948), *Aventuras de Juan Lucas* (dir. Rafael Gil, 1949), *Rumbo* (dir. Ramón Torrado, 1949), and *Un soltero difícil* (dir. Manuel Tamayo, 1950).

25. Canonical Andalusian *costumbrista* writers include Estebáñez Calderón, Fernán Caballero, Juan Valera, and Alarcón. The Álvarez Quintero brothers, whose many plays became Andalusian musical comedy films, are also considered to be among the most important of the Andalusian *costumbrista* writers. See DeCoster.

26. Apparently, with the rise of radio, film, and later television and the subsequent adaptation of cultural tastes to these new mediatic forms, the popularity and viability of the skits diminished to the point of being all but forgotten after the 1970s (Brandes, 239–40).

27. See Labanyi, "Making *Caciquismo* Respectable," in *Gender and Modernization*.

28. This could be a veiled reference to eastern European Roma immigration to Spain during World War II.

29. As Pierre Bourdieu has written, "The whole social structure is present in each [linguistic] interaction" (67).

30. For more on how law opens up spaces of subversion, see Goldberg, 148.

31. See Goldberg, 92, for ambiguity of law.

32. In *La copla sabe de leyes*, Rosa Peñasco explains how Spanish law functions as "a state of law" and is not re-created on the basis of precedents, as in U.S. law. "All public powers are subjected solely and exclusively to the law," which means that the law is fixed and that everything is then judged by that law, as opposed to the U.S. system of jurisprudence, in which a judge can refer to a collection of laws, a precedent, when making a judgment (50).

33. The hugely popular (in both Spain and Latin America) Mexican comic Cantinflas starred in *Allí está el detalle* (dir. Juan Bustillo Oro, 1940), a film that contains a court scene almost identical in nature to the one in the 1936 version of *Morena Clara*. Like Regalito and Trini, Cantinflas is the underdog whose verbal gymnastics outwit the authorities and puncture high seriousness and social pretension.

34. Lou Charnon-Deutsch also reads the film in this way (*Spanish*, 228).

35. In *Bringing Down the House* (2003), a lawyer, played by Steve Martin, inadvertently becomes the "victim" of a female African American convict, Charlene. She needs the legal system off her back, and he needs to pull his family back together and win back his wife. Even though Charlene is morally superior, street smart, and a better judge of human nature, she is merely a facilitator in the process of reuniting the white bourgeois family.

36. A subgenre of films about painters and their female Andalusian or racially exotic subjects could include *Canelita en rama, Debla, la virgen gitana, María de la O, Goyescas,* and *María Candelaria.*

37. The script reads: "You can't see the Gypsies, because they are what is unforeseen of this world, and you are a little ant who wants to take all of the wheat from the threshing floor to your granary; you won't stop until you marry a blonde who will make up in partying what she doesn't have in wit; your pillow will be a checkbook, and you'll die in a tankard of beer. Come on, smarty, give me a little coin, and I'll tell you that a suffragist with freckles is going to play tennis with you; not me, though, because I'm a *gitana* down to the roots of my hair and guys like you who talk about order and administration on an afternoon like this give me a headache. Goodbye! I too know English when it's convenient."

5. The Spanish Solution

1. See Jo Labanyi, "Miscegenation" and "Race, Gender and Disavowal," and Susan Martin-Márquez for analyses of *La canción de Aixa* and Africa in the Spanish imaginary.

2. "[German] Gypsies were forcibly sterilized under the 1933 Law for the Prevention of Hereditarily Diseased Offspring and castrated under the 1933 Law against Dangerous Habitual Criminals. The 1933 Denaturalization Law and 1934 Expulsion Law forced stateless and foreign Sinti and [Roma] to leave Germany" (Pine, 115–16).

3. Estimates of the number of Roma murdered range from 250,000 to 2 million (Fraser, 268; Hancock). Lisa Pine documents that over 1 million Gypsies were murdered either in the camps or in detainment roundups (113).

4. "Miscegenation is construed as the incorporation of the female native other into the individual and collective male colonizing body.... The Spanish colonial advocacy of miscegenation has traditionally allowed Spanish supporters of empire to declare that they are not racist.... It was this emphasis on the incorporation of the female native other that most clearly distinguished the racial orientation of Spanish fascist

thought from that of Nazism" (Labanyi "Race, Gender and Disavowal,"
219–20). See also Labanyi, "Women, Asian Hordes."

5. "The anti-Semitic figure of the Jew (to take *the* example of this sub-
lime object) bears witness to the fact that the ideological desire which
sustains anti-Semitism is inconsistent, 'self-contradictory' (capitalist
competition *and* pre-modern organic solidarity, etc.) In order to main-
tain this desire, a specific object must be invented which gives body to,
externalizes, the cause of the non-satisfaction of this desire (the Jew who
is responsible for social disintegration). . . . The (anti-Semitic figure of
the) 'Jew' is not the positive cause of social imbalance and antagonisms:
social antagonism comes first, and the 'Jew' merely gives body to this
obstacle . . . the main point is that the historical reality of Jews is ex-
ploited to fill in a pre-constructed ideological space which is in no way
inherently connected with the historical reality of Jews. One falls into
the ideological trap precisely by succumbing to the illusion that anti-
Semitism really *is* about Jews" (Žižek, *The Plague*, 76–77).

6. "It wasn't easy to ascertain what was truly meant by the exalta-
tion of racial values or teachings in our moral and religious principles.
Thus the surprise when we found out that the movies made in those first
years of the postwar were not clearly fascist. In truth, those fascist films
weren't made then or ever" (Taibo I, 15).

7. The distribution of Andalusian musical comedies to small towns
in Puerto Rico from the 1940s to the 1960s provided the main source of
conversation for women, who would see these films several times in one
year. Their recollections of the films were motivated by the romantic plot
line, however, not the political ideology (conversation with Lisa Paravisini,
February 2000).

8. According to Emilio García Riera, some of the Spanish films shown
in Mexico that featured folklóricas were *María de la O* (1936), *Carmen,
la de Triana* (1938), *La canción de Aixa* (1938), *El barbero de Sevilla* (1938),
Mariquilla Teremoto (1938), *Suspiros de España* (1938), *La gitanilla* (1940),
Marianela (1940), *Martingala (La copla andaluza)* (1939), *La patria chica*
(1943), *Embrujo* (1947), *Oro y márfil* (1946), and *La Lola se va a los puertos*
(1947).

9. Important to note are the parallels between Zarah Leander, the
Swedish songbird and star of several Nazi propaganda musical films—
Die grosse Liebe (1942)—and Spanish folklóricas. Like her Spanish coun-
terparts, Leander become an icon in Germany's gay scene of the 1980s.
Almodóvar also includes a bow to her in *Qué he hecho yo para merecer
esto* (1984), and Manuel Puig's novel *Kiss of the Spider Woman* and Héc-
tor Babenco's film adaptation of it also feature homages to Leander.

10. Marta Muñoz Aunión analyzes the receipts of the expenses incurred by Argentina and Rey and paid for by the Germans (29–31).

11. Charnon-Deutsch, D'Lugo, Gould, Labanyi, Vernon, Perriam, and Torrecillas have also concluded this.

12. For more on nineteenth-century female workers' rebellions in relationship to Carmen, see Pantoja, 58, and Capel Martínez.

13. "As for jouissance, it is perhaps the central or at least the most powerful category in Žižek's explanatory resources, a phenomenon capable of projecting a new theory of political and collective dynamics as much as a new way of looking at individual subjectivity. But to grasp the implications it is best to see jouissance as a relational concept rather than some isolated 'ultimately determining instance' or named force. In fact, it is the concept of the envy of jouissance that accounts for collective violence, racism, nationalism and the like, as much as for the singularities of individual investments, choices and obsessions: it offers a new way of building in the whole dimension of the Other (by now a well-worn concept which, when not merely added mechanically onto some individual psychology, evaporates into Levinassian sentimentalism)" (Frederic Jameson, "First Impressions: *The Parallax View* by Slavoj Žižek," *London Review of Books*, December 7, 2006, http://www.lrb.co.uk/v28/n17/jame02_.html).

14. The term *reyerta*, loosely referencing Lorca's poem from *Cante jondo*, typifies the dramatic, dark imagery that Saura captures in his rendition of the factory fight scene in *Carmen* (1983).

15. The Condor Legion was a German battle group sent directly from Germany to reinforce Franco's troops after the Nationalist failure to take Madrid in 1936: "Within a matter of days, a force of specialized units, equipped with the latest developments in German bomber and fighter aircraft and tanks and other motorized weapons was en route to Seville. Five thousand Germans landed in Cadiz on 16 November and a further seven thousand on 26 November along with artillery, aircraft and armored transport" (Preston, 203).

16. The Italian Fascists from the Corpo Truppe Volontarie also played a subordinate role in the bombing. The Basque government's figures released at the time stated that 1,654 civilians died and 889 were wounded.

17. In ¡Ay, Carmela! (dir. Carlos Saura, 1990), Carmen Maura sings "Suspiros de España," with the lyrics changed for the Nationalist troops.

18. Most Andalusian comedy musicals rarely emphasize capturing the anonymous mass or the proletariat. Even films such as *Canelita en rama*, which contains sequences of laborers in the fields, demand a wholly different social and critical analysis (See Labanyi, "Raza Género").

6. Recycling Folklóricas

1. See Chris Perriam's analysis of *Las cosas del querer* (1989), in particular his parsing out of the historical references to Miguel de Molina and his sexual identity that contrasts with Concha Piquer's marked conservatism, which in Chávarri's film is revised through Angela Molina's performance and star persona (see also Arroyo). "The oriental component of Spanish blood" had been contaminated by mixing with inferior races and therefore hindering Spaniards' abilities to operate in the modern world (Martin-Márquez, 175).

3. His last words, in a hoarse scream, "Here I am. I'm naked with no clothes," and his make-up that has sweated off challenge the discourse of appearances. The folklórica figure was, however, more authentic the more she outfitted herself in Andalusian and Gypsy-style dress and mannerisms.

4. See Barbara Fuchs's and Sherry Velasco's analyses of Cervantes and Catalina de Erauso and their contextualization of the history of transvestite culture in early modern literature, as well as displays of ambiguous sexuality.

5. Retana's pre–Spanish Civil War novels include *Al borde del pecado* (1917), *La carne de tablado (Escenas pintorescas de Madrid de noche)* (1918), *El crepúsculo de las diosas (Escenas alocadas de la vida galante)* (1919), *Ninfas y sátiros* (1919), *Las locas del postín* (1919), *El príncipe que quiso ser princesa* (1920), *El infierno de hielo* (1921), *El rayo de luna* (1921), *El tesoro de los nibelungos* (1922), *El escapulario* (1922), *El diablo de la sensualidad* (1922), *El octavo pecado capital* (1922), *El encanto de la cama redonda* (1922), *Raquel, ingenua y libertina* (1923), *Mi alma desnuda* (1923), *La confesión de la duquesa* (1923), *Flor del mal* (1924), *La virtud en el pecado* (1924), *El veneno de la aventura* (1924), *Carnaval* (1924), *La dama del Luxemburgo* (1925), *La conquista del pájaro azul* (1925), *El abismo rosa* (1925), *El más bello amor de Mercedes* (1925), *El tonto* (1925), *El Pobrecito Barba-Azul* (1928), *La ola verde* (1931), *A Sodoma en tren botijo* (1933), and *El fantasma de don Pingoberto* (1935).

6. For discussion on the difference between gay camp and other forms of camp in the context of Spanish popular fiction, see Mira, "After Wilde."

7. In 1930, in the prologue to his novel *De un mundo a otro* (1916), Insúa writes: "In 1921, upon returning to Spain, after having lived in France for the four years of the war and the first three years of the postwar, I had to fight in order to reconstruct my credit as a novelist, almost exhausted . . . they accused me of being exaggeratedly Francophilic. And perhaps venal [purchasable] . . . a sellout to the French" (quoted in McQuade, 230).

8. Several post-Franco films index the subtext of gay and queer gloss on the culture of the folklórica performance genre: *Las cosas del querer* (dir. Jaime Chávarri, 1989), *¡Ay Carmela!* (dir. Carlos Saura, 1990), *La Lola se va a los puertos* (dir. Josefina Molina, 1992), and *La niña de tus ojos* (dir. Fernando Trueba, 1998). Many films contain sequences that are devoted to commemorating the gay cult of the folklórica, as in *La mala educación* (dir. Pedro Almodóvar, 2004).

9. Retana's histories are *La reina del cuplé: El Madrid de la Chelito* (1963), *Historia de una vedette contada por su perro: Novela de buen humor: Amenidades de la vida teatral madrileña* (1954), *Historia del arte frívolo: España, 1900–1964* (1964), and *Historia de la canción española* (1967).

10. By "coming out," I refer to pre-Stonewall gay male terminology, which implies a ceremonious coming out even though one was already gay, rather than the post-Stonewall liberation definition, which connotes more of a confession—speaking truth to one's identity. Thanks to Hirám Pérez for this clarification.

11. The respectful treatment of the protagonist has been compared to films like *A un dios desconocido* (dir. Jaime Chávarri, 1977), *Cambio de sexo* (dir. Vicente Aranda, 1977), and *Ocaña*.

12. A revival of *Flor de Otoño* at the Centro Dramático Nacional in Madrid in 2005 was a critical and popular success.

13. Homophobia among the Spanish radical Left is also critiqued in its Basque context in *La muerte de Mikel* (dir. Imanol Uribe, 1984).

14. It is important to note that the real-life figure of Lluís Serrancant attempted to kill Alfonso XIII, not Primo de Rivera. Serrancant was not killed but set free during the Second Republic and allowed to occupy a government position. See "Un Hombre llamado Flor de Otoño," *Pueblo*, September 20, 1978.

15. The lyrics were written by Eduardo Montesinos, and the music was composed by José Padilla. Meller debuted the song in 1922 (Salaün, *El cuplé*, 310).

16. According to the online *hemeroteca* of *La vanguardia española*, between 1890 and 1973 there is only one mention of the word "travesti/s." Throughout 1974, "travestis" appears 132 times. Between 1880 and 1960, there were only 21 uses of the word "homosexual." In 1969, "homosexual" appears 110 times, and in 1977 and 1978, the word appears 190 and 147 times, respectively.

17. I thank Román Gubern for urging me to consider this point, one which needs much further investigation than I can dedicate here.

18. Cristina Moreiras Menor describes the transition and the period up to the present as "an experience that ranged from early exaltation

(midseventies until the beginning of the eighties)—a product as much of the happiness of novelty as of the disconnect from a painful and unwanted past—to complete disillusion upon facing the evidence that democracy had brought not only liberty but also an affective wound whose origin could be found in the uncertainty that this very democracy brought with it. From this uncertainty it passed to a phase in which the democratic gain is lived from the important experience of depreciation (what has become known as the *desencanto*)" (15–16).

19. See Pavlovic for an analysis of the body during the Franco regime and the transition.

20. Josep-Anton Fernández states, "This is particularly clear in Teresa M. Vilarós's rather hagiographical account of Ocaña, which practically ignores Ventura Pons's input and which, by imposing an almost exclusive Spanish point of view, renders the complexities of *Ocaña*'s cultural ascription invisible" (Fernández, 94; he refers to Vilarós, 180–98).

21. As Gema Pérez-Sánchez notes, this was not the first law in Spain that criminalized homosexuality: "In 1928, during the dictatorship of Primo de Rivera (1923–1931), the penal code included a direct reference to homosexuality within the section on 'crimes against honesty and public scandal' (164). With the beginning of the democratically elected Second Republic (1931–1936), however, the penal code was yet again reformed in 1932, and homosexuality as a crime against honesty and public scandal was deleted from the code (164)" (27).

Bibliography

Aldaraca, Bridget A. *El Ángel del Hogar: Galdós and the Ideology of Domesticity in Spain.* Chapel Hill: University of North Carolina Press, 1991.

Alleloula, Malek. *The Colonial Harem.* Minneapolis: University of Minnesota Press, 1986.

Allen, Theodore. *The Invention of the White Race: Racial Oppression and Social Control.* London: Verso, 1994.

Alonso, Luis Enrique, and Fernando Conde. *Historia del consumo en España: Una aproximación a sus orígenes y primer desarrollo.* Madrid, Spain: Debate, 1994.

Althusser, Louis. *For Marx.* London: New Left, 1969.

———. *Lenin and Philosophy.* New York: Monthly Review, 1971.

Álvarez, Rosa, and Ramón Sala Noguer. "Cifesa durante la guerra española." *Archivos de la Filmoteca* 4 (1989): 26–37.

———. *El cine en la zona nacional, 1936–1939.* Bilbao, Spain: Mensajero, 2000.

Álvarez Junco, José. *Mater dolorosa: La idea de España en el siglo XIX.* Madrid, Spain: Taurus, 2001.

Amado, Abel. *Raquel Meller: Su vida, su arte, y sus canciones.* Barcelona, 1956.

Amorós, Andres. *Luces de candilejas: Los espectáculos en España (1898–1939).* Madrid, Spain: Espasa Calpe, 1991.

Anderson, Perry. *Lineages of the Absolutist State.* London: Verso, 1974.

Aronna, Michael. *Pueblos Enfermos: The Discourse of Illness in the Turn-of-the-Century Spanish and Latin American Essay.* Chapel Hill: University of North Carolina Press, 2000.

———. "Testimonial Intent and Narrative Dissonance: The Marginal Heroes of *Biografía de un cimarrón* and *Canción de Raquel* by Miguel Barnet." Unpublished manuscript.

Arráiz, José María. "Lo que hemos visto." *Radiocinema* 24 (1939).

Arroyo, José. "Queering the Folklore: Genre and the Re-presentation of Homosexual and National Identities in *Las cosas del querer*." In

Musicals: Hollywood and Beyond, edited by Bill Marshall and Robynn Stilwell, 70–79. Exeter, UK: Intellect, 2000.

Baena, Francisco. *Los programas de mano en España*. Barcelona, Spain: FBP, 1994.

Balfour, Sebastian. *Deadly Embrace: Morocco and the Road to the Spanish Civil War*. London: Oxford University Press, 2002.

Ballesteros, Isolina. *Cine ins)urgente: Textos fílmicos y contextos culturales de la España osfranquista*. Madrid, Spain: Fundamentos, 2001.

———. "Mujer y Nación en el cine español de posguerra: los años 40." *Arizona Journal of Hispanic Cultural Studies* 3 (1999): 51–70.

Barreiro, Javier. "Las artistas de varietés y su mundo." In *Mujeres en la escena, 1900–1940*, edited by Maria Luz Gonzalez Peña, Javier Suárez-Pajares, and Julio Arce Bueno, 43–52. Madrid, Spain: Sociedad General de Autores y Editores, 1996.

———. *Cupletistas aragonesas*. Zaragoza, Spain: Caja de Ahorros y Monte de Piedad, 1994.

Bastide, Roger. "Color, Racism, and Christianity." *Daedalus* 96 (Spring 1967): 312–27.

Bazin, André. *What is Cinema?* Vol. 2. Translated by Hugh Gray. Berkeley: University of California Press, 1971.

Beach, Christopher. *Class, Language, and American Film Comedy*. Cambridge: Cambridge University Press, 2002.

Benjamin, Walter. "The Work of Art in the Mechanical Age of Reproduction." In *Illuminations*, 217–54. Translated by Hannah Arendt. New York: Schocken, 1985.

Bermúdez, Silvia. "De patriotas constitucionales, neoconservadores y periféricos: ¿Qué hace una España como tú en un entre siglos como éste?" *Revista de Estudios Hispánicos* 37 (2003): 341–55.

Berritúa, Luciano. "Frivolinas, la reconstrucción de un musical 'mudo.'" *Archivos de la Filmoteca* 34 (2000): 123–51.

Besas, Peter. *Behind the Spanish Lens: Spanish Cinema under Fascism and Democracy*. Denver, Colo.: Arden, 1985.

Bhabha, Homi K. *The Location of Culture*. London: Routledge, 1994.

Black, David A. *Law in Film: Resonance and Representation*. Urbana and Chicago: University of Illinois Press, 1999.

Boone, Joseph. "Vacation Cruises; or, The Homoerotics of Orientalism." In *Postcolonial Queer: Theoretical Intersections*, edited by John C. Hawley, 43–78. Albany: State University of New York Press, 2001.

Botti, Alfonso. *Cielo y dinero: El nacionalismo en España, 1881–1975*. Madrid, Spain: Alianza, 2008.

Bourdieu, Pierre. *Language and Symbolic Power*. Translated by Gino

Raymond and Matthew Adamson. Cambridge, Mass.: Harvard University Press, 1991.

Boyd, Carolyn P. *Historia Patria: Politics, History, and National Identity in Spain, 1875–1975*. Princeton, N.J.: Princeton University Press, 1997.

Brandes, Stanley. "Skits and Society: An Interpretation of Andalusian Folk Drama." *Western Folklore* 38, no. 4 (1979): 239–58.

Brooksbank Jones, Anny. *Women in Contemporary Spain*. Manchester, UK: Manchester University Press, 1997.

Brzoska, Michael, and Frederic S. Pearson. *Arms and Warfare: Escalation, De-escalation and Negotiation*. Columbia: University of South Carolina Press, 1994.

Burleigh, Michael, and Wolfgang Wippermann. *The Racial State: Germany 1933–1945*. London: Cambridge University Press, 1991.

Buscaglia-Salgado, José F. *Undoing Empire: Race and Nation in the Mulatto Caribbean*. Minneapolis: University of Minnesota Press, 2003.

Cabeza, José. *La narrativa invencible: El cine de Hollywood en Madrid durante la Guerra Civil Española*. Madrid, Spain: Cátedra, 2009.

Calvo Buezas, Tomás. *Racismo y solidaridad de Españoles, Portugueses, y Latinoamericanos*. Madrid, Spain: Ediciones Libertarias, 1997.

Candelario, Ginetta B. *Black behind the Ears: Dominican Racial Identity from Museums to Beauty Shops*. Durham, N.C.: Duke University Press, 2007.

Cánovas Belchi, J. "El cine mudo madrileño." *Cuadernos de la Academia de las Artes y las Ciencias Cinematográficas* October (1997): 47–57.

Canudo, Ricciotto. *L'usine aux images*. Chinon, France: Paris, 1927.

Caparrós Lera, José María. *El cine español bajo el régimen franquista (1936–1939)*. Barcelona, Spain: Publicacións i Edicións de la Universitat de Barcelona, 1983.

———. *El cine republicano español, 1931–1939*. Barcelona, Spain: Dopesa, 1977.

———. "Feature Films in the Second Spanish Republic, 1931–1936." *Historical Journal of Film, Radio and Television* 5, no. 1 (1985): 63–76.

———. *The Spanish Cinema: An Historical Approach*. Madrid, Spain: Film Historia, 1987.

———. "Spanish Cinema in the 1930's." *New Orleans Review*. 14, no. 1 (1987): 21–24.

Capel Martínez, Rosa María. "Life and Work in the Tobacco Factories: Female Industrial Workers in the Early Twentieth Century." In *Constructing Spanish Womanhood: Female Identity in Modern Spain*, edited by Victoria Lorée Enders and Pamela Beth Radcliff, 131–50. Albany, N.Y.: State University of New York Press, 1999.

Casas, Quim, and Mirito Torreiro. "Entrevista [with Pedro Olea]." In *Un cineasta llamado Pedro Olea*, edited by Jesús Angulo, Carlos F. Heredero, and José Luis Rebordinos, 85–111. Donostia, Spain: Filmoteca Vasca, 1993.

Cervantes, Miguel de. "La gitanilla." In *Novelas ejemplares*, edited by Francisco Rodriguez Marin. Madrid, Spain: Clásicos Castellanos, 1914.

Chamberlin, Vernon. "The Importance of Rodrigo Soriano's *Moros y cristianos* in the Creation of *Misercordia.*" *Anales galdosianos* 13 (1978): 105–9.

Chambers, Ross. *The Writing of Melancholy: Modes of Opposition in Early French Modernism.* Translated by Mary Seidman Trouille. Chicago: University of Chicago Press, 1993.

Charney, Leo, and Vanessa R. Schwartz, eds. *Cinema and the Invention of Modern Life.* Berkeley: University of California Press, 1995.

Charnon-Deutsch, Lou. *Fictions of the Feminine in the Nineteenth-Century Spanish Press.* University Park, Pa.: Penn State University Press, 1999.

———. *The Spanish Gypsy: The History of a European Obsession.* University Park, Pa.: Penn State University Press, 2004.

———. "Racial Fetishism in the Nineteenth-Century Illustrated Magazine." *HiperFeira* 1 (March 2002). http://www.sinc.sunysb.edu/Publish/hiper/num1/art/lou.htm.

———. "Exoticism and the Politics of Difference in Late Nineteenth-Century Spanish Periodicals." In *Culture and Gender in Nineteenth-Century Spain*, edited by Lou Charnon-Deutsch and Jo Labanyi, 250–70. New York: Oxford University Press, 1995.

Colmeiro, José. "Rehispanicizing Carmen: Cultural Reappropriations in Spanish Cinema." In *Carmen: From Silent Film to MTV*, edited by Chris Perriam and Ann Davies, 91–105. Amsterdam: Rodopi, 2005.

———. "Exorcising Exoticism: Carmen and the Construction of Oriental Spain." *Comparative Literature* 54 (2002): 127–44.

Colmeiro, José, Christina Dupláa, Patricia Greene, and Juana Sabadell, eds. *Spain Today: Essays on Literature, Culture, Society.* Hanover, N.H.: Dartmouth College, Department of Spanish and Portuguese, 1995.

Comas, Angel. *El star system del cine español de posguerra, 1939–1945.* Madrid, Spain: T and B, 2004.

Courtney, Susan. *Hollywood Fantasy of Miscegenation: Specular Narratives of Gender and Race.* Princeton, N.J.: Princeton University Press, 2005.

Cover, Robert. "Violence and the Word." *Yale Law Journal* 95 (1995): 1601–28.

Crary, Jonathan. *Techniques of the Observer: On Vision and Modernity in the Nineteenth Century.* Cambridge, Mass.: MIT, 1999.

de la Madrid, Juan Carlos. *Cinematógrafo y 'varietés' en Asturias (1896–1915).* Asturias, Spain: Asturgraf, 1996.

de la Plaza, Martín. *Conchita Piquer.* Madrid, Spain: Alianza, 2002.

de Mateo, Soledad. "Castañuelas para Franco: Nacionalismo y misticismo en la canción flamenquista de la postguerra española." PhD diss., SUNY–Stony Brook, 1996.

DeCoster, Cyrus C. "Valera and Andalusia." *Hispanic Review* 29, no. 3 (1961): 200–216.

del Rey Regillo, Antonia. "Los rótulos, o la disrupción narrativa en *Currito de la cruz* (1925)" *Secuencias* 2, no. 11 (2000): 49–63.

Deleito y Piñuela, José. *Origen y apogeo del "género chico."* Madrid, 1949.

Delgado, Elena. "La nación deseada: Europeización, diferencia y la utopia de la(s) España(s)." In *From Stateless Nations to Postnational Spain,* edited by Antonio Cortijo, Silvia Bermúdez, and Timothy McGovern, 207–23. Boulder, Colo.: Society of Spanish and Spanish American Studies, 2002.

———. "Reconstructions: An Introduction." *Journal of Spanish Cultural Studies* 4, no. 1 (2003): 3–10.

Dent Coad, Emma. "Constructing the Nation: Francoist Architecture." In *Spanish Cultural Studies: An Introduction,* edited by Helen Graham and Jo Labanyi, 223–25. New York: Oxford University Press, 1995.

Diawara, Manthia. "The Blackface Stereotype." *Black Cultural Studies.* blackculturalstudies.org/m_diawara/blackface.html.

Díaz López, Marina. "Las vías de la Hispanidad en una co-producción hispanoamericana de 1948: Jalisco canta en Sevilla." In *Los límites de la frontera: La co-producción en el cine español (VII Congreso de la Asociación Española de Historiadores del Cine),* edited by Marina López Díaz and Luis Fernández Colorado. *Cuadernos de la Academia* 5 (1999): 141–65.

Díaz de Quijano, Máximo. *Tonadilleras y cupletistas: Historia del cuplé.* Madrid, Spain: Cultura Clásica y Moderna, 1960.

Díaz del Moral, Juan. *Historia de las agitaciones campesinas andaluzas-Cordoba (Antecendentes para una reforma agrarian).* Madrid, Spain: Alianza, 1973.

Díez, Emeterio. "Los acuerdos cinematográficos entre el franquismo y el Tercer Reich (1936–1945)." *Archivos de la Filmoteca* 33 (1999): 35–59.

Díez Puertas, Emeterio. "Del teatro al cine mudo." In *De Dalí a Hitchcock:*

Los caminos en el cine: Actas del V Congreso de la AEHC, edited by Julio Pérez Perucha, 261–70. La Coruña, Spain: Centro Galego de Artes de Imaxe, 1995.

———. "El montaje del franquismo: La política cinematográfica de las fuerzas sublevadas." *Cuadernos de historia contemporánea* 23 (2001): 141–60.

Díez Sánchez, Juan. *Melilla y el mundo de la imagen.* Cuidad Autónoma de Melilla, Spain: Consejería de Cultura, Educación, Juventud y Deporte, 1997.

D'Lugo, Marvin. *The Films of Carlos Saura: The Practice of Seeing.* Princeton, N.J.: Princeton University Press, 1991.

Doane, Mary Ann. *The Emergence of Cinematic Time: Modernity, Contingency, the Archive.* Cambridge, Mass.: Harvard University Press, 2002.

———. *Femmes Fatales.* New York: Routledge, 1991.

Dougherty, Dru. "Theatre and Eroticism: Valle-Inclán's *Farsa y Liciencia de la Reina Castiza.*" *Hispanic Review* 55, no. 1 (Winter 1987): 13–25.

Du Bois, W. E. B. *The Souls of Black Folk.* New York: Bantam, 1989.

Ďurovičová, Nataša. "Translating America: The Hollywood Multilinguals, 1929–1933." In *Sound Theory/Sound Practice,* edited by Rick Altman, 138–53. New York: Routledge, 1992.

Dussel, Enrique. "Eurocentrism and Modernity (Introduction to the Frankfurt Lectures)." In *The Postmodernism Debate in Latin America,* edited by John Beverly, Michael Aronna, and José Oviedo, 65–76. Durham, N.C.: Duke University Press, 1995.

Dyer, Richard. *Only Entertainment.* London: Routledge, 2002.

———. *Stars.* London: BFI, 1979.

———. *White.* London: Routledge, 1997.

Elena, Alberto. *La llamada de África: Estudios sobre el cine colonial español.* Barcelona, Spain: Edicions Bellaterra, 2010.

———. "Notas sobre el documental colonial en España." In *Imagen, memoria y fascinación: Notas sobre el documental en España,* edited by Josep Maria Català, Josetxo Cerdán, and Casimiro Torreiro, 115–24. Madrid, Spain: Festival de Cine Español de Málaga/Ocho y Medio, 2001.

Elena, Alberto, and Javier Ordóñez. "Science, Technology, and the Spanish Colonial Experience in the Nineteenth Century." In *Nature and Empire: Science and the Colonial Enterprise,* edited by Roy MacLeod. Chicago: University of Chicago Press, 2000.

Elsaesser, Thomas. "Tales of Sound and Fury: Observations on the Family Melodrama." In *Home Is Where the Heart Is: Studies in Melodrama*

and the Woman's Film, edited by Christine Gledhill, 43–69. London: BFI, 1987.

Enders, Victoria Lorée. "Problematic Portraits: The Ambiguous Historical Role of the Sección Feminina of the Falange." In *Constructing Spanish Womanhood: Female Identity in Modern Spain*, edited by Victoria Lorée Enders and Pamela Beth Radcliff, 375–97. Albany, N.Y.: State University of New York Press, 1999.

Eng, David L. "The End(s) of Race." *PMLA* 123, no. 5 (2008): 1479–93.

Eng, David L., Judith Halberstam, and José Esteban Muñoz. Introduction to *Social Text* 23, nos. 3–4 (2005): 1–17.

Epps, Brad. "Between Europe and Africa: Modernity, Race, and Nationality in the Correspondence of Miguel de Unamuno and Joan Maragall." *Anales de Literatura Española Contemporánea* 30, nos. 1–2 (2005): 95–131.

Esdaile, Charles J. *Spain in the Liberal Age: From Constitution to Civil War, 1808–1939*. London: Blackwell, 2000.

Evans, Peter. "Back to the Future: Cinema and Democracy." In *Spanish Cultural Studies: An Introduction*, edited by Helen Graham and Jo Labanyi, 326–31. New York: Oxford University Press, 1995.

———. "Cifesa: Cinema and Authoritarian Aesthetics." In *Spanish Cultural Studies: An Introduction*, edited by Helen Graham and Jo Labanyi, 215–22. New York: Oxford University Press, 1995.

Fabian, Johannes. *Time and Its Other: How Anthropology Makes Its Object*. New York: Columbia University Press, 1983.

Fanes, Felix. *Cifesa: La antorcha de los éxitos*. Valencia, Spain: Instituto Alfonso Magnámino, 1982.

Fanon, Frantz. *Black Skin, White Masks*. Translated by Charles Lam Markmann. New York: Grove, 1967.

Fernández, Josep-Anton. "The Authentic Queen and the Invisible Man: Catalan Camp and Its Conditions of Possibility in Ventura Pons's *Ocaña, retrat intermitent*." *Journal of Spanish Cultural Studies* 5, no.1 (2004): 83–99.

Fernández Colorado, Luis. "Los expositores del imperio." In *Imagen, memoria y fascinación: Notas sobre el documental en España*, edited by Josetxo Cerdan, 65–74. Madrid, Spain: Ocho y Media, 2001.

Fernández Cuenca, Carlos. *Recuerdo y presencia de Florián Rey*. San Sebastián, Spain: Festival Internacional de Cine, 1962.

Feuer, Jane. *The Hollywood Musical*. Bloomington: Indiana University Press, 1993.

———. "The Self-Reflexive Musical and the Myth of Entertainment." In

Film Theory and Criticism, edited by Gerald Mast, Marshall Cohen, and Leo Braudy. New York: Oxford University Press, 1992.

Flesler, Daniela. *The Return of the Moor: Spanish Responses to Contemporary Moroccan Immigration.* West Lafayette, Ind.: Purdue University Press, 2008.

Font, Doménec. *De azul al verde: El cine español durante el franquismo.* Barcelona, Spain: Editorial Avance, 1976.

Fortuño Llorens, Santiago. *Alberto Insúa: Memorias: Antología.* Madrid, Spain: Fundación Santander Central Hispano, 2003.

———. "Introducción biográfica y crítica." In *El negro que tenía el alma blanca,* edited by Alberto Insúa and Santiago Fortuño Llorens, 9–56. Madrid, Spain: Clásicos Castalia, 1998.

Foster, Don. "Race, Space and Civil Society." In *Sameness and Difference: Problems and Potentials in South African Civil Society,* edited by James R. Cochrane and Bastienne Klein. Washington, D.C.: Council for Research in Values and Philosophy, 2000.

Foucault, Michel. *Discipline and Punish: The Birth of the Prison.* Translated by Alan Sheridan. New York: Vintage, 1995.

Fraser, Angus. *The Gypsies.* Oxford, UK: Blackwell, 1992.

Freixas, Ramón. "Cifesa: Un gigante con pies de barro." *Dirigido por* 104 (1983): 16–27.

Fuchs, Barbara. *Passing for Spain: Cervantes and the Fictions of Identity.* Urbana: University of Illinois Press, 2003.

Furman, Nelly. "The Languages of Love in Carmen." In *Reading Opera,* edited by Arthur Groos and Roger Parker. Princeton, N.J.: Princeton University Press, 1988.

Gaines, Jane M. *Contested Culture: The Image, the Voice, and the Law.* Chapel Hill: University of North Carolina Press, 1991.

———. *Fire and Desire: Mixed-Race Movies in the Silent Era.* Chicago: University of Chicago Press, 2001.

Gallardo Saborido, Emilio José. *Gitana tenías que ser: Las andalucías imaginadas por las coproducciones fílmicas España-Latinoamérica.* Seville, Spain: Centro de Estudios Andaluces, 2010.

Ganivet, Ángel. *El porvenir de España.* Madrid, Spain: Renacimiento, 1912.

García Carrión, Marta. *Sin cinematografía no hay nación: Drama e identidad nacional española en la obra de Florián Rey.* Zaragoza, Spain: Instituto "Fernando el Católico," 2007.

García Escudero, José María. *Cine español.* Madrid, Spain: Ediciones Rialp, 1962.

García Fernández, Emilio C. *El cine español entre 1896 y 1939: Historia, industria, filmografía y documentos*. Barcelona, Spain: Ariel, 2002.

———. *Historia illustrada del cine español*. Madrid, Spain: Planeta, 1985.

García Martínez, José María. *Del fox-trot al jazz flamenco: El jazz en España, 1919–1996*. Madrid, Spain: Alianza, 1996.

García Morente, Manuel. *Idea de la hispanidad*. 2nd ed. Madrid, Spain: Espasa Calpe, 1939.

García Riera, Emilio. *Historia documental del cine mexicano*. Vol. 1. Mexico City: Ediciones Era, 1969.

García Seguí, Alfons. "Cifesa, *La antorcha de los éxitos*." *Archivos de la Filmoteca* 4 (1989): 38–49.

Garland, Iris. "Early Modern Dance in Spain: Tortola Valencia, Dancer of the Historical Intuition." *Dance Research Journal* 29, no. 2 (1997): 1–22.

Garlinger, Patrick. "Sex Changes and Political Transitions; or, What Bibi Andersen Can Tell Us about Democracy in Spain." In *Traces of Contamination: Unearthing the Francoist Legacy in Contemporary Spanish Discourse*, edited by Eloy E. Merino and H. Rosi Song, 27–52. Cranbury, N.J.: Rosemont, 2005.

Gaudreault, André. "Del 'cine primitivo' a la cinematografía-atracción'" *Secuencias* 26, no. 2 (2007): 10–28.

Giddens, Anthony. *The Consequences of Modernity*. Palo Alto, Calif.: Stanford University Press, 1991.

Gilman, Sander. *Difference and Pathology*. Ithaca, N.Y.: Cornell University Press, 1985.

Gilroy, Paul. *The Black Atlantic: Modernity and Double Consciousness*. Cambridge, Mass.: Harvard University Press, 1993.

Ginger, Andrew. "Space, Time, and Desire in the Atlantic in Three Spanish Films of the 1920s." *Hispanic Research Journal* 8, no.1 (2007): 69–78.

Girbal, F. Hernández. "Hay que españolizar nuestro cine." *Cinegramas* 10, no. 2 (1935): 3.

Goldberg, David Theo. "Racial Americanization." In *Racialization: Studies in Theory and Practice*, edited by Murji and Solomos, 87–102. Oxford: Oxford University Press, 2005.

———. *The Racial State*. Malden, Mass.: Blackwell, 2002.

Gómez, Fran, and Luis Navarrete. "La mujer folklórica andaluza." In *Alicia en Andalucía: La mujer andaluza como personaje cinematográfico*, edited by Virginia Guarinos, 17–25. Granada, Spain: Filmoteca de Andalucía, 1999.

Gómez Santos, Marino. *Mujeres Solas*. Barcelona, Spain: Pareja y Borrás, 1959.

González Romero, Emilio. *Otros abogados y otros juicios en el cine español*. Barcelona, Spain: Laertes, 2006.

González Troyano, Alberto. *La desventura de Carmen: Una divagación sobre Andalucía*. Madrid, Spain: Espasa Calpe, 1991.

Goode, Joshua. *Impurity of Blood: Defining Race in Spain, 1830–1930*. Baton Rouge: Louisiana State University Press, 2009.

Gould, Evelyn. *The Fate of Carmen*. Baltimore, Md.: Johns Hopkins University Press, 1996.

Goytisolo, Juan. *España y los españoles*. Barcelona, Spain: Lumen, 1969.

Graham, Helen. "Popular Culture in the Years of Hunger." In *Spanish Cultural Studies: An Introduction*, edited by Helen Graham and Jo Labanyi, 237–45. New York: Oxford University Press, 1995.

Graham, Helen, and Jo Labanyi, eds. *Spanish Cultural Studies: An Introduction*. New York: Oxford University Press, 1995.

Gramsci, Antonio. *The Prison Notebooks*. Translated by Quentin Hoare and Geoffrey Noel Smith. New York: International, 1971.

Greer, Margaret R., Walter D. Mignolo, and Maureen Quilligan, ed. *Rereading the Black Legend: The Discourses of Religious and Racial Difference in the Renaissance Empires*. Chicago: University of Chicago Press, 2007.

Grugel, Jean, and Tim Rees. *Franco's Spain*. London: Arnold, 1997.

Gubern, Román. "El cine sonoro (1930–1939)." In *Historia del cine español*, 6th ed., edited by Román Gubern et al, 123–76. Madrid, Spain: Cátedra, 2009.

———. "Ruido, furia y negritude: Nuevos ritmos y nuevos sones para la vanguardia." In *Vanguardia española e intermedialidad: Artes escénicas, cine y radio*, edited by Albert Mechthild, 273–302. Madrid, Spain: Vervuert/Iberoamericana, 2005.

———. *Benito Perojo: Pionerismo y supervivencia*. Madrid, Spain: Filmoteca Española, Ministerio de Cultura, 1994.

———. "Claves de la aticipidad europea del cine español." *Archivos de la Filmoteca* 2 (1989): 18–27.

———. "La decadencia de Cifesa." *Archivos de la Filmoteca* 4 (1989): 58–65.

———. *1936–1939: La guerra de España en la pantalla*. Madrid, Spain: Filmoteca Española, 1986.

———. *El cine sonoro en la II República, 1929–1936*. Barcelona, Spain: Lumen, 1977.

Gubern, Román, and Doménec Font. *Un cine para el cadalso: 40 años de censura cinematográfica en España*. Barcelona, Spain: Editorial Euros, 1975.

Gubern, Román, José Enrique Monterde, Julio Pérez Perucha, Esteve Riambau, and Casimiro Torreiro, eds. *Historia del cine español*. 6th ed. Madrid, Spain: Cátedra, 2009.

Gunning, Tom. "'Now You See It, Now You Don't': The Temporality of the Cinema of Attractions." In *Silent Film*, edited by Richard Abel, 71–84. New Brunswick, N.J.: Rutgers University Press, 1996.

Hall, Stuart, and Paddy Whannel. *The Popular Arts*. New York: Pantheon, 1965.

Hancock, Ian. "Roma: Genocide of Roma in the Holocaust." In *Encyclopedia of Genocide*, 2 vols., edited by Israel W. Charny, 501. Santa Barbara, Calif.: ABC-CLIO, 1999.

Handley, Sharon. "Federico García Lorca and the 98 Generation: The Andalucismo Debate." *Anales de la literatura española contemporánea* 21 (1996): 41–58.

Hansen, Miriam. *Babel and Babylon: Spectatorship in American Silent Film*. Cambridge, Mass.: Harvard University Press, 1991.

Harrell-Bond, Barbara. "The Struggle for the Western Sahara." *American Universities Field Staff Reports* 38 (1981): 37–39.

Harvey, David. *The Condition of Postmodernity*. Oxford, UK: Blackwell, 1989.

Hernández Eguiluz, Aitor. *Testimonios en huecograbado: El cine de la Segunda República y su prensa especializada (1930–1939)*. Valencia, Spain: Ediciones de la Filmoteca, 2009.

Historia de España: Segundo grado. Zaragoza, Spain: Editorial Luis Vives, 1958.

Hopewell, John. *Out of the Past: Spanish Cinema after Franco*. London: BFI, 1986.

Insúa, Alberto. *Memorias*. Vol. 1. Madrid, Spain: Tesoro,1952.

———. *Memorias*. Vol. 2. Madrid, Spain: Tesoro, 1953.

———. *El negro que tenía el alma blanca*. 1922. Reprint, Madrid, Spain: Clásicos Castalia, 1998.

———. *La sombra de Peter Wald: Segunda parte de El negro que tenía el alma blanca*. 1942. Reprint, Madrid, Spain: Espasa Calpe, 1967.

Jameson, Fredric. "Modernism and Imperialism." In *Nationalism, Colonialism, and Literature*, edited by Terry Eagleton, Frederic Jameson, and Edward Said, 43–68. Minneapolis: University of Minnesota Press, 1990.

Kagan, Richard. "From Noah to Moses: The Genesis of Historical Scholarship on Spain in the United States." In *Spain in America: The Origins of Hispanism in the United States*, edited by Richard Kagan, 21–48. Urbana: University of Illinois Press, 2002.

Kaplan, E. Anne. *Looking for the Other: Feminism, Film and the Imperial Gaze*. New York: Routledge, 1997.

Keating, Michael. "The Minority Nations of Spain and European Integration: A New Framework for Autonomy?" *Spanish Cultural Studies* 1, no. 1 (2000): 29–42.

Kincheloe, Joe L., Shirley R. Steinberg, Nelson M. Rodríguez, and Ronald E. Channault. *White Reign: Deploying Whiteness in America*. New York: St. Martin's Press, 2000.

Kinder, Marsha. *Blood Cinema: The Reconstruction of National Identity in Spain*. Berkeley: University of California Press, 1993.

Kracauer, Siegfried. *Theory of Film: The Redemption of Physical Reality*. Princeton, N.J.: Princeton University Press, 1997.

Labanyi, Jo. "History and Hauntology; or What Does One Do with the Ghosts of the Past? Reflections on Spanish Film and Fiction of the Post-Franco Period." In *Disremembering Dictatorship: The Politics of Memory in the Spanish Transition to Democracy*, edited by Joan Ramón Resina, 65–82. Amsterdam: Rodopi, 2003.

———. "Musical Battles: Populism and Hegemony in the Early Francoist Folkloric Film Musical." In *Constructing Identity in Contemporary Spain: Theoretical Debates and Cultural Practice*, edited by Jo Labanyi, 206–21. London: Oxford, 2002.

———. "Internalisations of Empire: Colonial Ambivalence and the Early Francoist Missionary Films." *Discourse* 23, no. 1 (2001): 25–42.

———. *Gender and Modernization in the Spanish Realist Novel*. London: Oxford University Press, 2000.

———. "Miscegenation, Nation Formation and Cross-racial Identifications in the Early Francoist Folkloric Film Musical." In *Hybridity and Its Discontents: Politics, Science, Culture*, edited by Avtar Brah and Annie E. Coombes, 56–71. London: Routledge, 2000.

———. "Political Readings of Don Juan and Romantic Love in Spain from the 1920s to the 1940s." In *New Dangerous Liaisons: Discourses on Europe and Love in the Twentieth Century*, edited by Luisa Passerini, Liliana Ellena, and Alexander C. T. Geppert. London: Berghanh, 2010.

———. "Race, Gender and Disavowal in Spanish Cinema of the Early Franco Period: The Missionary Film and the Folkloric Musical." *Screen* 38, no. 3 (1997): 215–31.

———. "Raza género y denegación en el cine español del primer franquismo." *Archivos de la Filmoteca* 32 (1999): 23–42.

———. "Women, Asian Hordes and the Threat to the Self in Giménez Caballero's *Genio de España.*" *Bulletin of Hispanique Studies* 73 (1996): 377–87.

Laffranque, Marie. "Federico García Lorca: Nouveaux Textes en Prose" *Bulletine Hispanique* 56, no. 3 (1954): 260–300.

Lamont, Peter. *The Rise of the Indian Rope Trick: How a Spectacular Hoax Became History.* New York: Thunder's Mouth, 2004.

Lane, Jill Meredith. *Anticolonial Blackface: The Cuban Teatro Bufo and the Arts of Racial Impersonation, 1840–1895.* New York: New York University Press, 2000.

Lerena, Carlos. *Escuela, ideología y clases sociales en España.* Barcelona, Spain: Ariel, 1976.

Lewis, Tom. "Aesthetics and Politics." In *Critical Practices in Post-Franco Spain,* edited by Silvia L. López, Jenaro Talens, and Darío Villanueva, 160–82. Minneapolis: University of Minnesota Press, 1994.

———. "Structures and Agents: The Concept of 'Bourgeois Revolution' in Spain." *Arizona Journal of Hispanic Cultural Studies* 3 (1999): 7–16.

Loizidou, Elena. "Rebel without a Cause?" In *Law's Moving Image,* edited by Leslie J. Moran, Emma Sandon, Elena Loizidou, and Ian Christie, 45–60. London: Glasshouse Press, 2004.

Lombroso, Cesare. *Crime, Its Causes and Remedies.* Translated by Henry P. Horton. Boston: Little, Brown, 1918.

López García, Bernabé. "Imágenes del protectorado (1940–1960)" *Puertaoscura,* nos. 3–4 (1986): 75–77.

López Ruiz, José. *Aquel Madrid del cuplé.* Madrid, Spain: Avapiés, 1988.

Losilla, Carlos. "Su ciclo literario: Marginación y conformismo." In *Un cineasta llamado Pedro Olea,* 61–70. Donostia, Spain: Filmoteca Vasca, 1993.

Loyo, Hilaria. "A Carmenesque Dietrich in *The Devil Is a Woman*: Erotic Scenarios, Modern Desires and Cultural Differences Between the USA and Spain." In *Carmen from Silent Film to MTV,* edited by Chris Perriam and Anne Davies, 75–89. Rodopi, 2005.

Magy, Henriette. *Raquel, la vie et l'art de Raquel Meller.* Toulouse, France: Studio Téchnique D'Éditions, 1931.

Marantz Cohen, Paula. *Silent Film and the Triumph of the American Myth.* New York: Oxford University Press, 2001.

Mariscal, George. "The Role of Spain in Contemporary Race Theory." *Arizona Journal of Hispanic Cultural Studies* 2 (1998): 7–22.

Martín Corrales, Eloy. *La imagen del magrebí en España: Una perspectiva histórica, siglos XVI-XX.* Barcelona, Spain: Bellaterra, 2002.

Martín Fernandez, Miguel. *La comunidad gitana en Galicia.* Santiago de Compostela, Spain: Xunta de Galicia, 1992.

Martín-Gaite, Carmen. *Usos amorosos de la posguerra española.* Barcelona, Spain: Anagrama, 1987.

———. "Cuarto a espadas sobre las coplas de posguerra." *Triunfo* 529 (November 18, 1972): 36–39.

Martín Jiménez, Ignacio. "El cine de los años 20 y su relación con el espectáculo popular." In *De Dalí a Hitchcock: Los caminos en el cine: Actas del V Congreso de la AEHC,* edited by Julio Pérez Perucha, 375–84. La Coruña, Spain: Centro Galego de Artes de Imaxe, 1995.

Martin-Márquez, Susan. *Disorientations: Spanish Colonialism in Africa and the Performance of Identity.* New Haven, Conn.: Yale University Press, 2008.

———. *Feminist Discourse and Spanish Cinema: Sight Unseen.* New York: Oxford University Press, 1999.

Martínez-Bretón, Juan Antonio. "El control cinematográfico en la evolución del mudo al sonoro." In *El paso del mudo al sonoro en el cine español.* Actas del A.E.H.C., 110–27. Madrid, Spain: Editorial Complutense, 1993.

McClintock, Anne. *Imperial Leather: Race, Gender and Sexuality in the Colonial Contest.* New York: Routledge, 1995.

McGee, Patrick. *Cinema, Theory, and Political Responsibility in Contemporary Culture.* Cambridge: Cambridge University Press, 1997.

McQuade, Frank. "Sentimental Battles: An Introduction to the Works of Alberto Insúa." In *A Further Range: Studies in Spanish Literature from Galdós to Unamuno,* edited by A. H. Clarke, 219–37. Exeter, UK: University of Exeter Press, 1999.

Medina-Doménech, Rosa. "Scientific Technologies of National Identity as Colonial Legacies: Extracting the Spanish Nation from Ecuatorial Guinea." *Social Studies of Science* 39 (2009): 81–112.

Méndez-Leite, Fernando. *Historia del cine español.* 2 vols. Madrid, Spain: Rialp, 1965.

Mercer, Kobena. "Reading Racial Fetishism: The Photographs of Robert Mapplethorpe." In *Fetishism as Cultural Discourse,* edited by Emily Apter and William Pietz, 307–20. Ithaca, N.Y.: Cornell University Press, 1993.

Mignolo, Walter. *The Idea of Latin America.* Malden, Mass.: Blackwell, 2005.

Minguet Batllori, J. M. "Early Spanish Cinema and the Problem of Modernity." *Film History* 16, no. 1 (2004): 92–107.

———. "La regeneración del cine como hecho cultural durante el primer franquismo (Manuel Augusto Viñolas y la etapa inicial de *Primer plano*)." Biblioteca Virtual Miguel de Cervantes, 2000. http://www.cervantesvirtual.com/servlet/SirveObras/80272707323794507754491/p0000001.htm.

Mira, Alberto. "After Wilde: Camp Discourse in Hoyos and Retana, or the Dawn of Spanish Gay Culture." *Journal of Spanish Cultural Studies* 5, no. 1 (2004): 29–47.

———. *De Sodoma a Chueca: Una historia de la homosexualidad en España en el siglo XX*. Barcelona, Spain: Egales, 2004.

Mitchell, Timothy. *Flamenco, Deep Song*. New Haven, Conn.: Yale University Press, 1994.

———. "The Stage of Modernity." In *Questions of Modernity*, edited by Timothy Mitchell, 1–34. Minneapolis: University of Minnesota Press, 2000.

Moix, Terenci. *Suspiros de España: La copla y el cine de nuestro recuerdo*. Barcelona, Spain: Plaza y Janes, 1993.

Monterde, José Enrique. "Del melodrama histórico a la crónico de sucesos." In *Un cineasta llamado Pedro Olea*, edited by Jesús Angulo, Carlos F. Heredero, and José Luis Rebordinos, 37–50. Donostia, Spain: Filmoteca Vasca, 1993.

Mora, Carlos J. "The Odyssey of Spanish Cinema." *New Orleans Review* 14, no. 1 (1987): 7–20.

Morcillo, Aurora G. *True Catholic Womanhood: Gender Ideology in Franco's Spain*. Dekalb: Northern Illinois University Press, 2000.

Moreiras Menor, Cristina. *Cultura herida: Literatura y cine en la España democrática*. Madrid, Spain: Ediciones Libertarias, 2002.

Morgan, Rikki. "Nostalgia and the Contemporary Spanish Musical Film." *Revista Canadiense de Estudios Hispánicos* 20, no. 1 (1995): 151–56.

Morris, C. B. "'Bronce y Sueño': Lorca's Gypsies." *Neophilologus* 61, no. 2 (1977): 227–44.

Morse, William R. "Desire and the Limits of Melodrama." In *Melodrama*, edited by James Redmond, 17–30. Cambridge: Cambridge University Press, 1992.

Mulvey, Laura. "Visual Pleasure and Narrative Cinema." In *Film Theory and Criticism: Introductory Readings*, edited by Leo Braudy and Marshall Cohen, 833–44. New York: Oxford University Press, 1999.

Muñoz Aunión, Marta. "El cine español según Goebbels: Apuntes sobre la versión alemana de *Carmen, la de Triana*." *Secuencias. Revista de Historia del Cine* 20, no. 2 (2004): 25–46.

Murji, Karim, and John Solomos. "Racialization in Theory and Practice." In *Racialization: Studies in Theory and Practice*, edited by Murji and Solomos, 1–28. Oxford: Oxford University Press, 2005.

Myers, Tony. *Slavoj Žižek*. London: Routledge, 2003.

Navarrete Cardero, José Luis. "La españolada y Sevilla." *Frame: Revista de la Biblioteca de la Facultad de Comunicación* 2 (2007): 352–81.

Nash, Mary. "Protonatalism and Motherhood in Franco's Spain." In *Maternity and Gender Policies: Women and the Rise of the European Welfare State, 1880–1950's*, edited by Gisela Bock and Pat Thane, 160–77. London: Routledge, 1991.

———. "Un/Contested Identities: Motherhood, Sex Reform and the Modernization of Gender Identity in Early Twentieth-Century Spain." In *Constructing Spanish Womanhood: Female Identity in Modern Spain*, edited by Victoria Lorée Enders and Pamela Beth Radcliff, 25–50. Albany, N.Y.: State University of New York Press, 1999.

Negra, Diane. *Off-white Hollywood: American Culture and Ethnic Female Stardom*. London: Routledge, 2001.

Nietzsche, Friedrich. *The Works of Friedrich Nietzsche*. Vol. 11. Edited by Alexander Tille. Translated by Thomas Common. New York: Macmillan, 1896.

Oliver, Federico. *El negro que tenía el alma blanca: Adaptación teatral en seis jornadas*. Madrid, Spain: La Farsa, 1930.

Ortega y Gasset, José. "Teoría de Andalucía." In *Obras completas*, vol. 6. Madrid, Spain: Revista de Occidente/Alianza, 1983.

Pantoja, Dolores. "El diablo era mujer y andaluza." In *Alicia en Andalucía*, edited by Virginia Guarinos, 53–66. Granada, Spain: Filmoteca de Andalucía, 1999.

Parchesky, Jennifer. "Women in the Driver's Seat: The Auto-erotics of Early Women's Films." *Film History: An International Journal* 18, no. 2 (2006): 174–84.

Pavlovic, Tatjana. *Despotic Bodies and Transgressive Bodies: Spanish Culture from Francisco Franco to Jesús Franco*. Albany, N.Y.: State University of New York Press, 2003.

Payne, Stanley G. *The Franco Regime, 1936–1975*. Madison: University of Wisconsin Press, 1987.

———. *Spain's First Democracy: The Second Republic, 1931–1936*. Madison: University of Wisconsin Press, 1993.

Peller, Gary. "Race Consciousness." In *Critical Race Theory: The Key Writings That Formed the Movement*, edited by Kimerblé Crenshaw, Neil Gotanda, Gary Peller, and Kendall Thomas, 127–58. New York: New Press, 1995.

Peñasco, Rosa. *La copla sabe de leyes: El matrimonio, la separación, el divorcio y los hijos en nuestras canciones.* Madrid, Spain: Alianza, 2000.

Perednik, Gustavo D. "Naive Spanish Judeophobia." *Jewish Political Studies Review* 15, nos. 3–4 (Fall 2003), http://www.jcpa.org/phas/phas-perednik-fo3.htm.

Pérez Perucha, Julio. "Narración de un aciago destino (1896–1930)." In *Historia del Cine Español*, edited by Román Gubern, José Enrique Monterde, Julio Pérez Perucha, Esteve Riambau, and Casimiro Torreiro, 19–121. Madrid, Spain: Cátedra, 2000.

Pérez-Sánchez, Gema. *Queer Transitions in Contemporary Spanish Culture: From Franco to la Movida.* Albany, N.Y.: State University of New York Press, 2007.

Perriam, Chris. "*Las cosas del querer* (Chávarri, 1989)." In *Spanish Cinema: The Auterist Tradition*, edited by Peter Evans, 254–69. Oxford: Oxford University Press, 1999.

———. "Gay and Lesbian Culture." In *Spanish Cultural Studies: An Introduction*, edited by Helen Graham and Jo Labanyi, 393–95. New York: Oxford University Press, 1995.

Pine, Lisa. *Hitler's "National Community": Society and Culture in Nazi Germany.* London: Hodder Arnold, 2007.

Pineda Novo, Daniel. *Las folklóricas y el cine.* Huelva, Spain: Festival de Cine Iberoamericano, 1991.

Pingree, Geoffrey. "Modern Anxiety and Republican Cinema in Documentary Spain." In *Visualizing Spanish Modernity*, edited by Susan Larson and Eva Woods, 301–28. London: Berg, 2005.

Posadas, Carmen. *La Bella Otero.* Madrid, Spain: Planeta, 2001.

Pozo Arenas, Santiago. *La industria del cine en España: Legislación y aspectos económicos (1896–1970).* Barcelona, Spain: Edicions Universitat de Barcelona, 1984.

Preston, Paul. *Franco: A Biography.* New York: Basic Books, 1994.

Pulido, Ángel F. *Bosquejos médico-sociales para la mujer.* Madrid, 1876.

Pym, Richard. *The Gypsies of Early Modern Spain, 1425–1783.* Houndsmills, Basingstoke, Hampshire, UK: Palgrave Macmillan, 2007.

Pythian, Mark. *Arming Iraq: How the U.S. and Britain Secretly Built Saddam's War Machine.* Boston: Northeastern University Press, 1997.

Quesada, Luis. *La novela española y el cine.* Madrid, Spain: Ediciones JC, 1986.

Quintero, Antonio, and Pascual Guillén. *Morena clara.* Madrid, Spain: La Farsa, 1935.

Ramos, Olga María. *De Madrid al cuplé: Una crónica cantada.* Madrid, Spain: La Librería, 2001.

Read, Malcolm. "Cristóbal de Villón: Language, Education, and the Absolutist State." In *Subjectivity and the Modern State in Spain*, edited by Tom Lewis and Francisco Sánchez, 1–33. Minneapolis: University of Minnesota Press, 1999.

———. "Racism and Commodity Structure: The Case of Sab." *Journal of Iberian and Latin American Studies* 10, no. 1 (2004): 61–84.

Resina, Joan Ramon. "Laissez faire y reflexividad erótica en 'La gitanilla.'" *Modern Language Notes* 106, no. 2 (1991): 257–78.

Retana, Álvaro. *Historia de la canción española*. Madrid, Spain: Tesoro, 1967.

———. *Historia del arte frívolo*. Madrid, Spain: Tesoro, 1964.

Riambau, Esteve. "El periodo 'socialista' (1982–1995)." In *Historia del cine español*, 6th ed., edited by Román Gubern, José Enrique Monterde, Julio Pérez Perucha, Esteve Riambau, and Casimiro Torreiro, 399–454. Madrid, Spain: Cátedra, 2009.

Robinson, Nehemiah. *The Spain of Franco and Its Policies toward the Jews*. New York: Institute of Jewish Affairs, World Jewish Congress, 1953.

Rohr, Isabelle. *The Spanish Right and the Jews, 1898–1945: Antisemitism and Opportunism*. Brighton, UK: Sussex Academic Press, 2007.

Román, Manuel. *Memoria de la copla: La canción española: De Conchita Piquer a Isabel Pantoja*. Madrid, Spain: Alianza Editorial, 1993.

Rotellar, Manuel. *Cine español de la República*. San Sebastián, Spain: XXV Festival Internacional de Cine, 1977.

Roura, Assumpta. *Mujeres para después de una guerra: Una moral hipócrita del Franquismo*. Madrid, Spain: Flor de viento, 1999.

Ruiz, José, and Jorge Fiestas. *Imperio Argentina: Ayer, hoy y siempre*. Argantonio, Spain: Festival Internacional de Cine de Sevilla, 1981.

Ruiz Muñoz, María Jesús, and Inmaculada Sánchez Alarcón. *La imagen de la mujer andaluza en el cine español*. Seville, Spain: Centro de Estudios Andaluces, 2008.

Saiz Viadero, J. R., J. L. Gómez Barcelo, F. Saro Gandarillas, F. Díez Sánchez, J. Marqués López, and N. Delgado Luque, eds. *Memorias del cine: Melilla, Ceuta y el norte de Marruecos*. Cuidad Autónoma de Melilla, Spain: Consejería de Cultura, Educación, Juventud y Deporte, 1999.

Sajit. "Anita Delgado: Desi(red) in India." *Sepia Mutiny*, October 23, 2006. http://www.sepiamutiny.com/sepia/archives/003894.html.

Sala Noguer, Ramón. *El cine en la España republicana durante la guerra civil*. Bilbao, Spain: Ediciones Mensajero, 1993.

Salaün, Serge. *El cuplé*. Madrid, Spain: Espasa Calpe, 1990.

———. "The Cuplé: Modernity and Mass Culture." In *An Introduction*

to Spanish Cultural Studies, edited by Helen Graham and Jo Labanyi, 90–94. London: Oxford University Press, 1995.

———. "La mujer en las tablas: Grandeza y servidumbre de la condición feminina." In *Mujeres de la escena 1900–1940*, edited by María Luz González Peña, Javier Suárez-Pajares, and Julio Arce Bueno, 19–41. Madrid, Spain: Sociedad General de Autores y Editores, 1996.

Sánchez-Albornoz, Nicolás, ed. *The Economic Modernization of Spain, 1830–1930*. Translated by Karen Powers and Manuel Sañudo. New York: New York University Press, 1987.

Sánchez Oliveira, Enrique. *Aproximación histórica al cineasta Francisco Elías Riquelme (1890–1977)*. Seville, Spain: Universidad de Sevilla, 2003.

Sánchez Salas, Daniel. *Historias de Luz y Papel: El cine español de los años veinte, a través de su adaptación de narrativa literaria española*. Murcia, Spain: Filmoteca Regional Francisco Rabal, 2007.

———. "Memoria y arqueología del cine." *Revista de historia del cine* 5 (1996): 93–95.

Sánchez Vidal, Agustín. *El cine de Florián Rey*. Zaragoza, Spain: Caja de Ahorros de la Inmaculada Aragón, 1991.

———. *El cine de Segundo de Chomón*. Zaragoza, Spain: Caja de Ahorros de la Inmaculada, 1992.

———. *El siglo de la luz: Aproximaciones a una cartelera*. Zaragoza, Spain: Caja de Ahorros de la Inmaculada Aragón, 1996.

San Román, Teresa. *La diferencia inquietante: Viejas y nuevas estrategias culturales de los gitanos*. Madrid, Spain: Siglo Veintiuno, 1997.

Santaolalla, Isabel. *Los otros: Etnicidad y 'raza' en el cine español contemporáneo*. Zaragoza, Spain: Prensas Universitarias de Zaragoza, 2005.

Scanlon, Geraldine M. *La polémica feminista en la España contemporánea 1868–1974*. Translated by Rafael Mazarrasa. Madrid, Spain: Akal, 1986.

Schick, Irvin Cemil. *The Erotic Margin: Sexuality and Spatiality in Alteritist Discourse*. London: Verso, 1999.

Sedgwick, Eve Kosofsky. *Epistemology of the Closet*. Berkeley: University of California Press, 1990.

Sevilla Guzmán, Eduardo, and Manuel González de Molina. "Para una teoría del nacionalismo periférico: El caso andaluz." In *Aproximación sociológico al Andalucismo Histórico*, edited by Eduardo Sevilla Guzmán. Córdoba, Spain: Ayuntamiento, 1990.

Shahar, Shulamith. "Religious Minorities, Vagabonds and Gypsies in Early Modern Europe." In *The Roma: A Minority in Europe: Historical, Political, and Social Perspectives*, edited by Roni Stauber and Raphael Vago. Budapest, Hungary: Central European Press, 2007.

Shohat, Ella, and Robert Stam. *Unthinking Eurocentrism: Multicultural-ism and the Media.* New York: Routledge, 1994.

Sieburth, Stephanie. *Inventing High and Low: Literature, Mass Culture, and Uneven Modernity in Spain.* Durham, N.C.: Duke University Press, 1994.

Silverman, Kaja. *The Acoustic Mirror: The Female Voice in Psychoanalysis and Cinema.* Bloomington: Indiana University Press, 1988.

Simmel, Georg. "The Metropolis and Mental Life." In *Metropolis: Center and Symbol of Our Times,* edited by Philip Kasinitz. New York: New York University Press, 1995.

Singer, Ben. *Melodrama and Modernity: Early Sensational Cinema and Its Contexts.* New York: Columbia University Press, 2001.

Spector, Scott. "Was the Third Reich Movie-Made? Interdisciplinarity and the Reframing of 'Ideology.'" *American Historical Review* 106, no. 2 (2001): 460–84.

Sontag, Susan. *Illness as a Metaphor.* New York: Farrar, Strauss and Giroux, 1988.

Spain and the Jews. Madrid, Spain: Diplomatic Information Office, 1949.

Staiger, Janet. *Bad Women: Regulating Sexuality in Early American Cin-ema.* Minneapolis: University of Minnesota Press, 1995.

Stallaert, Christiane. *Etnogénesis y etnicidad: Una aproximación histórico-antropológica del casticismo.* Barcelona, Spain: Proyecto A, 1998.

Stamp, Shelley. *Movie-Struck Girls: Women and Motion Picture Culture after the Nickelodeon.* Princeton, N.J.: Princeton University Press, 2000.

Starr, Paul. *The Creation of the Media: Political Origins of Modern Com-munications.* New York: Basic Books, 2004.

Stoler, Ann Laura. *Race and the Education of Desire: Foucault's History of Sexuality and the Colonial Order of Things.* Durham, N.J.: Duke University Press, 1995.

Studlar, Gaylyn. *This Mad Masquerade: Stardom and Masculinity in the Jazz Age.* New York: Columbia University Press, 1996.

Taibo I, Paco Ignacio. *Un cine para un imperio: Películas en la España de Franco.* Madrid, Spain: Oberon, 2002.

Taylor, Clyde. "The Re-birth of the Aesthetic in Cinema." In *The Birth of Whiteness: Race and the Emergence of U.S. Cinema,* edited by Daniel Bernardi, 15–37. New Brunswick, N.J.: Rutgers University Press, 1996.

Tobing Rony, Fatimah. *The Third Eye: Race, Cinema, and Ethnographic Spectacle.* Durham, N.C.: Duke University Press, 1996.

Torrecilla, Jesús. *España exótica: La formación de la imagen española*

moderna. Boulder, Colo.: Society of Spanish and Spanish American Studies, 2004.

Torres, Augusto M. *Spanish Cinema: 1896–1983*. Madrid, Spain: Ministerio de Cultura, 1986.

Trumpener, Katie. "The Time of the Gypsies: A 'People without History' in Narratives of the West." *Critical Inquiry* 18, no. 4 (1992): 843–84.

Umbral, Francisco. *Memorias de un hijo del siglo*. Madrid, Spain: Ediciones El País, 1987.

Unamuno, Miguel de. *En torno al casticismo*. 11th ed. Madrid, Spain: Espasa Calpe, 1972.

Vázquez Montalbán, Manuel. *Crónica sentimental de España*. 2nd ed. Barcelona, Spain: Bruguera, 1980.

Velasco, Sherry. *The Lieutenant Nun: Transgenderism, Lesbian Desire, and Catalina de Erauso*. Austin: University of Texas Press, 2001.

Ventajas Dote, Fernando. "Historia de los rodajes cinematográficos en la provincia de Málaga: Las producciones de las primeras décadas del siglo XX (1909–1929)." *Isla de Arriarán: Revista cultural y científica* 26 (2005): 197–226.

Vernon, Kathleen. "Culture and Cinema to 1975." *The Cambridge Companion to Modern Spanish Culture*, edited by David T. Gies, 248–66. Cambridge: Cambridge University Press, 1999.

———. "Remaking Spain: Trans/national Mythologies and Cultural Fetishism in *The Devil Is a Woman* (Sternberg, 1935) and *Cet obscur objet du désir* (Buñuel, 1977)." *Journal of Romance Studies* 4, no. 1 (2004): 13–27.

Vidal, Nuria. "Humor, música y hermanos (El cine de Iquino en Cifesa)." *Archivos de la Filmoteca* 1, no. 4 (1989): 66–73.

Vilarós, Teresa M. *El mono del desencanto: Una crítica cultural de la transición española (1973–1933)*. Madrid, Spain: Siglo XXI, 1998.

Villarejo, Amy. "Tarrying with the Normative: Queer Theory and Black History." *Social Text* 23, nos. 3–4 (2005): 69–84.

Víllora, Pedro Manuel, collaborator. *Imperio Argentina: Malena Clara*. Madrid, Spain: Temas de Hoy, 2001.

Virilio, Paul. *The Vision Machine*. Bloomington: Indiana University Press, 1994.

Walkowitz, Judith R. "The 'Vision of Salome': Cosmopolitanism and Erotic Dancing in Central London, 1908–1918." *American Historical Review* 108, no. 2 (2003): 337–76.

Webber, Christopher. "La corte de faraón." *Zarzuela.net*. Last modified September 6, 2004. http://www.zarzuela.net/syn/faraon.htm.

———. "Introduction: Music, Dance, and the Politics of Passion." In *The Passion of Music and Dance: Body, Gender and Sexuality*, edited by William Washabaugh. Oxford, UK: Berg, 1998.

Williams, Linda. *Playing the Race Card: Melodramas of Black and White from Uncle Tom to J. J. Simpson*. Princeton, N.J.: Princeton University Press, 2001.

Winant, Howard. "The Theoretical Status of the Concept of Race." In *Theories of Race and Racism*, edited by Les Back and John Solomos. New York: Routledge, 2000.

Woodhull, Winifred. "*Carmen* and Early Cinema: The Case of Jacques Feyder (1926)." In *Carmen: From Silent Film to MTV*, edited by Chris Perriam and Ann Davies, 91–105. Rodopi: Amsterdam and New York, 2005.

Woods Peiró, Eva. "From Rags to Riches: The Ideology of Stardom in Folkloric Musical Comedy Films of the Late 1930s and 40s." In *Spanish Popular Cinemas*, edited by Antonio Lázaro-Reboll and Andrew Willis, 24–39. Manchester, UK: Manchester University Press, 2004.

———. "Radio Free *Folklóricas*: Cultural, Gender and Spatial Hierarchies in *Torbellino* (1941)." In *Gender and Spanish Cinema*, edited by Steven Marsh and Parvati Nair, 201–18. London: Berg, 2004.

Young, Robert J. C. *Colonial Desire: Hybridity in Theory, Culture, and Race*. London: Routledge, 1995.

Žižek, Slavoj. *The Plague of Fantasies*. Verso: London, 1997.

———. *The Sublime Object of Ideology*. London: Verso, 1989.

Zoido Naranjo, Florencia, and Juan Francisco Ojeda Rivera. "Diversidad, desigualdad y cohesion territorial en Andalucía." In *Geografía de Andalucía*, edited by A. Lopez Oniveros, 777–812. Barcelona, Spain: Riel, 2003.

Filmography

800 balas (dir. Álex de la Iglesia, 2002; 800 bullets).
¡A mí la legión! (dir. Juan de Orduña, 1942; My legion).
A un dios desconocido (dir. Jaime Chávarri, 1977; To an unknown god).
Águilas de acero or *Los misterios de Tánger* (dir. Florián Rey, 1927; Steel eagles or The mysteries of Tangiers).
El abuelo (dir. José Buchs, 1925; The grandfather).
The Adventures of Dollie (dir. D. W. Griffith, 1908).
Alalá or *El hijo del misterio* (dir. Adolf Trotz, 1933; Alalá or The son of mystery).
Alba de América (dir. Juan de Orduña, 1951; Dawn of America).
La alegre caravana (dir. Ramón Torrado, 1953; The happy [Gypsy] caravan).
Alhucemas (dir. José López Rubio, 1948).
Alma de dios (dir. Manuel Noriega, 1925; Soul of god).
Alma rifeña (dir. Jose Buchs, 1922; Riffian soul).
El amor brujo (dir. Carlos Saura, 1986; A love bewitched).
El amor gitano (dir. Segundo de Chomón, 1910; Gypsy love).
L'arpete (dir. Donatien, 1929; The seamstress).
Au revoir et merci (dir. Pierre Colombier and Donatien, 1926; Thank you and good-bye).
Agustina de Aragón (dir. Juan de Orduña, 1950).
Aventuras de Juan Lucas (dir. Rafael Gil, 1949; Adventures of Juan Lucas).
El bailarín y el trabajador (dir. Luis Marquina, 1936; The dancer and the worker).
Bambú (dir. José Luis Sáenz de Heredia, 1945).
El barbero de Sevilla (dir. Benito Perojo, 1938; The barber of Seville).
Barcelona en tranvía (dir. Ricardo de Baños, 1908; Barcelona by tramcar).
La Bejarana (dir. Eusebio Fernández Ardavín, 1926; The girl from Bejar).
¡Bienvenido, Mister Marshall! (dir. Luis García Berlanga, 1951; Welcome, Mister Marshall!).

La blanca paloma (dir. Claudio de la Torre, 1942; The white dove).
Bodas de sangre (dir. Carlos Saura, 1981; Blood wedding).
La bodega (dir. Benito Perojo, 1929; The wine cellar).
Bonheur conjugal (dir. Robert Saidreau, 1922; Happy couple).
Bringing Down the House (dir. Adam Shankman, 1993).
Broken Blossoms or *The Yellow Man and the Girl* (dir. D. W. Griffith, 1919).
Un caballero andaluz (dir. Luis Lucía, 1954; An Andalusian gentleman).
Un caballero de frac (dir. Roger Capellani, Carlos San Martín, 1931; A gentleman in coattails).
Un caballero famoso (dir. José Buchs 1942; A famous gentleman).
Cabrita que tira al monte (dir. Fernando Delgado, 1926; Kid goat goes to the mountain).
Calle Mayor (dir. Juan Antonio Bardem, 1956; Main Street).
Cambio de sexo (dir. Vicente Aranda, 1977; Sex change).
La canción de Aixa (dir. Florián Rey, 1939; The song of Aixa).
Canelita en rama (dir. Eduardo García Maroto, 1943; Cinnamon flower).
Carmen (dir. Giovanni Doria and Augusto Turqui, 1914).
Carmen (dir. Jacques Feyder, 1926).
Carmen (dir. Carlos Saura, 1983).
Carmen, la de Triana (dir. Florián Rey, 1938; Carmen from Triana).
Carmen, o La hija del contrabandista (dir. Ricardo de Baños and Ramón de Baños, 1911; Carmen, or The smuggler's daughter).
La casa de troya (dir. Manuel Noriega, 1925; College boarding house).
Castañuela (dir. Ramón Torrado, 1945; Castanet).
El centauro (dir. Antonio Guzmán Merino 1946; The centaur).
¡Centinela, alerta! (dir. Jean Grémillon and Luis Buñuel, 1937; Sentinel, alert!).
Chang: A Drama of the Wilderness (dir. Merian C. Cooper and Ernest B. Schoedsack, 1928).
Le chateau de la morte lente (dir. Donatien, 1927; The chateau of slow death).
La cigarra (dir. Florián Rey, 1948; The cricket).
City Lights (dir. Charles Chaplin, 1931).
El clavo (dir. Rafael Gil, 1944; The nail).
La Condesa María (dir. Benito Perojo, 1923; The Countess María).
Corazones sin rumbo (dir. Benito Perojo, 1928; Wandering hearts).
El correo del rey (dir. Ricardo Gascón, 1951; The king's mail).
La corte de faraón (dir. José Luis García Sánchez, 1985; The court of the pharaoh).

Las cosas del querer (dir. Jaime Chávarri, 1989, 1995; The things of love).
Una Cubana en España (dir Luis Bayón Herrera, 1951; A Cuban in Spain).
Cuentos de la Alhambra (dir. Florián Rey, 1950; Tales of the Alhambra).
El cura del aldea (dir. Florián Rey, 1926; The village priest).
Currito de la cruz (dir. Luis Lucía, 1948; Currito of the cross).
Curro Vargas (dir. José Buchs, 1923).
Dale betún (dir. Raymond Chevalier, 1934; Give him bootblack).
La dama de armiño (dir. Eusebio Fernández Aravín, 1947; The lady in ermine).
De Málaga a Vélez-Málaga (dir. Ricardo Baños, 1909; From Malaga to Velez-Malaga).
Debla, la virgen gitana (dir. Ramón Torrado, 1951; Debla, the Gypsy virgin).
Desembarco en Alhucemas (Estado Mayor del Ejército, 1925; Landing in Alhucemas).
The Devil Is a Woman (dir. Josef von Sternberg, 1935).
El día que nací yo (dir. Pedro Olea, 1991; The day I was born).
La Dolorosa (dir. Jean Grémillon 1934; The sorrowful one).
La Dolores (dir. Florián Rey, 1939; The sorrowful one).
Doloretes (dir. José Buchs, 1925; The sorrowful one [Catalan]).
Don Juan Tenorio (dir. Ricardo Baños, 1922).
La Duquesa de Benamejí or *La reina de Sierra Morena* (dir. Luis Lucía, 1949; The Duchess of Benamejí or The queen of the Sierra Morena).
L'eau du Nil (dir Marcel Vandel, 1928; Water of the Nile).
Embrujo (dir. Carlos Serrano de Osma, 1946; Charmed).
El Embrujo de Sevilla (dir. Benito Perojo, 1930; The charm of Seville).
Es mi hombre (dir. Carlos Fernández Cuenca, 1927; My man).
España en Marruecos (Estado Mayor del Ejército, 1925; Spain in Morocco).
España heroica (dir. Joaquín Reig, 1937; Heroic Spain).
Eugenia de Montijo (dir. José López Rubio, 1948).
La fiesta sigue (dir. Enrique Gómez, 1948; The party goes on).
Filigrana. (dir. Luis Marquina, 1949; The filigreed one).
Forja de almas (dir. Eusebio Fernández Ardavín, 1944; Forge of souls).
El frente de los suspiros (dir. Juan de Orduña, 1942; The battlefront of sighs).
Frivolinas (dir. Arturo Carballo, 1926; Frivolities).
El gato montés (dir. Rosario Pi, 1936; The wild cat).
El genio alegre (Fernando Delgado 1939, 1957; The cheerful temper).
Gentleman's Agreement (dir. Elia Kazan, 1947; *La barrera invisible*).

Gigantes y cabezudos (dir. Florián Rey, 1926; Carnival figures).

La gitana blanca or *Los arlequines de seda y oro* (dir. Ricardo de Baños, 1919; The white Gypsy or Harlequins of gold and silk).

La gitana y el rey (dir. Manuel Bengoa, 1945; The Gypsy and the king).

La Gitanilla (dir. Ariá Gual, 1914; The little Gypsy girl).

La Gitanilla (dir. André Hugón, 1923; The little Gypsy girl).

La Gitanilla (dir. Fernando Delgado, 1940; The little Gypsy girl).

Goyescas (dir. Benito Perojo, 1942; Goyaesque).

Grass: A Nation's Battle for Life (written by Richard Carver and Terry Ramsaye, 1925).

¡Harka! (dir. Carlos Arévalo, 1941).

La hermana San Sulpicio (dir. Florián Rey, 1927, 1934; Sister San Sulpicio).

La hermana San Sulpicio (dir. Luis Lucía, 1952; Sister San Sulpicio).

Héroe a la fuerza (dir. Benito Perojo, 1941; Hero by force).

Los héroes de legión (dir. Rafael López Rienda, 1927; The heroes of the legion).

La hija de Juan Simón (dir. Nemesio M. Sobrevilla and José Luis Sáenz de Heredia, 1935; Juan Simon's daughter).

La hija de Juan Simón (dir. Gonzalo Delgras 1957; Juan Simon's daughter).

Un hombre llamado Flor de Otoño. (dir. Pedro Olea, 1978; A man called Flower of Autumn).

El hombre que se reía del amor (dir. Benito Perojo, 1932; The man who laughed at love).

Inéz de Castro (dir. Manuel Augusto García Viñolas and José Leitão de Barros, 1944).

Jalisco canta en Sevilla (dir. Fernando de Fuentes, 1948; Jalisco sings in Seville).

The Jazz Singer (dir. Alan Crosland, 1927).

Los judíos de la patria española (dir. Ernesto Giménez Caballero, 1931; Jews of the Spanish homeland).

King Kong (dir. Merian Cooper and Ernest B. Shoedsack, 1933).

Lady Harrington (dir. Hewitt Claypoole Grantham-Hayes and Fred LeRoy Granville, 1927).

La leona de Castilla (dir. Juan de Orduña, 1951; The lioness of Castille).

La loca de la casa (dir. Luis R. Alonso, 1926; The crazy housewife).

Locura de amor (dir. Juan de Orduña, 1948; The mad queen).

La Lola se va a los puertos (dir. Juan de Orduña, 1947; Lola goes to the ports).

La Lola se va a los puertos (dir. Josefina Molina, 1992; Lola goes to the ports).

The Loves of Carmen (dir. Raoul Walsh, 1927).

Las luces de Buenos Aires (dir. Adelqui Migliar, 1931; The lights of Buenos Aires).

Mabel at the Wheel (dir. Mabel Normand, Mack Sennett, 1914).

Macarena (dir. Antonio Guzmán Merino, 1944).

La mala educación (dir. Pedro Almodóvar, 2004; *Bad Education*).

La malcasada (dir. Francisco Gómez Hidalgo, 1926; The unhappy wife).

El malvado Carabel (dir. Edgar Neville, 1935; The evil Carvel).

Malvaloca (dir. Benito Perojo, 1926; Hollyhock).

Malvaloca (dir. Luis Marquina, 1942; Hollyhock).

Malvaloca (dir. Ramon Torrado, 1954; Hollyhock).

María Antonia 'La Caramba' (dir. Arturo Ruiz Castillo, 1951).

María Candelaria or *Xochimilco* (dir. Emilio Fernández, 1944).

María de la O (dir. Francisco Elías, 1936).

María de la O (dir. Ramón Torrado, 1954).

Marianela (dir. Benito Perojo, 1940).

Mariquilla terremoto (dir. Benito Perojo, 1938; Mariquilla the bombshell).

Martingala (La copla andaluza) (dir. Fernando Mignoni, 1939; The trick [Andalusian Song]).

Le martyre de Sainte-Maxeuse (dir. Donatien, 1927; The martyr of Sainte-Maxeuse).

Maruxa (dir. Henry Vorins, 1923).

El mayorazgo de Basterretxe (dir. Mauro Azcona, 1928; The primogeniture of Basterretxe).

Me casé con una estrella (dir. Luis César Amadori, 1951; I married a star).

The Melody Trail (dir. Joseph Kane, 1935).

La menace (dir. Henri Pouctal, 1915; The menace).

La mentira de la Gloria (dir. Julio Fleischner, 1946; Gloria's lie).

Mercedes (dir. José María Castellví and Francisco Elías, 1933).

La misión blanca (dir. Juan de Orduña, 1946; The white mission).

Miss Edith (dir. Donatien, 1928).

El misterio de la Puerta del Sol (dir. Francisco Elías, 1929; The mystery of the Puerta del Sol).

Misterio en la marisma (dir. Claudio de la Torre, 1943; Mystery in the marsh).

Los misterios de Tánger (dir. Florián Rey, 1927; The mysteries of Tangiers).

Morena Clara (dir. Florían Rey, 1936; The light-skinned one).

Morena Clara (dir. Luis Lucía, 1954; The light-skinned one).

La muerte de Mikel (dir. Imanol Uribe, 1984; The death of Mikel).

Una mujer en peligro (dir. José Santuguni, 1936; A woman in danger).

Nanook of the North (dir. Robert J. Flaherty, 1922).

La negra (dir. Oscar Micheaux, 1919; The black woman).

El negro que tenía el alma blanca. (dir. Benito Perojo, 1926, 1934; The black man with the white soul).

El negro que tenía el alma blanca. (dir. Hugo del Carril, 1951; The black man with the white soul).

La niña de la venta (dir. Ramón Torrado, 1951; The girl of the inn).

La niña de tus ojos (dir. Fernando Trueba, 1998; The girl of your dreams).

Nobleza baturra (dir. Juan Vila Vilamala, 1925; [Aragonese] Rustic chivalry).

Nobleza baturra (dir. Florián Rey, 1935; [Aragonese] Rustic chivalry).

Nocturno (dir. Marcel Silver, 1927; Nocturne).

Los nuevos españoles (dir. Roberto Bodegas, 1974; The new Spaniards).

Ocaña: Retrat intermitent (dir. Ventura Pons, 1978; Ocaña: An intermittent portrait).

Olé torero (dir. Benito Perojo, 1948; Olé bullfighter).

Les opprimés or *La rosa de Flandes* (dir. Henry Rousell, 1923; The oppressed or The rose of Flanders).

Oro y márfil (dir. Gonzalo Delgrás, 1947; Gold and ivory).

La patria chica. (dir. Fernando Delgado, 1943; Hometown).

The Peachbasket Hat (dir. D. W. Griffith, 1909).

Pepe Conde (dir. José López Rubio, 1941).

El pobre Valbuena (dir. José Buchs, 1923; Poor Valbuena).

Polvorilla (dir. Florián Rey, 1956; Little dust storm).

La princesa de los ursinos (dir. Luis Lucía, 1947; The princess of the ursines).

Puerta del Sol (dir. Alexandre Promio, 1896).

La pura verdad (dir. Florián Rey, Manuel Romero, 1931; The pure truth).

Qué he hecho yo para merecer esto (dir. Pedro Almodóvar, 1984; What have I done to deserve this?).

Rataplán (dir. Francisco Elías, 1935; Ra-ta-ta).

Raza or *El espíritu de una raza* (dir. José Luis Sáenz de Heredia, 1942; Race or The spirit of a race).

Regeneración (dir. Domenec Ceret, 1916; Regeneration).

La reina mora (dir. José Buchs, 1922; The Moorish queen).

La reina mora (dir. Eusebio Fernández Ardavín, 1937; The Moorish queen).

La reina mora (dir. Raúl Alfonso, 1955; The Moorish queen).
Reina santa (dir. Henrique Campos, 1947; Saintly queen).
El relicario (dir. Ricardo de Baños, 1933; The reliquary).
Rescued by Rover (dir. Lewin Fitzhamon and Cecil M. Hepworth, 1905).
La Revoltosa (dir. Florián Rey, 1924; The unruly girl).
Rojo y negro (dir. Carlos Arévalo, 1942; Red and black).
Ronde de nuite (dir. Marcel Silver, 1926; Night watch).
Romancero marroquí (dir. Enrique Domínguez Rodiño and Carlos
 Velo, 1939; Moroccan ballad).
Rosario la cortijera (dir. José Buchs, 1924; Rosario the farm girl).
Rosario la cortijera (dir. León Artola, 1935; Rosario the farm girl).
Salida de Misa de doce de las Calatravas (dir. Ramón del Río, 1896;
 Leaving Mass at twelve from the Calatravas).
Del schottis al charlestón (dir. Ernesto González, 1927; From the
 Schottische to the Charleston).
La señorita de Trévelez (dir. Edgar Neville, 1936; Miss Trevelez).
La Sévillane (dir. André Hugon and Jorge Salviche, 1943; The
 Sevillian).
El sexto sentido (dir. Eusedbio Fernández Ardavín and Nemesio M.
 Sobrevila, 1929; The sixth sense).
Simba: The King of the Beasts (written by Martin E. Johnson and Terry
 Ramsaye, 1928).
La sin ventura (dir. Benito Perojo, 1923; The luckless lady).
The Singing Fool (dir. Lloyd Bacon, 1928).
La sobrina del cura (dir. Luis Alonso 1925; dir. Juan Bustillo Oro 1954;
 The priest's niece).
Un soltero difícil (dir. Manuel Tamayo 1950; A difficult bachelor).
The Son of the Sheik (dir. George Fitzmaurice, 1926).
A Star Is Born (dir. William Wellman, 1937).
A Star Is Born (dir. George Cukor, 1954).
Superstition andalouse (dir. Segundo de Chomón, 1912; Andalusian
 superstition).
Suspiros de España (dir. Benito Perojo, 1938; Sighs of Spain).
Tacones lejanos (dir. Pedro Almodóvar, 1991; High heels).
Tercio de quites (dir. Emilio Gómez Muriel, 1951; Bullfighting song).
La terre promise (dir. Henry Rousell, 1925; The promised land).
Torbellino. (dir. Luis Marquina, 1941; Twister).
La torre de los siete jorobados (dir. Edgar Neville, 1944; The tower of
 seven humpbacks).
Un tren escocés (dir. Unknown, 1898; A Scottish train).
Tsirk (dir. Grigori Aleksandrov and I. Simkov, 1936; Circus).

Los últimos de Filipinas (dir. Antonio Román 1945; The last ones from the Philippines).

The Vagabond (dir. Charles Chaplin, 1916).

La Venenosa (dir. Roger Lion, 1928; The poisonous one).

La verbena de la Paloma (dir. José Buchs, 1921; Fair of the Virgin of the dove).

La verbena de la Paloma (dir. Benito Perojo, 1935; Fair of the Virgin of the dove).

La verbena de la Paloma (dir. José Luis Sáenz de Heredia, 1963; Fair of the Virgin of the dove).

La vida de los gauchos en México (dir. Unknown, 1898; The life of the gauchos in Mexico).

Violetas imperiales (dir. Henry Rousell, 1923; Royal violets).

Vistas de las capitales de Europa (dir. Unknown, 1898; Views of the capitals of Europe).

Yo canto para ti (dir. Fernando Roldán, 1933; I sing for you).

Yo soy ésa (dir. Luis Sanz, 1990; I'm the one).

Zouzou (dir. Marc Allegret, 1934).

Index

Eva Woods Peiró is associate professor of Hispanic studies and director of the Media Studies Program at Vassar College. She is the coeditor (with Susan Long) of *Visualizing Spanish Modernity* (2005).